Negotiating Rapture

NEGOTIATING RAPTURE

The Power of Art
to Transform Lives

Richard Francis

With essays by

Homi K. Bhabha

Georges Didi-Huberman

David Morgan

Lee Siegel

With contributions from

Yve-Alain Bois

Wendy Doniger

Kenneth Frampton

Martin E. Marty

John Hallmark Neff

Annemarie Schimmel

Sophia Shaw

Helen Tworkov

Museum
of
Contemporary
Art

Chicago

Negotiating Rapture: The Power of Art to Transform Lives was published in conjunction with the exhibition of the same title at the Museum of Contemporary Art, Chicago, 21 June–20 October 1996. The exhibition was conceived and organized by Richard Francis, with the assistance of Sophia Shaw, and presented on the occasion of the inauguration of the new museum.

The catalogue was made possible by a grant from the Elizabeth F. Cheney Foundation.

The Museum of Contemporary Art (MCA) is a non-profit tax-exempt organization. The MCA's exhibitions, programming, and operations are member supported and privately funded through contributions from individuals, corporations, and foundations. Additional support is provided through the Illinois Arts Council, a state agency, and American Airlines, the official Airline of the Museum of Contemporary Art.

Lead corporate sponsors for the Museum of Contemporary Art's grand opening and inaugural year are American Airlines, Bank of America, Hal Riney & Partners, Marshall Field's and Target stores, Philip Morris Companies Inc., and the Sara Lee Corporation.

Published by the Museum of Contemporary Art, 220 East Chicago Avenue, Chicago, Illinois, 60611. Distributed by The University of Chicago Press.

ISBN 0-933856-40-7

Library of Congress Catalogue Card Number 95-81492

Produced by the Publications Department of the Museum of Contemporary Art, Chicago, Donald Bergh, Director, and Amy Teschner, Associate Director.

Edited by Sue Taylor.
Designed by Philip Burton.

Printed and bound by Friesens, Altona, Manitoba, Canada.

Cover: Lake Michigan, early morning, December 1995. Photograph by Joe Ziolkowski.

Photography Credits

Illustrations accompanying the essays and "Travel Guide" have been provided by the owners of the works or their agents, as indicated in the captions. The following list credits photographers to whom a separate acknowledgment is due: **cat. nos. 1, 11, 13, 25, 65, 67, 73, 77, 82:** John Weinstein; **cat. nos. 2, 33, 59, 62, 64, 66, 75, 85, 86:** Joe Ziolkowski; **cat. no. 4:** Hickey and Robertson, Houston; **cat. no. 6:** Ben Blackwell; **cat. no. 12:** Ian Fraser-Martin; **cat. nos. 20–24:** Ricardo Blanc; **cat. no. 29:** Michael Cavanagh, Kevin Montague; **cat. no. 34:** D. Harris; **cat. no. 35:** Michael Tropea; **cat. no. 36:** Jim Strong; **cat. nos. 39–40:** Eric E. Mitchell; **cat. no. 41:** Craig Anderson, Des Moines; **cat. no. 42:** Sarah Harper Gifford, courtesy PaceWildenstein; **cat. no. 58:** Lee Stalsworth; **cat. no. 63:** Rick Echelmeyer; **cat. nos. 69, 74:** Susan Einstein; **cat. no. 70:** Richard Stoner; **cat. no. 73:** Kenneth Hayden; **cat. no. 76:** Ellen Page Wilson, courtesy PaceWildenstein; **cat. no. 80:** David A. Loggie; **cat. no. 83:** Kira Perov and Squidds and Nunns.

Copyright Permissions

This catalogue was made possible by
the generous support of the
Elizabeth F. Cheney Foundation.

Francis Bacon

Joseph Beuys

James Lee Byars

Lucio Fontana

Shirazeh Houshiary

Anselm Kiefer

Agnes Martin

Bruce Nauman

Barnett Newman

Ad Reinhardt

Bill Viola

Art, "the mirror held up to nature," provides a reflection of the interior self. For of all man's endeavors, art, with its plenitude and resonance, has the capacity to articulate those primordial and eternal mysteries that inhabit the psyche—the soul, the secret realities—and make them perceptible through image, symbol, and metaphor. . . . We need art's organizing power to impose order on nature, both physical and human; to defend against the chaos of fragmentation and dissolution; and to clarify our perceptions and conceptions about existence, life, and death.

Since the age of Enlightenment, the arts have been a vehicle for conveying much of the mystery and transcendental yearning the Church was able to contain before it became rationalized. Art in modern times bears a resemblance to religious ritual and the sense of deeply felt shared experience. As a surrogate for religion, art combats the emptiness and malaise that permeates these anxious, dehumanized times. In short, it creates a world of imagination that can transfigure the human spirit.

x

—Joseph R. Shapiro
Founding President of the Museum of Contemporary Art,
accepting the first Joseph R. Shapiro Award for a Distinguished
Collector of Art, awarded by The David and Alfred Smart
Museum of Art, The University of Chicago, 11 October 1995.

It is with pride and celebration that we present *Negotiating Rapture* as the first loan exhibition in the new Museum of Contemporary Art. Our new structure, designed by the internationally acclaimed Berlin architect Josef Paul Kleihues, fulfills more than a decade of anticipation and planning, and will better enable us to realize the museum's mission to present, interpret, collect, and preserve contemporary art for a diverse audience. Located on a glorious site along Chicago's Magnificent Mile, with the historic Water Tower to the west and Lake Michigan to the east, the new building adds to the great architectural vitality of Chicago while providing an appropriate showcase for major temporary exhibitions such as this one and for our permanent collection. With sufficient galleries for aspects of the collection to be continually on view, and to accommodate our developing programs, we can establish contexts and more effectively relate modern and contemporary art to society and, in the case of *Negotiating Rapture*, to artistic traditions on a global scale.

Some of our audience may enter the museum believing that contemporary art is inaccessible, dislocated from accepted artistic traditions and unrelated to daily life. One of the many challenges for a museum devoted solely to contemporary art is demonstrating that art created in the present does relate to the history of art, and although artistic ideals take different forms throughout the ages, works of art made now often have qualities consistent with those made in the past. Visitors to this exhibition will discover how the diverse artists represented—Francis Bacon, Joseph Beuys, James Lee Byars, Lucio Fontana, Shirazeh Houshiary, Anselm Kiefer, Agnes Martin, Bruce Nauman, Barnett Newman, Ad Reinhardt, and Bill Viola—address issues that have also been of concern to artists of past generations: through the artmaking process, they attempt to satisfy a universal human desire for a heightened physical and emotional experience, to achieve a transcendent or spiritual state. *Negotiating Rapture* connects contemporary investigations to older traditions through the inclusion of old-master paintings, drawings, and prints as well as objects from other fields—archaeology, architecture, literature, science, philosophy, and religion. We believe that the exhibition will touch viewers because it foregrounds faith and spirituality in an era when such searches and rediscoveries are rarely acknowledged in a museum context.

One person who has always understood the relationship of art to this "transcendental yearning" is Joseph R. Shapiro, Founding President of the Museum of Contemporary Art, and it gives us great pleasure to honor him in the opening pages of this book, where he has permitted us to cite his reflections on the profound spiritual significance of the art of our time. That significance is powerfully apparent in *Negotiating Rapture*, an achievement we owe to Richard Francis, Chief Curator and James W. Alsdorf Curator of Contemporary Art, whose international perspective and classical training have given us a philosophically challenging—and stunningly beautiful—exhibition with which to inaugurate the new Museum of Contemporary Art. Finally, we are most grateful for the support of the Elizabeth F. Cheney Foundation; their generosity has allowed us to document this important project in a catalogue of corresponding scope and scholarly value.

Kevin E. Consey
Director and Chief Executive Officer

xi

Few curators could expect the support and sustained interest of their trustees in the way in which the Exhibition Advisory Committee of the Museum of Contemporary Art was involved in this show, and I thank them.

I am most grateful to the lenders to the exhibition, and to all those colleagues in other museums and galleries who have made special efforts to enable works to be shown, particularly colleagues in Chicago who have welcomed the new museum so warmly by their generosity.

The writers for the catalogue have enriched this project enormously and many have extended welcome support and advice. I would like also to thank the designer, Philip Burton, and editor, Sue Taylor, as well as the directors of the Elizabeth F. Cheney Foundation, whose crucial early support made this publication possible.

All of my colleagues at the MCA have risen to the challenge of a complex and hard-to-explain exhibition with great style and enthusiasm, none more so than my curatorial assistant and collaborator, Sophia Shaw.

As I have worked on the project, I have realized my debt to Christopher Dixon, who introduced comparative religion and taught me to love literature at Oakham School. In my research, I found his correspondence from Oakham with Thomas Merton, who had preceded us both there. *Et quasi cursores . . . lampada tradunt.*

And I am especially grateful to my wife, Tamar, and daughter, Jasmine, for putting up with me during the whole process.

Richard Francis, Chief Curator
James W. Alsdorf Curator of Contemporary Art

Abbey of Gethsemani, Trappist, Kentucky

Allen Memorial Art Museum, Oberlin College, Ohio

Anonymous lenders

The Art Institute of Chicago

The Arts Club of Chicago

Benesse Corporation, Naoshima Contemporary Art Museum, Japan

Christine and Isy Brachot, Brussels

The Brooklyn Museum, New York

The Carnegie Museum of Art, Pittsburgh

Leo Castelli Gallery, New York

Edward C. Cohen, New York

Des Moines Art Center, Iowa

Mr. and Mrs. Daniel W. Dietrich II

The Duke of Devonshire and the Chatsworth Settlement Trustees, Derbyshire, England

The Field Museum, Chicago

Fondation Cartier pour l'Art Contemporain, Paris

Froehlich Collection, Stuttgart

Solomon R. Guggenheim Museum, New York

Hirshhorn Museum and Sculpture Garden, Smithsonian Institution, Washington, D.C.

William Morris Hunt Memorial Library, Museum of Fine Arts, Boston

Indiana University Art Museum, Bloomington

The Israel Museum, Jerusalem

Emily Fisher Landau, New York

Lannan Foundation, Los Angeles

LINC Group, Chicago

Lisson Gallery, London

Susan and Lewis Manilow

Agnes Martin

McMaster University, Hamilton, Ontario

The Menil Collection, Houston

Merton Legacy Trust

The Mies van der Rohe Archive, The Museum of Modern Art, New York

Adriana and Robert Mnuchin

The Pierpont Morgan Library, New York

Museo Civico di Bassano del Grappa, Italy

Museum of Contemporary Art, Chicago

The Museum of Contemporary Art, Los Angeles

The Museum of Modern Art, New York

National Archives, Washington, D.C.

The Nelson-Atkins Museum of Art, Kansas City, Missouri

The Newberry Library, Chicago

Anthony d'Offay Gallery, London

Mr. and Mrs. David Pincus

Anna Reinhardt

Penny Pritzker and Bryan Traubert

Arthur M. Sackler Museum, Harvard University Art Museums

San Francisco Museum of Modern Art

Spertus Museum, Chicago

Marcia and Irving Stenn, Chicago

Tate Gallery, London

Lynn and Allen Turner

The University of Chicago Library

Walker Art Center, Minneapolis

xiii

Negotiating Rapture:
The Power of Art
to Transform Lives

On my arrival in the United States the religious aspect of the country was the first thing that struck my attention; and the longer I stayed there, the more I perceived the great political consequences resulting from this new state of things. . . .

As long as a religion is sustained by those feelings, propensities, and passions which are found to occur under the same forms at all periods of history, it may defy the efforts of time; or at least it can be destroyed only by another religion. But when religion clings to the interests of the world, it becomes almost as fragile a thing as the powers of earth. It is the only one of them all which can hope for immortality; but if it be connected with their ephemeral power, it shares their fortunes and may fall with those transient passions which alone supported them.

Alexis de Tocqueville[1]

An explanation, inevitably partial (both limited and partisan), of the enduring but frail human belief in the possibility of bliss or ecstasy is offered here through some art made since 1945. *Negotiating Rapture* tries to show some of the ways in which recent artists have sought and revealed the types of experience that, in previous periods, have been put in the care of religious proselytes of various kinds, be they monks, mystics, or other spiritual adherents. The need for rapture, for those moments of such exalted pleasure that we no longer recognize our rootedness in the material world, is demonstrated by the eleven artists represented in the exhibition, each differently and with a surprising variety of methods. The spiritual, religious piety, and extreme states have always aroused complex and often contentious issues, and the questions this exhibition asks are inevitably large and difficult: Is a spiritual dimension necessary for a full life? Can art, most particularly abstract art, help us understand spiritual mystery? Does the common claim that the museum has replaced the cathedral—evidence of late capitalism's hegemony over our material and sacred lives—have any real substance? Can artists aspire to feelings associated with religion as methods to express themselves? Is this useful or relevant for people who are not making art, but are its consumers, the museum's patrons? If we can answer "yes" to some (or all) of these questions, then how do we understand the rapture of art, how do we deal or do business with it? The short answer is "not easily," since the negotiation of rapture requires knowledge and some faith.

Richard Francis

NEGOTIATING RAPTURE,

AN INTRODUCTION

This exhibition and book attempt to provide a number of access points for the spectator, or deal-maker, to gather data. The process is approached more in the spirit of a sharing of knowledge than in the didactic style of "Rapture 101" because every journey is individual; there is no single or simple path. Mine begins and is, of course, conditioned by my training as an art historian of the modern period and my background as a high-church Anglican, inevitably coloring any approach I might make. Search and journey are important metaphors because they are characteristic of both the production of art and the practices of religious seekers. Similarly, religious contemplation—concentrated thought about apparently inexpressible subjects—is like time spent in the studio, and the

2

1. Alexis de Tocqueville, *Democracy in America*, vol. 1, ed.
 Phillips Bradley (New York: Alfred A. Knopf, 1945), 308, 311.

need for solitude or isolation from the problems of everyday life is also common to both. That is why the exhibition begins with an image of a Christian saint going into the desert for enlightenment (cat. no. 29) and ends with Bruce Nauman's question/statement of the true artist's succor to all of us (cat. no. 54). The difficulty and individuality of the search alert us that we should not dictate or expect any universal or definitive answers to our questions.

What can be asserted, however, is that when we find individuals who have sought enlightenment we expect them to explain the world to us, to reveal some of its mysteries. Not, as some scientists do, by explaining the mechanics, but by uncovering the mystical part of the mystery. Einstein saw this underlying challenge when he said, "The most beautiful, the most profound emotion that we can experience is the sensation of the mystical. It is the fundamental emotion that stands at the cradle of true art and science."[2] What we want from all these seekers, be they contemplatives or mystics, scientists or poets, are explanations about what is happening in the world. The exhibition becomes an explanation of some ideas about the world through the agency of art. This postmodern description implies relative importance, and relations from one object to another and from spectator to object, which modernists would have thought impure or improper. In effect it becomes possible, outside the confines of self-referential modernism, in which art refers only to art, to look at ideas and systems that encompass our humanness, to dare to discuss rapture, for example, in ways a modernist could not have considered. We can re-interpret not only the art but the ways in which we describe its interrelation with the world. And one of the ways we construct our sense of reality is uncovered here through descriptions in art that are emotional, spiritual, or religious.

The exhibition is conceived around one particular definition of rapture—those precise periods of blissful transport with which religion and sexuality are familiar—and includes works of art from 1945 through 1995. These objects are "linked" by artifacts and works of art from different periods and cultures. It is important that while the religious quality of rapture is acknowledged, it is separated from its limited political qualities, as de Tocqueville had found essential for the health of the American governmental system.[3] The intervention of the political into the debate leads inexorably to the erosion of what are properly called moral (in the sense of humanist) values of creativity. Our concern, therefore, is detecting and revealing the presence in this exhibition of sensations of enchantment that transcend our bureaucratic systems. This I take to be the religious meaning of rapture: that it involves transport, the subject being moved, often in a state of ecstasy, as Ganymede is transported by Zeus in one of the link images in the exhibition— Giulio Clovio's *The Rape of Ganymede* (cat. no. 12). Here the beautiful youth is abducted by an eagle (his raptor), and the words have the same Latin root, *raptus*, meaning "taken by force." Ecstasy and bliss are physical and visible. The Clovio drawing serves as a transition in the exhibition from Agnes Martin, whose spirituality is natural in the sense of the American Transcendentalism of Thoreau and Whitman, to Francis Bacon, whose rapture came from exploring taboos. Bacon was antagonistic to the organized religion of his birthplace but used its symbols and its opposition to his homosexuality as a

2. Albert Einstein quoted in Committee on Psychiatry and Religion, Group for the Advancement of Psychiatry, *Mysticism: Spiritual Quest or Psychic Disorder?* 9:97 (November 1976): 788.

3. I am anxious, too, that a general definition of rapture should not be confined by the Protestant Christian definition of The Rapture, the moment of ascension to heaven. Preserving the blissful, universal quality of the experience which is a part of many religious beliefs is most important.

springboard for his creativity. What the exhibition seeks to explore are the extended meanings of the kinds of transport, the potential, displayed literally in the Clovio drawing, to be transcendent and transformative.

Richard Francis

The connection between mythology and religion, which has often been investigated by historians, is not the subject of this exhibition. Rather, *Negotiating Rapture* acknowledges that, from the perspective of art historians of the contemporary period, the effects of mythology and religion on society are similar. Both bear emotive interpretations of the world and both are potentially destructive if they are used to explain politically determined views of social change. Myth and religion have often been converted through acculturation to tragedy as a means of containing or civilizing them. Nietzsche wrote in *The Birth of Tragedy* of their systematic emasculation: "Under the stern, intelligent eyes of an orthodox dogmatism, the mythical premises of a religion are systematized as the sum total of historical events; . . . the feeling for myth perishes, and its place is taken by the claim of religion to historical foundations. . . .Through tragedy the myth attains its most profound content, its most expressive form."[4]

The rubric under which the exhibition ambitiously claims to relate rapture and its attendant artistic form, tragedy, is negotiation. Negotiation implies a contract between two: it usually assumes an object that is transferable as the outcome of the transaction. In the negotiation of rapture, there is no tangible object but rather a form of intercourse between the producer and conceptions and emotions that flow from the idea of rapture. In the case of the art object, the negotiation is twofold: first between the artist and the concepts, then between the engaged spectator and the ideas implicit in the work that has been created. I would like to approach the question by using technology as an analogy. Martin Heidegger wrote:

> Because the essence of technology is nothing technological, essential reflection upon technology and decisive confrontation with it must happen in a realm that is, on the one hand, akin to the essence of technology and, on the other, fundamentally different from it. Such a realm is art. But certainly only if reflection on art, for its part, does not shut its eyes to the constellation of truth after which we are *questioning*.[5]

If we substitute art for technology in this paradigm, we prompt reflection upon art in a context where the ideas we need to use are almost beyond our means of expression. Push the terms one stage further so that "art" replaces "technology," and "art" needs to be replaced by another term. That term might be "mythology" or "religion," but if we heed Nietzsche's caution we should probably choose "tragedy." If we do this, the debate becomes about subjects that differ substantially from what we assume art's subjects in the late modern period are permitted to be. Can the carefully encoded art-as-art be about tragic and emotional subjects?

Perhaps we can pin it down by making the technological metaphor concrete. In a startling description of the creative process, Leo Steinberg, writing of Robert Rauschenberg, explains the artist's ability to absorb and reflect the complexity of the world by comparing the artist's mind to the cluttered surfaces of his combine paintings. These flat "work surfaces," upon which anything may be placed or presented, Steinberg likens to a "dump,

4. Friedrich Nietzsche, *The Birth of Tragedy*, trans. Walter Kaufmann (New York: Vintage Books, 1967), 75.

5. Martin Heidegger, "The Question Concerning Technology," *The Question Concerning Technology and Other Essays*, trans. William Lovitt (New York: Harper and Row, 1977), 4.

reservoir, switching center, abundant with concrete references freely associated as in an internal dialogue: the outward symbol of the mind as a running transformer of the external world, constantly ingesting incoming unprocessed data to be mapped in an over-charged field."[6] The artist's role, in what is now an old-fashioned metaphor, is to transform an electrical current from one voltage to another, to step it up or step it down and make it compatible with the common voltage, and, although Steinberg is careful to acknowledge the difficulty of the real process, it remains a modernist determinate exercise. If, however, we extended the comparison from the electric to the electronic age, where data is collected and stored electromagnetically, the information is available to be read in an infinite variety of ways, some of which might touch the essence of the machine's connection with the world. This is the postmodern paradigm, where the spectator's position becomes part of the negotiation, and where in this exhibition we have added a number of links to prompt some of the connections that could be made.

An alternative definition of negotiation, from psychoanalysis, is concerned with the form of the interaction rather than its content, and may be closer to the meaning of negotiation as it is intended in this exhibition. "Psychoanalysis is a theory about a theory, or what may be called a metatheory . . . one that concerns itself with the communicative process that goes on between persons so that they may achieve some sort of shared reality. It stands in marked opposition to a theory of indoctrination, which has associations to submission, compliance, and lack of participation. Results of negotiation are quite different from fixed beliefs which allow for no form of alteration."[7]

The artist, dealing with the rapturous, is concerned with the form of the problem, with the theory of art and its relation to rapture. The interpretation of this formally laden process results in the works of art. They bear the evidence of the processes of thought and physical action that are the means of their construction. The extension of the process allows us to examine relations between and among the artist, the work, and the spectator. In this case, a shared reality derives from the negotiation the spectator makes with the work in its museum context. The work stands for the artist's negotiation to reveal or, in a religious phrase, "to bear witness to" the rapture that preceded it in its making in the studio. The spectator is not being indoctrinated but allowed to observe the journey on the *via negationis*, the progress of the ascetic to enlightenment. The second negotiation, which takes place in public, differs from the first because the communication is from object to spectator rather than from maker to object. This is the important distinction; the artist's work is private, solitary, and contemplative.

The temptation is thus to put the artist in the same category as seer, because the connections between the worlds of contemplative religion and artmaking seem so obvious. However, if we examine the role of the contemplative we find that it is usually opposed to the active,[8] and the artist, because of the physical nature of production, is always an active participant in the world. The production is a translation of the world by means of the creative act; it may be closer to the mystical than to the contemplative, for mystical experience, it has been argued, is a stage en route to pure contemplation, where the

6. Leo Steinberg, "Other Criteria," *Other Criteria: Confrontations with Twentieth-Century Art* (New York: New York University Press, 1972), 88.

7. Arnold Goldberg, "Psychoanalysis and Negotiation," *Psychoanalytic Quarterly* 56 (1987): 109–29. I am indebted to Dean Brockman for this reference.

8. I am taking a position consistent with Christian theology, where prayer and physical labor are often counterposed. Many other religions incorporate action within contemplation.

ultimate state is an ecstatic trance, a moment of great lucidity.⁹ The difficulty with using "mystic" or "mystical" is that these terms often suggest a weak or intellectually inadequate response, the softened edges of a populist attempt to be "in touch" with the "beyond." In the history of religion, both mystic and contemplative have conservative and traditional characteristics, using their ascetic and moral position to recuperate the faith. In the words of the Trappist monk (and mystic, possibly) Thomas Merton, the mystical is a "rehabilitation of the sensible."¹⁰ He concludes that the solitary is an exploration of meanings "with which my consciousness never manages to be quite simultaneous but in which my body is present"—in other words, a trance or a moment of inspiration. Ernst Kris has shown that "inspiration" in art history and comparative religion means both breathing and spiritual or divine influence.¹¹ Given our sense of what Merton called "existential nausea,"¹² our unwillingness to step outside the experiential "reality" we make for ourselves, breathing is our only reasonable pursuit, in the sense of, at best, giving breath to those moments of creativity. Perhaps it is about being trained, like yogis or athletes (or women giving birth), to breathe, to create a world for ourselves which is self-sustaining and, because of its deliberately limited reference, provides the route for new exoteric knowledge. The description of the contemplative is also a description of the artist in the studio; the exercises that monks and mystics perform are similar to the processes of the artist, solitary, thoughtful, and breathing, in the sense of making manifest, the ideas that link the single thinker to the world outside. The esoteric provides the path to the exoteric: mysticism, contemplation, science, and art can be historically joined by esoteric knowledge to create a complex and self-absorbed picture of our knowledge of the world.

This exhibition began with the desire to show the work of certain modern artists as individuals searching for an understanding of the relation between their creativity and their place in the world. It joins them to religion and contemplation, but is anxious to stay close to the objects, the place where the artist contracts the transfer. Contemplation seeks virtue and truth in its religious description; modernism had the same ambitions (as seen in several of the artists here). Perhaps the best we can hope for, and the exhibition can offer, is a series of partial descriptions of the world to help us understand or bear it. An archaic creation myth recounts that God was sacrificed and dismembered by demons. From his dead limbs sprang up the various parts of the visible world. The visible world is his dead body. The word "world" bears witness to the myth; it comes from the Old English *weorold*, which probably stems from *wer* or "man" (still found in *werewolf*, "man-wolf") and *ald*, "full-grown" or "big," hence "old."¹³

9. See the Committee on Psychiatry and Religion, *Mysticism*, where "a state of rapture is differentiated from the state of ecstasy on the basis of its sudden, violent onset and the occurrence of gross mental disorganization," 719.

10. Thomas Merton, "A Vow of Conversation," *Journals 1964–65*, ed. Naomi Burton Stone (New York: Farrar, Strauss and Giroux, 1988), 17. The full entry for 20 January 1964 is: "Importance of that solitude which is a solitary spiritual, material, rehabilitation of the sensible. The sensible around me becoming conscious of itself in and through me. A solitude in which one allows this virginal silence, this secret, pure, unrelatable consciousness in oneself. The reality 'before all thesis,' before the beginning of the dialectic and En-Soi. The singular and timeless (not part of any series) mutual exploration of silences and meanings with which my consciousness never manages to be quite simultaneous but in which my body is present. The self-awareness of the great present in which my body is fully and uniquely situated. 'My' body? Not as 'had' by me!"

11. Ernst Kris, *Psychoanalytic Explorations in Art* (New York: Schocken Books, 1964), 291.

12. Even Jean-Paul Sartre in his *War Diaries* is affected by the universal and solitude: "I should like to note down here—as an exercise and example, and in order to give the pages that precede and will follow their proper tonality—. . . the conformation of the world such as it appears to me . . . the paths that criss-cross it, its holes, its traps, its perspectives. . . . This elevation, which makes itself out to be a roof of the world, certainly represents my will to *dominate the war*. Hence, here I am atop this fine, serenely dominant sugarloaf. Whirlwind of icy gray wind about the house: the house is now a ship atop a wave, now a lighthouse. Of an evening, when I'm alone in the warm room where we spend most of our time it's a lighthouse: I know that I'm in a round tower. The wind and cold isolate me. For me, cold has always had the affective resonance of 'purity' and 'solitude.'" *War Diaries: Notebooks from a Phoney War 1939–40*, trans. Quintin Hoare (London: Verso, 1984), 129.

Maybe.

Or we could be hoping for the metaphysical truth that Walt Whitman assumed when he wrote, "I see a great round wonder rolling through the air," without the certitude of Henry Vaughan's "great ring of pure and endless light,"[14] but always at T. S. Eliot's "still point of the turning world."[15] And maybe we should be grateful that, in William Carlos Williams's phrase, it will always be "a splash quite unnoticed."[16]

13. Elémire Zolla, "Traditional Methods of Contemplation and Action," in *Contemplation and Action in World Religions*, ed. Yusuf Ibish and Ileana Marculescu (Houston: Rothko Chapel, 1978), 117.

14. Henry Vaughan, "The World," in *Immortal Poems of the English Language*, ed. Oscar Williams (New York: Washington Square Press, 1952), 145:

"I saw Eternity the other night
like a great ring of pure and endless light,
all calm, as it was bright,
and round beneath it; Time in hours, days, years
driv'n by the spheres
like a vast shadow mov'd, in which the world and all her train
were hurl'd."

15. T. S. Eliot, "East Coker," *Collected Poems 1909–1962* (London: Faber and Faber, 1963), 197.

16. William Carlos Williams, "Landscape With the Fall of Icarus," part 2 of "Pictures from Brueghel" (1962), *William Carlos Williams Selected Poems*, ed. Charles Tomlinson (New York: New Directions Books, 1985), 238:

"According to Brueghel
when Icarus fell
it was spring

a farmer was ploughing
his field
the whole pageantry

of the year was
awake tingling
near

the edge of the sea
concerned
with itself

sweating in the sun
that melted
the wings' wax

unsignificantly
off the coast
there was

a splash quite unnoticed
this was
Icarus drowning."

Nothing, *at first sight*, is less negotiable than rapture. With stealth and singularity, the moment of rapture transforms the long labor of devotion, sacred or amorous, into the sudden surrender of human agency. If rapture is transcendent, it is also subliminal. Just below the threshold of consciousness, under the skin, rapture's passage turns the body translucent, and the mind is blinded by a rush of light. In rapture, the relation of the self to itself—now mediated by an other, God, the lover—becomes de-realized. "It is clear," writes Jacques Lacan of Saint Teresa and others like her, "that the essential testimony of the mystics is that they are experiencing [*jouissance*], but know nothing about it."[1] If the testimony of rapture consists in a kind of breach between experience and knowledge, then what account can it give of itself? More significantly, who speaks for rapture? Can it be witnessed or represented? Can there be a "subject" of rapture if it introduces a caesura in both time and knowledge?

Nothing, *at first sight*, is less rapturous than negotiation. It is a form of trade or traffic, articulation and exchange, connection with contention, which seeks equivalences in the everyday world. Concerned principally with making relations, or "closing the deal," negotiation is, most significantly, a discourse of disclosure. Unlike rapture, which is about the "absolutely dissymmetrical relation to the wholly other," negotiation strives toward an "equalization through a common denominator."[2] If rapture is sublime seizure, a caesura in everyday life, negotiation (*neg* [not]+*otium* [ease, quiet]) emanates from the noise, the unquiet of the day's business. The common denominator to which negotiation aspires and which it attempts to articulate is nothing less than the web and weave of life: speech and action, the defining attributes of humanity. Contrary to common sense, the disclosure of negotiation is not merely the revelation of some common currency of circulation; negotiation discloses a certain dis-ease in the endgame of exchange, precisely because it is centrally concerned with the enunciation of the players of the game—the *self-*disclosure of the agents, and agency, of negotiation is the very essence of human action and utterance. In Hannah Arendt's remarkable description, "[a] life without speech and without action—and this is the only way of life that in earnest has renounced all appearance and all vanity in the biblical sense of the word—is literally dead to the world; it has ceased to be a human life because it is no longer *lived among men*."[3]

Aligning negotiation with these systems of social exchange—language, action, signification, representation—places it at the center of modern life, at the cusp of the creation of commodities and the initiation of communication. Concerned primarily with the disclosure of the human subject *as agent*, negotiation is the ability to articulate differences in space and time, to link words and images in new symbolic orders, to intervene in the forest of signs and mediate what may seem to be incommensurable values or contradictory realities. If rapture erupts as ineffable experience, negotiation insists on the *necessity of narrative*

Homi K. Bhabha

AURA AND AGORA:

ON NEGOTIATING RAPTURE AND

SPEAKING BETWEEN

for
Toni Morrison

8

1. Jacques Lacan, "God and the *Jouissance* of The Woman. A Love Letter," in Juliet Mitchell and Jacqueline Rose, eds., *Feminine Sexuality and the école freudienne*, trans. Jacqueline Rose (New York: W. W. Norton, 1982), 147.

2. Jacques Derrida, *The Gift of Death*, trans. David Wills (Chicago: University of Chicago Press, 1995), 91.

3. Hannah Arendt, *The Human Condition* (Chicago: University of Chicago Press, 1958), 176 (my emphasis).

neg (not) + otium
ease or
quiet
negotiation

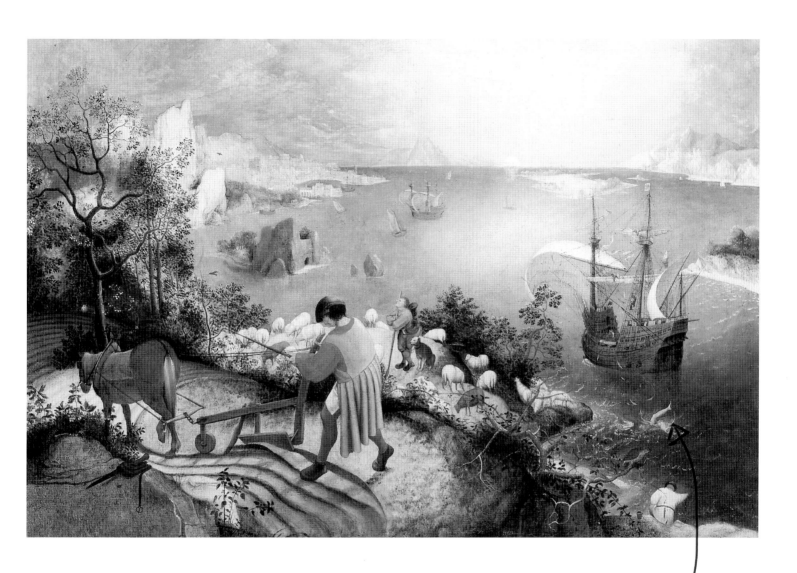

Pieter Bruegel the Elder (Flemish, 1525–1569),
Landscape with the Fall of Icarus, 1558, panel
transferred to canvas, 29 x 44 1/8 in. (73.7 x 112.1
cm), Musées Royaux des Beaux-Arts, Brussels.

9

"in which human beings appear to each other . . . *qua man*. . . . an initiative from which no human being can refrain and still be human."[4]

At first sight then, rapture and negotiation occupy quite different worlds. Rapture's world is "the word within a word, unable to speak a word,"[5] the self surrendered to the sublimity of the non-self. Negotiation's domain is self-disclosure in narrative, *qua the human*, as the very condition of communal and quotidian life. Is there a passage from the *aura* of rapture to the *agora*, or marketplace, of negotiation? It is this complex question that *Negotiating Rapture* asks us to consider. The deliberate ambition—or purposeful ambiguity—of its very title suggests that art may be the bridge between aura and agora, especially if we refuse each term its discrete space and insist that both states of being and meaning should confront the alterity or limits of their discursive fields. Can we force rapture's lips, press the silent, sublime word to speak and disclose its agency, which is, after all, the task of negotiation? In a similar move, can we unveil an uncharacteristic moment of radical uncertainty of selfhood and subjectivity in the "unquiet" trade of negotiation? When human cacophony ceases, does a deeper mystery open up in the disclosure of "man?"

Attempting to translate "negotiating" and "rapture" in terms of each other, twinning and twisting them, has brought us face to face with the problem of narrative address in art—the process of articulating aura and agora, linking the sublime with the temporal location of the spectator, the reader, the witness. My interest in narrative goes beyond the merely formal aspects of plot, story line, figurative field, textual or spatial system. It is narrative as the discourse of self-disclosure, the production of subjects and the positioning of spectators that I want to pursue here. Art's peculiar power as a form of address arises through its *mediation* between sublime silence and the din of everyday sight and sound.

The position of the spectator, art's addressee, is neither the situation of the artist ravished by the lightning of inspiration, nor the sudden illumination of aura that confronts the viewer's eye when he or she is momentarily distracted from the business of the agora. In both these cases there is a certain passivity ascribed to artist and audience that does not represent the profoundly ambivalent nature of the artwork itself and its dialogic interface with the world in which it dwells. For art has the capacity to reveal the almost impossible, attenuated limit where aura and agora overlap, to find a language for the high horizons of humanity itself and—in its finest selves, its inspired othernesses, its visionary styles, its vocabularies of vicissitude—to reveal its own fabulation, its fragility, at the moment of its articulation. It is not that art's auratic ambition is somehow humbled by the unspectacular wisdom of everyday life—nothing so simple. What is revealed between the ecstatic and the everyday is a *mediatory in-betweeness* that belongs neither to aura nor agora—and this, in all its mystery and its ordinariness, is "the human position."

"Musée des Beaux Arts"

About suffering they were never wrong,
The Old Masters: how well they understood
Its human position; how it takes place
While someone else is eating or opening a window or just walking dully along;
How, when the aged are reverently, passionately waiting
For the miraculous birth, there must always be

Homi K. Bhabha

10

Mediatory in-betweeness

4. Ibid.

5. T. S. Eliot, "Gerontion," *T. S. Eliot Selected Poems* (New York: Harcourt, Brace, and World, 1964), 31.

Children who did not especially want it to happen, skating
On a pond at the edge of the wood:
They never forgot
That even the dreadful martyrdom must run its course
Anyhow in a corner, some untidy spot
Where the dogs go on with their doggy life and the torturer's horse
Scratches its innocent behind on a tree.

In Brueghel's *Icarus*, for instance: how everything turns away
Quite leisurely from the scene of the disaster; the ploughman may
Have heard the splash, the forsaken cry,
But for him it was not an important failure; the sun shone
As it had to on the white legs disappearing in the green
Water; and the expensive delicate ship that must have seen
Something amazing, a boy falling out of the sky,
Had somewhere to get to and sailed calmly on.

—W. H. Auden[6]

The human position, as Auden lays it before us, is not about suffering; it is about art's signification of suffering (see illus. p. 9). This means, of course, that the Old Masters are doubly framed, once as painting, then again as poetry: the spectators of "the miraculous birth" or those who view "something amazing" are not simply the skating children in the one case and the seafarers in another. Overlooking and mediating the entire interaction between the rapture of suffering and the busy banality of negotiation are the poet's narrative voice and the artist's vision, which reside neither inside nor outside the poem or painting but hover on the edges of inscription and spectation. The narrative voice lingers at the limits of both poetic line and visual image, at once describing "reading" the Old Masters and, ironically, reinscribing them. In the role of translator between painting and poetry, the narrator engineers the juxtaposition of aura and agora and then produces the necessary negotiation of rapture. So, for instance, it is the narrator as spectator who, in rhyming "passionately *waiting*" with "to happen, *skating*," constructs an ironic affiliation between the passionate mystery of death, passing away, and the children's everyday pastime—skating on thin ice. The cycles of birth and death are naturalistically brought together as a kind of inevitability, but much more significant is the incommensurable gap in self-awareness between the aged and the young. It is the time lag between the exigency of the event—tragic or miraculous—and the delayed awareness of its significance that is enacted in the *temporal tension* that great art represents. That such radically different dispositions of being and feeling as dreadful martyrdom and the doggy life nevertheless inhabit the same cycle of human existence at its two ends—birth and death, youth and age—is an affirmation of "the human position." For art, in the unresolvable "side-by-sideness" of insight and insouciance in that uneasy space and time *in between* birth and death, opens up a space of survival in the interstices between aura and agora.

The negotiatory power to put together what everyman *desires* to rend asunder, signifies the banal mystery of art's *mediatiory narrative*. We must not be too hastily dismayed by the complex distance between suffering and spectatorship that Auden attributes to the work of art. Let us not be judgmental about a perceived lack of empathy on the part of the

6. W. H. Auden, "The Musée des Beaux Arts," in Oscar
Williams, ed., *Immortal Poems of the English
Language* (New York: Washington Square Press, 1952), 580.

motley crowd of playing children, ships' captains, and ploughmen—ordinary people in general. Painting and poem reveal the distance between the vision of sublimity and the everyday world of making-do, the indifference of "not particularly wanting it to happen," or "having somewhere to get to," or even scratching your arse as a response to the awesome; but these experiences of "everything turn[ing] away," just missing the miraculous, have a much deeper significance than that of narrative pathos or an ethic of narcissistic self-absorption. We must go beyond the solipsistic reflection that "for him, it was not an important failure."

In Auden's reading, for instance, *turning away* from a vision of a white-and-gold winged boy cruising out of the sky like a cherub to sink like a stone opens up a space of interpretation—between boy and boat, between something amazing or rapturous and something strategic and negotiatory, "somewhere to get to and sailed calmly on." It is from this elisional space-time of interpretation that the lesson of art's "human position" is to be learned. Between the fleeting visibility of art and the position from which a possible narrative or plausible record might emerge—"the ploughman *may*/Have heard," "the delicate ship . . . *must* have seen"—both Bruegel and Auden pose the poignant issue of art's survival: as translation, revision, recognition, communication, misrecognition, circulation, mischance—or, indeed, Auden's own reinvention and reinscription of Breugel's painting. But note that the tentative interpretational tone—*may . . . must* have—reveals an aesthetic and ethical dilemma. It suggests that the continuance and influence of rapture depends upon an understanding of interpretation as an intervention into the very signifying structure of the artwork. The legend of art, the power of its persuasion through time, depends upon an attenuation and relocation of its "being" as both event and significance. In the very act of mediation or representation there is a necessary threat to art's originary or essentializing presence. This is artistic rapture's most difficult negotiation with the agora of interpretation, for in order to ensure the survival of art, its authenticity or autonomy has to be partially erased.

If rapture is to be communicated at all, then the ineffable experience has to be addressed from a perspective outside itself. But this outsideness, paradoxically, is not external to the artwork; it is part of the process by which art comes to be *authorized* in the acts of spectatorship and interpretation. Interpretations are not merely second-order readings that belatedly elaborate some pure essence or expression that the work emanates *ab novo*, in a kind of sublime spontaneity. Interpretation, quite literally, turns the work inside out: it enunciates, even exacerbates, the multiple fields of visuality and surfaces of significa- tion that are articulated in the work. By drawing out these elements, as one draws a thread from a piece of silk, the entire fabric is transformed, its structure laid threadbare and visible, its connections and causalities rendered contingent, its "totalities" turned textural and tendentious. Interpretation is not so much an adjunct activity as it is a disjunctive process that questions the very presence or "being" of the work of art as *a beginning, as an activity of authorship*. "In place of blazing genesis," Stephen Greenblatt writes, "one begins to glimpse something that seems at first far less spectacular: a subtle, elusive set of exchanges, a network of trades and trade-offs, a jostling of competing representations, a negotiation between joint stock companies. Gradually these complex, ceaseless borrowings and lendings have come to seem more important, more poignant even, than the epiphany for which I had hoped."[7]

7. Stephen J. Greenblatt, *Shakespearean Negotiations: The Circulation of Social Energy in Renaissance England* (Berkeley: University of California Press, 1988), 7.

Without epiphany, what authority can rapture claim? Within the unease of negotiation is there a kind of sublimity? Do aura and agora tremble before each other? Of the spectator of the *mysterium tremendum*—the gaze of God—Jacques Derrida has this to say: "I don't see him [God] looking at me, even though he looks at me while facing me, and not like an analyst from behind my back. . . . But most often I have to be led to hear or believe, I hear what he tells through the voice of another, a messenger, an angel, a prophet, a messiah or postman, a bearer of tidings, an evangelist, an *intermediary* who speaks *between* God and myself."[8]

The intermediary enunciates the same doubt at the point of intercession—to be *led to* believe leaves open the possibility of unbelieving or being misled—as do the Icarian poet and painter in questioning the intentionality of the artwork at the moment of its performance—the painted ship of fools that may have just missed recognizing a disastrous miracle. The intermediary neither simply reveals God's gaze nor directly reflects the sublime of rapturous experience. The interposing of a "voice of another" discloses a form of agency and a relation to knowing in a situation where, as Lacan suggests, the essential testimony of rapture is to experience but know nothing of it. And this agency of the intermediary is nothing less than language itself, or that metaphoric and substitutive process of representation that configures the signifying field of the arts more generally.

"Speaking between" God and myself, the art of the intermediary, is the locus of interpretation *as intervention*. In this sense, "speaking between" is, *at one and the same time*: interruption (speaking outside the time and space of the given "subject," neither God nor myself); interpretation (reading between the lines); and the disclosure of agency, where the intermediary becomes the process of intersubjectivity, the web of communication and community, the agora "in which human beings appear to each other *qua (hu)man*. "Speaking between" is spectatorship from the "human position," where the viewer does not stand before the object as voyeur, nor the critic or reader merely reconstruct the narrative retroactively. The human position marks the "midstness" of the intermediary in its relation to the other, both spectatorial and performative, which is no longer an "absolute dissymmetry" but gets drawn into the discourse of negotiation. For "as soon as one speaks, as soon as one enters the medium of language, one loses that very singularity."[9] But the intermediacy of representation does not lead in a straight and uncomplicated line from the singular to the social.

The disclosure of agency in language and visual representation, achieved through the absolute dissymmetry of the signifier and the signified (the gaze and the look, the sign and the symbol) is also a displacement of any anterior or binary relation between God and me, art and spectator, or artist and object. For the intervention of interpretation raises the most profound questions about the "authority" of the artwork, not probing art "in itself," but opening up the ambivalent perspective of the "outside-in," as I have described it above, revealing the liminal and disjunctive locations that both ensure the survival of art and attenuate its sovereignty.

13

8. Derrida, *Gift of Death*, 91 (my emphases).

9. Ibid., 60.

Interpretation, as an act of intervention, opens up the necessity of relating art as representation, a mimetic and metaphoric practice, to the wider institutional issues of the social regulation of culture. The adjudication of the aesthetic, once the intermediary and intercessive structure of the artwork is revealed, is a problematic issue. For what is contained within—and without—the realm of art? The very boundaries of what is art and what is not, the relation between fact and fabulation or the quotidian self and figural identity—these enigmatic intimations of the human position are issues that Auden has already made us face. It is not that he suggests an equivalence among these varied realms of experience, far from it. Auden's interest lies in the side-by-sideness of the incommensurable and the unnoticed, the ambivalence of event and affect as they coexist in the web of life, in a kind of art that subtly displays the mystery of mischance. The critical issue lies in the temporal disposition of the definition. How can we conceive of the object or event of art when it includes that which overlooks it or passes it by; that which misunderstands it because of the disjunctive time and life spans of art's human location; that which presupposes, in its interpretation and representation, the very attenuation of art's intention in favor of the act of cultural translation?

Arendt's meditations on this matter are particularly significant for us, not least because she sees human "inter-est," the custom of shared being, as a mode of the intermediate:

> Action and speech go on between men as they are directed toward them, and they retain their agent-revealing capacity. . . . These interests constitute, in the word's most literal significance, something which *inter-ests*, which lies between people, and therefore can relate and bind them together. Most action and speech is concerned with this in-between. . . . For all its intangibility, this in-between is no less real than the world of things that we visibly have in common. We call this reality the web of human relationships, indicating by the metaphor its somewhat intangible quality.[10]

> It is because of this already existing web of human relationships, with its innumerable, conflicting wills and intentions, that action almost never achieves its purpose; but it is also because of this medium, in which action alone is real, that it "produces" stories with or without intention as naturally as fabrication produces tangible things. . . . In other words, the stories, the results of action and speech, reveal an agent, but this agent is not an author or producer. Somebody began it, and is its subject in the twofold sense of the word, namely its actor and sufferer, but nobody is its author.

This genealogy of "inter-est" resonates with my revision of rapture as a "speaking between" aura and agora. At first sight, it seems obvious that Arendt speaks from the side of negotiation, the *vita activa*, as the discursive space peculiarly suited to the revelation of the creative agent. But then, if we interpret her notion of the "inter-est which lies between people," in an interventionist style, we realize that there is a family resemblance between her liminal narrative of the communal "in-between" and Auden's inscription of artistic authority as hovering between the Old Masters and the unknowing children, somewhere in between aura and agora.

Arendt does not so much affirm the presence of the social process as she reveals the enigmatic nature of the "in-between" and the ambivalent character of social agency itself. And, once again, it is the *intermediary* structure of narrative—"produc[ing]" stories

10. Arendt, *Human Condition*, 182–3; the subsequent citation is from p. 184.

with or without intention"—that both initiates and interrogates the authority of the social agent. If negotiation is an agent-revealing activity, its disclosures can only be made in connection with an already existing web of human relationships that provides a horizon of expectation. But, in a paradoxical sense, the instantiation of agency *as narrative* demands an "originality" and mastery that seeks to be free of that which is already existing— agency wants to disclose itself as the author of the human web itself.

As with the rapture of the *mysterium tremendum*, narrative is intercessive, and any notion of singularity or sovereignty is lost once we find ourselves in the human position of "speaking between." For her part, Arendt describes this process as "subjection" in a double sense, as both actor and sufferer of a narrative of which nobody is the author. And here, finally, in the secular vocation of art's negotiated rapture appears a moment similar to the "lack" of sacred knowledge that accompanies divine rapture. For it is the absence of any controlling authorial intention in figuration or fabulation, coming almost face to face with the *deus absconditus* that haunts any claim to a final and sufficient cause in the realm of social determinism, that allows us, ironically, to see the connections between aura and agora. Suddenly, rapture's *intermediary* condition, which is the mystic silence interrupted by the narrative voice that "speaks between," finds itself in the company of negotiation's human *inter-est*. The web of human relations established through language and action demands the disclosure of agency—both actors and sufferers—while producing a narrative of human society that nobody authors.

It is, finally, the *non-disclosure* of the author as a general or universal condition of meaning, being, or seeing that makes artistic agency what it is: an interpretational ethics and an interventionist aesthetics that is at once liminal and luminous. Art produces stories and pictures—historical or personal—which survive and seduce because they continually raise alternatives and *agonists* to their own existence—specters of memory, phantoms of the future, proxies for the present. Artistic activity, whether creative or critical, poses the problem that narratives and figurations, signs and scenarios, *both may and may not* have an *intention* (no author), and, at the same time, raise an urgent need to disclose agency, to interpret the relation between the actor and the sufferer, the dying aged and the skating children, Icarus and the cruise ship.

Without epiphany or "authority" there emerges, in the place of origin or singular presence, the double-bind of the subject: the birth of the creator or the spectator who *cannot* transcend the process of artwork but is placed in the *in-between*, in the midst of his or her own production as an agent, in the very interstices of intention and interpretation. For that is the law of the human position: the spectator or interpreter has to live with, and within, the knowledge that "somebody began it"—the story, the web of human rela- tionships, the *inter-est*, the painting, the installation, the verse, the critique—while acknowl- edging the fact that nobody is its author.

To be both actor and sufferer is, again, to be in the doubly inscribed position of Icarus, at once the actor in Breugel's art, and then, doubled, the icon of scant, unwitnessed suffering in Auden's poem. It is this twofold subject that Bill Viola envisages as the *double spectatorial subject* in his 1983 installation *Room for Saint John of the Cross* (cat. no. 83). Viola's insight into rapture lies in grasping its human position, where mystical visions are set side by side with mechanical and digital reproductions. There are no conclusions

15

to be drawn, no finitude of "truth" to be derived from the parallelism of the spaces or the replication of images. The architecture of the installation establishes a spatial narrative of repetition and echo: a large dark room contains a small dark cubicle; the back wall of the room shimmers and shakes with a hand-held video image of a large snow-covered mountain, while the cubicle displays a fourteen-inch color-monitor image of a snow-covered mountain; the room echoes with the sound of wind; the mountain in the monitor is swept with the rush of wind moving through trees and bushes. Amidst these icons of repetition there rises, above the brush of the breeze and the sough of wind, from the deep dark cubicle, a sign of singularity: a voice reciting a poem of Saint John of the Cross:

Homi K. Bhabha

> To come to the pleasure you have not,
> you must go by a way in which you enjoy not,
> To come to the knowledge you have not,
> you must go by a way in which you know not.

Why this world of double images in Viola's re-creation of Saint John's incarceration? What is the function of repetition and intermediacy at the heart of rapture—dark room, dark cell; screen-mountain, monitor-mountain; sighing wind, sacred voice?

One obvious answer would be to emphasize the visible narrative of transcendence in the physical structure itself, making one's passage through the dark room and cubicle, playing on the contrasted planes of light and dark. The dark empty spaces of white noise are pierced by the screens of light and luminous snowcapped mountains. Rapture such as this, the sudden rupture of the dark night of the soul, is a visionary moment achieved through the deprivation of the senses and the exercise of the spirit, so that the vision within can be projected without. The corporeal or material divisions inside/outside are transcended in a divine "con-fusion" of which the sublimity of the moving movie-mountain is a symbol. Saint John's poems speak frequently of flying over mountains and fortifications. In this reading, then, the repetition of spaces and images tends toward a certain identity of subject and object, self and other, mind and matter, which transcends or erases selfhood in epiphany. The disclosure of the agent would be a distraction from the absolute dissymmetry, the authorship of divinity itself.

There is another narrative of doubling and repetition that relates more to Saint John's by ways of "not knowing": "To come to the knowledge you have not,/ you must go by a way in which you know not." This coming to knowledge is more about the *intermediary* and iterative process (than a transcendence of identity) and refers to the structure of making the artwork. The "way in which you know not" addresses the now-familiar issue of the intermediary, but this time in the name of human interest and the place of the spectator. It does not so much address the mystic experience as the location of this work *in between* rapture and negotiation. Viola sends us to Saint John by a way we know not, by making us look through a glass—or a screen—darkly, and doubly. The revelatory, singular vision of the saint's words are attenuated in the construction of the piece itself: the Pandora's box of dark spaces, the uncanny interruption of repeated images and simulated sounds, the fabrication of a taped voice read by another's voice. The multimedia structure of the installation deprives the sublime scenario of an "it"-self; the spectator's intrusion as intermediator, in between the various surfaces of inscription and figuration, distracts from a transcendent sublimity by processing spectation through the work's material

construction. Then, there is a form of mimetic distraction that follows on from the material disposition of space, surface, and light. The juxtaposition of dimension and scale involved in the side-by-side doubling of dark spaces—large room, small cubicle—and light images—screen-mountain, miniature monitor-mountain—displaces the gaze forever and, uncannily, sideways—*abseits*. The double and disjunctive dimensionality of both time and space insists on the self-disclosure of the spectatorial agent as the subject of the sacred snowcapped mountain; but such agency is both partial and unself-possessed because the mountain, as visual sign, forms part of a lateral, metonymic movement on the projective plane of the work. Viola's architectural embodiment of rapture distracts and terrifies us in a fundamental sense—for God or art can never be heard, only *overheard*, just as the best strategies of negotiation are usually *underplayed*.

On the grounds of this reading, the doubles—spaces, mirrors, wind, and voice—are more directly related to the problem of production and the position of spectation. The iterative economy of the installation is less a passage to the luminous mountain than a labor of negotiating the "sign" of what it means to be "experiencing [*jouissance*] but [to] know nothing about it." From this perspective, it is not what can be seen or heard— mountains, verses, light, dark, the jug of water—that is the focal point of the work. It is the empty window, the *emptiness* of the window—neither light nor dark, screen nor "seen," word nor image—that becomes the place of the human *web*, for as Viola says of video art, "the level of the use of the tool is a direct reflection of the level of the user."

It is here, through the emptiness of the small window that the spectator turns *intermediary*, "seeing between" the different scales of darkness (big and small rooms) and the different quantities of light (large and small mountains). Here, all of a sudden, something ensues that is of human *inter-est* in the sense that Arendt lends to the term. For when the viewer stands at the empty window something takes place in between the media that inhabit the installation space side by side—instead of singular epiphany, there is suddenly the noise of enunciation. At the empty window, a certain "speaking between" starts to happen: the saint's voice finds the viewer's eye in a state of distraction; the soughing, godly wind echoes and elides the caught breath, the sigh, of the human spectator; and the still, shimmering vision of snowcapped mountains, erect and epiphanic, meets the daunted, sagging frame of the human body, its fragility barely upheld by the bruised, barefoot ardor of art's questing pilgrim.

There, for a spare moment, you have it, negotiation's rapture. If you miss it, turn the page, peel off a dollar bill, draw the curtains, or open a window . . . listen . . . look . . . it will happen again . . . when you do not especially want it to happen . . . when you have somewhere to get to and sail calmly on. . . .

Rapture. The word reverberates sex and religion; discriminations between erotic and beatific dimensions of human experience deteriorate in the echoes of the two syllables. The etymological resonances are violent: in the beginning rapture is a seizure, abduction, enchantment, and loss of control. Although the overpowering feelings described by the term are universal, evaluations of them, the constructions of sentiments and cultural sensibilities out of the complex of sensations themselves, must differ from time to time and place to place; and those appraisals are articulated and codified in the divergent languages of those times and places. Each language has its own unique powers and uncanny magic, just as each has its own frustrating semantic limits. The English noun— 'rap-chər—is romantic and seductive.

Lee Siegel

THE FABLE OF THE COURTESAN, THE ASCETIC, AND THE KING:

EROTIC, RELIGIOUS, AND AESTHETIC RAPTURE IN INDIA

While I do not know of a lexically equivalent word, charged with the same evocative multivalences and affective meanings, in an Indian language,[1] I realize that it was a sense of rapture and a yearning for what I imagined it might be that first drew me to India. Fantasy is implicated in all raptures, and a fantasy of India enraptured me during adolescence: I fancied that there they knew a rapture more exquisitely voluptuous than anything possible in what I perceived to be a thoroughly puritanical and profoundly vapid America. It was after all 1959, and I was a student at a Christian military high school. A copy of the *Bhagavadgītā* had fallen into my hands and, although I do not recall where it came from, I remember shuddering as I read a passage more stunning than anything I had ever before encountered in a book. A majestically terrifying god revealed himself to a rapt witness: "Wherever I look, I see your infinite forms, each one itself infinite in each and every form; I tremble in panic as I gaze upon the billions of blazing heads, arms, thighs, feet, and torsos, and infinite gaping eyes and mouths with sharp, horrific tusks. Ablaze, you graze the sky and the jagged teeth of your myriad incendiary mouths are the flames of the all-consuming fires of time. You lap up all worlds, suck all cosmoses into your gloriously conflagrating mouth; the dreadful rays of incandescent light with which you bristle illuminate and incinerate the universe."[2]

I craved more. And since the *Kāmasūtra* was the only other Indian text of which I had heard at the time, I turned to it next and was equally, but differently, enraptured. Too embarrassed, too young, and too broke to purchase the book, and inspired by pubescent deviance, I stole a copy. Deviance lends itself to rapture, an experience that is implicitly illicit and antinomian, excessive and transgressive. Clandestinely I studied the copulatory

1. There are no convincing cognates in the Sanskritic branch of the Indo-European languages for the Latin *rapere/raptus*. The Sanskrit words I have translated as "rapture" are words for an intense joy that point in the divergent semantic directions coalesced in the English term. Words such as *samādhi, nirvṛti,* and *ānanda* have strong religious and soteriological resonances, while *harṣa, prīti,* and *rati* stress the essentially erotic nature of pleasure. Vaman Shivam Apte's *Student's English-Sanskrit Dictionary*, 3d ed. (Pune: Motilal Banarsidass, 1920), offers both *harṣonmāda* (a "joyous madness," suggesting love and sexuality) and *ānandātireka* (an "excess of bliss," implying an ascetic or devotional religiosity) as equivalents of the single English word. My

colleague George Tanabe has explained to me that in Japanese (following the *Kenkyūsha New Japanese-English Dictionary* [Tokyo: Kenkyusha, 1954]) there are two terms for "rapture": one, *kyōki,* like *harṣonmāda,* means "crazy joy"; the other, *uchōten ni naru,* a Buddhist term literally referring to "being taken up to heaven" (much like the Pentecostal Christian use of "rapture"), has come to be used metaphorically for secular experiences of extreme delight, as "being ecstatic over one's success."

2. *Bhagavadgītā* 11.16–30, paraphrased in keeping with the way I remember it on that first reading long ago.

postures represented by the Indian artists and lucubrated over the ancient text: "A horse having once attained the fifth degree of motion goes on with blind speed, regardless of pits, ditches, and posts in his way; in the same manner, a loving pair become blind with passion in the heat of congress, and go on with great impetuosity, paying not the least regard to excess."[3]

The book evoked a world in which rapture could be easily negotiated, in which sex was free and good, and in which one could surrender to rapacious needs and raptorial longings without recriminations from parents, teachers, or the law. An exotic rapture, at once steamy and hallowed, was epitomized by a very distant and mysterious land. I ached to see the blazing god and become blind with that oriental passion. I purchased a recording of sitar music and, listening to it alone in bed late at night, bid alien ragas to carry me away.

My fantasies, raptures, and reveries are different now. Although I still have not seen god nor attempted all those positions, I have been to India and continue to be interested in the relationship between religious and erotic raptures in Indian cultural traditions. There is an ancient story that, in my mind, both distinguishes between and reconciles the two spheres of rapture—the tale of Rishyashringa and the courtesan.[4]

The Rape of the Ascetic: Erotic Experiences of Rapture

Once upon a time there was a terrible drought in the kingdom: withered branches of desiccated trees were skeletal hands reaching in supplication to heaven for rain. In fear of the famine and pestilence with which the cloudless sky threatened the world, the king, on behalf of his despairing subjects, summoned his counselors, priests, and sorcerers to the court for advice as to what rite or magic would bring the fecundating monsoon.

One of the royal advisors responded: "There is a young ascetic in the forests of the kingdom— Rishyashringa, the son of a hermit. It is on his account that Indra refuses to give us rain. His austerities are so ardent, his asceticism so fervent, that he has sapped the sky of its waters. As long as he is immersed in his fiery yogic trances, it will not rain. He must be seduced; his chastity threatens the world. If he can be made to affirm this world, to relish sensual pleasure and spill his seed, the rains will certainly come and the earth, as land and goddess, will feel the rapture and be fertile once again. But that will be no easy task: the boy, reared from birth in the ashram, has never even seen a woman. How can he be tempted when he knows nothing of feminine charms and the transports of love? His virile chastity will not easily be broken."

Assembling his courtesans, the king offered a reward to any one of them who might have the wiles to seduce the chaste ascetic. One beguiling lady, well versed in the fine arts and

3. *Kāmasūtra* 2.7. This is Richard Burton's translation, the one I read as a teenager. The equine metaphor aptly illustrates the way in which rapture is a loss of control.

4. For an insightful discussion of the story of Rishyashringa, see Wendy Doniger O'Flaherty, *Asceticism and Eroticism in the Mythology of Śiva* (Oxford: Oxford University Press, 1972), 42–52. The name Rishyashringa, meaning "Antelope-Horn," was given to the boy because he had a single horn growing on his head; he was the offspring of a hapless female antelope who happened to drink water into which an ascetic (the boy's father) had accidentally (and non-rapturously) spilled his semen. Having had no human mother, Rishyashringa did not experience the pleasure of contact with a woman even as an infant at the breast. Regression to that early phase of ego-feeling, before the infant has learned to distinguish his or her own ego from the external world, was, incidentally, the way in which Freud (in *Civilization and Its Discontents* [1930]) analyzed the religious rapture that Romain Rolland, after his experiences in India, had called the "oceanic feeling." (See *The Standard Edition of the Complete Psychological Works of Sigmund Freud*, vol. 21, trans. James Strachey [London: Hogarth Press and the Institute of Psycho-analysis, 1964], 64–65.) I have relied, in my retelling of Rishyashringa's story, primarily on the versions in the epic *Mahābhārata* and the Buddhist *Jātaka*s.

physical sciences of love, accepted the challenge and set out immediately on her mission. Hiding outside the ashram, she waited until the old hermit left his son alone to gather food for the evening meal.

When the moment came, she entered the hermitage and, reverentially prostrating herself before Rishyashringa, announced the purpose of her visit: "I am an ascetic like yourself and I wish to practice austerities with you. I want you to teach me your yogic practices and spiritual exercises, all your methods of concentration, including the meditational positions you assume. In return I shall initiate you into my discipline; I will teach you the postures in which I experience the supreme union."

When the young ascetic, having never seen a woman before, asked why she had two large bumps on her chest, she explained: "I am swollen there from being bitten by mosquitoes and— believe me—they itch. Would you be so kind as to scratch them and massage them with this soothing balm?" While graciously complying with the request, Rishyashringa noticed that there were no genitals visible through the strangely handsome mendicant's diaphanous loincloth, and he asked the reason for it. "My penis was bitten off by a bear," the courtesan cunningly responded: "It hurts quite a lot. Would you please rub some of this healing ointment upon my wound? And would it be too much to ask you to kiss it and make it better?"

The courtesan, in her pose as an ascetic, aroused such feelings of delight, such curiosity and admiration in Rishyashringa that he could not help but revere her as one of the most adept and accomplished of yogis. When he importuned her for initiation, his wish was duly granted. Sitting alone in deep yogic trance, he had experienced the rapture of samādhi *before; but never had it been as overwhelmingly powerful as this. This was truly divine.*

The sky began to fill with clouds, and at the very moment when Rishyashringa reached the pinnacle of his delirious ecstasy, there was a burst of rain and the earth herself trembled with the rapture of the storm.

The people of the land, grateful to their king and his courtesan, were drenched as they danced in the fields and streets, sharing in the rapture of earth, sky, and each other.[5]

Rapture. The word reverberates sex; it echoes with the ardent cries of both the victims and celebrants of desire. The word, in its respective etymological and associative insinuations of both rape and orgasm, intimates the terror of sex and the bliss of it. Its highlights accentuate abysmal darknesses inherent in all desire.

The linguistic kinship between rape (as abduction or sexual assault) and rapture (as ecstasy or passionate transport) suggests ways in which the development of our language has both served and reflected patriarchal values: in terms of actual experience, the aggressive act of rape is universally personally abhorred and individually feared, socially

5. The mosquitoes and the bear appear in the *Naḷinikā Jātaka*
 (526 in the V. Fausbøll edition [London: Trübner, 1877–
 96]); the standard translation of E. B. Cowell (Cambridge:
 Cambridge University Press, 1895–1907) renders the Pali
 passage into Latin (perhaps on the assumption that persons
 disciplined enough to know Latin would be sufficiently s
 elf-controlled not to be "carried
 away" by the words of the courtesan).

THE FABLE OF THE
COURTESAN, THE ASCETIC,
AND THE KING:
EROTIC, RELIGIOUS, AND
AESTHETIC
RAPTURE IN INDIA

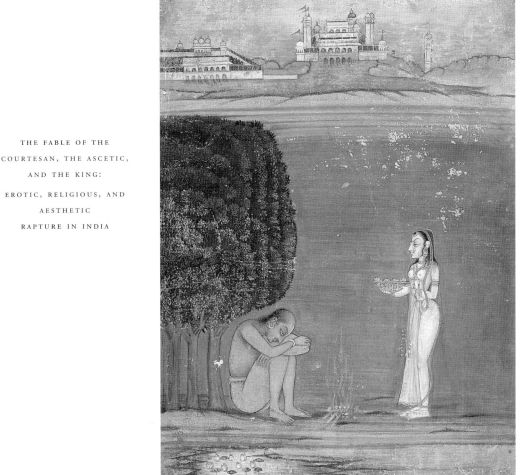

Indian, Rajasthan, Kishangarh, *The Courtesan and the Ascetic*, c. 1750, opaque watercolor, gold on paper, sheet 8 x 5 7/8 in. (20.3 x 14.9 cm), image 7 7/8 x 5 13/16 in. (20 x 14.8 cm), Los Angeles County Museum of Art, Gift of Mr. and Mrs. Michael Douglas.

outlawed and collectively censured; and yet menacing masochistic fantasies of being raped are not uncommon in individuals who in no way, and under no conditions, actually wish to be raped, nor do those who have salaciously sadistic fantasies of taking another by force necessarily want to do so or to see rapists go unpunished. It is in fantasy that fears and desires are confronted and resolved, that the vexing and illicit relationship between rape and rapture is fathomed, and that the furtive alliance between pain and pleasure is revealed.[6] Collective fantasies, moreover, are monumentalized in art: the similarity of the

6. Lynn S. Chancer, in a sociological discussion of rape fantasies, has explained their frequency in women in terms of "the feminine gender socialization producing a relatively greater tendency toward masochism. At least through a masochistic fantasy, pleasure can be permitted, if only because guilt has been neutralized by a situation in which the masochist is no longer responsible; and the masochist expiates the sin of pleasure through the simultaneous experience of punishment. Given double standards of sexuality for men and women in patriarchal societies, and their legacy of shame, guilt, and repression for women about their sexual feelings, it is not in any way remarkable that such fantasies among women would be common" (*Sadomasochism in Everyday Life* [New Brunswick, N.J.: Rutgers University Press, 1992], 58).

Sadomasochism was codified into a fine art with its own exacting conventions in the chapters of the *Kāmasūtra* that deal with biting, scratching, and slapping (2.4, 5, 7), methods, Pandit Vatsyayana explains, both to intensify and express the sexual rapture he illustrates with the analogy of the horse galloping out of control. The very concept of rapture suggests the way in which the potencies of pleasure are enhanced by a lacing or spiking with pain.

Rape is, incidentally, an extremely common motif in modern Indian films, movies produced to satisfy the fantasies of a largely male audience; the majority of that audience have, or will have, arranged marriages—a form of matrimony that is, in the sense that the will or desires of the bride are irrelevant, an institutionalized form of rape.

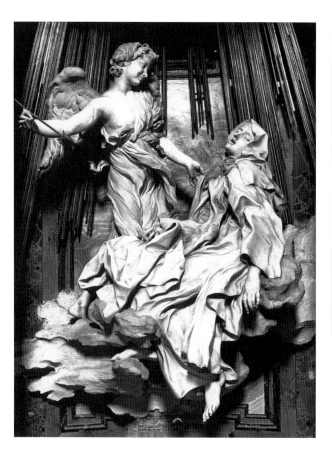

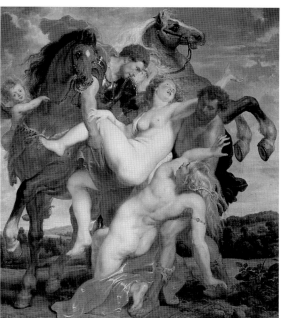

Gianlorenzo Bernini (Italian, 1598–1680), *The Rapture of Saint Teresa*, 1645–52, marble, height 138 in. (350 cm), Cornaro Chapel, Santa Maria della Vittoria, Rome.

Peter Paul Rubens (Flemish, 1577–1640), *Rape of the Daughters of Leucippus*, c. 1616–17, oil on canvas, 87 1/2 x 82 1/4 in. (222.3 x 209 cm), Alte Pinakothek, Munich.

affects aroused by being enraptured and being raped is apparent in a comparison of Gianlorenzo Bernini's sculptural depiction of the mystical rapture of Saint Teresa (illus. above) in whom the religious experience of being seized by God is portrayed as essentially erotic, and Peter Paul Rubens' painting of the mythical rape of the daughters of Leucippus (illus. above), where the martial event of being seized by an enemy is illustrated in erotic tones.[7]

"The Marriage Rite of Demons" (*rākṣasa-vivāha*) is a Sanskrit lexeme for rape explicated in the *Kāmasūtra* as "when a man, followed by a gang of his buddies, sees a girl in some village or in a park, kills or chases away her friends and guardians, and then abducts her."[8] Rishyashringa is raped by the courtesan in the sense that, in antagonism to his dedication to austerities and in defiance of the will of his guardian, he is tricked into sexual

THE FABLE OF THE
COURTESAN, THE ASCETIC,
AND THE KING:
EROTIC, RELIGIOUS, AND
AESTHETIC
RAPTURE IN INDIA

intercourse. He is ravished and enraptured; he loses control. The figurative being carried away in our version of the story is followed by a literal abduction in epic recensions in which the enamored Rishyashringa follows the courtesan back to the city to pursue a worldly life in the palace of the king.

The ascetic project, with its severe austerities and the profound passivity of yoga, is, in psychological terms, masochistic. But the renunciatory life in the rural hermitage is an inversion of a voluptuous existence in the urban court where women are enamored masochists, and men are cool, suave, and genteel sadists. "No I do not miss him and, no, my breasts do not heave," a courtesan, as rendered by the seventh-century Sanskrit poet Amaru, insists: "No, no goosebumps, and no, my face is not sweating. No, not at all, until that cheat, that ravishing bastard, appears. And then, yes, the mere sight of him, seizes my heart, soul, and breath away. Yes, my mind, usually so predictable, perversely experiences a beatific rapture."[9] The poet uses a fundamentally religious word, "*samādhi*," a yogic term, for the orgasmic climax of the seduction, of being taken against her will—which is to say, of being raped.

A poetic English usage of the word "rapture" has established an association of it, as it refers to an overwhelmingly intense pleasure, with orgasm as the climactic sensation accompanying the biological release of tumescence in erectile organs. Rapture is an erotic seizure. "In liquid raptures I dissolve all o'er," moaned John Wilmot (1648–1680), the raunchy Earl of Rochester, in "The Imperfect Enjoyment," a poem about premature ejaculation: "[I] Melt into sperm, and spend at every pore." Alexander Pope (1688–1744), echoing the same semantic condensations in his translation of Ovid's fifteenth *Heroic Epistle*, "Sappho to Phaon," also correlates rapture with feelings of dissolution and death: "You still enjoyed, and yet you still desired,/ Till all dissolving in the trance we lay,/ And in tumultuous raptures died away."[10]

Coinciding associations are intimated in Sanskrit literature. Amaru strings a series of phonemes into an extended and compact erotic compound: "tight-embraces-crushed-

7. The rape of the daughters of Leucippus by Castor and Pollux, like the rape of the Sabines, was socially justified as necessary to populate an emerging society. The liturgy of later Roman marriages re-enacted the rape of the Sabines: the groom pretended to seize and carry off his bride, festively to rape her, much to the pleasure, or even rapture, of them both; our own custom of the groom carrying the bride across the threshold may well be an atavistic remnant of that rite.
 "Every lover who falls in love at first sight," Roland Barthes has reflected, "has something of a Sabine Woman (or of some other celebrated victim of ravishment)" (*A Lover's Discourse: Fragments*, trans. Richard Howard [New York: Farrar, Straus and Giroux, 1978], 188). The French word for rape, *ravissement*, gives, I think, equal semantic weight to both the desired and dreaded implications of the experience. Barthes' equation of rape and love at first sight (*enamouration*), is well understood in Sanskrit literature: "When loving glances first afflict the heart and passions grow ardent," the poet sings, "then even to wander there on the road near her house is a rapture more sacred than that of making love" (*Amaruśataka* [Bombay: Nirnaya-Sagara Press, 1900] 100). (This and all other translations that follow, unless otherwise noted, are my own.) I would want to go further than Barthes, to suggest that every lover, male or female, anyone who feels either a desire or a pleasure that is not controllable, is in some sense a victim, fortunate or not, of rape.

8. *Kāmasūtra* of Vatsyayana (Bombay: Nirnaya-Sagara Press, 1900) 3.5.

9. *Amaruśataka* 84.

10. The most common Sanskrit words for orgasm (*kṣobha* and *samvega*) indicate shaking, agitation, paroxysm, flurry, and (explicitly in the case of the word *uttāpa*) a boiling over or an eruption. The pleasure of rapture is an apoplectic and malignant one. An Ayurvedic doctor I interviewed in India in 1985 (for a book on comedy), explaining to me that epilepsy was a form of sexual dysfunction, interpreted the Sanskrit term for epilepsy (*apa-smāra* [which probably has to do with forgetfulness]), as "a reference to Smara, the god of sexual love." Galen in the second century, in *On the Affected Parts,* made the same correlation between the sexual act and epilepsy, between orgasm and convulsion. There was, by the way, an interesting shingle outside the office/shop of the Indian doctor: "Specialist in Women and Other Diseases."

breasts-bristling-rapture-powerful-passion-swelling-feeling-girdle-skirt-slipping-faint-whispers." And suddenly the compound, like the string of jewels girdling the girl's hips, is broken and there is a rapturous syllabic staccato: "No. No. Too much. No. No. No. Stop. No." And then, in the moment of silence and stillness that follows detumescence, her lover wonders: "Is she asleep, or dead, or has she disappeared—dissolved, melted, absorbed into my heart?"[11] The prosody reflects the experience.

The rhetorical consolidation of rapture, orgasm, and death is, perhaps, rooted in physiology: "The ejection of sexual substances in the sexual act corresponds in a sense to the separation of soma and germ plasm," Freud explained. "This accounts for the likeness of the condition that follows complete sexual satisfaction to dying and the fact that death coincides with the act of copulation in some lower animals."[12] Freud's analysis would have been understood by the father of Rishyashringa: the ascetic must remain chaste in order to be redeemed from death, in order to prevent a luminous spiritual rapture from degenerating into a darkly carnal one.

When the ascetic ejaculates, dark clouds suddenly burst open and release their pent-up rain onto the earth. The projected causal connection and correspondence between human interactions and natural forces that is assumed in the story of Rishyashringa and the courtesan provided the basis for a system of Indian fertility magic. Nature itself can be enraptured. The courtesan is called upon to work the very magic that the king's thaumaturgists were unable, because of the power of Rishyashringa's austerities, to perform.

The austerities that the young ascetic had been taught were intended to abolish the boundaries between subject and object; yoga was a mode of deliverance from everything transitory, of liberation from time and space. The courtesan's mockery of asceticism in her presentation of sexual union as a form of yoga (and of orgasm as a kind of *samādhi*) is comic. And yet in India, as in Europe, the joke has been taken seriously. "Rapture" has been uttered and understood as a religious term linked to both love and death, thereby providing a cognitive coupling between the two. The word rings with soteriology.

The Conquest of the Courtesan: Religious Experiences of Rapture

Deep in the forest, gathering roots and wild berries for the evening meal, the father of Rishyashringa was suddenly drenched by the rain. Realizing at once that the storm was a sign that his son's austerities had been disturbed, that asceticism itself was being mocked by Indra, if not Kama, the aged renouncer rushed back to the hermitage in fear and anger only to discover Rishyashringa languorously slouched on the ground with an uncanny look on his face: the smile was at once blissful and melancholy; slight tears in his eyes betokened a joy that sorrows over its limits.

"Father," Rishyashringa muttered with uncharacteristic wistfulness, "the most extraordinary mendicant visited our hermitage today while you were away. His rosaries and garlands were strung neither with rudraksha beads nor bones but with crystalline jewels and fragrant flowers; his hair was more braided than matted into locks entwined with golden threads and chains; the ashes on his body were aromatic powders; his loincloth was silken and diaphanous; the pot that he carried contained a delicious water, which he called 'wine.' This learned

11. *Amaruśataka* 40. Cf. 101: "As my beloved came to bed my robe slipped loose of its own accord the skirt barely clung to my thighs that is all I remember now once we touched I could not know who he was who was I and how much less our love."

12. Sigmund Freud, *The Ego and the Id* (1923) in *The Standard Edition*, vol. 19 (1961), 47.

THE FABLE OF THE
COURTESAN, THE ASCETIC,
AND THE KING:
EROTIC, RELIGIOUS, AND
AESTHETIC
RAPTURE IN INDIA

guru was charitable with his knowledge: after I explained to him the renunciatory yogic exercises that you have passed on to me, he generously delineated and demonstrated the methods of his own spiritual discipline; and then, as one adept for another, he initiated me into his occult practices, showing me how to perform yoga, to experience union, in the most extraordinary and recondite positions. The samadhi for which we as yogis strive, came suddenly, overwhelmingly, and by force, transporting me beyond the confines of time and space. Flesh trembled as consciousness dissolved, as all ego activity was suspended, and the rapture that seized me in that moment was followed by a peace more profound than any that I have known from the meditations in which I have previously engaged. It was, I suppose, because of the sudden rains that he parted. But now, without him, I feel adrift and alone, deprived of spiritual life. I must beg for permission to leave the ashram, to renounce this renunciatory practice for the more rigorous religious discipline into which I was initiated today. I must find this holiest of holy men and follow him, devoting myself whole heartedly to asceticism under his guidance. I want to dissolve myself in the rapture that his yoga bestows."

The old hermit was furious with his son: "That was no yogi, that was a woman! You have been beguiled, ravished with deceits, dragged down into the mud of carnal attachment, reintrenched in the world of death. As our sacred texts warn: woman is, by her very nature, the destroyer of men. They are demons, seductresses lovely and cruel, who stalk the earth to ravage the minds and hearts of ascetics. You must do penance and make offerings to Shiva, the ever-chaste Lord of Yoga, and then, inspired by the austerities of that god, embark again in chastity upon the true eremitic path, storing your seed, burning up the illusory ego, and isolating eternal spirit from evanescent flesh. The ultimate rapture is attained through renouncing desire, harnessing the senses, controlling the flesh, and stilling the mind."

And Rishyashringa, driven to repentance by the words of his father, once again intent on liberation from the great round of birth and death, immersed himself in austerities. Eyes closed, legs folded, palms upward in his lap, breathing slowly and evenly, he strove to know the moment when the raindrop falls into the sea, to experience the rapture that comes with being obliterated, released, merged forever and ever in the sea of Brahman.

Rapture. The word reverberates religion; it resounds with the seraphic sighs of saints and proselytes. Its meaning is inextricably embedded in the history of its Christian usage. Although the word is syncopated by theology, its sexual repercussions have repeatedly aroused the Christian soul and made it ache for what is forbidden and beyond the bounds of ecclesiastical piety. Devout minds have anxiously sought to resolve that petulant ache with mystical soteriologies or apocalyptic visions.

Saint Francis of Sales (1567–1622), while articulating the synonymy of "rapture" (the masculine *ravissement*) and "ecstasy" (the feminine *extase*), also demarcated a discrepancy between them: "Ecstasy is called 'rapture' because it is by means of ecstasy that God entices us; and rapture is called 'ecstasy' because it is by means of rapture that we abandon ourselves and remain out of ourselves for the sake of union with Him." The celebrant of the "sweet, gentle, and delightful seductions" that draw the soul to God warns that they have the power "to ravish and derange." He contrasts sacred rapture with that profane, "infamous and abominable rapture" that is experienced if the soul is "lacking in charity or enticed by carnal delights." That tempting ecstasy is perfidious, and that rapture "inflates rather than edifies the spirit."[13] Rapture is fraught with temptation and danger—it

25

13. Saint Francis of Sales, *Traité de l'amour de Dieu* (Annecy, 1895) 7.4–6.

is ferocious and predacious, involuntary and wholly disorienting. Francis could have been speaking for the father of Rishyashringa; while he indicates the analogy of sexual and religious experiences, he distinguishes sharply between them. The evaluative bifurcation is a matter of the object of eros, that object making the experience either annunciatory or condemnatory; the cause of rapture, not the sensation of it, determines its sacrality or profanity.

Rishyashringa has obstructed the rain by means of his *tapas*, a word originally and essentially meaning "heat," but referring particularly, in the story of the rape of the ascetic, to religious austerities and zealous mortifications, the dynamics of which are understood in terms of an internalization of the Vedic fires of sacrifice. The biological (and concomitant psychological) presumption inherent in the vocabulary is that asceticism (and chastity in particular) is a matter of augmenting and storing this fiery energy; *tapas* is squandered in sexual intercourse. As sexual release is experienced as a rapture, so too is the burning up of the transient ego, the release of the self from this painfully persistent round of birth and death. That is *mokṣa, samādhi*—the great release, a meta-rapture.

Rapture

Saint Teresa of Avila (1515–1582), who no doubt influenced Saint Francis, and whose vulnerabilities to beatific raptures and propensities to orgasmic ecstasies have been monumentalized in our imaginations by Bernini, repeatedly noted that *el rapto* is essentially involuntary and absolutely irresistible; it cannot be controlled, neither hindered nor precipitated. Rapture, she confesses, "is a shock, striking quick and sharp, before you know what has happened to you. You cannot help it or yourself. It is felt as a cloud or seen as a mighty eagle, snatching you up and ascending with you on its wings. You are being carried away, *raped*, and you do not know where you are being taken. I must admit that this rapture terrified me at first—how could I help but be afraid when I saw my body being lifted from the earth?"[14] Rape, in Catholic mystical theology, provided a psychologically powerful metaphor for a certain experience of God: the soul, against will and despite motive, is abducted, stripped bare, penetrated, and utterly overwhelmed; in an unsolicited suspension of discriminative consciousness, there is a non-premeditated realization of the way in which two can be one. This mystical salvation comes through ravishment, a result of the mission of a ravishing god, not on account of deliberate spiritual endeavors of the ravished supplicant.

The Vidarbhan princess Rukmini was literally raped by Krishna (the god who revealed himself in the *Bhagavadgītā*), seized and carried away. But the rape was an apotheosis: as a consequence of that violation, the woman realized her identity as the goddess; and when, on the eve of the current age of tribulation, she made his funeral pyre her own, she was transported up to heaven to enjoy a pristine, eschatological rapture.[15]

Protestant theologians, soberly proclaiming a complete distinction between the platonic *eros* and the Pauline *agape,* severed all affinities between profane, carnal love and sacred, spiritual love: the two were neither homologous nor analogous. Sexuality, even in its most vigorously sublimated and rigorously spiritualized form has, in Protestant theology, nothing to do with Christian love. Erotic beatitudes, no less than beatific sexual

14. Saint Teresa of Avila, *Vida de Santa Teresa de Jesús*, ed. Fr. Diego de Yepes (Buenos Aires, 1946) 20.3, 7, 9 (my emphasis).

15. *Hṛta*, the participle used in the text (*Viṣṇu Purāṇa* [Gorakhpur: Gita Press, n.d.] 5.26.6), like the Latin *raptus,* means "seized," "taken away"; the narrowing of the meaning into "rape" comes with the author's reference to the act as the *rākṣasa-vivāha* (5.26.11).

THE FABLE OF THE
COURTESAN, THE ASCETIC,
AND THE KING:
EROTIC, RELIGIOUS, AND
AESTHETIC
RAPTURE IN INDIA

encounters, are delusory. Thus the psychological and figurative experience of being lifted up from the earth and spiritually carried away of the Catholic mystics becomes the physical and literal ascent into heaven of conservative Protestant chiliasts by means of an unimaginatively fundamentalist reading of I Thessalonians 4:16–17. In that epistle, Paul, who had himself experienced a transformative rapture on the road to Damascus, announces that when the Lord raises the dead in Christ, those who believe and are still alive "shall be caught up together with them in the clouds to meet the Lord in the air." The poetic rapture that was the erotically spiritual transport articulated by Teresa became banalized (by way of a mainstream Protestant use of the term "rapture" for the Second Coming of Christ) into the puritanical and paranoiac Pentecostal rapture referred to on a bumper sticker I saw recently on a '92 Dodge Dart: "Warning: In case of Rapture, This Car will be Unmanned." Rapture remains a loss of control.[16]

Asian mythology is no less millenarian. This is the Kali Age, the time of darkness and degeneration, and in it the Indian seer is no less apocalyptic than the prophets of Christian doom. The end is at hand: "Decay persists in the Kali Age until the annihilation of human beings," the Vedic sage Parashara announces; and the tribulation culminates in the coming of an avatar—the horseman Kalkin, like a warrior at Armageddon, will wipe out corruption, devastating all who are evil in thought or action. And following this tribulation, there will be a kind of rapture: "The hearts of humanity will become as pure as crystal; they will be awakened as at the end of night. These new perfected beings, the redeemed residue of humanity, once transformed, will give birth to those who will thrive in a Golden Age of Purity."[17]

There is, however, a significant difference between the Christian and Hindu cosmologies of rapture. While the former results in the resurrection of the body into a state of everlasting joy, the Indian imagination does not dare to conceive of a corporeal ecstasy that is anything other than essentially transient; the gods themselves are subject to time and death. Entropy, though reversible, will ultimately continue to reassert itself, and the Golden Age will once again yield, through time, to yet another Iron Age and another and another; as light must succumb to darkness, heat to cold, and movement to stillness, so all rapture will eventually dissipate into despair. Thus liberation from the microcosmic cycle of birth, death, and rebirth within the macrocosmic cycle of creation, destruction, and re-creation must be the ultimate aspiration of a penitent Rishyashringa. Finally he strives for the non-rapturous rapture of the immaculately transcendental peace of eternal oblivion.

In one version of the story of the yogi and the courtesan, Rishyashringa marries his seducer and she comes to live with him in the hermitage, "possessed by love, religiously waiting upon him and obediently serving him as loving *bhaktā*."[18] The adoring wife of the epic literature became the model for a certain kind of Indian religious sensibility, that of devotion, of *bhakti*. This devotion, as taught by the *Bhagavadgītā* and other normative texts, was initially calm, cool, and collected, rigorously controlled and hardly rapturous. But (probably through South Indian influences) a new form of *bhakti* developed by the end of

16. The year of the Dodge is not insignificant: it was in 1992 that the evangelical Mission for the Coming Days actually made headlines with their announcement that the apocalyptic rapture was, absolutely without a doubt, imminent. A pamphlet published by that group in February of that year of our Lord, using biblical references to compute the exact time and date of the event, ends with a prayer that "each and every one of you will serve and love our Lord Jesus until the time of the Rapture, 24:00 of 28 October 1992, and then join us to meet the Lord in the air."

17. *Viṣṇu Purāṇa* 4.24.25–29.

18. *Mahābhārata* (Pune: Bhandarkar Oriental Research Institute, 1933–59) 3[33]113.24.

the first millennium. This *bhakti*, a passionate and fiery love for god in which rapture was a symptom, a method, and a goal, is epitomized by the lovelorn milkmaids of Vraja who, intoxicated by the beauty of Krishna, fell into convulsive raptures at the mere thought of the bewitchingly beautiful deity. "Once our hearts were set within our homes, but then you abducted us, ravishing those hearts," one sings, and cries out on behalf of the group: "Place the cool lotus which is your hand upon our burning breasts and fevered faces." The amorous god lured the milkmaids away from the protection of their fathers or husbands into the forest, where "he embraced them, touched their hands, ran his fingers through their hair, and caressed their thighs and breasts; he aroused them by joking with them and scratching them with his fingernails. And then he made love to them. . . . The women were intoxicated, their hearts enraptured by the way he walked, by his sexy smile and his sweet talk. . . . Every one of them experienced the supreme rapture, the great pleasure of feasting their eyes upon him."[19]

In emulation of the mythical milkmaids of Vraja, a legion of medieval saints, male and female, sang of the beatitudes of love, of the rapture experienced through the grace of Krishna. One of the most renown of them, Chaitanya (1486–1533), was a prime exemplar of a state in which the experience of ecstasy comes not from the will or action of the devotee but from the sudden and surprising attack of a passionate god. It is a seizure that overwhelms the saint. Once, the hagiographer explains, Chaitanya just happened to hear the flute of a village boy and it reminded him of Krishna's flute: "He was ravished by the sound and lost all sense of himself in the sacred frenzy of love. He fell on the ground and foamed at the mouth."[20] Throughout the hagiography, he is described as being overcome by madness, frenzy, and hysteria as he danced and sang, weeping and laughing, in holy, erotic raptures. Identifying himself with Radha (the milkmaid who emerged in poetry as Krishna's favorite), he would, as if to lure the god, dress up as her, pretend to be her as he danced and sang passionate love songs. Then it would happen: he would lose all control, and in a spasmodic rapture, a seizure and abduction of his ego, he would become Radha, deliriously suffering that rapture as her rapture.

In contrast to Chaitanya who, like Saint Teresa, remained physically chaste while being spiritually raped and emotionally enraptured, there were members of the Sahajiya cult of Bengal who believed that sexual rapture could be epiphanic, that sexual union was sacred to the degree that during it the man realized himself as a manifestation of Krishna while his consort recognized herself as Radha: "The essence of beauty springs from the eternal play of man as Krishna and woman as Radha. Devoted lovers in the act of loving seek to reach the goal," announces a Bengali song attributed to the fifteenth-century Sahajiya poet Chandidas. "Using one's body as a medium of prayer and loving spontaneously is the Sahaja love."[21]

What was comic in the story of Rishyashringa—the boy's innocent acceptance of sexual union as an esoteric religious discipline, a yoga leading to *samādhi*—becomes suddenly serious in the Sahajiya movement as an essentially Tantric form or method of Krishnaite *bhakti*. While the emotional *bhakti* of medieval saints promised the heated

19. *Bhāgavata Purāṇa* (Bombay: Nirnaya-Sagara Press, 1910) 29.34, 41, 46; 30.2; 32.9. Throughout the text, verbal forms that refer to being seized, abducted, transported, i.e., raped (*gṛhīta, apahṛta, ākṣipta*) are used. *Nirvṛta* is the word I have translated as "supreme rapture."

20. *Caitanya-caritāmṛta* of Krishnadasa Kaviraja (Calcutta: Gaudiya Math, 1958) (*Madhyalīlā* 18. 151–52); my rendering follows the rough translation of Nagendra Kumar Ray (Puri: Sri Sri Chaitanya-Charitamrta Karalaya, 1959).

21. Chandidas, translated by Deben Bhattacharya in *Love Songs of Chandidas, The Rebel Poet-Priest of Bengal* (London: George Allen & Unwin, 1967), 105, 82.

rapture that comes from loving God, the ritualistic *tantra* of the same period affirmed the cool rapture that results from being God. There were antinomian Tantric cults in which ritual sexual union became a means of *samādhi*. In Tantric literature in general, however, sexual union is sacramental not as a method of experiencing rapture (in the sense that rapture implies a loss of control or a ravishment), but rather as a way of checking it, a mode of storing *tapas* (equated in this context with the retention of semen); it is practiced dispassionately. The Tantric adept, like the courtesan who seduced Rishyashringa, is profoundly in control. And like the courtesan, the Tantric hero has power; his sexual activity is both an expression of that power and a method of augmenting it.

The Vacillations of the King: Aesthetic Experiences of Rapture

Once upon a time there was a king named Bhartrihari who, inspired by the loveliness of the women in his harem and charmed by the manifold manners in which they applied their mastery of the amorous arts to entertain him, composed songs in celebration of the exquisite transports of passion. He was a connoisseur of the beauty manifest in the flowers of the royal garden, the courtesans in the royal palace, and the poetry that was recited and the art that was viewed in the royal hall. Those women, with those flowers strung in their hair, girdled with strings of rubies, gathered to listen to that poetry:

"*Renounce sense pleasures*" *is but a homiletic platitude,*
 Holy prattle from loquacious mouths that theologize;
 But who on earth can adopt such a solemn attitude
 And give up ruby-girded loins and water-lily eyes?[22]

One day an ascetic came from the forest to the palace to offer the king a wonderful gift—a strangely delicious fruit that the yogi claimed had a magical power to bestow eternal youth on the one who tasted of it. The mendicant explained that it had been given to him by a god in reward for the firmness of his chastity and the rigor of his austerities.

The king was so enamored with one particular courtesan in his harem that he, in hopes of sustaining her loveliness forever, endowed the nectarous fruit to her. She, in turn, and for the same reason, bestowed it upon her secret paramour who then lovingly tendered it to a woman who, unbeknownst to anyone, had ravished his heart. That lady, another of the courtesans of the harem, so adored her lord, the king, that she, with a bow at once reverential and passionate, presented it as a gift to him, that he might preserve his youthful vigor and demeanor for her. The moment that he saw it, he was stricken with grief, utterly disenchanted, and wholly overwhelmed by a realization of the inconstancy of love and the transience of all erotic raptures:

22. *Śṛṅgāraśataka* of Bhartrihari 71 (D. D. Kosambi critical edition, 147). Three collections of poetry—one a set of moral maxims (*nītiśataka*), one a century of erotic poems (*śṛṅgāraśataka*), and one an anthology of stanzas on renunciation (*vairāgyaśataka*)—have been attributed to him. I have used the editions of both W. L. S. Pansikar (Bombay: Nirnaya-Sagara Press, 1917) and that of Kosambi (Bombay: Singhi Jain Series, no. 23, 1948).

Me: I'm in love
 with a woman who's in love
 with a man who's in love
 with a woman who's in love
with me.
 Fuck her! fuck him!
 fuck the other woman!
 fuck love and Love!
and me! [23]

In disgust and with the ambition of renouncing a life in which amorous joy is all too fragile, Bhartrihari fled to the forest and searched for the ascetic that he might return the magic fruit and find refuge in his ashram. When with perfect detachment, the holy man tossed the fruit aside, a wily monkey darted down from the tree and made off with the gift.

The ascetic initiated the king into yogic practices, taught him the ancient discipline with all the dedication that the father of Rishyashringa showed for his son. Eagerly discarding his royal robes for the scant, rough garb of ascetics, the king immersed himself in fiery austerities, embarked in chastity on the eremitic path, storing his seed, and striving to burn up the illusory ego and to isolate eternal spirit from evanescent flesh. He recited:

Inevitably the ones we have enjoyed in love,
 no matter how long they have abided with us,
 abandon us;
Suffering that separation, how is it that a man,
 his heart so ruptured, still does not
 let go of them?
If they wander off of their own free will,
 the heart is tormented with a misery,
 unequaled and infinite;
But if he lets go of them of his own accord,
 the heart will realize a rapture,
 serene and endless. [24]

Often during his meditations he would be assailed by memories of the palace: he pictured the smile of a courtesan, heard the tinkling of her anklet bells, and smelled, in the Malabar breezes, the fragrant sandal talc that cooled her breasts. Ravished by recollections, he could not help but return to his palace. Memory (Smara) is, after all, one of the many names of Kama, the harassing god who is love.

Back in the world, once again taking women of flesh and blood into his embraces, it was not long before he realized that it was his own imagination, his fantasies as a poet, that had prompted him to abandon the ashram for the palace:

Lee Siegel

30

23. This stanza (311 in the Kosambi edition), a seemingly late addition to the Bhartrihari collection, is no doubt the seed of what was to become this legend.

24. "The ones we have enjoyed" is for *viṣayā[ḥ]*, which includes not only people but all objects of enjoyment. "Rapture that is serene and endless" is for *śama-sukham anantam*, which the commentator (in the Pansikar edition) glosses as the "highest bliss" (*paramānanda*) and explains: "The happiness of love is worldly, the greatest happiness is divine; it is the result of the peace that comes by giving up desire" *Vairāgyaśataka* 12 (Kosambi 157).

"Lips like rubies, teeth like pearls"
 describes the oral orifice of girls;
"Hair like flax and alabaster skin,"
 describes scalp and hide that's feminine;
"Limpid pools," describes just eyes:
 ideals made up of poets' lies,
Ugliness turned into beauty
 out of some artistic duty.[25]

THE FABLE OF THE
COURTESAN, THE ASCETIC,
AND THE KING:
EROTIC, RELIGIOUS, AND
AESTHETIC
RAPTURE IN INDIA

Once again the king sought refuge in the forest. Eyes closed, legs folded, palms upward in his lap, breathing slowly and evenly, he strove to know the moment when the raindrop falls into the sea, to experience the rapture that comes with being obliterated, released, merged forever and ever in the sea of Brahman. But on the brink of that oblivion, he suddenly felt a need to visit the palace once more, to say good-bye to those who had given him pleasure, despite the transience of that delight.

Back and forth he went between the palace and the ashram—seven times in all—ever torn between sensual indulgence and ascetic renunciation:

In this world, passing, insubstantial, ever changed,
 There are two ways in which one's life may be arranged:
There is piety, austerities, and devotion,
 Overflowing with a nect'rous knowledge of high truth;
No? Well, then pursue another sort of emotion—
 And touch with lust that part hidden, low (and uncouth),
Within the firm laps of women prone to pleasure,
 Loving ladies with warm thighs and breasts beyond measure.[26]

Perched in the branches of a tree in the ashram, the monkey who had filched and devoured the magic fruit could not help but burst out with laughter over the poem and the irresolute king who recited it.

While in the ashram, nostalgic for the erotic rapture of love, the king authored amorous songs; while in the palace, missing the yogic rapture of Brahman, he wrote verses on renunciation. But all the while, in both realms, he composed poetry, finding his ultimate solace in the delectable rapture of poetry itself, in a transcendent world created in, by, and as art, a sublime kingdom entirely free from the constraints of reality and not dependent on anything but itself.[27]

25. I have taken the liberty of using English clichés for Sanskrit ones. Literally rendered, the stanza is far more condemnatory: "The bulbs that are her teats are compared to golden pitchers; her face, that receptacle of sputum, is compared to the hare-marked moon [as receptacle of the nectar of immortality]; her thighs, putrid with dribbles of piss, are said to rival elephants' trunks. Thus a form that is disgusting is made delectable by various poets" (Kosambi 159).

26. *Śṛṅgāraśataka* 37.

27. The legends considerably postdate the actual historical Bhartrihari (mentioned by the Chinese pilgrim I-tsing in his seventh-century account of Buddhist India); my sources include the *Vikramacarita* (Cambridge, Mass.: Harvard University Press, 1926) and the *Bhartṛharinirveda* of Harihara (Bombay: Nirnaya-Sagara Press, 1892).

Lee Siegel

Rapture. The word reverberates religion and sex; and those reverberations are established, heard, and reconciled in the figurative manipulations of language that constitute poetry.

The Sanskrit poet was called *kavi*, a word that originally implied a priestly seer, gifted with insight and a holy voice in which he could, by the power of his magical praises, invoke and confront sacred forces within and without. The Sanskrit word for "poetry," "*kāvya*," is a qualitative rather than a formal or stylistic term, describing any work of prose or verse that is infused with a particular and conventionally delineated *rasa*, an aesthetic flavor, mood, or sentiment. Innately abiding like instincts within the human heart, according to the theorists, are basic emotions such as love, merriment, sadness, courage, anger, fear, and so forth. In the theater or literary text (or, implicitly at least, in other art forms, including painting and sculpture), the affects and effects of these emotions may be represented in such a way that they are transformed or enhanced to precipitate an aesthetic experience, a *rasa*, in the heart of a spectator, reader, or viewer. That sublime *rasa* could be fully savored, it was argued, only by people who, through many births and diligent study, had cultivated a capacity to take a transcendental pleasure in the universality of the sentiment. They were the *rasika*s, literary gourmets, who relished the good taste of poetry, the flavor produced through a harmonious blending of lovely images, melodious words, and majestic ideas. They were tastefully dispassionate rapturists.

There were Indian aestheticians who equated the experience of the *rasika* or connoisseur with that of the yogi or ascetic, and correlated the pure experience of a poetic sentiment with the religiously idealized experience of the oneness of the ineffable Brahman as the absolute ground of existence. The aesthetic moment was understood as a sacred one, a rapture, an eternal instant in which one was seized, carried out of oneself, utterly transported. Art sanctified the world.

The twelfth-century critic Mammata argued that poetry has the power to engender a world that is "free from the constraints of reality, uniformly rapturous, and not dependent on anything but itself." Poetry, he held, can bestow the "immediate realization of a transcendent rapture." In the moment that the *rasa* is tasted, he asserted, "everything else falls into oblivion and one feels as if one were experiencing the absolute rapture of Brahman."[28] A work of art, like the magical fruit presented to king Bhartrihari, can, through its delectable taste, redeem us from the confines of time and space. Disparities between the erotic and the religious evaporate in the heat of rapture. Dissolution is the resolution and absolution.

I return to the memory, revived by the invitation to write this essay, of being an adolescent, lying in bed alone, late at night. Listening to the sitar music and the sound of rain, I was seized by fantasies. A teenage imagination conjured up an Indian god with terrifying manifold mouths, tusked and gaping, each one a blazing furnace that beckoned with incendiary promises of a frightening yet tempting eternity. I saw the smile of a girl in the fire, a young Indian girl from one of the erotic miniatures in the book I had stolen; she

28. *Kāvyaprakāśa* of Mammata (Pune: Bhandarkar Oriental Research Institute, 1965) 1, 4. Poetry, and art more generally, has, by the lies it tells and the illusions it creates, the potential to redeem us from our suffering even if it is that very suffering that is depicted or celebrated in the poem or work of art. In his "In Memory of W. B. Yeats," W. H. Auden speaks of the poet who "Sing[s] of human unsuccess/ In a *rapture* of distress" (my emphasis).

THE FABLE OF THE
COURTESAN, THE ASCETIC,
AND THE KING:

EROTIC, RELIGIOUS, AND
AESTHETIC
RAPTURE IN INDIA

was, no doubt, as ravishingly beautiful as the courtesan who initiated the youthful Rishyashringa into the mysteries of sexual love. Overwhelmed, as surely anyone on the threshold of adulthood must naturally be, with melodramatic anxieties about death and love, I got out of bed and tried to write a poem by candlelight. It was, most likely, pretentious and self-indulgent, awkward and, no doubt, sensationally sentimental. I cannot recall the words scrawled on the page, but I do remember that it was about that imaginary oriental god and girl. And I remember what it was called—"Rapture."

In a characteristically polemical statement on "art as art" in 1962, Ad Reinhardt rigidly distinguished the work of art from any other kind of object. Art, he insisted, was to be enshrined in the museum as an object *sui generis*. Yet in spite or perhaps because of his iconoclastic contention that a work be encountered wholly on its own terms, Reinhardt's dicta bear telling traces of religious rhetoric:

> When an art object is separated from its original time and place and use and is moved into the art museum, it gets emptied and purified of all its meanings except one. A religious object that becomes a work of art in an art museum loses all its religious meanings. No one in his right mind goes to an art museum to worship anything but art, or to learn about anything else.[1]

A religious object loses all meanings except, that is, the devotional and contemplative posture of worship. Art belongs to its new shrine, the museum, where it is isolated from the profane world of nonartistic meanings. Although the aesthetic object may no longer be religious in an institutional sense, the viewer's encounter with it, according to Reinhardt, retains something of the aura of veneration. This suggests that fine art since the seventeenth century, as Reinhardt pointed out in his essay, has undergone a significant transfiguration, as it were: from the *sacred* context of religious devotion to what we might call the *spiritual* domain of aesthetic contemplation.

David Morgan

SECRET WISDOM AND
SELF-EFFACEMENT:

THE SPIRITUAL IN ART IN THE
MODERN AGE

But surely no word is used less happily these days when talking about art than "spiritual." It conjures up everything from auras and artists in robes to the mysteries of the sublime and the great white cube of the gallery-chapel. But the semantic imprecision of the term is perhaps best dealt with by laying down a clear set of definitions which will recuperate a word that is, it would seem, irreplaceable. "Sacred" I take to designate any ritual, object, or text linked to religious institutions; by "spiritual" I mean an understanding or experience of the human self as related in a vital way to an other—not just any other, but a world or person or place that presents a compelling claim which can be ignored only at great expense to one's sense of well-being. This other may be religious in the formal sense; but it may also be quite unrelated to official religious practices and beliefs. Whether it is one's God or the ethical encounter of another human being, the spiritual is the relation that unfolds in one's response to the other, bringing with it a new sense of personal identity.

Art and Religion

Visitors to art museums have not failed to observe the similarity between the exhibition of works of art and the ritualized presentation of relics, liturgical items, icons, and statuary.[2] Artistic and religious experiences are distinguished by a special consciousness of objects as symbolic and not strictly instrumental. Protocols shape the practices of art and religion, requiring from participants a response that observes a prescribed etiquette, one that addresses the object or act as constituting an end in itself.

The preparation of this essay has benefited enormously from the thoughtful assistance of Richard Francis, Sue Taylor, Sally Promey, and Deborah Haynes. —D. M.

1. Ad Reinhardt, "Art-as-Art," *Art International* 6:10 (December 1962); reprinted in Charles Harrison and Paul Wood, eds., *Art in Theory, 1900–1990: An Anthology of Changing Ideas* (Oxford: Blackwell, 1992), 807.

This fetishization of objects, words, and actions is typically authorized in both art and religion by the metaphysical apparatus of transcendence. The transcendent is that which cannot be grasped by reason or the conventions of use. The transcendent is set apart from the profane world, requiring a distinct, self-generated ritual for access, disarming those who would approach it, insisting that they be mindful of the threshold it draws and the failure of ordinary categories to apprehend the liminal.[3] In the context of organized religion, a cult and priestly caste typically enact the special (often "revealed") protocol of divine access in the form of liturgy, pilgrimage, monastic rituals, or religious education. In the case of art, the caste consists of the entire intelligentsia that gathers before the work of art to possess and interpret it: collectors, scholars, museum staff, critics, and literati.

Art and religion may also helpfully be compared with one another on the basis of their social purpose as forms of critical reflection, on the one hand, and as an authorization of prevailing forms of power, on the other. While it is misleading to differentiate these two absolutely—no cultural form is probably ever just reflective or just authoritative—a careful analysis of the social operation of religious institutions and works of art will show that one purpose is often preponderant. The formative influence of art and religion most frequently takes one of two directions: first, to move adherents to reflect critically on the very basis of their identities, indeed, to challenge dominant constructions of authority, social order, and imagination and replace them with a new sense of purpose; second, to privilege certain mores and authorize particular relations of power. We can refer to the first as the critical or cognitive purpose of art or religion, and to the second as the functional purpose. Functionalism assumes that cultural forms such as art and religion exist to preserve order, to enable a social mechanism to operate consistently in a way that ensures and authorizes the persistence of certain patterns of behavior. Rather than constructing a sense of the real or asking why the world is the way it appears to be, art and religion may be used to maintain values and ideas, rituals and institutions that organize society in a particular way. Hence the parades, processions, fairs, speeches, medals, and ceremonies of commemoration that have accompanied the installation of so many bronze statues (religious and otherwise) in parks and public squares in order to enshrine a given set of memories and public texts. In these solemn moments, governments exercise the authority of memory. Certainly such official acts interpret the world for those who subscribe to the official account of events and the pantheon of civic heroes and moral exemplars, but the chief purpose of the monument is to canonize certain thoughts and proscribe others. Such monuments deepen the existing channels of power that shape life rather than tell one what life means. These monuments tell the viewer what to think rather than explore what thinking itself may entail. Conversely, the cognitive role of art, religion, or any other cultural form such as jurisprudence or science is to reflect upon the state of affairs as such, to attain a distanced, self-reflexive posture of evaluation that is willing to throw into doubt the status quo in order to seek out a preferred state of existence.

35

2. In sociological research published in 1969, sixty-six percent of manual workers who were asked which place a museum reminded them of most replied a church—see Pierre Bourdieu and Alain Darbel, *L'Amour de l'art* (Paris: Editions de Minuit, 1969), appendix 4, table 8; cited in John Berger, *Ways of Seeing* (London: BBC and Penguin, 1972), 24. For a recent reassessment of the museum as a ritualistic space, see Carol Duncan, *Civilizing Rituals: Inside Public Art Museums* (New York: Routledge, 1995), chapter 1.

3. This definition of transcendence obviously stresses religious experience. For a very different notion of the term in art, one based on the phenomenological philosophy of transcendentalism, see David J. Glaser, "Transcendence in the Vision of Barnett Newman," *Journal of Aesthetics and Art Criticism* 40:4 (Summer 1982): 415–20.

This distinction may illumine the differences between the avant garde and more traditional art: the former assumes a cognitive purpose, the latter a functional one. What advocates consider "progressive" or "serious" or "avant-garde" art is art that ponders the conditions of its existence, including its relation to other spheres of human activity. Avant-garde art questions the foundational presuppositions governing artistic practice and appreciation as well as any aspect of the social world such art takes as its subject, whereas traditional art exists in order to preserve the canon of art and all that it transmits by virtue of its stability and conservatism. This is a broad definition, to be sure, and one that is not without a host of qualifications, not the least of which is the irony that most art that would go by the name of "avant garde" is, in fact, ensconced in the tradition of the avant garde and not any more progressive, relatively speaking, than the most moribund and banal bronze statue of a long-forgotten war hero standing in a municipal park. Much so-called avant-garde art performs the conservative purpose of affirming a posture of protest for the sake of appearing progressive. Although the banal bronze statue might become a poignant occasion for reflecting on the boundaries of the ordinary world and the functional consciousness that defines it (as Duchamp's toilet bowl did), in its public erection and ritual veneration the purpose of the statue is not to probe the structures of its familiarity, but to assert them. Simply put, avant-garde art is any art that calls into question the dominant habits of thought and perception that shape consciousness by occluding the problem of those habits' foundations. Thus, as general as the distinction between critical and functional purposes is, it serves to point out that the religious and the aesthetic should be compared and contrasted in regard to their social purpose.

From Sacred to Spiritual

If the working definition of the spiritual presented above as a compelling claim exercised by an other is applied to works of art, particularly the works in this exhibition, at least two modes of the spiritual in art become apparent. I propose to call these two modes the Faustian and the kenotic. The Faustian designates something secret that one desires to know and whose disclosure is brought about by the work of art; the kenotic refers to a gripping experience that inspires a searching reassessment of prevailing wisdom. There are doubtless many other ways to apply the spiritual to art, but these two categories address distinctive and prevalent conceptions of the human self. The Faustian, the first way, diagnoses the human problem of suffering as ignorance and seeks deliverance from this state through the acquisition of gnosis or secret wisdom. The kenotic view, on the other hand, sees the problem as ontological and pursues regeneration or rebirth, transcendence of the limited stature of the human condition by divestment or emptying out (*kenosis*) of the self in the quest for something better. According to these definitions, therefore, the spiritual in human experience is the perception of humanity's limits and the proposal of a path for overcoming these limits. The spiritual in art, we might say, consists of the artistic configuration of human boundaries and their negotiation in the experience of a work of art. Analysis may stress either the role of the artist or the reception of the work. The preponderance of this essay falls on the latter, the beholder's share.

Both the Faustian and the kenotic methods address the limit or threshold of personal identity. Both work by constructing a sense of the liminal and its surpassing or climbing over (*trans-scendere*), but each articulates this act rather differently. The Faustian approach, like its namesake, seeks a special kind of knowledge, one based not on arbitrary signifiers but on magical symbols, a knowledge that touches and moves the heart

of things. This theurgic quest is indebted to the hermetic, alchemical, and kabbalistic sciences of the Renaissance, which sought out an Adamic *Ursprache* or universal language of symbols and natural objects that could unlock the secrets of nature. The artistic appropriation of this sensibility resulted in various attempts at aestheticized hieroglyphics evident in art from Romanticism to the present. For instance, Philipp Otto Runge's *The Four Times of the Day* (illus. below) is a complex visual allegory that keys the life of the soul to the cycle of morning, noon, evening, and night as well as to ancient mythology and the symbols of Christian mysticism. Often in the images of the Surrealist Remedios Varo, the artist acts as the primordial co-creator of nature. In *Creation of the Birds* (illus. below), the artist—seen as an owl, the symbol of wisdom or *sophia*, co-creator of the universe according to Proverbs 8:22–31—generates nature's forms as distillations of celestial elements and the artist's own inner harmonics. In both Runge's and Varo's works, the cipher-script and the gnosis it encodes seductively promise the viewer an expansive vision into the mystery of things. Such an approach almost invariably postures the artist as a shaman or spiritual adept. Moreover, it argues that reality is not what it seems and that without the key of understanding one will be at the whim of forces beyond one's control.[4]

4. For a lengthy consideration of modern art influenced by
 this intellectual and occult tradition, see Maurice Tuchman
 et al., *The Spiritual in Art: Abstract Painting 1890–1985*
 (Los Angeles: Los Angeles County Museum of Art, 1986).

Philipp Otto Runge (German, 1777–1810), *The Four Times of the Day: Morning, Afternoon, Evening, Night*, 1803–1805, engravings on paper, each sheet 30 x 22 13/16 in. (76.2 x 58 cm), The Art Institute of Chicago, Clarence Buckingham Collection.

Remedios Varo (Mexican, b. Spain, 1908–1963), *Creation of the Birds (Wisdom)*, 1957, pencil on prepared paper, 19 11/16 x 24 7/16 in. (50 x 62 cm), private collection, Mexico City.

Control through the occult sciences was the attraction of the practical application of the Kabbalah and alchemy. The hermetic speculations of Paracelsus, Robert Fludd, and many others in the sixteenth and seventeenth centuries were part of the early modern formation of faith in the power of technical knowledge to deliver humankind from suffering. Knowledge of nature meant control over it. In the hermetic tradition, the natural world was viewed as a system of corresponding strata that interacted harmonically. In the encyclopedic work of Emanuel Swedenborg, for instance, divine intercourse with the natural world was mediated by humanity. Moral conduct affected God just as immoral behavior affected nature. Knowledge of the hieroglyphic correspondences afforded an insight into the interrelations of the natural, moral, and celestial levels of the cosmos.[5] In the twentieth century, Joseph Beuys reflects the belief in a theurgic manipulation of the social world through artistic activity in his utopian notion of a social-artistic organism.[6] Indeed, the aim of the Fluxus movement, in which Beuys was importantly involved, to merge art and life can be read as a theurgic strategy of changing life through artistic activity. Beuys himself was quite clear on his belief in the emancipating power of art:

> The most important thing to me is that man, by virtue of his products, has experience of how he can contribute to the whole and not only produce articles but become a sculptor or architect of the whole social organism. The future social order will take its shape from compatibility with the theoretical principles of art.[7]

The hermetic tradition was not without its contemplatives such as Hasidic masters or the Christian mystic Jakob Boehme. But the focus on the contemplative experience as the basis of negotiating transcendence is more fully characteristic of the kenotic approach to the threshold of human existence. Accordingly, the viewer who seeks truth (whatever that may be) gazes intently on the work of art. In this act of contemplation, the mind abstracts itself from the world of ordinary sensations and desires and enters what advocates of disinterested contemplation have consistently described as a state of mind that transcends personal interest.

The kenotic method is densely interwoven in the history of modern aesthetics. By the eighteenth century, painting had taken its place in the taxonomy of the arts whose appreciation was to be "disinterested," that is, not a matter of appealing to or arousing such passions as hunger or sexual desire. Artistic beauty was to engage the refined viewer as something "perfect in itself," as Karl Philipp Moritz put it in 1785. Moritz and others elevated the aesthetics of disinterestedness to a spirituality of art. As Martha Woodmansee has demonstrated, Moritz's idea of dispassionate observation was substantially indebted to pietistic views on selflessness and the abandonment of the self in the face of God. "We seem to lose ourselves in the beautiful object," Moritz wrote, "and precisely this loss, this

5. See Emanuel Swedenborg, *An Hieroglyphic Key*, trans. Robert Hindmarsh (London: Hindmarsh, 1792), 55. For a study of the epistemology of similitudes, see Michel Foucault, *The Order of Things: An Archaeology of the Human Sciences* (New York: Vintage Books, 1973), 17–30. On theurgy, see John G. Bourke, "Hermeticism as a Renaissance World View," in *The Darker Vision of the Renaissance*, ed. Robert S. Kinsman (Berkeley: University of California Press, 1974), 101–2, and Frances A. Yates, *Giordano Bruno and the Hermetic Tradition* (Chicago: University of Chicago Press, 1964), 44–61. Jewish Kabbalists believed that the proper observation of biblical commandments could restore the divine harmony lost in the creation of the universe; see Moshe Idel, "Qabbalah," *The Encyclopedia of Religion*, ed. Mircea Eliade (New York: Macmillan, 1987), 12:121.

6. Beuys, it should be pointed out, also drew from German idealism: recalling Friedrich Schiller's philosophical reflections on the creation of a democratic state, Beuys argued that real political change would not occur until humanity had undergone aesthetic education; see Joseph Beuys, "Not Just a Few Are Called, But Everyone," *Studio International* 184: 950 (December 1972): 226–28; reprinted in Harrison and Wood, *Art and Theory*, 892.

7. Ibid., 890–91.

forgetfulness of ourselves, is the highest stage of pure and disinterested pleasure which beauty grants us."[8] The roots of transcending the self in contemplation of that which is good in and of itself originated in medieval mysticism. Thinkers in Germany during the late eighteenth and early nineteenth centuries consciously transposed mystical and theological motifs onto aesthetic experience. Following Moritz, Arthur Schopenhauer described the act of looking at a work of art as contemplative in the extreme. In 1819, he defined genius as

> the capacity to remain in a state of pure perception, to lose oneself in perception. . . . In other words, genius is the ability to leave entirely out of sight our own interest, our willing, and our aims, and consequently to discard entirely our own personality for a time, in order to remain pure knowing subject, the clear eye of the world.[9]

For Schopenhauer, this romantic conception of genius invested aesthetic experience and the artist with a redemptive function that secured art from the banality of modern bourgeois life. Schopenhauer's aesthetic of sublime self-effacement took disinterestedness to its logical extreme. Rapt contemplation became the principal mark of this manner of aesthetic experience—the kind of all-consuming attention that lulled the viewer into self-forgetfulness. A modern instance of this ecstasy appears in the connoisseur Bernard Berenson's poignant description of "the aesthetic moment":

> In visual art the aesthetic moment is that flitting instant, so brief as to be almost timeless, when the spectator is at one with the work of art he is looking at, or with actuality of a kind that the spectator himself sees in terms of art, as form and colour. He ceases to be his ordinary self, and the picture or building or statue, landscape, or aesthetic actuality is no longer outside himself. The two become one entity; time and space are abolished and the spectator is possessed by one awareness. When he recovers workaday consciousness it is as if he had been initiated into illuminating, exalting, formative mysteries. In short, the aesthetic moment is a moment of mystic vision.[10]

The negation of self and the world of conventional knowledge in the contemplation of works of art bears a striking similarity to the practice of spiritual contemplation. According to the anonymous author of the widely read fourteenth-century mystical treatise *The Cloud of Unknowing*, contemplation entailed a forgetting of the self and all created things, after which followed an encounter with the divine.[11] *The Cloud of Unknowing* as well as the "dark night of the soul" narrated by Saint John of the Cross in the sixteenth century (two important sources from which Thomas Merton drew) articulated an apophatic method of contemplation. To approach God it was necessary to abandon attachment to things in what was called the "cloud of forgetting." Everything had to be left behind, for nothing could be used to image the divine, who was encountered only in the "cloud of unknowing." As the second commandment insisted, God had no likeness; literally, God was like no other and should not be confused with any image or object. The Jewish tradition enforced

8. Karl Philipp Moritz quoted in Martha Woodmansee, "The Interests in Disinterestedness: Karl Philipp Moritz and the Emergence of the Theory of Aesthetic Autonomy in Eighteenth-Century Germany," *Modern Language Quarterly* 45:1 (March 1984): 32–33.

9. Arthur Schopenhauer, *The World as Will and Representation*, 2 vols., trans. E. F. J. Payne (Indian Hills, Colo.: Falcon's Wing Press, 1958), 1:185–87.

10. Bernard Berenson, *Aesthetics and History* (Garden City, N.Y.: Doubleday, 1954), 93.

11. *The Cloud of Unknowing and The Book of Privy Counseling*, ed. William Johnston (Garden City, N.Y.: Image, 1973), 49.

this with the threat of death: no one could see God and live. God, in other words, was utterly transcendent. Yet he revealed himself in his covenant with Israel, set down in Torah. And the mystical traditions of Christianity, Sufism, and the Kabbalah did not hesitate to image the relationship of the soul with the divine. But the apophatic method stressed that any image, verbal or visual, remained merely instrumental. Finally, the God of mono-theism eluded all signification. Truth itself, God, could only be encountered in the cloud of unknowing that enshrouded the divine and removed it from any form of apprehension. Only by dying oneself could one encounter the deity directly. Thus, the very act of negating the human apprehension of God preserved the possibility of God's self-revelation to the contemplative. By canceling their own will, the mystics opened themselves up to the infusion of divine will.

Two moves characterize the spiritual in German idealism and Christian mysticism. First, both traditions situate the spiritual and the aesthetic experience on the boundary of the ordinary or utilitarian world. Second, by stressing the importance of kenosis, the negation of the self, German idealism and Christian mysticism alike identify the subjugation of the will rather than the acquisition of knowledge as the necessary therapy for human suf-fering. From the idealist philosophies of Hegel and Schopenhauer to Wassily Kandinsky, Wilhelm Worringer, and Freud can be traced a tradition of the metaphysics of the will residing in the Germanic aesthetic of *expression*. The work of art was understood as a visual manifestation of an invisible impulse discerned and articulated by the artist and achieved by subordinating the self or the world of appearances to the revelatory expression of the inner thrust of this will. The spiritual in art, according to Kandinsky, exists whenever an artist has accommodated the will to expression, what Kandinsky called the "inner necessity."[12] In this romantic tradition, the will expresses itself in the physiognomy of the artwork, constituting a revelation of the invisible.

In the apophatic or negative method, the spiritual contemplative becomes passive in a manner that parallels the role of disinterested contemplation in aesthetic experience. Having been deprived of the instruments of apprehension and the satisfaction of need, the viewer/believer is pushed to the limit of the conventional sphere of control, the ordinary domain of the self. At this boundary something mysterious happens: the self dies and is reborn. Revelation or transformation ensues only at the expense of the ego. In the tradition of the liminal, where such elements as ecstasy and the eclipse of individuality in the sub-lime mark the advent of the divine or the rapture of artistic experience, the subject enters the presence of something greater than itself.

Premised on this spirituality of the pouring out of the self, a work of art is not worth serious consideration unless it is felt like a wound, as Saint Teresa or Saint John of the Cross would describe it, or as Roland Barthes did in a more specific fashion for photography in his last book, *Camera Lucida*. Each photograph, according to Barthes, possesses a *punctum*, a single sharp point, obvious or not, which pricks the viewer with paradox and sheer pres-ence.[13] Art that speaks powerfully is art that makes a claim on the viewer, exacting a stigmatum, leaving the mark of its presence on the body. The spiritual in art is not a formal feature embedded in the surface of the image, but something that happens between the work and the viewer, or better, the worlds in which the viewer exists. The work touches us where we touch others, at the seams of worlds held together with pain and desire.

12. Wassily Kandinsky, *Concerning the Spiritual in Art*, trans. M. T. H. Sadler (1914; New York: Dover, 1977).

13. Roland Barthes, *Camera Lucida. Reflections on Photography*, trans. Richard Howard (New York: Hill and Wang, 1981), 26–27.

Transcendence and Transformation

If there is a single common element available in the works of the exhibition and in the varieties of spirituality it is the experience of being brought to the limits of the self and peering nakedly into the beyond. My world crumbles before the looming prospect of a reality that threatens to replace the foundations of the familiar. My sense of order is jumbled, my status called into question, whatever I took to be certain may be thrown into doubt. This experience of the liminal may be configured as transcendence or as trans-formation. The two should not be confused. Transcendence posits a mystery present in the work of art as the encounter with a metaphysical order beyond or hidden within the ordinary, sensuous world. Transformation, on the other hand, confronts enigma in the work, the disturbing sense that the world is not right. Theodor Adorno spoke of the enigmatic aspect of artworks as their fragmentary character, their status as damaged, less than whole, or incomplete. We might say injured with the wound of violation.[14] If the sublime and the contemplative experience in idealist thought were aimed at union with the divine, elevation to a mystical wholeness, and identity with the cosmic all—that is, transcendence as such—transformation consists of change in the sublunar world alone. One thinks of Freud's transposition of the Schopenhauerian *Wille* into the psychological domain of the Id or It; the result was to eliminate platonic dualism from the aesthetic act and confine expression to the operation of symbolic transformation. Enigma cancels the metaphysical contract with the holy that any conception of the sacred must presuppose. But the fragmentary is not without hope. It makes space in which to live by refusing to say everything, by resisting completion and presence. In this very absence it affirms the utopian possibility of the world as it ought to be.

In the case of the transcendent, the mystery is what promises to unveil itself in the wake of the apocalyptic passing of reality. With the enigma, the self faces its limit, envisions the end of worlds in order to escape their tyranny. Transformation means the rupture of the ordinary domains and patterns of authority, the dense cityscape of *doxa* that conduct the traffic of thought. Transformation portends the possibility of an alternative self and social order, while enigma preserves a radical open-endedness, vigorously resists perfection in the sense of ontological completion or metaphysical resolution. But in either mystery or enigma, transcendence or transformation, something must die in order for something new to live. Death and rebirth and their dialectic of conflict are the characteristic moments of the human self and the principal features of spirituality and its artistic evocation.

If art is to perform a truly transformative task, it must address a world, the place where people dwell, the set of stories that collectively interpret human existence in a peculiar way. The work may call this system into question or broaden its horizon. The Faustian and the kenotic approach transformation in different ways. The first would change the world by the mystical power of art as a world-symbol, whereas the second presumes to change the individual viewer and therefore the viewer's relation to and perception of the world. Both avenues have been pursued by the avant garde. Rooted in the aesthetics of empathy and the sublime, which tend to regard artistic value as a state of mind rather than an objective affair, the theory of the avant garde broadly holds that to change consciousness is to change social reality and the public life of humanity.

Whether Faustian or kenotic, action on the world is effected through action on the symbolic world of the work of art. This is the enchantment of the avant garde with its

14. Theodor Adorno, *Aesthetic Theory*, trans. C. Lenhardt,
ed. Gretel Adorno and Rolf Tiedemann (London and Boston:
Routledge & Kegan Paul, 1984), 184.

mythology of artistic autonomy. Disinterestedness and art for art's sake were the ideals put in place in the nineteenth century to underscore the autonomy of art as a world in itself, to experience beauty as a self-contained or perfected formal unity, a "little world," as Goethe once characterized the effect of opera. In the twentieth century, abstraction such as Kazimir Malevich conceived it sought to promote disinterestedness as such, complete detachment from appearances as a way of divesting spirit from material boundaries, as if the two could be neatly separated. The dream of abstraction was that the work of art would speak for itself, operate above and beyond particular myths, communicating universally and directly because it avoided the peculiarities of appearances.[15] This dream is no longer compelling in a world where universals are too easily shown to be the tools of imperialism. Despite ourselves, we are inclined to regard all artistic efforts as negotiations in a cultural marketplace that instantly commodifies the new. Transcendence is very hard to believe.

Negotiating Rapture

Negotiating rapture is a cultural transaction, a bartering for ecstasy since transcendence is bankrupt for those willing to invest only in the transformation of the self. This is not surprising when we consider that the self has become a hotly contested site, the object of a mass-mediated scramble for control in an age when advertising tells us more about ourselves and who we are (or want to become) than any priest, guru, or religious oracle. Sundered from communities, defined increasingly by single-interest political groups, identity is no longer inherited, but forged within the fray of culture wars. The ties that bind are not ontological, but contractual, and therefore susceptible to endless renegotiation.

But rapture is not only a religious event constrained to the premodern world, for it can be defined in economic terms as the ecstatic release from debt. Religion, after all, is an economy; redemption and loss are religious as well as financial terms. The Christian doctrine of redemption understands Jesus to pay the debt incurred by sin, and Jesus himself taught the parable of the talents wisely invested. Religion and art are both systems of exchange and always have been. The question that must be asked is what these systems do to the human self: do they invest it in a determinist mode, constructing it as a function of economic exchange? Or do they allow for self-determination? Purists like Reinhardt vehemently resist the notion of reducing the work of art to a simple transaction: Reinhardt dreamed of an art in which there was "nothing that is not of the essence":

> Everything into irreducibility, unreproducibility, imperceptibility. Nothing "usable," "manipulable," "salable," "dealable," "collectible, "graspable." No art as a commodity or a jobbery. Art is not the spiritual side of business.[16]

Like Barnett Newman or Agnes Martin, Reinhardt created difficult art, art that is virtually imperceptible and requires a long investment of time and effort to reap any return, because the artist deplored the prospect that art might become an instrument of easy pleasure or a means of achieving a nonartistic end. By negating art as conventional beauty Reinhardt preserved the idea of art as art. His barely discernible patterns of color, which concentrate our vision on a domain that largely transcends the range of human sensations, urge us to conclude that art exists for its own sake, independent of our sensuous awareness (cat.

15. See Johannes H. Birringer, "Constructions of the Spirit: The Struggle for Transfiguration in Modern Art," *Journal of Aesthetics and Art Criticism* 42:2 (Winter 1983): 137–50, for a discussion of Malevich and the spirituality of abstraction.

16. Reinhardt, "Art-as-Art," 809.

nos. 69–75). But this came at the price of enshrouding art in an aesthetic cloud of unknowing. Many view Reinhardt's work (as well as Newman's and Martin's) with the greatest reluctance, asking why it is necessary to make art so recondite and so autonomous in order to preserve its freedom. The search for artistic purity became absolute in Reinhardt.

The spiritual in art in the modern age has worked frequently along two axes. First, by nurturing a sense of the enigmatic, a profound skepticism, a sensibility of suspicion, but one that is nonetheless prepared to hope. This is the *via negativa*, the artistic avenue expressing the kenotic impulse. Second is the *via positiva*, the Faustian way—the theurgy of Beuys's utopian art or the opaque theosophies of Kandinsky and Piet Mondrian in which the artist acts as a visionary genius whose creative works expand human consciousness and prompt an epoch's spiritual development. Buried deep in the modernist project is a commitment to progress conceived in this manner. The crisis in the second half of the twentieth century has consisted largely of the loss of faith in this notion of progressive cultural and social evolution. The question central in the minds of many artists, critics, and art historians in the late twentieth century in light of the loss of this faith is simply: does art still possess the power to speak to the culture about things that matter? Can the apophatic method break free of a system of exchange that makes art a commodity?

The strategy of much avant-garde art, like the mystic's path to illumination, has been to strip away the accretions and conventions of culture as if they were barnacles adhering to the hull of pure art. Progress along this path of negation has been measured by mounting acts of iconoclasm.[17] Art since the Second World War is often fixed on plunging into the wilderness of negation, where it divests itself of cultural illusions, the *maya* of artistic hype and self-promotion. Chief among the cultural constructions to be dismantled is the artist. Bruce Nauman seems deeply skeptical about the prospect of the artist as a revealer of spiritual truths. Consider the gaudy neon spiral advertising the artist's craft of revelation, as if hawking mystic truths in the hubbub of the cultural marketplace (cat. no. 54), or his window piece called *The True Artist Is an Amazing Luminous Fountain*, a thin layer of transparent Mylar through which we look upon the world outside, filtered through the artist's statement (see illus. p. 44). Nauman mixes the Albertian metaphor of the painting as a window with the romantic figure of the artist as a generative source, suggesting that both belong to a rhetoric that is bankrupt. But his dissatisfaction does not end with the rhetoric of art. Nauman probes the very metaphysic of matter and spirit. *Room with My Soul Left Out, Room That Does Not Care* (see illus. p. 44) constructs a Euclidean space through which the body passes, mapped out in a matrix of perpendicular axes, as if such a contraption could trap the soul, trace it over space and time, exposing it to the manipulative visual hunger of the viewer. Such voyeuristic emplotment of the soul recalls a pornographic film apparatus: pay your dime and watch the lady dance.

Still, in a world in which people regularly move in and out of apartments, christening each new space with the rituals of identity that involve cleaning, redecorating, displaying one's things—in a world in which we construct our identity with the clothes we wear and

43

17. For a study of negation in twentieth-century art and theological thought, see Mark C. Taylor, *Disfiguring. Art, Architecture, Religion* (Chicago: University of Chicago Press, 1992).

David Morgan

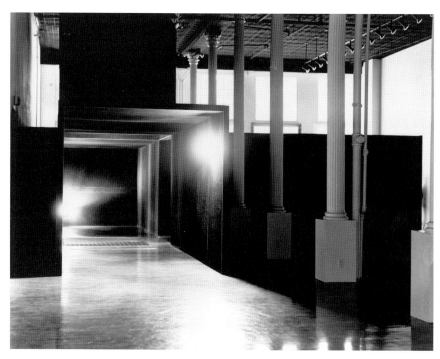

Bruce Nauman (American, b. 1941), *The True Artist Is an Amazing Luminous Fountain*, 1966, transparent rose-colored Mylar, 96 x 72 in. (243.8 x 182.9 cm), Hallen für neue Kunst, Schaffhausen, Switzerland.

Bruce Nauman (American, b. 1941), *Room with My Soul Left Out, Room That Does Not Care* (detail of interior, right; model, above), 1984, wood, foamcore, wire, graphite, 60 1/2 x 61 x 62 in. (153.7 x 154.9 x 157.5 cm), Leo Castelli Gallery, New York.

44

the space in which we dwell, rooms *ought* to care. The new space is appropriated, made to conform to the idea of one's presence such that the space becomes one's own place, the locus and womb of personal identity. Our rooms house an ecology of the self, a niche or cultural habitat to which we belong. As the first orbit of the world around the nucleus of the ego, the dwelling space becomes the immediate expression of the self, the index of the body encoded in the configuration of furniture, the storage of clothing and utensils, the shuffle of everything that does not stay in its place. Hegel gave philosophical expression to this anthropocentric ideal and linked it directly to the creation of art:

The universal and absolute need out of which art, on its formal side, arises has its source in the fact that man is a *thinking* consciousness, i.e. that he draws out of himself, and makes explicit for *himself*, that which he is, and, generally, whatever is. The things of nature are only *immediate and single*, but man as mind *reduplicates* himself, inasmuch as prima facie he is like the things of nature, but in the second place just as really is *for* himself, perceives himself, has ideas of himself, thinks himself, and only thus is active self-realizedness.[18]

According to Hegel, human self-consciousness unfolds in theoretical and practical activity. In the latter case, the human being achieves self-consciousness "by the modification of external things upon which he impresses the seal of his inner being, and then finds repeated in them his own characteristics. Man does this in order as a free subject to strip the outer world of its stubborn foreignness, and to enjoy in the shape and fashion of things a mere external reality of himself."[19] But this empathic imperative is disturbing. Nauman, and for his part, Bill Viola no less (see cat. no. 83), set out not to demolish human spirituality but to dismantle the tenacious cultural edifice of anthropocentric projection, the imperialism of homo sapiens in constructing a world-artifice that is the comfortable mirror of the being enthroned in the center. By deconstructing the romantic myth of the artist, by pursuing the kenotic impulse to the very end, Nauman and Viola may open up the possibility of something else. If rapture is the ecstatic transcendence of conventional categories, then the kenotic path seems calculated to negotiate rapture to great effect.

The Faustian element informs the work of several artists in the exhibition who regard the natural world as bearing an organic harmony with human forces. In the case of Beuys, an ecology of alchemical transformations claims to join humanity and nature in a unity which the tradition of Cartesian rationalism has put asunder.[20] According to Beuys, changing the self leads toward changing the world because the two mingle in the vessel of human consciousness. To transform the inner world of thought by transforming perception of the outer world is the key to social and economic change. Beuys wished for viewers to encounter the world not as a series of dead objects to be manipulated, but as a living totality whose parts spoke a visual language of sensations. His studies of leaves (cat. nos. 5, 12), carefully pressed and annotated, bear a transparency that invites the viewer to see through them as if toward the primordial plant (*Urpflanze*) of Goethe's research, one of Beuys's early interests (another was Leonardo).[21] Beuys's botanical studies recall the hermetic hymns to the divine clothed in nature as they were designed by Runge, Goethe's young friend, and argue for a merging of art and science into a single visual discourse. Beuys's search for a mystical taxonomy also drew from a modern master of hermeticism, Rudolf Steiner, whose work deeply informed Beuys's thought about the therapeutic power of art.[22] The attempt, finally, is to discover the eurythmic expression of the soul in the social organism, to discern the organic relation between symbol, thought, and referent. For if the connection is not merely arbitrary, thought can be made to affect the referent through the intermediating symbol in a hermetic act of magic.

45

18. G. W. F. Hegel, *On Art, Religion, Philosophy*, ed. J. Glenn Gray (New York: Harper Torchbooks, 1970), 57–8 (emphases in original).

19. Ibid., 58.

20. On Beuys and Cartesianism see David Adams, "Joseph Beuys: Pioneer of a Radical Ecology," *Art Journal* 51:2 (Summer 1992): 26–34.

21. Heiner Stachelhaus, *Joseph Beuys*, trans. David Britt (New York: Abbeville Press, 1991), 35.

22. See ibid., 35–39. On Runge and theosophical themes, see Karl Möseneder, *Philipp Otto Runge und Jakob Böhme* (Marburg an der Lahn: J. G. Herder-Institut, 1981).

Anselm Kiefer also alludes to the mythos of intrinsic meanings implanted by nature or God in expansive German landscapes. Like Beuys's leaves, compressed in memory and evoking walks in the country, Kiefer's work is imbued with cultural memory, calling forth the heroic fields of national achievement and tragedy. His 1981 *Icarus—March Sand* (illus. below) portrays a skeletal, winged figure falling to the Brandenburg Mark, which is ontologically present as broad bands of sand mixed with binder, a kind of Teutonic mortar slathered on the paint surface and redundantly labeled "*märkischer Sand*." Who is Icarus and what does his death imply? Is he Deutschland fallen from its imperial aspirations? Or is he art, as curator Mark Rosenthal has suggested, on a spiritual quest to "heal the decayed land" but failing miserably at the task?[23] The seductively sublime spaces in Kiefer's painting invariably lead one to ponder whether Kiefer is meditating on the impotence of art as a form of cultural renewal or rehearsing the heroic vocabulary of German national mythology. In light of the deeply bifurcated nature of the Faustian and kenotic moments of modern humanity—the impulse toward knowledge/ignorance and annihilation/preservation—one wishes to resist a monolithic reading of his images. Kiefer's reflections on the German character naturalized in the landscape are ironic, therefore, and all the more poignant for their hymnic preoccupation with the indices of *Deutschtum*. The size of his work speaks directly to the viewer as do the monumental geometries of pyramids and stark interior spaces. The power of cultural enchantment is precisely the painting's capacity to work on us despite our demythologizing of its conjurations.

The Faustian element in Beuys and Kiefer consists of the theurgic manipulation of nature, cosmos, or God through the gnosis encoded in the work of art—whether it is Beuys's alchemy of heat or Kiefer's dense references to German history or the Kabbalah. Theurgy posited a formative influence over natural and supernatural elements. Modern aesthetics

23. Mark Rosenthal, *Anselm Kiefer* (Chicago: Art Institute of Chicago; and Philadelphia: Philadelphia Museum of Art, 1987), 80. For a trenchant critique of Rosenthal's approach to Kiefer and of Kiefer's art in particular, see Arthur C. Danto, *Encounters & Reflections: Art in the Historical Present* (New York: Farrar, Straus and Giroux, 1990), 237–42.

Anselm Kiefer (German, b. 1945), *Icarus—March Sand*, 1981, oil, emulsion, shellac, sand on photograph, mounted on canvas, 114 3/16 x 141 3/4 in. (290 x 360 cm), Museum of Contemporary Art, Tokyo.

has widely asserted the theurgic power of art over nature. Oscar Wilde, for instance, insisted that life imitates art, that the world appears the way it does because the artist creates its appearance in the work of art. Art "makes and unmakes many worlds. . . . Hers are the 'forms more real than living man,' and hers the great archetypes of which things that have existence are but unfinished copies."[24] Images of the landscape, Wilde believed, shape our vision by teaching us what to recognize and what to ignore. Such formative vision represents a faith in the power of art to transform the world. This is indeed the faith of modernism, a faith whose fire has not yet died, though it is sorely tested by the deep contemporary suspicion that images are only rhetorical representations deployed to persuade or control.

The great myth of the avant garde is that images transform reality in a rapturous transposition of mind and matter. The spiritual in art is just this mythic exchange, a negotiation that empowers the subject as determinant rather than determined, as free to make the world rather than forced to be made by it. In this eschatological season, at the end of a long millennium, it is as easy to understand the nostalgic longing for modernism as it is hard to resist it. But we must resist the intoxicants of the day: nationalism, racism, ethnocentrism, and isolationism, in short, the longing to belong. Enchantment—symbolic action on the cosmos—must be accompanied by the other components of the modern experiment: democracy, reason, and communities (such as family, government, polity, church, or university) that can nurture cooperation and forbearance.[25]

Art that explores these communities and institutions, art that tests democracy, art that invites the exercise of reasoned discourse remains spiritual and hopeful often by pursuing an apophatic or critical path. I do not wish to contrast enchantment and reason too starkly for they seem inseparable in human culture: democracy portrays itself as progressive, reason as egalitarian, and such communities as family, nation, and academy are immersed in rituals and myths that cast a heady spell.[26] Perhaps it is enough to insist that the theurgy of art not be limited to the ontology of the autonomous work, but extended to the ethical encounter that offers us a moral existence. In a word, the spiritual in art is not contained in the work but unfolds in the real and imagined worlds of the work's viewer. As such, the spiritual in art, if it is to perform the cognitive purpose of art and reflect critically on the nature of human existence, does not present ultimate resolutions, but compelling questions, the consideration of which renews our pact with the future.

47

24. Oscar Wilde, "The Decay of Lying," from *The Works of Oscar Wilde: Intentions* (Boston: T. T. Brainard Publishing Company, 1909), 37.

25. I have considered the theme of cultural enchantment in the art and thought of Franz Marc in David Morgan, "The Art of Enchantment: Abstraction and Empathy from German Romanticism to Expressionism," *Journal of the History of Ideas*, 57:2 (April 1966): 317–41.

26. In the wake of such reductionist enterprises as positivist anthropology and Freudian psychoanalysis, Leszek Kolakowski argued that "the project of a total demythologizing of culture appears chimerical," *The Presence of Myth*, trans. Adam Czerniawski (1966; Chicago: University of Chicago Press, 1989), 124. Humans, he concluded, cannot live without myth.

Kolakowski maintained that the human need for intelligibility, the permanence of human values, and the continuity of the world represents the same desire for order that science and technology serve but never fully satisfy because, unlike myth, science and technology cannot on their own terms legitimately address "ultimate" questions about human existence (2–5). Kolakowski argued persuasively, therefore, that myth is not simply an indulgence of the irrational, but a fundamental predilection for order. Rather than being merely instinctual, myth replaces impulses of fear and anxiety with a conceptual technology that affirms the human presence in the universe (115). In support of this conclusion, one has only to imagine how less authoritative science in the modern age would be were the mystic apparatus of progress and patriarchal benevolence removed from it.

Looking at someone carries the implicit expectation that our look will be returned by the object of our gaze. Where this expectation is met (which, in the case of thought processes, can apply equally to the look of the mind's eye and to a glance pure and simple), there is an experience of the aura to the fullest extent. . . . Experience of the aura thus rests on the transposition of a response common in human relationships to the relationship between the inanimate or natural object and man. The person we look at, or who feels he is being looked at, looks at us in turn. To perceive the aura of an object we look at means to invest it with the ability to meet our gaze. The experience corresponds to the discoveries of the mémoire involontaire. *(These discoveries, incidentally, are unique: they are lost to the memory that seeks to retain them. Thus they lend support to a concept of the aura that comprises the "unique apparition of a distance." This designation has the advantage of clarifying the cult nature of the phenomenon. The essentially distant is the inapproachable: inapproachability is in fact a primary quality of the cult image.) Proust's great familiarity with the problem of the aura requires no emphasis.*

Walter Benjamin "On Some Motifs in Baudelaire," 1939[1]

The Supposition of the Object: "That of which our eyes will never have their fill"

What is the sense today, sixty years after Walter Benjamin, of reintroducing the question, the hypothesis, the *supposition of the aura*? Is not the art contemporary to us inscribed within—does it not inscribe within itself—what Benjamin called "the age of mechanical reproduction," an age supposed to have produced the death, the withering at the very least, of the aura?[2] Many historians and critics of twentieth-century art have drawn a lesson from that "age of mechanical reproduction," have drawn its consequences for the very *production* of artistic objects.[3] But such reflections on reproducibility, on the "loss of originality" and of "origin," have proceeded as if foregrounding these notions must inevitably make the "archaic" and outdated question of the aura, linked as it was to the world of "cult images," fall away and hence disappear.

Georges Didi-Huberman

translated by
Jane Marie Todd

THE SUPPOSITION OF THE AURA:

THE NOW,

THE THEN, AND MODERNITY

But *falling away* is not the same as disappearing. Fortunately, we no longer have to bow our knees before statues of gods—I note in passing that Hegel already registered this fact at the beginning of the nineteenth century, and that others had done so before him.[4] But we bow our knees, if only in fantasy, before many other things that hang over us or hold us down, that "look at" us or leave us stunned. As we know, Benjamin speaks of the "decline of the aura" in the modern age, but for him, "decline" does not mean disappearance. Rather, it means (as in the Latin *declinare*) moving downward, inclining, deviating, or inflecting in a new way. Benjamin's exegetes have sometimes wondered

48

1. W. Benjamin, "On Some Motifs in Baudelaire" (1939), in *Illuminations: Essays and Reflections*, ed. H. Arendt, trans. H. Zohn (New York: Schocken Books, 1969), 188 [translation modified].

2. W. Benjamin, "The Work of Art in the Age of Mechanical Reproduction" (1936), in *Illuminations*, 217–51.

3. See, for example, A. Danto, *The Transfiguration of the Commonplace* (Cambridge, Mass.: Harvard University Press, 1981), and R. Krauss, *The Originality of the Avant-Garde and Other Modernist Myths* (Cambridge, Mass.: MIT Press, 1985).

4. "[Greek] statues are now only stones from which the living soul has flown, just as the hymns are words from which belief has gone. The tables of the gods provide no spiritual food and drink, and in his games and festivals man no longer recovers the joyful consciousness of his unity with the divine." G. W. F. Hegel, *Phenomenology of the Spirit* (1807), trans. A. V. Miller (Oxford: Oxford University Press, 1977), 455. "No matter how excellent we find the statues of the Greek gods . . . it is no help; we bow the knee no longer." Idem, *Aesthetics: Lectures on Fine Art*, trans. T. M. Knox (Oxford: Clarendon Press, 1975), 1:103.

whether his position on the aura was not contradictory, or whether one ought not to oppose his "early thoughts" on the question to his "mature" views, his (quasi-Marxist) philosophy about the destruction of the aura to his (quasi-messianic) thinking on its restoration.[5]

To that, we must first reply that the notion of aura is diffused throughout Benjamin's oeuvre. Its incorporation into his oeuvre was a response to a transhistorical and profoundly dialectical experience; therefore, the question of whether the aura has been "liquidated" or not proves to be a quintessentially false question.[6] We must further explain that while the aura in Benjamin names an *originary* anthropological quality in the image, the *origin* for him does not in any way designate something remaining "upstream" from things, as the source of a river is upstream from it. For Benjamin, the origin names "that which emerges from the process of becoming and disappearance," not the source but "a whirlpool in the river of becoming [that] pulls the emerging matter into its own rhythm."[7]

Hence decline itself is part of the "origin" so understood, not the bygone—albeit founding—past, but the precarious, churning rhythm, the dynamic two-way flow of a historicity that asks, without respite, even into our own present, "to be recognized as a restoration, a restitution, and as something that by that very fact is uncompleted, always open."[8] The "beauty that rises from the bed of ages"—as Benjamin writes with reference to Proust and the *mémoire involontaire*—is never outdated or liquidated; reality never ceases to "sear the image"; remembrance continues to offer itself as a "relic secularized." And since silence is fundamentally auratic in its manifestation—as Benjamin writes of Baudelaire—modern or even postmodern man, the man of "mechanical reproducibility," is obliged, in the midst of the noisy labyrinth of mediations, information, and reproductions, sometimes to impose silence and submit to the uncanniness of what comes back to him as aura, as thirst-inducing apparition.[9] Let us say, to outline our hypothesis, that whereas the value of the aura was *imposed* in the religious cult images—that is, in the protocols of dogmatic intimidation within which the liturgy has most often brought forth its images—it is now *supposed* in artists' studios in the secular era of mechanical reproduction.[10] Let us say, to dialecticize, that *the decline of the aura supposes*—implies, slips underneath, enfolds in its fashion—*the aura as an originary phenomenon of the image*. It is, to be faithful to Benjamin in the productive instability of his exploratory vocabulary, an "uncompleted" and "always open" phenomenon. The aura and its decline are thus part of the same system (and have undoubtedly always been so in every age of the aura's history: we need only

5. See R. Tiedemann, *Studien zur Philosophie Walter Benjamins* (Frankfurt: Suhrkamp, 1973); P. Bürger, "Walter Benjamin: Contribution à une théorie de la culture contemporaine," *Revue d'Esthétique*, new series 1 (1981): 27; R. Rochlitz, "Walter Benjamin: Une dialectique de l'image," *Critique* 39 (1983): 287–319.

6. See C. Perret, *Walter Benjamin sans destin* (Paris: La Différence, 1992), 97–99.

7. W. Benjamin, *The Origin of German Tragic Drama*, trans. J. Osborne (London: New Left Books, 1977), 46 [translation modified].

8. Ibid. [translation modified].

9. W. Benjamin, "A Small History of Photography" (1931), in *One-Way Street and Other Writings*, trans. E. Jephcott and K. Shorter (London: New Left Books, 1979), 243 [translation modified]; idem, "On Some Motifs in Baudelaire," 183–87; idem, "Central Park," *New German Critique* 34 (Winter 1985): 44, 48.

10. For the moment, I refer to the *studio* because institutional *exhibitions* (galleries, museums) often have a tendency to reproduce—while at the same time transforming of course— the intimidating and dogmatic liturgy of the old rituals of display, the old *monstrances* (*ostensions*) of images. This fundamental aspect would need a specific analysis devoted to it.

read Pliny the Elder, who was already complaining about the decline of the aura in the age of the reproducibility of antique busts).[11] But the aura persists, resists its decline precisely as *supposition.*

What is a supposition? It is the simple act—not so simple in reality—of placing below (*ova supponere*: placing eggs to be incubated). It means submitting a question by *substituting* certain parameters of what is believed to be the response. It means producing a *hypothesis*—also "underneath"—which then becomes capable of offering not only the principal "subject" of a work of art, but also its deepest "principle."[12] Can we, then, *suppose the aura* in the visual objects that twentieth-century art, from Piet Mondrian to Barnett Newman to Ad Reinhardt, for example, offers to our view? We can at least try. We are prepared to admit that the construction of such a supposition remains awkward—cumbersome, heavy with the past in one sense, too facile, even dubious in another.

In the first place, it is cumbersome for any discourse of specificity: isn't the aura, which designated that dimension of "other presence" literally required by the age-old world of cult images, condemned to obsolescence as soon as a visual object is in itself its own "subject"? Hasn't modern art emancipated itself from the "subject," the "subject matter"— whether "natural," "conventional," or "symbolic"—which Erwin Panofsky placed at the foundation of any comprehension of the visual arts?[13] To that we must reply that there are other ways of understanding "subject matter"—the "subject" as "matter"—than the way proposed by Panofskian iconology. Moreover, our supposition is cumbersome only for those historical or aesthetic discourses closed upon their own axioms. In fact, discourses of specificity usually present themselves as (pseudo)axiomatic, and the consequence of their closure—their tone of certainty—has often been to pronounce supposedly definitive death sentences. The modernist will say, for example, that "the aura is dead"; the post-modernist, that "modernism is dead"; and so on. But the supposition of the aura is not satisfied with any sentence of death (historical death, death in the name of a meaning of history), inasmuch as that supposition is linked to a question of *memory* and not of history in the usual sense, in short, to a question of living on (*survivance*, Aby Warburg's *Nachleben*). It is within the order of reminiscence, it seems to me, that Benjamin raised the question of the aura, as Warburg had raised that of the *Pathosformeln*: beyond, therefore, any opposition between a forgetful present (which is triumphant) and a bygone past (which has, or is, lost).

As a result, the supposition of the aura must confront the very dubious alibi of the ideologies of restoration: resentment of all sorts in the face of modernity, the redemptive "return" to the values of the art of the past, nostalgia for religious subject matter, a claim made for "spirituality" and "sense" against all "deconstructions" or "destructions" effected by twentieth-century art.[14] Let us add that the middle position between these two extreme discourses—putting the past to death or restoring the past—is not much better

Georges Didi-Huberman

50

11. Pliny the Elder, *Natural History* 35.1–14. See also G. Didi-Huberman, "*Imaginum pictura . . . in totum exoleuit*: Der Anfang der Kunstgeschichte und das Ende des Zeitalters des Bildes," *Kunst ohne Geschichte? Ansichten zu Kunst und Kunstgeschichte heute*, ed. A.-M. Bonnet and G. Kopp-Schmidt (Munich: Beck, 1995), 127–36 (French version forthcoming in the journal *Critique*).

12. "Subject of a work of art" and "fundamental principle" are two meanings of the Greek word *hypothèsis*.

13. E. Panofsky, "Iconography and Iconology: An Introduction to the Study of Renaissance Art," in *Studies in Iconology: Humanistic Themes in the Art of the Renaissance* (New York: Oxford University Press, 1939), 3–31.

14. See G. Didi-Huberman, "D'un ressentiment en mal d'esthétique" (1993), in *L'art contemporain en question* (Paris: Galerie nationale du Jeu de Paume, 1994), 65–88; and its sequel, "Post-scriptum: Du ressentiment à la *Kunstpolitik*," *Lignes* 22 (1994): 21–62.

THE
SUPPOSITION OF
THE AURA:
THE NOW, THE THEN,
AND
MODERNITY

when it tries to reconcile the iconographism of Panofskian subject matter with the radical abstraction of artists such as Newman or Reinhardt. While something like an auratic quality may *live on* in the works of these painters, may even *underlie* them, this cannot mean it *lives on as such*. To try to "re-iconographize" abstract art, or to reinject into it *as such* notions like "ecstasy," "spirituality," "mysticism," etc., would be to make a muddle of everything. Kazimir Malevich was *not* a painter of icons, Mondrian was *not* (or rather, decided to stop being) a symbolist theosophical painter. Newman was *not* a Kabbalist, and Reinhardt was *never* a theologian, not even of negativity.

The uneasiness and misunderstanding that today pervade all aesthetic discourse are no doubt linked, at least in part, to the fact that this discourse generally cannot understand the nonspecificity—the anthropological dimension—of twentieth-century artworks except by returning to the use of age-old categories more or less tied to the religious world. There is certainly an analogy—an anthropological, but also a phenomenological and metapsychological analogy—between Dante's description of a pilgrim who, looking at the veronica in Rome, "cannot satisfy his hunger,"[15] and Benjamin's definition, in the context of Baudelaire, of the aura as "that of which our eyes will never have their fill."[16] In both cases, what is offered to our view *looks at its viewer* (Benjamin called this "the ability to meet our gaze"). In both cases, this relation of the gaze implies a *dialectic of desire*, which supposes alterity, lost object, split subject, a nonobjectifiable relationship.[17]

Given the highly problematic terms "gaze" and "desire," there is no longer any reason to be satisfied with the sententious—judicatory—vocabulary of art criticism, or to seek "grace" in a vocabulary of empathy or transcendence. The difficulty of our problem lies in this: in opposition to a discourse of specificity that pronounces and carries out its dogmatic death sentences (the aura is dead, so much the better), and to a discourse of nonspecificity that invents eternal and ahistorical entities (let us seek transcendence, let us seek the sacredness of the veronica in a Newman painting), we must in each instance formulate something like a "specificity of the nonspecific." Let me explain: we must seek in each work of art the articulation between *formal singularities* and *anthropological paradigms*. We must therefore articulate two apparently incommensurate orders. And the point of articulation between these two orders may lie—our second hypothesis—in the dynamic of *labor*, in the process of making art. We must seek to understand *how* a Newman painting supposes—implies, slips underneath, enfolds in its fashion—the question of the aura. *How* it maneuvers the "image-making substance" in order to impose itself on the gaze, to foment desire. *How* it thus becomes "that of which our eyes will never have their fill."

The Supposition of Time: "The origin is now."

What the usual aesthetic positions lack for approaching the problem of the aura, then, is a temporal model capable of accounting for the "origin" in the Benjaminian sense, or the *Nachleben* in the Warburgian sense: in short, a model capable of accounting for the events of memory, not the cultural facts of history. "In a certain sense," Georges Bataille wrote, "every problem is that of a *use of time*."[18] To speak of "dead" things or "outdated" problems—in particular with respect to the aura—or to speak of "rebirths"—even when it concerns the aura—is to speak from within an order of consecutive *facts*, an order that

51

15. Dante, *Divine Comedy*, *Paradise* 331.103–5: "Qual è colui che forse di Croazia/ viene a veder la Veronica nostra,/ che per l'antica fame non sen sazia."

16. Benjamin, "On Some Motifs in Baudelaire," 187.

17. See J. Lacan, "Subversion du sujet et dialectique du désir dans l'inconscient freudien" (1960), in *Ecrits* (Paris: Le Seuil, 1966), 793–827.

18. G. Bataille, "Méthode de méditation" (1947), *Oeuvres complètes* (Paris: Gallimard, 1973), 5:201 [my translation].

knows nothing of the indestructibility, transformability, and anachronism of memory *events*.[19] This is the least apt "use of time" for understanding the relics (*survivances*), declines, and resurgences proper to the aesthetic domain. Even a circular model such as that of eternal return disputes the validity of the naive belief in the "return of the same."[20] Thus we can see in the model of history-as-forgetting and that of history-as-repetition, models so often implicit in the discourses of modern art, a continued implementation of the most idealist model of art history. I am referring to the Vasarian model, which asserted in the sixteenth century: "The Renaissance is forgetting the Middle Ages now that it is repeating Antiquity."[21] To say today that we must forget modernism so that we can repeat the ecstatic or sacred origin of art is to use exactly the same language.

If we thus refute peremptory death sentences as well as nostalgic rebirths, *what time must we suppose* from now on? We should not be surprised to rediscover, if not the constructed model, then at least the flash of an intuition in Benjamin himself. That intuition has also remained outside contemporary commentaries on the decline of the aura and the loss of originality. Yet, it is part of the same system as the Benjaminian supposition of the aura and of the *origin* understood as a reminiscent present where the past is neither to be rejected nor to be reborn, but quite simply to be brought back as an *anachronism*.[22] Benjamin designates this notion by the less than explicit expression "dialectical image."

Why "dialectical"? Because Benjamin, the author of "Theses on the Philosophy of History,"[23] was seeking a logicotemporal model that could take contradictions into account, never taming them but rather concentrating and crystallizing them into the density of any unique artistic production. He was seeking a model that could retain from Hegel the "prodigious power of the negative" and yet reject Hegel's reconciliation and synthesis of Spirit. With the dialectical image, Benjamin proposed an open, undogmatic—even relatively drifting—use of the philosophical dialectic, which he distorted, like other writers and artists of his time: Carl Einstein, Bataille, S. M. Eisenstein, and even, in another register, Mondrian.[24]

Why an "image"? Because, in Benjamin, the image designates something completely different from a *picture*, a figurative illustration. The image is first of all a *crystal of time*, both a construct and a blazing shape, a sudden shock:

> It isn't that the past casts its light on the present or the present casts its light on the past: rather, an image is that in which the Then and the Now come into a constellation like a flash of lightning. In other words: image is dialectics at a standstill. For

19. On the notion of memory event, see M. Moscovici, *Il est arrivé quelque chose: Approches de l'événement psychique* (Paris: Ramsay, 1989).

20. See G. Deleuze, *Nietzsche et la philosophie* (Paris: PUF, 1962), 55: "It is not the same that comes back, it's the coming back that is the same as what is becoming" [my translation].

21. [My translation]. See G. Didi-Huberman, *Devant l'image: Question posée aux fins d'une histoire de l'art* (Paris: Minuit, 1990), 65–103.

22. We should note the convergence of this model with the metapsychological model of a Freudian theory of memory as detailed by Pierre Fédida, especially in "Passé anachronique et présent réminiscent," *L'Écrit du Temps* 10 (1986): 23–45.

23. W. Benjamin, "Theses on the Philosophy of History" (1940), in *Illuminations*, 253–64.

24. See S. Buck-Morss, *The Origin of Negative Dialectics: T. W. Adorno, W. Benjamin, and the Frankfurt Institute* (Hassocks, G. B.: Harvester Press, 1977). On the use of the dialectic in Bataille and Eisenstein, see G. Didi-Huberman, *La ressemblance informe, ou le gai savoir visuel selon Georges Bataille* (Paris: Macula, 1995), 201–383. On the use of the dialectic in Mondrian, see Y.-A. Bois, "L'iconoclaste," in *Piet Mondrian* (Milan: Leonardo Arte, 1994), 338–43.

while the relation of the present to the past is a purely temporal, continuous one, the relation of the Then to the Now is dialectical—not development but image, leaping forth. Only dialectical images are authentic . . . images.[25]

THE
SUPPOSITION OF
THE AURA:
THE NOW, THE THEN,
AND
MODERNITY

This strange definition has at least two consequences, and it is crucial to clarify them if we are to address the problem of twentieth-century art, its position in relation to the aura, and its role in the relation between the "Now" and the "Then." First, Benjamin's definition valorizes a *parameter of ambiguity* essential to the structure of any dialectical image: "Ambiguity," writes Benjamin, "is the pictorial image of dialectics."[26] In this way, he lays claim to certain aesthetic choices (the only authentic image is one that is ambiguous) while at the same time dissociating the dialectical operation from any clear and distinct synthesis, any teleological reconciliation.

Second, Benjamin's definition valorizes a *critical parameter*, revealing the dialectical image's enormous potential for intervening in theoretical debates (art, according to Benjamin, goes straight to the heart of problems of cognition). To produce a dialectical image is to appeal to the Then, to accept the shock of memory while refusing to submit or "return" to the past; for example, it is to welcome the signifiers of Theosophy, the Kabbalah, or negative theology, *awakening* these references from their dogmatic sleep as a way of deconstructing and criticizing them. It is to criticize modernity (the forgetting of the aura) through an act of memory and, at the same time, to criticize archaism (nostalgia for the aura) through an act of essentially *modern* invention, substitution, and designification. Benjamin dismissed with the same gesture myth and technology, dreaming and waking, Carl Jung and Karl Marx. He returned to the fragile moment of *awakening*, a dialectical moment in his eyes because it lies at the evanescent, ambiguous borderline between unconscious images and necessary critical lucidity. That is why he conceived of art history itself as *Traumdeutung*, "dream interpretation," to be elaborated on the Freudian model.[27]

This historical and critical supposition, which I evoke all too briefly here,[28] allows us to move beyond or displace a number of sterile contradictions that have disrupted the aesthetic domain in the matters of modernity and memory, and especially the pictorial *materiality* inherent in the adventure of abstract art and its notoriously *idealist* references. Nearly all the great artists, from Wassily Kandinsky to Jackson Pollock, from Malevich to Reinhardt, from Mondrian to Newman, from Marcel Duchamp to Alberto Giacometti, have too quickly irritated or delighted their interpreters by their use, sometimes light-hearted, sometimes profound, of "spirituality," "original art," orthodox theology, Theosophy, even alchemy. . . . And most historians spontaneously forget that a philosophical, religious, or ideological claim on the part of an artist does not in any way constitute an *interpretive key* to his oeuvre, but rather requires a *separate and joint interpretation*—that is, a dialectically articulated

53

25. W. Benjamin, "N [Re The Theory of Knowledge, Theory of Progress]," in *Benjamin: Philosophy, History, Aesthetics*, ed. G. Smith (Chicago: University of Chicago Press, 1983), 49 [translation slightly modified].

26. W. Benjamin, "Paris, Capital of the Nineteenth Century" (n.d.), in *Reflections: Essays, Aphorisms, Autobiographical Writings*, ed. Peter Demetz, trans. E. Jephcott (New York: Schocken, 1978), 157. This formula is commented on in Perret, *Walter Benjamin sans destin*, 112–17.

27. Benjamin, "N." It seems to me that this fragment on the theory of knowledge and progress is the best methodological introduction possible to the very problem of art history.

28. I have attempted to develop certain aesthetic implications of this supposition in G. Didi-Huberman, *Ce que nous voyons, ce qui nous regarde* (Paris: Minuit, 1992), in particular 125–52.

interpretation—of the aesthetic interpretation as such.[29] Whether they *are* "materialists" or "idealists"—and in general they never ask themselves the question in those terms—whether they *claim* to be "avant-garde" or "nostalgic," artists *make* their artworks in an order of plastic reality, formal labor, which must be interpreted for what it *offers*. This means it must be understood in its capacity as a *heuristic* opening, and not in terms of an *axiomatic* reduction to its own "programs." That is another reason art history is related to *Traumdeutung*. Let us note that artists' writings, parallel to the artworks themselves, very often manifest the same *critical ambiguity* supposed in the relation Benjamin called the "dialectical image."[30]

Georges Didi-Huberman

From this perspective, the case of Newman seems to me exemplary and of flawless clarity. We know that in 1947 Newman's artworks and declarations led Clement Greenberg to form a suspicious judgment, typical of what I have called the model of specificity, a model trapped within the vicious circle of history-as-forgetting (modernism as the forgetting of tradition) and history-as-rebirth (antimodernism as return to tradition). Greenberg's suspicion was directed precisely at Newman's use of certain words stemming from philosophical and religious traditions: "intangible reality," "uniqueness," "ecstasy," "transcendental experience," "symbolical or metaphysical content." And Greenberg found

29. This is an essential point of method, which Panofsky formulated clearly in 1932—even though he sometimes forgot to apply it to his own interpretations. See E. Panofsky, "Zum Problem der Beschreibung und Inhaltsdeutung von Werken der bildenden Kunst" *Logos* 21 (1932): 103–19. "And even if Dürer had expressly declared, as other artists later attempted to do, what the ultimate plan of his work of art was, we would rapidly discover that that declaration bypassed the true essential meaning [*wahren Wesenssinn*] of the engraving and that the declaration, rather than offering us a definitive interpretation, would itself be greatly in need of such an interpretation" [my translation].

30. Regarding Mondrian, for example, Jean-Claude Lebensztejn has recently proved to be unfair and almost naive in criticizing Bois's interpretation because it drops the theosophical paradigm. Lebensztejn makes the criticism with as much vehemence as if Bois were speaking of Masaccio's *Trinity* while spurning the Christian dogma that provided its iconographical program. J.-C. Lebensztejn, review of the exhibition *Piet Mondrian: 1872–1944* [La Haye, Washington, New York], *Cahiers du Musée National d'Art Moderne* 52 (1995): 139–40. Far from ignoring the role of Theosophy in Mondrian's art, Bois says it "plays the role of a detonator, and it is very probable that Mondrian would have remained a talented provincial landscape artist if he had not come into contact with it." Bois, "L'iconoclaste," 329 [my translation]. Lebensztejn pretends to ignore the obvious fact that the philosophical or religious commitment of a twentieth-century artist cannot be compared with an iconographical program of the quattrocento. It is the very notion of *program* that is in question here—a notion whose deconstruction abstract art has obviously completed, along with the deconstruction of the entire traditional iconographical approach.

Nonetheless, without articulating it clearly, Lebensztejn is getting to the heart of the problem, which concerns the logical and temporal structure to be drawn from the relations in play—*ambiguous, critical* relations—between idealism and material engagement (plastic engagement as such), between the discourse of meanings laid claim to and the formal labor actually performed. It is probable that Bois has not yet completely articulated that structure in writing that "it is the materiality of the painting itself that [in Mondrian]

guarantees the efficacy of his 'struggle against matter'" ("L'iconoclaste," 330 [my translation]). Significantly, it is at that moment in his analysis that Bois comes closest to the question of the dialectic. A remarkable analysis of this type of dialectical reversal has also been done for the case of Paul Gauguin, in J. Clay, "Gauguin, Nietzsche, Aurier: Notes sur le renversement matériel du symbolisme," in *L'éclatement de l'impressionisme* (Saint-Germain-en-Laye: Musée Départemental du Prieuré, 1982), 19–28.

In Ad Reinhardt as well, the "ecstatic," "auratic," and "religious" references are not lacking: "Sacred space, separate, sacred against profane. . . . Contemplative act, continuous absorbed attention, kind of sanctity. . . . Transcendent, transpersonal, transfigurative, transparent. . . . Detached territory, pure region, timeless, absolute. . . . Painting 'began' by making sacred the things it decorated? . . . Form fixed by tradition, mandala, ritual, tanka, Xian, 4 evangelists. . . . Gate, door, image of opening, possibility of transcendence. . . . Product of past. Religious aura." A. Reinhardt, *Art-as-Art: The Selected Writings*, ed. B. Rose (New York: Viking Press, 1975), 192–93. But, as we also know, these references belong to the same system as the deep-seated irreligiosity of what is an essentially ironic and critical artist. See J.-P. Criqui, "De visu (le regard du critique)," *Cahiers du Musée National d'Art Moderne* 37 (1991): 89–91.

How, then, to express the structural necessity of that apparent contradiction? Bois, it seems to me, *almost* succeeds by making the argument for the fragile relation contained, precisely, in the word *almost* (Y.-A. Bois, "The Limit of Almost," in *Ad Reinhardt* [Los Angeles: Museum of Contemporary Art and New York: Museum of Modern Art, 1991], 11–33). But in the *almost*—what linguists call a "derealizing modifier," which tends solely to attenuate the information of the word to which it is applied (see O. Ducrot, "Les modificateurs déréalisants," *Journal of Pragmatics* 24 [1995]: 145–65)—the structural necessity fails to express itself as such; the terms of the relation remain unresolved, in a "lesser" and not critical state. Only the Benjaminian hypothesis of the dialectical image succeeds, I believe, in expressing that necessity, that true "power of ambiguity." See Didi-Huberman, *Ce que nous voyons*, 149–52.

THE
SUPPOSITION OF
THE AURA:
THE NOW, THE THEN,
AND
MODERNITY

such uses "archaic," he said, permeated by "something half-baked and revivalist in a familiar American way," something he found excessive and pointless for artistic activity as such, pointless, in short, for its "specificity."[31]

Newman gave a vehement response to these arguments: according to him, they stemmed from an "unintentional distortion based on a misunderstanding."[32] What misunderstanding? That of imagining, in an extremely traditional frame of mind all in all, that the relation between certain words (coming from an age-old tradition) and a certain pictorial tradition must inevitably be expressed in terms of a "program," that is, in iconographical terms. Newman refutes the idea that the use of the word "mystical" corresponds to a "principle" for him or to an a priori, that is, to his assumption of a preexisting belief. He refuses to be seen as a "program maker," laying claim to a transformed and transforming—today we would say deconstructive—use of these words from the Then. And how does he transform and deconstruct the meaning of such words, if not by taking on the Now of a singular, absolutely new, and *originary* experience, of a pictoriality that dismisses in a single gesture the figurative past and the stylistic present of abstract, albeit "purist," art? That is why, in his response, Newman does not hesitate to rub together, hence to "irritate"—as a way of decomposing their accepted usage—the words "ecstasy" and "chaos," the expressions "transcendence" and "nonmaterial stenography," and the (at the very least interesting) expression "materialistic abstractions." This is a way of positing himself, if not exactly as a "master in contradictions," as Thomas Hess said,[33] then at least as a master of the *dialectical image* in Benjamin's sense.

It is significant that all Newman's writings between 1945 and 1949—that is, during the gestation period that saw the implementation of his most novel, most decisive, and most definitive pictorial problematic[34]—manifest most acutely a *thinking of the origin* that has nothing to do with a nostalgia for the past, but that concerns precisely the productive collision between the Now and an unexpected, reinvented Then. His thinking has nothing to do with an aim of restoration or "rebirth," but engages the very issue of a radical modernity.[35] Hence, the new (origin as whirlpool) requires us to rethink from top to bottom art history itself, that is, the relation an artist *now* maintains with the past (origin as source). That is why, in "The Plasmic Image," Newman devotes so much time to rethinking primitive art, in a mode more anthropological than aesthetic, valorizing "ecstasy," "desire," and "terror" at the expense of beauty itself. According to him, the poor comprehension and use of such primitive art—recourse to the criterion of the ornamental, for example—have waylaid the entire modern notion of abstraction.[36]

31. C. Greenberg, "Review of Exhibitions of Hedda Sterne and Adolph Gottlieb" (1947), in *The Collected Essays and Criticism*, ed. J. O'Brian (Chicago: University of Chicago Press, 1986), 2:189. Greenberg adds: "But as long as this symbolism serves to stimulate ambitious and serious painting, differences of 'ideology' may be left aside for the time being. The test is in the art, not in the program."

32. B. Newman, "Response to Clement Greenberg" (1947), in *Barnett Newman: Selected Writings and Interviews*, ed. J. P. O'Neill (New York: Alfred A. Knopf, 1990), 162. Subsequent quotations in this paragraph are from pp. 162–64.

33. T. B. Hess, *Barnett Newman* (New York: Museum of Modern Art, 1971), 15–16.

34. On this pictorial period in Newman, see J. Strick, "Enacting Origins," in *The Sublime Is Now: The Early Work of Barnett Newman, Paintings and Drawings, 1944–1949* (New York: PaceWildenstein, 1994), 7–31.

35. On the importance of the origin motif in Newman's writings, see J.-C. Lebensztejn, "Homme nouveau, art radical," *Critique* 48 (1991): 329–35.

36. B. Newman, "The Plasmic Image" (1945), in *Selected Writings*, 138–55, especially 139: "The failure of abstract painting is due to the confusion that exists in the understanding of primitive art [as well as that] concerning the nature of abstraction." See also idem, "The First Man Was an Artist" (1947), in *Selected Writings*, 156–60.

Hence, the new (origin as whirlpool) requires *beginning* not with something like the idea of a golden age—represented here by Greek art—but on the contrary with its *destruction* (a direct and explicit echo of the state of the "civilized" world in 1945, when the painter felt he was truly "beginning" his work).[37] The origin, as Newman proposes it in a very dialectical notion, is first of all the *destruction of the origin*, or at the very least its distortion, its "making strange." That is why the artist of today can feel much closer to a fetish from the Marquesas Islands, about which he understands nothing, than to a Greek statue which nonetheless constitutes his most intrinsic aesthetic past. The collision between the Now and the "decomposed" Then logically leads to the "barbarian"— Newman's term—decomposition of traditional aesthetic categories; and the timeless quality of our "imaginary museums" had been wrongly conceived in terms of those categories. Thus, for heuristic purposes, Newman attempts certain conceptual discriminations— "plasmic" versus "plastic," "sublime" versus "beautiful"[38]—that are designed above all to deconstruct our own familiarity with the art of the past.

In the end, what is the origin (origin as whirlpool) if not the wrenching implementation of that *critical ambiguity* that Benjamin implicitly characterized with the notion of the dialectical image? What does it mean to originate in the whirlpool of an artistic practice, if not to appeal to a certain memory of the Then in order to decompose the present—that is, the immediate past, the recent past, the still dominant past—in a determined rejection of all "revivalist" nostalgia? Interpretations that spontaneously use the temporal categories of influence, or the semiotic categories of iconography, go astray when they try to make Newman a spokesperson for or an heir to the "Jewish tradition."[39] We must rather hypothesize that a certain kind of *critical memory*—of the Jewish tradition among other things—permitted Newman to create the collisions and destructions he was seeking in order to *originate* his pictorial practice in what he saw as the sclerotic present of abstraction.

In short, the critique of the present—the appeal to categories such as "primitive art" or "the sublime"—also included a critique of all nostalgia. Newman was laying claim to the Now to the utmost degree. I believe that, without betraying Newman, we could paraphrase his famous title of 1948, "The Sublime Is Now," by saying that, for him, the *supposition of artistic time* implies the dialectical and critical proposition that *the origin is now*. It is from within the reminiscent Now that the origin appears, in conformity with a fundamental anachronism that modernist criticism has as yet been unable to take on. "The image we produce is the self-evident one of revelation, real and concrete, that can be understood by anyone who will look at it without the nostalgic glasses of history."[40]

The Supposition of Place: "The apparition of a distance"

And that "revelation"—an ancient, ambiguous, and critical word in relation to all formalist specificity—is characterized by Newman strictly as a *revelation and a conversion of space*. This is a way of radically transforming the usual sense of the word and at the same time giving it back its material and phenomenological specificity, which, for my part, I shall call a *supposition of place*. In an admirable text written in 1949, Newman gave

37. See B. Newman, "The New Sense of Fate" (1947–48), in *Selected Writings*, 164–69. In these pages, the motifs of archaic art, tragedy, and the destruction of Hiroshima are all tied together.

38. Newman, "The Plasmic Image," 138–55; and idem, "The Sublime Is Now" (1948), in *Selected Writings*, 171–73. On the aesthetics of the sublime and Newman, see J.-F. Lyotard, *L'inhumain: Causeries sur le temps* (Paris: Galilée, 1988), 98–118.

39. See Hess, *Barnett Newman*; B. Richardson, "Barnett Newman: Drawing His Way into Painting," in *Barnett Newman: The Complete Drawings, 1944–1969* (Baltimore: Baltimore Museum of Art, 1979), 14.

40. Newman, "The Sublime Is Now," 173.

the first description of an experience of this kind. It took place among the "simple walls made of mud" of the Indian tumuli in Ohio. The title of the text, "Ohio, 1949," is simply the name of the site and the numeral designating the time.[41] But we should add that, despite the article's brevity, Newman also thought of titling it "Prologue for a New Aesthetic," which says a great deal about the theoretical stakes of that altogether phenomenological and private description.

THE
SUPPOSITION OF
THE AURA:
THE NOW, THE THEN,
AND
MODERNITY

It was an unexpected, overpowering experience—and not a programmatic decision based on some aesthetic axiom. It was literally the experience of an *apparition*. In that excursion of Newman's among a few archaic walls stripped of any ornamental or aesthetic pretension, it was none other than "the self-evident nature of the artistic act, in its utter simplicity" that suddenly appeared to the American painter.[42] But, in order to be approached by words, that experience of "simplicity" required—or better yet, revealed— the productive ambiguity of a two-way flow or two-beat rhythm, a *dialectic*. To speak of that space made of crude patches is to speak contradictorily, to crystallize at least two contradictions: on the one hand, the experience was that of a *here . . . and beyond*; on the other, it was that of a *visibility . . . and beyond*. Here, there is "nothing that can be shown in a museum or even photographed; [it is] a work of art that cannot even be seen, so it is something that must be experienced there on the spot."

What does this mean? That the *visible* spectacle, objectifiable and describable, of the landscape opens onto something I shall call an experience of the *visual*; and that *space*— the objectifiable coordinates within which we situate an object or ourselves—opens onto an experience of *place*.[43] When Newman describes the "feeling that here is the space," we must understand that the *here*, the *here* of the place, only works to deconstruct the usual certainties we have of the space when, spontaneously, we seek to objectify it. That is why the affirmation of that *here* goes hand in hand with an acerbic critique of "the clamor over space" with which all of art history has assaulted our ears, from the time of Renaissance perspective to the so-called "pure" space of Mondrian.[44]

The axiomatics and aesthetics of space are one thing: a shared experience objectified into a specific fact in the history of plastic styles. The experience of place as Newman approaches it here is something else again: it is, he says, a "private," not a shared, experience, a *subjective event* and not a measurable fact. The end of "Ohio, 1949" communicates the essential feature, through the very surprise it elicits in the reader: what Newman is speaking of in that experience of archaic places—the Egyptian pyramids will now seem to him little more than pretty ornaments in comparison—is nothing other, he writes, than "the physical sensation of time." Why, suddenly, fall back on time? Once our stupor has passed, we begin to understand what is at issue: Newman, very probably without knowing it, has just given a first, strictly Benjaminian, definition of the *aura*: "a strange weave of space and time."[45] And we gradually understand that almost all the phenomenological qualities Benjamin had invoked in his definitions of the aura are found not only in what Newman *articulated* about his temporal experience of place, but also in what he *produced*, precisely beginning in the years when, from the response to Greenberg to "Ohio, 1949," his pictorial and theoretical problematic was definitively set in place.

57

41. B. Newman, "Ohio, 1949," in *Selected Writings*, 174–75.

42. Ibid., 174.

43. I take the liberty of using conceptual distinctions elaborated in a certain number of my earlier studies.

44. Newman, "Ohio, 1949," 175.

45. Benjamin, "A Small History of Photography," 250.

What is the aura, and more precisely, what is that "strange weave of space and time"? Benjamin responds with a formula that has remained famous: it is "the unique apparition of a distance, however close it may be."[46] And, in that definition, there is of course the *apparition* or "revelation" Newman speaks of. There is also that *uniqueness*, that "simplicity" Newman experienced so intensely among the vestiges of archaic Indian architecture. But, to understand better the phenomenology at play here, we must, I think, move back to the visual and pictorial experience for which the artist's texts serve as displaced witnesses and readable aftereffects. We must therefore confront that *uniqueness* from the near side of the "atmospheric" experience of the lived landscape,[47] must approach it, that is, in the concrete procedure to be observed in the key artwork of that entire period, the painting *Onement I*, and more particularly, the 1947 drawing that served as its heuristic starting point (both illus. p. 59).

Newman's entire production in 1947 was limited to two paintings and two drawings.[48] *Onement I*—which was first an untitled ink drawing, its title coming precisely from the pictorial result it went on to produce—is of modest dimensions, but in it there appears, definitively asserted, the famous principle of the "zip," which characterized the artist's later "style." It thus functions as Newman's first "absolute image,"[49] obtained directly, without modification or rectification, in immediacy and in apparition, so to speak. The experimentation proper to the drawing—which we find in earlier graphic studies—now finds something like its decisive and definitive *opening movement*: the white opening in the center of the drawing in fact achieves, in a more general way, a procedural opening that will lead Newman to use adhesive strips in the paintings, strips that both *reserve* and *reveal* the zips of paint elaborated on vast neutral backgrounds.

The opening I am speaking of thus possesses this first characteristic of the aura, which Benjamin defined as a "unique apparition." It possesses that quality of *uniqueness* Newman laid claim to as the "absolute beginning" of his oeuvre, a genesis without a preconceived program.[50] This becomes even clearer in Newman's assertion that the vertical zip, far from dividing the visual field, instead constitutes it as an indivisible unity.[51] Finally, the very title *Onement I*—one would have expected *Uniqueness* or *Oneness*, and hardly the Roman numeral I next to a word that apparently means the same thing—powerfully suggests by its very strangeness the condition of *singular uniqueness* that Benjamin recognized in every auratic image.

A second characteristic of the aura can be recognized, albeit more subtly, in the 1947 drawing: this is what Benjamin called the *apparition of a distance*. The distance in question is not in any way the "foreshortened" object we perceive at the very end of linear

46. Benjamin, "The Work of Art in the Age of Mechanical Reproduction," 222 [translation modified]. I have commented on this definition in *Ce que nous voyons*, 103–23.

47. We should note the analogy between this kind of experience and those that will later be related by other American artists such as Tony Smith (see Didi-Huberman, *Ce que nous voyons*, 63–84) or, twenty years later, James Turrell in the Arizona desert. G. Didi-Huberman, "L'homme qui marchait dans la couleur," *Artstudio* 16 (1990): 6–17.

48. Richardson, "Barnett Newman: Drawing His Way into Painting," 17. On Newman's graphic production in general, see also A. Pacquement, "Le parcours des dessins," and B. Rose, "Barnett Newman: Les oeuvres sur papier," both in

Barnett Newman: Les dessins, 1944–1969 (Paris: Musée national d'art moderne/Centre Georges Pompidou, 1980), 7–10 and 12–29.

49. Rose, "Barnett Newman," 26.

50. See Hess, *Barnett Newman*, 55–85; H. Rosenberg, *Barnett Newman* (New York: Abrams, 1978), 48; and Strick, "Enacting Origins," 8.

51. "I feel that my zip does not divide my paintings. . . . It does not cut the format in half or whatever parts, but it does the exact opposite: it unites the thing. It creates a totality." B. Newman, "Interview with Emile de Antonio" (1970), in *Selected Writings*, 306.

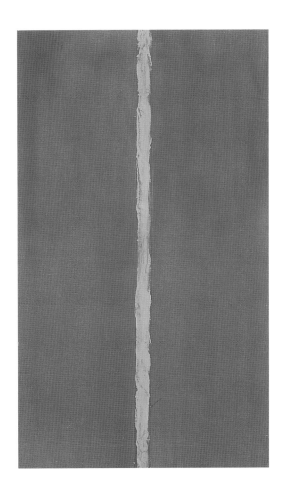

Barnett Newman (American, 1905–1970), *Drawing (Onement 1)*, 1947, ink on paper, 10 7/8 x 7 3/8 in. (27.6 x 18.7 cm), Mr. and Mrs. B. H. Friedman, New York.

Barnett Newman (American, 1905–1970), *Onement I*, 1948, oil on canvas, 27 1/4 x 16 1/4 in. (69.2 x 41.2 cm), The Museum of Modern Art, New York, Gift of Analee Newman.

perspective. The drawing *Onement I*, in fact, does not objectify any spatiality of distancing (we need to oppose spatial *distancing* to *distance* as the phenomenological property of place). It even subverts all the usual values related to the superposition of figure and ground: hence, the black of the drawing no more withdraws behind the white vertical shape than the white withdraws behind the two patches of black ink. *Onement I* can thus in no case be interpreted figuratively, as a double door left ajar before us: first, because the edges of the central zip "ooze" or "bleed" as a result of the procedure of adhering, then removing—ripping off—the material strip, which is designed to reserve the white of the drawing's support while the ink is being spread; and second, because the saturated zones of black, far from being uniformly compact, reveal a disintegration in the brushstroke, a loss of adhesiveness that makes the gesture itself visible, and with it, a fraying of the brush hairs. These are the marks, the voluntary traces of the procedure, which the pictorial version of *Onement I* will push to the extreme, decisively asserting the incompleteness of the painting.[52]

Phenomenologically speaking, the auratic *distance* invoked by Benjamin can be interpreted as the *depth* that Erwin Straus, then Maurice Merleau-Ponty, constituted as the fundamental sensorial paradigm of "distance" and place, a concept far from any "spatial depth" that could be objectified by measurement or by perspective.[53] If in *Onement I*

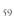 59

52. On that decision to make *Onement I* incomplete, see Hess, *Barnett Newman*, 55–56; and especially Y.-A. Bois, "Perceiving Newman" (1988), in *Painting as Model* (Cambridge, Mass.: MIT Press, 1990), 190–92.

53. See Didi-Huberman, *Ce que nous voyons*, 103–23.

Newman breaks definitively with any objectifiable depth of space, he reconnects, it seems to me, with the "physical sensation" of a *depth of place*. In that sense, Hubert Damisch was quite right, evoking Newman—but also Pollock—to challenge the "so-called rejection of the so-called convention of depth."[54] Like all great American painting of the period, Newman's effort requires a "specific optics" whose theory and phenomenology remain to be set forth.

Georges Didi-Huberman

In *Onement I*, that phenomenology certainly includes a vision of closeness, given the restricted dimensions of the drawing.[55] But, as Benjamin says, "however close the apparition," a *distance* suddenly irrupts within it. It irrupts here in the *reserve*, in the *retrait*[56] contrived (and not drawn, outlined, or situated) by Newman. In that sense, it places us squarely before a kind of *dialectic of place*—close/distant, in front of/inside, tactile/optical, appearing/disappearing, open/closed, hollowed out/saturated—which confers on the image its most fundamental auratic quality. It is an inchoate rhythm of black and white, a "physical sensation of time" that gives to the image-making substance the *critical ambiguity* that Jean Clay, speaking of Pollock and Mondrian, so aptly named "flat depth."[57]

Why is that ambiguity of the place rhythmic, appearing and disappearing at the same time? Because something in it *passes through*—infiltrates, mixes with, permeates—and disintegrates any certainty about space. This something is again the *aura*, which we must now understand in terms of a third characteristic, which returns to the most archaic and "physical," the most *material* sense of the word *aura*. This meaning is that of breath, of the air that surrounds us as a subtle, moving, absolute place, the air that permeates us and makes us breathe. When in *Onement I* Newman reveals the reserve of the support by stripping off the zip the way one might pull a gag off someone's mouth, he creates not so much a spatial form as a *rush of air*. When his brush heavy with ink presses on the paper, it does not so much draw as *exhale* its pigmentary matter; when he lifts it slightly off the support, it *inhales*, creates a kind of subtle *voluminosity*—Merleau-Ponty's word—which, above the paper, again produces a kind of *rush of air*. The aura of this drawing would thus be related to something like a respiration.[58] And all Newman's later drawings only reinforce that impression of *breathing surfaces* which produce, as their graphic traces, the subtle rhythm of scanning—not aerial or atmospheric but *auratic* scanning.

54. H. Damisch, "Stratégies, 1950–1960" (1977), in *Fenêtre jaune cadmium, ou les dessous de la peinture* (Paris: Le Seuil, 1984), 166. And he adds, "as if the effect of depth in painting could be reduced to a procedure, an arbitrary formula" [my translation]. For his discussion of a "specific optics," see p. 165.

55. But recall that, for Newman, what counts is the *scale*, which has nothing to do with the objective dimensions of the work of art. See P. Schneider, *Les dialogues du Louvre* (1969) (Paris: Adam Biro, 1991), 131 and 149. "The size is nothing: what matters is the scale."

56. [*Retrait*: Both the removal of the adhesive strip and the mark or trace left once it has been removed. —trans.]

57. J. Clay, "Pollock, Mondrian, Seurat: La profondeur plate," *L'atelier de Jackson Pollock* (Paris: Macula, 1978; ed. 1994), 15–28. Let us recall here the decisive theoretical role played by the staff of the journal *Macula*, in 1976–79, regarding the questions of surface and depth. See especially C. Bonnefoi, "A propos de la destruction de l'entité de surface," *Macula* 3–4 (1978): 163–66; and idem, "Sur l'apparition du visible," *Macula* 5–6 (1979): 194–228.

58. Here I arrive, by other paths, at what Pierre Fédida, speaking of Paul Cézanne, Giacometti, and André du Bouchet, magnificently called "the indistinct breath of the image" [my translation]. See P. Fédida, *Le site de l'étranger: La situation psychanalytique* (Paris: PUF, 1995), 187–220.

We could, moreover, continue the excellent analyses of Bois on Mondrian ("L'iconoclaste," 313–77) by working with the hypothesis that Newman's characteristic stumping at the edges, his elaborations on the frame, and his interruptions in the zips may stem from that *logic of air*, or rather of the aura.

THE
SUPPOSITION OF
THE AURA:
THE NOW, THE THEN,
AND
MODERNITY

The Supposition of the Subject: "I'm the subject. I'm also the verb."

To speak in these terms, I readily admit, amounts to speaking in *anthropomorphic* terms of a kind of painting that asserts, and this is obvious, that it is radically *abstract*. It is not "man" that Newman thematizes in *Onement I*—it is "place" itself and the (auratic) conditions for its visual dialectic, its phenomenology.[59] Yve-Alain Bois is right to insist on a certain anti-anthropomorphism in Newman and, as a result, to relativize the influence of Giacometti on the genesis of the painting *Onement I*.[60] For it is precisely with *Onement I* that Newman's paintings definitively cease to contain the vitalist and genetic ideograms recognizable in the works of the preceding years, *Gea* (1945) or *Genetic Moment* (1947), for example. If *Onement I* indeed offers this "genetic moment" of which all the critics speak— taking their cue from the painter himself—it does not in any case offer itself as the iconography of a biblical or kabbalistic subject matter in which we would have to recognize the "division" between darkness and light accomplished by YHWH, or the reddish brown associated with the Hebrew play on the words "Adam" and "*adamah*" (earth), or the "uniqueness" of Adam and Eve according to the Zohar, or even the uniqueness of the "one and only" God of monotheism.[61]

All these readings, which in spite of themselves pull Newman's art toward narration, the symbol, and anthropomorphic figuration, very quickly go astray in embracing the idea of a *program*, which the artist found so repugnant. These readings are only aftereffects of readability and resemantization. Bois is thus right to restore to Newman's art its pure phenomenological dimension, its visual dimension of *being there*—or, as I would say, of *being in place*.[62] But, immediately, anthropomorphism itself is found to be dialectically reimplicated in that operation: not eliminated (outdated, vanished), but transformed (reinvented, resupposed). A modernist critic might no doubt decree the end of anthropomorphism in Newman's abstract art; but it is better to suppose that with their specific manner of abstraction, Newman's paintings require that we ourselves transform our spontaneous concept of anthropomorphism, that is, the relation between "shape" and "humanity."

Newman himself formulated this problematic relationship, which he certainly sensed was fundamental to his entire oeuvre. He named this relation—in philosophically "modern" but artistically bewildering terms—the "subject" or "subject matter": "The central issue of painting is the subject matter. . . . My subject is anti-anecdotal."[63] Is this a return to the Panofskian subject matter? Not at all. It is, on the contrary, its dialectical decomposition, its critical reformulation where, in an almost Freudian vein, the primacy of a *subject position* imposes itself. In the years 1945 to 1948, Newman began to approach that subject position through words such as "desire," "terror," "ecstasy," and even "metaphysical

59. See B. Newman, "Frontiers of Space: Interview with Dorothy Gees Seckler" (1962), in *Selected Writings*, 251: "Instead of using outlines, instead of making shapes or setting off spaces, my drawing declares the space. Instead of working with the remnants of space, I work with the whole space."

60. Bois, "Perceiving Newman," 195 and 310–11.

61. See Hess, *Barnett Newman*, 55–56; Rosenberg, *Barnett Newman*, 61. Another interpretation even accomplishes the tour de force of reconciling the Jewish messianic *yihud* and the Christian *kènôsis* in an allegorism of "nonfigurativity." See D. Payot, "Tout uniment," in *L'art moderne et la question du sacré*, ed. J.-J. Nillès (Paris: Le Cerf, 1993), 163–89.

62. See Bois, "Perceiving Newman," 193–96 and 203.

63. Newman, "Frontiers of Space," 250.

exercise."[64] Later, he offered a grammatical—and no longer strictly "expressionist"—analogy to the notion of subject, by insisting on the *relations* that link the subject and the object in the temporal, dynamic, performative "exercise" or experiment indicated by the *verbal* dimension of a sentence:

> When I was a young kid studying French, I studied with a man, Jean-Baptiste Zacharie, who used to teach French by saying, "*Moi, je suis le sujet*, I'm the subject; *vous, vous êtes l'objet*, you are the object; *et voici le verbe*," and he'd give you a gentle slap on the face. The empty canvas is a grammatical object—a predicate. I am the subject who paints it. The process of painting is the verb. The finished painting is the entire sentence, and that's what I'm involved in. . . . I'm the subject. I'm also the verb as I paint, but I'm also the object. I am the complete sentence.[65]

We sense quite well that in these two variations on a single theme, both the dimension of the object and that of the verb—both the *product* and the *process*—focus attention on the *subjective instance* incarnated by the artist himself. Newman is attempting, here as elsewhere, to formulate the paradox of an "abstract art where the subject takes precedence,"[66] an art that asserts the *subject* (as Surrealism did) but, by being "abstract," *supposes* such an assertion without thematizing it, without signifying it—simply by bringing all its attention to bear on the effective, dynamic, and even affective relation between the *matter* and the support, or what the French language designates so well with the term *subjectile*.[67]

Newman's claim to an effectivity and an affectivity in his practice of abstraction thus forced him twice to modify the usual notion of subject matter: first, he rejected any iconographical "thematization" in favor of a more philosophical affirmation of the artist as subject; and second, he rejected any narcissistic "romanticizing" in favor of a reflection on the procedural relation that, in the act of painting, unites the words "subject" and "matter." His "grammatical" definition of painting amounts to conceiving artistic labor dialectically, in terms of a three-way relationship among *subject*, *matter*, and *subjectile*, as a kind of Borromean knot where any pressure exerted on one term structurally modifies the position of the others. Hence, in *Onement I*, the operation carried out on the *subjectile*—the central reserve, the removal of the masking strip, and the "respiration" of the brush in the case of the drawing; the interruption of this same process in the case of the painting, where Newman left his color test as it was, on the adhesive strip affixed vertically to the center of the painting—that experimental operation or *supposition* transforms the usual effectivity of the *matter* as it is normally deposited on the canvas by the brush. In the same way, the suspension of that operation, its "critical ambiguity," transforms the usual position of the *subject* facing his work in progress. We could say, paraphrasing Jacques Lacan, that the zip in *Onement I* functions as a "unary trace" (*trait unaire*) in Newman's work: in a single stroke, it has transformed everything, has literally invented the "subject" of his painting.[68]

64. Newman, "The Plasmic Image," 145; and idem, "The Sublime Is Now," 171–75ff.

65. B. Newman, "Interview with Lane Slate" (1963), in *Selected Writings*, 251 and xiii (in another version corrected by Newman himself).

66. In Lebensztejn's very apt expression in "Homme nouveau, art radical," 327 [my translation].

67. On the notion of the "*subjectile*," see J. Clay, "Onguents, fards, pollens," in *Bonjour Monsieur Manet* (Paris: Centre Georges Pompidou, 1983), 6–24; G. Didi-Huberman, *La peinture incarnée* (Paris: Minuit, 1985), 25–62; and J. Derrida, "Forcener le subjectile," *Antonin Artaud: Dessins et portraits* (Paris: Gallimard, 1986), 55–108.

68. Fundamental in this respect is the reflection found in B. Newman, "The Fourteen Stations of the Cross, 1958–1966" (1966), in *Selected Writings*, 189: "It is as I work that the work itself begins to have an effect on me. Just as I affect the canvas, so does the canvas affect me."

THE

SUPPOSITION OF

THE AURA:

THE NOW, THE THEN,

AND

MODERNITY

We can then understand that the subjective position of the painter, far from being reducible to some *affective* abandon (as we too often imagine with respect to Abstract Expressionism), is to be deduced from an *effective* choice, that is, a procedural choice. Conversely, this relationship illuminates the very notion of procedural choice (as we too often imagine it with respect to Minimalism, for example) from the angle of a *subject position*. There is no procedural "negotiation" without a displacement, a "rapture" of the subject, just as there is no "rapture" of a subject without the procedural and even logical "negotiation" of a heuristic working rule.[69] To say this, to note this in *Onement I*, is again, I believe, to speak of the aura. It is to detect in the "supposition of the aura" something that Newman's art teaches us even beyond what Benjamin may have said about the aura. The most beautiful gift that an "auratic" work like Newman's can make to the notion of the aura is to modify it, to transform it, to displace it.

We know that, for Benjamin, the *aura* as "apparition of a distance, however close it may be" was opposed to the *trace*, which was defined as the "apparition of a proximity."[70] According to him, that opposition conditions our attitude as spectators of human labor: the auratic images of the past are in fact often—as the example of the veronica forcefully attests—objects made in such a way that people will believe they were not "made by the hand of man."[71] In them the aura *imposes itself*, as I said, to the degree that the image-making procedure remains secret, miraculous, beyond reach. With *Onement I*, in contrast—as with a number of twentieth-century artworks—the aura comes into being, is *supposed*, through the gaze's proximity to a procedural trace as simple as it is productive, as effective as it is ambiguous. In this type of artwork, trace and aura are no longer separated; as a result, we can even recognize the work as an unprecedented combination, which I shall call for the occasion an *auratic trace*. In this case, the procedural effectivity— and the hand does not always intervene directly in the procedure, as we see in the *retrait* of the central zip in *Onement I*—produces the "apparition of a distance" and, so to speak, succeeds in *making us touch depth*. In this contact, it is our relation to human labor that is implicated, transformed, and renewed.

That may be why the twentieth-century artist succeeds in giving us the gift of artworks that "look at us," beyond any objective relation, beyond anything "we see" in them: a double distance is established, in which our proximity to the formal labor—to the *subjectile* and to the matter—establishes the auratic respiration. That respiration does not impose anything on us, but confronts us with the simple choice of *looking* or not looking, of implicating or not the visual effectiveness of the subject. That may be how the aura "declines" today, how it is declined and enfolded through its contact with the subject, the matter, and the *subjectile*. That may be how we can *suppose* the aura as we face a drawing, however modest, by Barnett Newman.

63

69. In particular, this is the lesson of Gilles Deleuze's remarkable analysis of the work of Samuel Beckett. See G. Deleuze, "L'épuisé," afterword to S. Beckett, *Quad et autres pièces pour la télévision*, trans. E. Fournier (Paris: Minuit, 1992), 55–106.

70. "The trace is the apparition of a proximity, however far away that which left it may be. The aura is the apparition of a distance, however close that which evokes it may be. With the trace, we grasp the thing; with the aura, the thing becomes our master." W. Benjamin, *Gesammelte Werke* (Frankfurt: Suhrkamp, 1972–89; 2d ed. 1991), 5:476 [my translation].

71. See Didi-Huberman, *Devant l'image*, 224–47, and especially the vast survey by H. Belting, *Bild und Kult: Eine Geschichte des Bildes vor dem Zeitalter der Kunst* (Munich: Beck, 1990) [*Likeness and Presence: A History of the Image before the Era of Art*, trans. E. Jephcott (Chicago: University of Chicago Press, 1994)].

Richard Francis
Sophia Shaw

NEGOTIATING RAPTURE:

A TRAVEL GUIDE

TO THE EXHIBITION

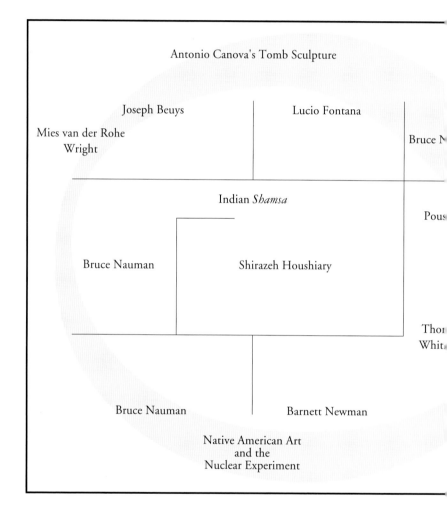

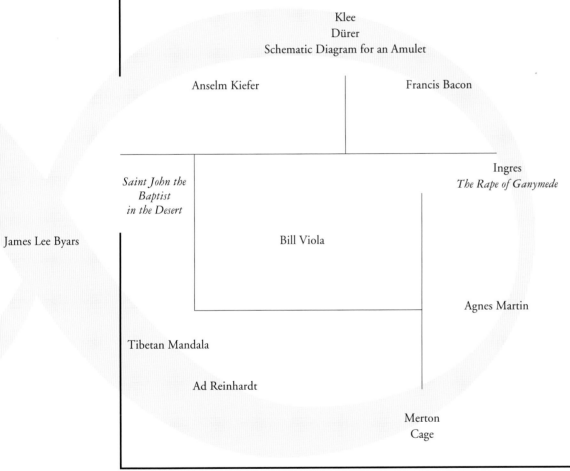

Klee
Dürer
Schematic Diagram for an Amulet

Anselm Kiefer Francis Bacon

 Ingres
Saint John the *The Rape of Ganymede*
Baptist
in the Desert

James Lee Byars

 Bill Viola

 Agnes Martin

Tibetan Mandala

 Ad Reinhardt

 Merton
 Cage

It is an intellect
Of windings round and dodges to and fro,

Writhings in wrong obliques and distances,
Not an intellect in which we are fleet: present
Everywhere in space at once, cloud-pole

Of communication.

—Wallace Stevens[1]

This section is planned as a sort of travel guide to the ideas and works in *Negotiating Rapture.* You can read it, like a travel book, with pleasure before you make the trip, but you will more likely pack it in your bag and refer to it after a day's wandering. Then you might read a part to find out where you had been and what it was you had seen. The journey is at once an exploration of some of the many themes in this catalogue and routes through the exhibition itself. This guide, therefore, is intended to help viewers and readers navigate some of the possible paths and to provide clues as to where to find more information. Since the exhibition is not linear and there are branches and diversions, these notes do not form a single narrative. Instead, they are discrete stories, linked to the works on view and illuminated by the philosophy, religion, and poetry we have associated with them.[2]

Plan of the Exhibition

The exhibition is arranged within two large square rooms, with individual galleries built for each principal artist. These galleries flow from one to another, connected by lobbies with vitrines containing books, manuscripts, architectural drawings, maps, objects from Buddhist, Christian, Islamic, Judaic, and Native American traditions, and works of art from outside the contemporary period. These materials provide "links" among the principal artists. (Here, quotations between notes function in a similar way.) The path through the exhibition follows a figure eight, crossing over in the center. You can join at any of four access points and, completing a circuit, have an understanding of the way in which the exhibition's ideas proceed from artist to artist.[3] The route thus inscribed resembles an infinity sign in mathematics, where particular follows particular in a specified order but always returns to the point of origin. Sometimes the route is more like a moebius strip where one must cross from one side of the idea to its obverse to remain on track. This cognitive mapping is reflected in the artists' works and in the way we have positioned them in the galleries. The notes, biographies, and essays that follow here offer signposts along the route, the equivalent of the listings and maps of varying detail and focus in a travel guide.

Works by the principal artists form the major highway through the exhibition, providing a variety of aesthetic experiences, modulated by the equally important links.[4] In these notes, we offer descriptive information to elucidate individual works, and evocative passages to illuminate ideas. In the catalogue, readers may flit from artist to artist and place to place, constructing their own routes and

1. Wallace Stevens, "The Ultimate Poem Is Abstract," *The Collected Poems of Wallace Stevens* (London: Faber and Faber, 1984), 429–30.

2. Another way to think of this is as a hypermedia application where there are connections among many places, and where you create for yourself an interactive mapping of ideas.

3. The path will take the viewer on two metaphorical journeys, one from the spiritual to the historical as represented by the works of Ad Reinhardt, Agnes Martin, Francis Bacon, Anselm Kiefer, and Bill Viola, and one extending from the classical toward the natural as exemplified by the works of Barnett Newman, Bruce Nauman, Joseph Beuys, Lucio Fontana, and Shirazeh Houshiary, with James Lee Byars at the center.

collecting data in different ways. This interactivity is intended; the exhibition's resource is as manifold as the connections viewers make, creating maps of images and ideas.

Some of the artists embrace, while others strongly deny, religious and philosophic ideas, which we have also tried to outline. The experience of rapture induced by negotiating these ideas belongs to the artist, but the role of the spectator is not passive, as Thomas Merton, monk and religious writer, clearly explained:

> The artist and the spectator share together an intellectual and spiritual experience in the creative enjoyment of the work of art. The artist . . . seizes upon and manifests to the spectator something profoundly alive in the world that could not be conveyed in any other way. The discovery of this unique view of reality is the source of aesthetic enjoyment. In this creative act, which the spectator shares, there occurs an aesthetic revelation of being and of life, not in the sense of philosophic or religious exhortation but in the sense that the work of art itself is an inscrutable sign of a deep and hidden reality. This sign has an eternal and universal significance.[5]

4. It may be useful to demonstrate one pathway through the exhibition. A work by Paul Klee is in a case between rooms of works by Anselm Kiefer and Francis Bacon. Klee's *Angelus Novus* once belonged to the cultural theorist Walter Benjamin, who wrote a story about it connecting the drawing to Judaic mysticism, his Jewishness, and his exile. The drawing is connected by this German heritage to Kiefer and displayed next to Albrecht Dürer's famous *Melancholia* print of 1514. Dürer's subject connects to Saturn, the god of both creativity and melancholy, and the role of cultural artifact as metaphysical carrier. The complexity of cultural ideas in the Dürer is paralleled by a sefirotic diagram, which is a meditation on the Kabbalah and linked to Benjamin and Klee. Kiefer deals directly with the Kabbalah, whose terms were used by Barnett Newman in titling his paintings. A sub-routine would relate Kiefer's book about Chernobyl and an early Kabbalist from that city with the kabbalistic terminology used by the scientists who constructed the first atomic pile at the University of Chicago, to the art of the Southwest,

where Bruce Nauman works (and where the bomb was tested) and to Newman's description of the religious art of the Northwest Coast (and back to Henry David Thoreau and Walt Whitman—and by extension to John Cage and Thomas Merton), and so on.

5. Thomas Merton, "Art as Virtue and Experience in Art and Morality," in *The New Catholic Encyclopedia* (New York: Mc Graw Hill, 1967), 865.

Those chosen to reveal the meaning of religious truth have, in many cases, undergone a rite of passage or an initiation by being tested alone in arduous physical circumstances. A journey alone into the desert or wilderness, a pilgrimage to holy ground, is often the metaphor for such a journey of personal revelation; when the body is most vulnerable, the soul becomes sensitive to inspiration. The Christian religion uses the motif of the saint, one called to religious sensitivity, as a seeker of spiritual understanding. *Negotiating Rapture* begins with *Saint John the Baptist in the Desert* by an Italian painter of the fifteenth century (cat. no. 29).[1] The panel depicts Saint John in the wilderness of Judea where he received his prophetic call (Luke 3:2). It was also in the desert that John began his ministry, characterized by the act of baptism (purifying the body with water), which he viewed as the final act of the cleansing process, meaningful only after the recipient had cleansed his or her own soul.

Saints and artists, through their journeys to personal revelation, work in similar ways. This panel introduces experiences presented all through *Negotiating Rapture*: solitude, struggle in contemplation, and processes akin to ritual. The themes are universal and exist throughout the history of art. The artists in this exhibition use modern and postmodern aesthetics to convey their discoveries. The Saint John panel is a signpost to these equivalences, an indicator of the type of journey that is beginning. The theme of Christian saints reappears in this exhibition in the seventeenth-century painting by Nicolas Poussin, *Landscape with Saint John on Patmos* (cat. no. 68), and in a contemporary installation by Bill Viola, *Room for Saint John of the Cross* (cat. no. 83). Viola wrote:

> Desert Solitude is an early form of visionary technology. It figures strongly in the history of religion. Individuals have used it to hear the voices of the past and future, to become "prophets," to receive images or, for Native Americans, to host "vision quests." It seems that when all the clutter and noise of the everyday life is reduced to such brutal minimalism, the usual "control valves" are released and images well up from within. The boundaries between the software of the private interior and the hardware of the exterior landscape are blurred; their forms intermingle and converge.[2]

In addition, the role of the seer or prophet is implied in the works of Native Americans, particularly the shaman tradition of the Northwest Coast (cat. nos. 13, 25, 65).

1. Hellmut Wohl, *The Paintings of Domenico Veneziano, c. 1410–1461* (New York: New York University, 1980), 149–50, illus. p. 180. This painting was tentatively attributed to Domenico Veneziano in a National Gallery of Art publication in the early 1940s. Saint John's life was painted often in the Renaissance, sometimes in complete cycles, as in the group of six panels by Giovanni di Paolo at the Art Institute of Chicago and the National Gallery, London. John is shown at his most vulnerable in the Domenico Veneziano panel in the National Gallery of Art, Washington, D.C.

2. Bill Viola, *Reasons for Knocking at an Empty House: Bill Viola Writings 1973–1994*, ed. Bill Viola and Robert Violette (Cambridge, Mass.: MIT Press and London: Anthony d'Offay Gallery, 1995), 164.

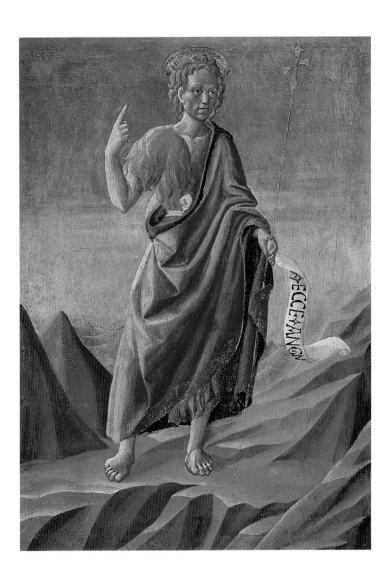

69

Italian, Florentine, *Saint John the Baptist in the Desert*, c. 1440–50, Indiana University Art Museum, Bloomington, Kress Study Collection, cat. no. 29.

To come to the pleasure you have not,
you must go by a way in which you enjoy not.
To come to the knowledge you have not,
you must go by a way in which you know not.
To come to the possession you have not,
you must go by a way in which you possess not.
To come to be what you are not,
you must go by a way in which you are not.

—Saint John of the Cross[1]

Bill Viola believes that individuals can rely only upon themselves, on their own opinions, talents, and resources, to make life decisions, to gain contentment, and to create art. In his writings and in the themes around which he creates, he relays this sentiment often: "Many video artists have . . . fallen prey to this propaganda of high fashion and mystique in advanced technology [saying], If only I had this new camera, this latest VTR, then I would really make good video art. . . . Technology always seems to lead us away from ourselves . . ."[2] Viola, therefore, uses technology to direct the viewer toward personal discovery. His sound and video installation *Room for Saint John of the Cross* (1983, cat. no. 83) evokes the small, dark, hot prison cell in Toledo, Spain, in which a Carmelite friar, John of the Cross (1542–1591), was confined for nine months in 1577 because he had angered the officials of one religious order by remaining loyal to another.[3] Although tortured and suffering in his confinement, John used his conditions to reach clear communications with the Divine. Inspired by revelations, he composed beautiful poems about God and love and wrote papers about the power of spiritual joy.

Working from language, Viola keeps a notebook as, he states, "a kind of travelogue, mapping a personal course through various readings, quotes, associations, observations, experiments, and ideas for pieces. . . ."[4] This mixture becomes understandable when the parts are restructured and organized to make an individual piece. His art is one of combination and precision, with the links and connections left in place but sometimes not used. For *Saint John of the Cross*, for example, he has in his notebooks references to mandalas, to Christian and other mystics, including the thirteenth-century poet Jalaluddin Rumi, whom he quotes: "New organs of perception come into being as a result of necessity—therefore, increase your necessity so that you may increase your perception." Viola adds that "the real work of the contemporary video artist, then, after acquiring the necessary technical skills, is in the development and understanding of the self. This is where the really hard work is. The level of the use of the tools is a direct reflection of the level of the user."[5]

Viola's intention is to lead the viewer to higher levels of the mind. His handwritten note "Preface to Videotapes" explains:

1. Saint John of the Cross, quoted in Bill Viola, *Reasons for Knocking at an Empty House: Bill Viola Writings 1973–1994*, ed. Bill Viola and Robert Violette (Cambridge, Mass.: MIT Press, London: Anthony d'Offay Gallery, 1995), 117.

2. Ibid., 71.

3. In 1571, at the request of Saint Teresa (who had experienced an ecstasy in 1559, see illus. p. 22, John had become the spiritual director and confessor of an unreformed order of Discalced Carmelites at the convent of the Incarnation at Avila. Poor relations between the Discalced and Mitigated Carmelites led to John's arrest in 1577, when he refused to leave his post and was brought to prison in Toledo. See Alban Butler, *Butler's Lives of the Saints*, vol. 4, ed, Herbert Thurston and Donald Attwater, (Westminster, Md.: Christian Classics, 1981), 413–18; Father Bruno de J. M., ed., *Three Mystics: El Greco, St. John of the Cross, St. Teresa of Avila* (New York: Sheed & Ward, 1949), 96–187.

4. Bill Viola, quoted in "Putting the Whole Back Together: Bill Viola in Conversation with Otto Neumaier and Alexander Pühringer," in Alexander Pühringer, *Bill Viola* (Salzburg: Salzburger Kunsverein, 1994), 140.

5. Viola, *Reasons for Knocking*, 71.

BILL VIOLA WAS BORN IN FLUSHING, NEW YORK, in 1951. He received a B.F.A. from the College of Visual and Performing Arts, Syracuse University, New York, in 1973, having concentrated in electronic music and becoming interested in performance art and experimental filmmaking. His first exhibitions and his work as a technical consultant at the Everson Museum of Art in the early 1970s brought Viola into contact with video artists such as Peter Campus, Frank Gillette, Bruce Nauman, and Nam June Paik. From 1974 to 1976, Viola worked in Florence, as technical director of a video studio, assisting European and American artists with their productions. In 1980 and 1981, Viola went to Japan as a Japan/U.S. Creative Arts fellow and later as the artist-in-residence at Sony's Atsugi Laboratories. During this year, Viola researched Japanese culture, learned new developments in video technology, practiced Zen meditation, and became close to Zen priest and painter Daien Tanaka. In 1983, Viola taught video at the California Institute for the Arts in Valencia, and created numerous video and sound installations, including *Room for Saint John of the Cross* (cat. no. 88). Throughout the 1970s and 1980s, he traveled to the Solomon Islands, Java, the Tunisian Sahara, Japan, Tibet, Fiji, and the desert of the southwest U.S., producing audio and video recordings of different natural landscapes and diverse cultural rituals. In 1988, he produced his first computer-controlled video productions. Viola represented the U.S. at the 1995 Venice Biennale. The artist lives and works in California.

Further reading

Pühringer, Alexander. *Bill Viola*. Exh. cat. Salzburg: Salzburger Kunstverein, 1994 [extensive bibliography and chronology].

Syring, Marie Luise, ed. *Bill Viola: Unseen Images*. Exh. cat. Düsseldorf: Verlag R. Meyer, 1992 [extensive bibliography].

Viola, Bill. *Reasons for Knocking at an Empty House: Bill Viola Writings 1973–1994*. Edited by Bill Viola and Robert Violette. Cambridge, Mass.: MIT Press and London: Anthony d'Offay Gallery, 1995.

Zeitlin, Marilyn A., ed. *Bill Viola: Survey of a Decade*. Exh. cat. Houston: Contemporary Arts Museum, 1988.

The idea of spiritualism is chiefly the idea of higher mind—beyond genius of any other category of thought so culturally defined. The human mind is capable of reaching incredible levels of a higher knowledge, which some call union with God. In any event, these levels are not culturally determined, but are to varying degrees universal, common to peoples all over the world. It is through this channel, the psychological method, that the following images attempt an approach to the beauty and depth of the mind.[6]

Saint John was concerned in the poem "Dark Night of the Soul" that rapture was too easily achieved and was the result of submission to extreme emotions "by reason of the weakness and corruption of the sensual nature. Hence arise the raptures and trances and dislocations of the bones which always happen when the communications are not purely spiritual."[7] Viola's ambition is to maintain a channel to this purely spiritual communication through the conservative emotional structure of his work.

6. Ibid., 27.

7. Saint John of the Cross, "Of the Dark Night of the Spirit," *Dark Night of the Soul*, ed. and trans. E. Allison Peers, book 2, chap. 2, from the critical edition of P. Silverio de Santa Teresa, C.D. (electronic edition scanned and edited by Harry Plantinga).

▶ Bill Viola, *Room for Saint John of the Cross*, 1983, The Museum of Contemporary Art, Los Angeles, The El Paso Natural Gas Company Fund for California Art, cat. no. 83.

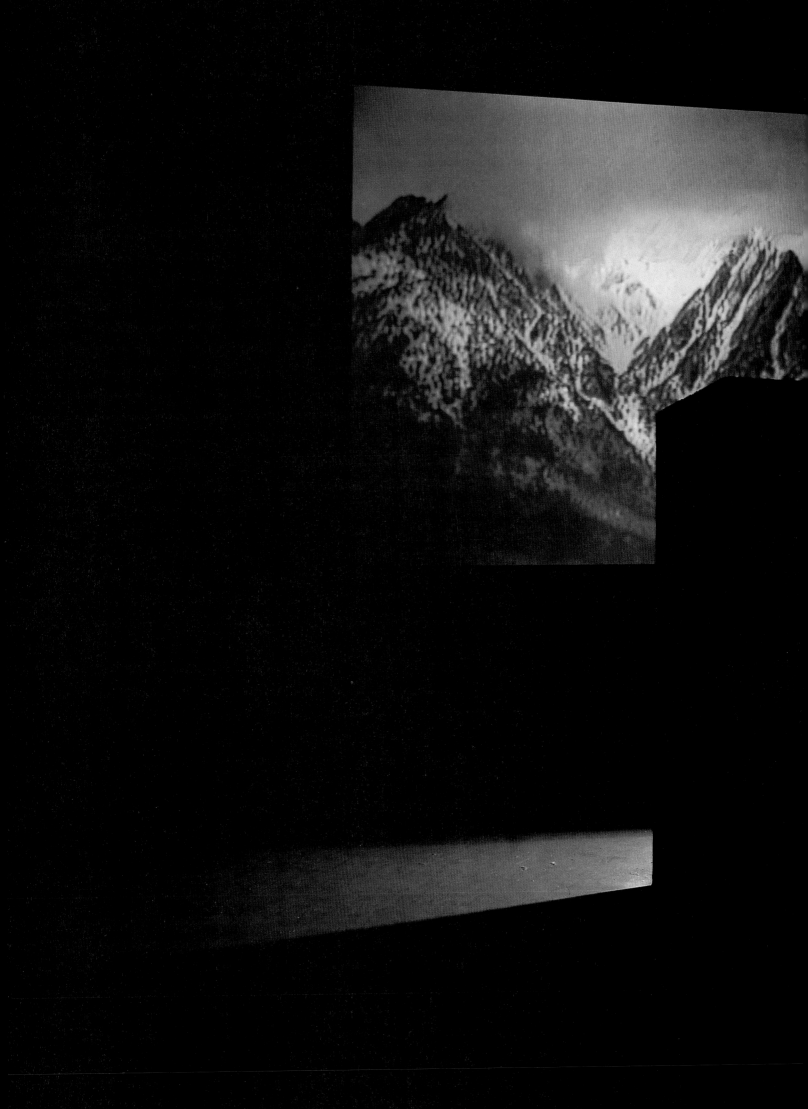

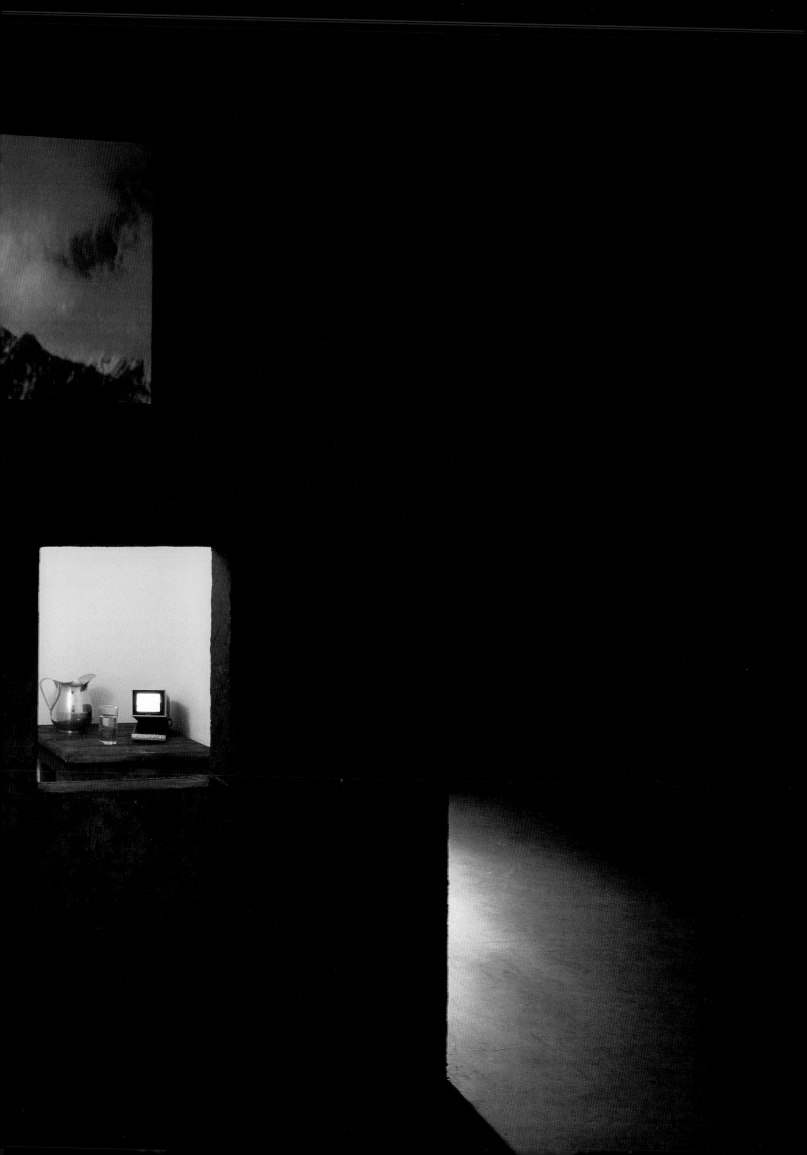

Sainthood is—or should be—a rare status. yet, given twenty centuries and global experiences, even a single religion acquires a long roster of saints. *The Book of Saints* compiled by Benedictine monks in Great Britain is a who's who of over ten thousand of them.[1] The most popular name among these is John—as in John the Baptist, John the Evangelist, John of the Cross. Indeed, *The Book of Saints* lists 232 Johns, and the entries give a sense of what a saint was or was considered often to be. Idiosyncrasy not only will not rule one out; it may help qualify a person for a category that demands extraordinariness. Starting at the fringes of the canonized community can shed light on the concept of sainthood embodied by the heroes and heroines of holiness at its core.

Martin E. Marty

SAINTS AND
THEIR JOURNEYS

Thus, saints tend to be generous to others and hard on themselves. Saint John Cini "della Pace" (d. 1433), a Pisan, founded many charitable organizations as well as a congregation of flagellants, whose discipline called on them to whip themselves. Next, saints are obedient. Saint John the Dwarf, a fifth-century figure famed for his absentmindedness, told to do some watering, paid scant attention to his task. He watered his walking stick, which promptly sprouted and became known as "the tree of obedi-ence." Saints leave worldly comforts behind and make pilgrimages into the realms of simplicity. "*Pan y Agua,*" admirers called Saint John Bread-and-Water (d. 1150), who fasted life long on only those staples.

Where saints abide and where they journey is often a decisive issue. Some stay at the crossroads and in the city, but Saint John of Patmos was on an island when he received his apocalypse, his revelation. The desert attracted many. Thus Saint John Climacus (d. 649), named for his book *The Climax* or *Ladder of Perfection*, was called in from the remote Arabian Desert to serve as Abbot of Mount Sinai at age seventy-five. He hurried back to the desert hermitage, there to die. Some seem to end their journeying early; Saint John the Silent (d. 558) resigned as Bishop of Colonia, shed his name and identity, and had himself "walled-up" in the laura of Saint Sabas to keep the world of nearby Jerusalem at a distance.

After the issue of place comes that of action and character. Saints might be humble, but they tend to have courage and derring-do. Saint John the Wonder-Worker (d. 750) worked so many miracles and gained such an awe-filled following that emperor Leo the Isaurian could not follow his impulse to silence or kill him. Thousands, however, *were* martyred, often in clusters. Thus in seventeenth-century Nagasaki, the avenging Japanese, who resented the Christian conversions, crucified or beheaded Saints John Foiamon, John Ivanango, John Kingocu, John Kisaka, John of Korea, John Montajana,

John Nangata, John Tomake, John Yano, and even more Johns.

All this emphasis on the name John throws focus almost accidentally on the saint as male. But if the Roman Catholic Church limited the vocations and roles of women in many respects, it practiced non-discrimination in respect to sainthood. Many, too many, women became saints as victims of abuse, rape, or murder when resisting rape. Feminists may admire them more than they admire the church that seemed to glorify victimhood. Over against these, however, one can pose the familiar Saint Joan of Arc (1412–1431), no stranger to arms—and, hence, a problem for pacifists. Saints, by the way, almost always create problems for someone or other in their heritage.

The church also found it easier to canonize women religious, people in cloisters and cells and convents, than those who were heroic homemakers, lay people in ordinary roles. Some moderns would like to see "Saint" before the name Dorothy Day (1897–1980), founder of the Catholic Worker movement and an urban American worker of wonders, but she was too accessible, too unguarded about her flaws, too "worldly" to attract much notice by canonizers. Among those most opposed to the notion of sainthood for her would have been the scrupulously modest Day herself or her own family. Moral, or at least point to be noted: one does not have to be declared a saint to have been a saint.

All the saints mentioned belong to the Roman Catholic canon, which alone has a formal process for declaring people saints. Eastern Orthodox Christianity also reveres saints, among them another John, the great Saint John Damascene (d. 749), a theologian who escaped persecution by irritated emperors because he lived on Muslim soil. Protestants, like other Christians, often name their churches after saints, but prefer biblical ones, like Saint John and Saint Luke. Unlike Catholics, Protestants do not venerate or pray to or through saints, though they respect many and emulate some, like Saint Francis of Assisi (1181–1226). Other religions have equivalents to saints. Jews have tended to avoid the category: God saves a people and works through a people. Yet Jews revere individuals like Abraham and Moses in ways that match Christian regard for saints. Islam, another prophetic religion, shuns the canonizing of humans, however exemplary, but honors certain figures. One can see parallels to saints in *lamas, gurus,* and *arahants* and their kinds in Eastern religions.

Saints journey. They make pilgrimages or attract others to their shrines and cells. We read, for example, of Saint John of the Grating (d. 1163), a Breton, whose shrine was surrounded by metal railings; hence he was called "*de Craticula.*" Saints journey, metaphorically, from sinnerhood to sainthood. Many move from positions of prominence to obscurity, only to be discovered generations

after their death. While some are good-humored and
even humorous, most saints come equipped with
a burden of agony as they make their travailed journeys.
⁓any, the route to sainthood has been intellectual:
⁓ved from figurative Athens to Jerusalem,
⁓son to havens of faith, while still celebrat-
'ified ways. For others, the way was
ncis, they turned their backs on lux-
ɒe and cityscape pronouncing
ctively, trying to exemplify love.
⁓ional or mystical roads. Some
ɪscend time and place,
⁓ɹ_pults oɪ tne eternal to their neighbors.

Such journeys were always problematic, but many believe
sainthood to be unreachable, even inconceivable in
a secular or—as some would have it—a godless epoch.
Novelist Albert Camus agonized over the question in *The
Plague*, pondering whether one can be a saint if God
does not exist. Camus's contemporary, United Nations
Secretary General Dag Hammarskjöld, no saint but
someone who moonlighted as a mystic, wrote in his spir-
itual diary, *Markings*: "In our era, the road to holiness
necessarily passes through the world of action."[2]
Contemplation and passivity may have their places.
But in this century of wars and Holocaust, exiles
and hunger, inequity and injustice, those who take to the
spiritual road are likely to encounter people of action,
some of whom they may consider to be saints.

1. See *The Book of Saints: A Dictionary of Servants of God*,
 6th rev. ed., comp. the Benedictine monks of Saint
 Augustine's Abbey, Ramsgate (Wilton, Conn.: Morehouse
 Publishing, 1989).

2. Dag Hammarskjöld, *Markings*, trans. Leif Sjöberg and W. H.
 Auden (New York: Alfred A. Knopf, 1964), xxxi.

Mandala, circle enclosing square
Rules, regularities, symmetry, flower, cross,
wheel
Square sanctuary, 4 doors, walls, points
Seat of divinity
Yantra, diagram, device, geometrical, chart
Concentric circles, lotus petal, interpenetrating
triangles
Corolla of 64 varicolored petals
Inner circle, aureole, park blue, outside circle,
red, lilac
Halo, nimbus? Divine radiance, emanation
Star, octagon, 8 petals of mystic lotus
 Western, radial, axes
 Indian, concentric
 Chinese, movement
"Dome of heaven," dome on dome, vault, sky,
"most high"
"Round above, square below," time-space
World mountain, sumeru, "celestial parasol"
Cosmic pillar, tree, vine, "navel of the earth"
"The infinite is a square without angles," Old
Chinese

Holy ground, sacred space, fixed point,
threshold, limit
Entrance, "gate," sign, ritual, "pure region"
Holy of holies, breakthrough from plane to
plane
Mount Meru, Kiaba, ziggurat, 7 heavens,
temple, cathedral
Celebration, spectacle, time of origins, new,
pure
No change, no exhaustion
Recoverable, repeatable, circular time,
transhuman
Starting over at beginning non-historical
Eternal return, repetition transmundane
Made, unmade, remade
Open self to the general & universal

 —Ad Reinhardt[1]

The word "mandala" means essence container, a "sphere of nurturance of the essence, a magical and sacred realm, created by the artistry of enlightened compassion in order to nurture beings, develop toward enlightenment. Mandalas are the perfected environments of the Buddhas, built on the foundation of their perfect wisdom."[2] A mandala, used in Hinduism and Buddhism as a vehicle and support for meditation, deals with the first two forms of tantric yoga, action (*kriya*) and performance. All mandalas are geometric in design, and many are three-dimensional architectural forms. The viewer, through meditation, leaves the outside perimeters of the phenomenal world, enters and visually moves toward the center (*axis mundi*) or goal, where the cleaner mind can allow for a reintegration with the cosmos. Traditionally, Tibetan paintings with mandalas are mounted on elaborate silk brocades, rolled for ease of transport and unrolled for devotion and meditation by the nomadic Tibetans, who wandered in search of seasonal pastures.

This nineteenth-century Tibetan painting (cat. no. 81) depicts a large mandala floating in a landscape of mountains and clouds. At the center is a protective deity in *yabyum*, that is, a father-mother figure in sexual union, with three heads and six arms, holding a flower, chopper, bow and arrow, bell (or bowl), and club. The *yum* or female also has six hands, with attributes undetermined. Many chosen deities or *yidam* and fierce *dharmapala*, who protect the Buddha teaching, surround the central pair. Above the mandala, a golden Shakyamuni appears in the *bhumisparsamudra* or earth-touching gesture, flanked by two red-hatted lamas or teachers. At the bottom of the painting, the female *dharmapala* Lha-mo is shown riding upon her mule, with the bodhisattva Simhanada Avalokitesvara seated on a roaring lion at the left and a three-headed, six-armed unidentified deity at the lower right. Two *naga*, mythical serpent- or dragonlike beings, emerge from the water at the lower edge of the painting.

Even without knowledge of such iconography or the devotional practice that should accompany the object, many Western artists have used the form of the mandala as a means of meditation for the spectator. For example, Bill Viola has used the methodology of the mandala. The significance of this kind of meditative practice for certain artists in New York in the 1950s, moreover, parallels its importance for Thomas Merton and other students of comparative religion at the same period. Similarly, Ad Reinhardt traveled and studied the art of many Eastern cultures and drew, both in his irreverent cartoons and in his personal notebooks, mandala forms.

1. Ad Reinhardt, undated notes, *Art-as-Art: The Selected Writings of Ad Reinhardt*, ed. Barbara Rose (New York: Viking Press, 1975), 189.

2. Marilyn M. Rhie and Robert A. F. Thurman, *Wisdom and Compassion: The Sacred Art of Tibet* (New York: Harry N. Abrams, Inc., 1991), 391.

Tibetan, *The Mandala of a Yi-dam*, 19th century,
The Nelson-Atkins Museum of Art, Kansas
City, Missouri, Bequest of Joseph H. Heil, cat. no. 81.

I might, also, touch on some religious aspects of black, because I've been called a number of names like "the black monk" and so on. I suppose it began with the Bible, in which black is usually evil and sinful and feminine. I think a whole set of impositions have affected our attitudes toward white and black—the cowboy with the white hat and white horse, and the villain with the black gloves. . . . There is a relation in Christianity to the black hell void and the white heaven myth, the blackness of darkness that is involved with formlessness or the unformed or the maternal, the hidden, guilt, origin, redemption, faith, truth, time.

—Ad Reinhardt[1]

Mandalas

and to

Contemplation

Ad Reinhardt's position in Abstract Expressionism was always that of an outsider; he regularly distanced himself from his peers. After 1954, he attempted to use no lines and no color, and made only "black" paintings (see cat. nos. 71–75) from 1960 until his death seven years later. He called the black works the "last paintings," not because he believed that painting was dying,[2] but because he believed that these works pressed along the extremes of the possibilities of the medium itself. Reinhardt wanted to make paintings that revealed no narrative, gesture, or action: "No lines or imaginings, no shapes or composings or representings, no visions or sensations or impulses, no symbols or signs or impastos, no decoratings or colorings or picturings, no pleasures or pains, no accidents or ready-mades, no things, no ideas, no relations, no attributes, no qualities—nothing that is not of the essence."[3] He used nearly black pigments (many colors can be detected), to achieve absolutely flat, matte surfaces, which would not reflect and therefore did not seem to extend further than the confines of the two-dimensionality of the canvas and its handmade frame.

Although Reinhardt made it clear that his works were not religious, they are like mandalas since they ask the viewer to concentrate on, and become sensitive to, their slightest gradations in color and form. They become "ritual aids" to contemplation.[4] Reinhardt studied philosophy and comparative religion at Columbia University and incorporated the techniques and practice not only of mandalas but sources as diverse as the patterns of Oriental carpet designs into his art.[5] The severity of the last paintings has diverted us. He has been encumbered by a heritage that places Kazimir Malevich and Piet Mondrian as precursors and the Minimalists as heirs, but we need to see that in his painting he used geometric forms such as the cross in relation to his writings and the other knowledge he had accumulated and not as an isolated formal exercise.

Reinhardt insisted on art as art, while allowing that the work was touching other, spiritual areas: "The one meaning in art comes from art working and the more an artist works, the more there is to do. . . .The one direction in fine or abstract art today is in the painting of the same one form over and over again, the one intensity and the one perfection come only from long and lonely routine attention and repetition." He was emphatic about studio practice, working alone to perfect the transmission of the idea: "The one freedom is realized only through the most conscious art-discipline and through the most regular studio-ritual."[6] Photographs of Reinhardt in the studio suggest a monk, whose attention is focused on questions best attempted through meditative practices

1. Ad Reinhardt, "Black as Symbol and Concept" (1967), *Art-as-Art: The Selected Writings of Ad Reinhardt*, ed. Barbara Rose (New York: Viking Press, 1975), 86–87.

2. Yve-Alain Bois, *Ad Reinhardt* (Los Angeles: Museum of Contemporary Art and New York: Museum of Modern Art, 1991), 14.

3. Reinhardt, "Art-as-Art" (1962), in *Selected Writings*, 56.

4. Pricilla Colt, "Notes on Ad Reinhardt," *Art International* 8:8 (20 October 1964): 34.

5. Walter Smith, "Ad Reinhardt's Oriental Aesthetic," *Smithsonian Studies in American Art* 4:3–4 (Summer/Fall 1990): 29.

6. Reinhardt, "Art-as-Art," 58.

AD REINHARDT (1913–1967) WAS BORN TO Lutheran parents in Buffalo, New York, and grew up in Brooklyn and Queens. At Columbia University, New York, he studied fine art, art history, and theory with Meyer Schapiro, and became close friends with Thomas Merton. Reinhardt graduated with a B.A. in 1935, and from 1936 to 1937 studied art history in Columbia's Graduate School for Fine Arts and painting at the American Artists School, the National Academy of Design, and Columbia Teachers College. Simultaneously, he worked as a commercial artist and political cartoonist. In 1937, he joined American Abstract Artists, founded the previous year to promote exhibition opportunities for abstract artists, and was appointed to the easel division of the Federal Art Project of the Works Progress Administration, in which he participated until 1941. He studied Indian, Islamic, Chinese, and Japanese art history at the Institute of Fine Arts, New York University, before serving in the U.S. Navy, and again from 1946 to 1952. Beginning in 1947, Reinhardt taught full time at Pratt Institute, Brooklyn College, and Hunter College, and made extensive trips to Asia, the Middle East, and Europe.

Reinhardt's paintings of the late 1930s and early 1940s were predominately abstract works inspired by Juan Gris, Joan Miró, and Pablo Picasso, and colorful collages and paintings influenced by the work of Stuart Davis, who had a studio next door. During the late 1940s and early 1950s (when Reinhardt was friends with Barnett Newman and Mark Rothko), Reinhardt fluctuated between bright colors and the darker hues he would use exclusively after 1956 in his almost-black paintings.

Further reading

Bois, Yve-Alain. *Ad Reinhardt*. Exh. cat. Los Angeles: Museum of Contemporary Art and New York: Museum of Modern Art, 1991 [extensive bibliography].

Inboden, Gudrun and Thomas Kellein. *Ad Reinhardt*. Exh. cat. Stuttgart: Staatsgalerie, 1985.

Lippard, Lucy R. *Ad Reinhardt*. New York: Harry N. Abrams, 1981 [extensive bibliography].

Reinhardt, Ad. *Art-as-Art: The Selected Writings of Ad Reinhardt*. Edited by Barbara Rose. New York: Viking Press, 1975.

common to many religions. Thus he allows us to establish the importance not only of the contemplative tradition for the state of rapture but the significance of the studio as a site of retreat and practice for its negotiation. This is important for all the artists in the exhibition, but it may be worth linking the unlikely pair of Reinhardt and Bruce Nauman (see cat. nos. 54–56) as formidable users of the contemplative space. The notion of contemplative practice follows from that of Saint John and is clear in the photography of Reinhardt's friend Thomas Merton (see cat. nos. 43–52).

Ad Reinhardt, *Abstract Painting, 1950–51*, 1950–51,
Lannan Foundation, Los Angeles, cat. no. 69.

Ad Reinhardt, *Abstract Painting, Blue*, 1952, The
Carnegie Museum of Art, Pittsburgh, Museum Pur-
chase: Gift of the Women's Committee,
cat. no. 70.

▲ Ad Reinhardt, *M*, 1955, Walker Art Center,
Minneapolis, Gift of Virginia Dwan, cat. no. 72.

◄ Ad Reinhardt, *Untitled (Composition No. 104)*,
1954–60, The Brooklyn Museum, New York, Gift of
the Artist, cat. no. 71.

Ad Reinhardt, *Small Painting for T. M.* (Thomas Merton), 1957, Abbey of Gethsemani, Trappist, Kentucky, cat. no. 73.

Ad Reinhardt, *Abstract Painting, 1960–1965*, 1960–
65, Lannan Foundation, Los Angeles, cat. no. 74.

86

Ad Reinhardt, *Abstract Painting*, 1962, Museum of
Contemporary Art, Chicago, Gift of William J.
Hokin, cat. no. 75.

"ABSTRACTION"

RETREAT FROM LIKENESS IN THEORY OF PAINTING

[handwritten manuscript notes, largely illegible]

CREATIVE PROCESS

[handwritten manuscript notes, largely illegible]

Ad Reinhardt, *Untitled (Manuscript)*, Anna Reinhardt, cat no. 76.

Thomas Merton moved from a childhood in France and England, via New York and the Abbey of Gethsemani in Trappist, Kentucky to a death by electrocution in Bangkok. This journey encompassed all the extremes of modern culture, mysticism, and spirituality. Within religion, for example, he traveled from the stultifying Anglicanism of an English minor public school, through conversion to Catholicism, contact with D. T. Suzuki and Zen, and, at the age of twenty-six, entered the most demanding of religious orders where he felt, for the first time, "at home." He pressed the monastery to allow him solitude and hermetic meditation; over a number of years, slowly and painfully, he created an ecumenism that incorporated Eastern religions, including the meditative practice of Zazen (which persists at Gethsemani). In the process of his life, Merton voluminously documented his changes of mind and his responses to religious thought and politics. From the obscurity of his monastery in rural Kentucky, he has come to have an enormous influence on succeeding generations of Christians and others seeking spiritual enlightenment.

Merton was a friend of Ad Reinhardt, with whom he studied in philosophy class at Columbia University (Reinhardt graduated in 1935, Merton in 1937); they maintained a sporadic correspondence throughout their lives. Reinhardt made a painting for Merton (cat. no. 73), which hung in his cell at Gethsemani (and later in the kitchen at the hermitage, which, in part, accounts for its current condition). Merton also became a photographer toward the end of his life, using borrowed cameras and relying on the advice of, among others, Ralph Eugene Meatyard, who lived in Louisville.[2] Merton's images of the world immediately around him, his meditations on nature, on his beloved Kentucky Knobs (the hills that surround Gethsemani), relate to Thoreau and the American naturalist and transcendental tradition. These photographs (see cat. nos. 43–52) are precise and ordinary (in the sense of everyday), have something of the aesthetic of Abstract Expressionism (the period that Merton was in New York), but also seem to relate to the English traditions of Samuel Palmer and William Blake. Perhaps Merton, in these images, is approaching a mysticism of visual experience that paralleled his search in literature and religion.

Merton has become a lodestone for many artists in their need to understand the world through their art. Driven at every stage by a desire to encompass more information about the world's religious ideas, Merton began with the Romanticism of Blake, from whom he made links to both painting and literature, and thence the English mystics, notably Julian of Norwich, the author of *The Cloud of Unknowing*, and the later Romanticism of Wordsworth.[3] Merton's

1. Thomas Merton, quoted in Walter Smith, "Ad Reinhardt's Oriental Aesthetic," *Smithsonian Studies in American Art* 4:3–4 (Summer/Fall 1990): 43.

2. See Ralph Eugene Meatyard, *Father Louie: Photographs of Thomas Merton* (New York: Timken Publishers, 1991), and Deba Prasad Patnaik, ed., *Geography of Holiness: The*

Photography of Thomas Merton (New York: Pilgrim Press, 1980).

3. Especially in *The Prelude*: "and when the deed was done/I heard among the solitary hills/ Low breathings coming after me, and sounds/ of indistinguishable motion, steps/Almost as silent as the turf they trod." William Wordsworth, *The Prelude* (New York: Woodstock Books, 1993 [1850]), 16.

postgraduate essay on Blake gave him the key to his own intellectual and spiritual course:

> . . . at sixteen I had imagined that Blake, like the other Romantics, was glorifying passion, natural energy for their own sake. Far from it! What he was glorifying was the transfiguration of man's natural love, his natural powers, in the refining fires of mystical experience: and, that, in itself, implied an arduous and total purification, by faith and love and desire, from all the petty materialistic and commonplace and earthly ideals of his rationalistic friends.[4]

4. Thomas Merton, *The Seven Storey Mountain* (New York: Harcourt Brace & Company, 1948), 202–3.

89

Thomas Merton, *Rocks*, 1960s, Merton Legacy Trust, cat. no. 44.

Thomas Merton, *Water*, 1960s, Merton Legacy Trust, cat. no. 52.

Reinhardt similarly explored the mystical, discovering what is called the *via negationis*, a "theology of darkness." The arduous phase of Merton's search was an interior journey during which he wrote a now classic text on the life of Saint John of the Cross (published in 1952 in *Saints for Now*, edited by Clare Booth Luce). His project involved not only the urge for solitude but the embrace of Eastern religions. On a parallel course, Reinhardt wrote to Merton about art, and one passage, although cynical and ironic, conveys his dedication to Eastern principles: "Latest idea is, what is religious and sacred in a work of art is its perfection, form, artistic content, which is not anything you can pin down, as excellence or specific quality or etc. or anything like that. This is an old 'puritanical,' Moslem and Zen idea. Jewish too?"[5] Merton's answer can be found in his *Asian Journal*, published posthumously in 1973, where he defined his conception of the integration of perception and experience: "Everything I think or do enters into the construction of a mandala. It is the balancing of experience over the void, not the censorship of experience. And no duality of experience—void. Experience is full because it is inexhaustible void. It is not mine. It is uninterrupted exchange. . . .The self is merely a locus in which the dance of the universe is aware of itself as complete from beginning to end— and returning to the void."[6]

Merton was always seeking "undiluted reality," a phrase echoed by several artists in this exhibition, notably Agnes Martin and Francis Bacon. In his last speech, delivered in Bangkok, he articulated an optimistic belief in the liberating possibilities of that search:

> What is essential in the monastic life is not embedded in buildings, is not embedded in clothing, is not necessarily embedded even in a rule. It is somewhere along the line of something deeper than a rule. It is concerned with this business of total inner transformation. All other things serve that end. . . . It is the view that if you once penetrate by detachment and purity of heart to the inner secret of the ground of your ordinary experience, you attain to a liberty that nobody can touch, that nobody can affect, that no political change of circumstances can do anything to. . . . I am just saying that somewhere behind our monasticism and behind Buddhist monasticism, is the belief that this kind of freedom and transcendence is somehow attainable.[7]

Begining and Dance of the Universe aware of itself

5. Ad Reinhardt, letter from 1962, in "Five Unpublished Letters from Ad Reinhardt to Thomas Merton and Two in Return," ed. Joseph Masheck, *Artforum* 17:4 (December 1978): 25.

6. Thomas Merton, *The Asian Journal of Thomas Merton*, ed. Naomi Burton, Brother Patrick Hart, and James Laughlin (New York: New Directions, 1973), 68.

7. Ibid., 340–42.

91

▲ Thomas Merton, *Tree Roots*, 1960s, Merton Legacy Trust, cat. no. 50.

◄ Thomas Merton, *Grasses by Door*, 1960s, Merton Legacy Trust, cat. no. 43.

◄ Thomas Merton, *Rocks*, 1960s, Merton Legacy Trust, cat. no. 45.

. . . [R]eturning to the Book of Changes*: the Hexagram on Grace (which is the hexagram on art) discusses the effect of a work of art as though it were a light shining on top of a mountain penetrating to a certain extent the surrounding darkness. That is to say, art is described as being illuminating, and the rest of life as being dark. Naturally I disagree. If there were a part of life dark enough to keep out of it a light from art, I would want to be in that darkness, fumbling around if necessary, but alive and I rather think that contemporary music would be there in the dark too, bumping into things, knocking others over and in general adding to the disorder that characterizes life (if it is opposed to art) rather than adding to the order and stabilized truth, beauty and power that characterize a masterpiece (if it is opposed to life).*

—John Cage[1]

The notes of John Cage's *Chess Pieces* (cat. no. 10), written for unprepared piano and imposed upon the grid of a painted chessboard, comprise a musical chess game. The work, according to musicologist Martin Erdmann, exhibits an intentional "child-like playfulness" in its use of musical motifs,[2] not surprising as it was conceived for a 1943–44 group exhibition at the Julien Levy Gallery in New York, which featured works about chess in honor of Marcel Duchamp. Cage, who was primarily a composer but also a painter and draughtsman, had begun to compose music in the early 1930s, and from 1950 on employed the concept of chance. In the early 1940s, at László Moholy-Nagy's invitation, Cage taught composition and experimental music at the Institute of Design in Chicago. Like many artists in New York during the following decade, including Agnes Martin and Ad Reinhardt, he became interested in Eastern meditative techniques, including the *Tao Te Ching* of Lao Tzu and subsequently incorporated some of these techniques into his chance methods of composing. By creating the trigrams or hexagrams, using thrown coins of the *I Ching*, for example, he would determine the pauses, pitch, or time for his compositions; in this way, he developed a complex musical and literary practice in which chance procedures revealed the underlying nature of the creative process. Cage used many texts for his compositions, including Thoreau's journal (see cat. no. 80), which he transformed in 1970 into *Song* and *Another Song*, published in 1981.

In the 1950s, Cage had asked one of his students, Gita Sarabhai, what her teacher in India had thought was the purpose of music. Her reply was "to sober and quiet the mind, thus rendering it susceptible to divine influences." Cage was impressed by this notion and began to find other sources wherein the same sentiment was expressed. "I decided then and there that this *was* the proper purpose of music. In time, I also came to see that all art before the Renaissance, both Oriental and Western, had shared this same basis, that Oriental art had continued to do so right along, and that the Renaissance idea of self-expressive art was therefore heretical."[3]

1. John Cage, "Composition as Process: Communication, part III" (1958), *Silence* (Middletown, Conn.: Wesleyan University Press, 1961), 45–46.

2. Martin Erdmann, unpublished notes. Erdmann delivered a paper on the manuscript for *Chess Pieces*, from the estate of the composer, during the John Cage Symposium at the Institut für neue Musik at the Hochschule der Künste, Berlin (23–25 November 1995).

3. John Cage, quoted in Calvin Tompkins, *The Bride and the Bachelors* (New York: Viking Press, 1965), 98–99.

John Cage, *Chess Pieces*, 1943, private collection,
Chicago, cat. no. 10.

The Age of Enlightenment left Western intellectuals and artists in a lasting predicament. Suspicious of the cult of science, they were also alienated from theologies that could not accommodate scientific discovery and from religious institutions devoid of true spiritual vitality. In the nineteenth century, the need to integrate religion and science was of particular concern to Paul Carus (1852–1919), editor of the Open Court Publishing Company in La Salle, Illinois. In 1893, Carus attended the World's Parliament of Religions in Chicago, where he befriended Soyen Shaku, the Zen abbot of Engaku-ji in Kamakura, Japan. Carus had long advocated a religion that, once cleansed of archaic superstitions, would complement modern science. But only after the Parliament did he identify Buddhism as the religion most appropriate for this integration. Henceforth, he used his position at Open Court to disseminate Buddhist teachings.

Helen Tworkov

SPIRITUAL MATTERS:

ZEN

IN AMERICAN ART

Foremost among his efforts was *The Gospel of Buddha*, a collection of writings from the Buddhist canon, first published in 1894. When Carus sent Soyen Shaku a copy of the book, the abbot gave it to D. T. Suzuki, then a young lay student living in his monastery, to translate into Japanese. Shortly after, Carus invited Suzuki to La Salle where, for eleven years, he performed odd jobs for the Carus household and translated Asian texts for publication.

By mid-century, Suzuki had become the world-renowned philosopher of Zen, writing prodigiously and lecturing in America and Europe. But when he took up residence in New York to teach at Columbia University in 1949, the American experience was far different from that of La Salle at the beginning of the century. From one perspective, the 1950s represent the complacent glory years of the American Dream, between World War II and Vietnam, when for every problem—from polio to the Cold War—a solution seemed to hover on the horizon. So entrenched is this *Life*-magazine portrait of the postwar decade in the American psyche that such phenomena as abstract painting, the Beats, or the burgeoning interest in Zen Buddhism appear aberrant. Yet while the lasting influences of these movements testify to their signifi-cance, they reveal as well the capac-ity of subterranean forces to critique, and to function as moral witness to, their own times. The more stultified mainstream America became regarding matters of money, material-ism, and the military-industrial com-plex, the more cloying and paranoid the government, the greater the impetus to rebel.

During this era of deadly conformity, many artists and intellectuals became professed atheists, yet an examina-tion of their work, diaries, and correspondence, suggests that God—in whatever manifestation—was not the object of rejection; rather, it was the bureaucracies of religion they found unacceptable. Atheism became a sophisticated denial of religions conventions, but this posture often masked deeply personal and private investigations into the nature of God.[1] Although many Westerners, even those disillusioned with their own traditions, could not bring themselves to explore non-Judeo-Christian teachings, when these investigations did come into contact with Buddhist doctrine, they pro-ceeded, in ways similar to scientific approaches to reality, without contradiction. For those hungry to explore such alternatives, Suzuki offered inspired possibilities for a new approach to spiritual matters.

Suzuki did not burden Westerners with the disciplined and precise methodology of Zen, honed for hundreds of years by Japanese customs. His concern was to alleviate cultural impositions for his Western audience, and he emphasized the capacity of the human mind to attain enlightenment. His own Buddhist name, Daisetz, means "Great Stupidity," implying a mind emptied of precon-ceptions and therefore free to experience life as it is. The radicalism of Zen lies in its insistence on emptying the small egocentric mind of all personal and cultural descriptions. This peeling off of layers, this letting go of prefabricated images, concepts, and ideas of "self" is a process of uncovering another sense of being—or Buddha nature or Mind—which is already there, intact, alive, waiting to see the light of day. It is a state of being that is inherently interdependent with the whole universe. This understanding of reality is the primary tenet of Buddhism and the one most obviously in alignment with contemporary science, specifically with quantum mechanics. In Buddhist teachings, the experience of separation, of a distinct I and you, subject and object, reflects a fundamental misunderstanding of reality, for it accounts for one aspect only, what Buddhists call the relative, but not for the absolute. The process of realization is one of gaining awareness of what already exists.

A tradition that called for experience, experimentation, and self-reliance appealed enormously to Suzuki's American followers, especially those who refused to have their spiritual impulses mediated by mouthpieces of religious dogma. For his readers, Suzuki was the arch philosopher of Zen; for those who knew him, his presence authenticated his message. Embodying Zen in the manner of masters, he eliminated the gap between preaching and practicing, and the common failure to achieve this among clergy or intellectuals in the West made his presence seem all the more remarkable. Suzuki attracted some of the most creative thinkers of this century, including Erich Fromm, Karen Horney, Aldous Huxley, C. G. Jung, Ad Reinhardt, and Arnold Toynbee. His influence is also felt in the work of Thomas Merton, the only contemporary Christian monastic to earn the respect of the intellectual avant garde. The Merton-Suzuki correspondence, which began in 1959 and continued throughout the 1960s, was one of ecumeni-cal discussion and mutual education. With the publication of Merton's *Zen and the Birds of Appetite*

(1968), the monk joined Suzuki, Alan Watts, and Jack Kerouac in advancing the popularity of Zen in the United States; in addition, Merton conferred credibility upon Zen for Christian clergy.

At Columbia, John Cage was among those who attended Suzuki's weekly lectures. According to Robert Coe, Suzuki's first class concerned Buddha's final teachings, "emphasizing the interdependence of all things in a world of phenomenal abundance. This was the world and sensibility that Cage embraced in all his subsequent writings and works, doing . . . much to introduce a deliberately Buddhist view into the cultural discourse of the West."[2] Cage aimed to eliminate the experience of separation between art and artist in his work, between sound and listener, observer and the observed. The twentieth century's investment in the tradition of artist as master, high priest, or lofty producer of an aesthetic event gave way in Cage to the dissolution of a crystallized self into the myriad components of his context. In his famous three-part composition *4' 33"* (1952), for instance—in which the pianist never touches a key— Cage asked that we listen to what *is*, requiring his (confounded and often angry) audience to let go of all expectations and preconceptions about "music," about a "concert," and actively to participate in the sounds of silence. His influence on all forms of inter-active and spontaneous theater and art is still felt today.

Cage talked openly about his engagement with Zen; he always acknowledged Suzuki as his teacher, and the intent and singularity of his work reveals the Zen connection quite clearly. With other artists involved with Suzuki, such as Ad Reinhardt, or with Agnes Martin who speaks of drawing "daily sustenance" from Taoism,[3] the dynamic between Asian philosophies and their work remains more speculative. Unschooled inclinations toward a contemplative sensibility attracted many Euro-Americans to Eastern thought, especially since, with the exception of Native Americans and Quakers, they found little support for those qualities within their own society. Art itself had become increasingly loud, startling, flamboyant, signature-oriented, and—with the advent of Pop—was soon to be co-opted by the cult of personality which had previously been the domain of Hollywood stars. Certainly one did not have to be in contact with Asia to embrace silence or to produce art in which personality was not the feature attraction, yet there are affinities between the way Asian philosophies view reality and how that reality is expressed in the work of Reinhardt, Martin, several of the color field painters, Mark Rothko, Robert Ryman, and so many others. Paramount to both Reinhardt and Martin, for example, is the utter absence of glitz, of stridency or aggression; nothing cries out for recognition. Rather, their work is an invitation to enter a contemplative space, a space that requires the mind to slow down, dispense with commentary, and take on a posture of receptivity—in other words to assume the attitude of an acolyte.

The 1950s yielded books about Zen; it inspired conversation, dialogue, art. But those wishing to practice had to travel to the East.[4] The next decade witnessed the formation of Zen practice centers in the United States under the aegis of Asian masters. By the end of the 1970s, those teachers had formally transmitted Buddhist teachings to their American heirs. Today, there are Zen practice centers in every state, and while Japanese Zen was the first Buddhist tradition to take root here, it has now been joined by Buddhist traditions from every country in the East.

Suzuki, Kerouac, and Watts captivated audiences with the possibility of spontaneous liberation, but said little about the work that generates and grounds this experience. The subsequent development of American Zen centers, with their focus on formal posture and silent meditation, gave rise to an attitude among some students that all the discussion that had preceded "real" practice was not Zen at all. For some twenty years, through the 1970s and 1980s, Suzuki's books were derided for their lack of methodology, Kerouac was dimly recalled as verbose and dissolute, and Watts was characterized as something of an alcoholic windbag who played at being the Zen avatar of Mill Valley. Yet it was precisely their liberal, visionary commitment that eased Zen into the intellectual life of the West and inspired the formal training that followed. The recent reassessment of these pioneers affirms their unequivocal place in the history of Western Buddhism, and while there remains a world of difference between reading about Zen and engaging in practice, the wide-eyed zeal and countercultural optimism that spurred the Zen boom of the 1960s has given way to more sober and generous considerations among practitioners themselves. The definitions of "real" practice, once spouted with adolescent abandon, have expanded into a more seasoned acceptance of how difficult and personal the practice always is. Cultivating spiritual awakening in a land addicted to power and materialism requires above all a radical receptivity—to art, music, or to books that may inspire formal practice. It requires minds that are still and centered—which is subversive in our culture—minds stripped clean, light and white like an empty canvas.

95

1. Many of these investigations are documented in Roger Lipsey, *An Art of Our Own: The Spiritual in Twentieth-Century Art* (Boston: Shambhala Publications, 1988).

2. Robert Coe, "Taking Chances: A Conversation between Laurie Anderson and John Cage," *Tricycle: The Buddhist Review* 1:4 (Summer 1992): 53.

3. Barbara Haskell, "Agnes Martin: The Awareness of Perfection," in Barbara Haskell, ed., *Agnes Martin* (New York: Whitney Museum of American Art, 1992), 95.

4. Students of the lay Zen teacher Nyogen Senzaki (1876–1958) in Los Angeles were the exception.

I have been talking directly to artists but it applies to all. Take advantage of the awareness of perfection in your mind. See perfection in every thing around you. See if you can discover your true feelings when listening to music. Make happiness your goal. The way to discover the truth about this life is to discover yourself. Say to yourself: "What do I like and what do I want." Find out exactly what you want in life. Ask your mind for inspiration about everything.

—Agnes Martin[1]

Agnes Martin made a personal journey from farm to city to high mesa (Saskatchewan to New York to Taos) which, in many ways, replicates the journeys of saints or ascetics. She began in a rural environment, entered the urban, and returned to a rural but different place, close to the desert. Moving to the sacred region (certainly for many Native Americans, but also for modernists like Georgia O'Keeffe and D. H. Lawrence) of New Mexico twice, she came back to New York after the first time to establish her career, but needed the solitude she could create in the Southwest to maintain her practice as an artist. Her pictures may contain no religious subject matter, but they always retain a sense of contemplative engagement with the world.

Much has been made of Martin's other-worldliness, her removal from social norms and the similarities between this and religious asceticism. In denying that she is religious she suggests instead that she has followed a course of solitary thinking in order to find her own voice, much in the manner of mystics. And although she would deny any religious content or intention in either the journey or the work, the course she chose can be related to Zen practice and its modes of meditation and action. Martin had been in touch with Zen through her friendships with Ad Reinhardt and Ellsworth Kelly, among others, when she lived in Coenties Slip in Manhattan in the 1950s. She had heard of D. T. Suzuki and used, both at this period and later, Lao Tzu's *Tao Te Ching* and other writings. Martin in effect established a Buddhist view modulated by her response to the environment in which she found herself. Hers might be described as a Buddhism tempered by a puritan work ethic and reverence for nature.

Martin recognizes that perfection or Buddhahood is unattainable, but her work suggests an approach toward this state.[2] Characteristically for each painting, she creates rectangular forms within a square format: "When I cover the square surface with rectangles," she explains, "it lightens the weight of the square, destroys its power."[3] Her works are simply made and reflect her growing self-confidence and awareness. Compare, for example, the repeated single strokes of gold leaf in *Grey Stone II* (1961, cat. no. 36) with the floating colored acrylic washes of *Untitled No. 3* (1974, cat. no. 41). The former was produced during

1. Agnes Martin, "Beauty Is the Mystery of Life" (1989), in Barbara Haskell, ed., *Agnes Martin* (New York: Whitney Museum of American Art, 1992), 10–12. See cat. no. 42.

2. Martin's writings about perfection evoke the words of Shosan Suzuki: "Attainment of Buddhahood properly means to 'become empty.' It means that you return to the primordial state (of nondifferentiation) in which there is not a speck of 'I,' 'the other,' the Truth, and the Buddha. It means that you thrust away everything, wash your hands of everything, and produce for yourself an infinite space of freedom. This cannot be actualized as long as there remains in your mind anything at all, even the thought of enlightenment," quoted in Toshihiko Izutsu, "Meditation and Intellection in Japanese Zen Buddhism," in *Contemplation and Action in World Religions*, ed. Yusuf Ibish and Ileana Marculescu (Houston: Rothko Chapel, 1978), 54–55.

3. Agnes Martin, "Answer to An Inquiry" (1967), in Dieter Schwarz, ed., *Agnes Martin: Writings/Schriften* (Winterthur, Switz.: Kunstmuseum Winterthur, 1992), 29.

AGNES MARTIN WAS BORN IN 1912 IN NORTHERN
Saskatchewan, Canada, where her parents home-
steaded a wheat farm. She moved to Bellingham,
Washington, in 1931 and studied art and
education at Western Washington College of
Education, receiving her teaching certificate
in 1937. In 1941, she enrolled in the Teachers
College at Columbia University, New York,
received her B.S. in 1942 and, after painting inde-
pendently and teaching art, her M.A. in 1952.
During these years, Martin lived, painted, and
taught art in New York and throughout
the Southwest. In 1957, with the support of Betty
Parsons, the art dealer of Mark Rothko, Barnett
Newman, and Ad Reinhardt, Martin
moved to Coenties Slip, a downtown New York
warehouse district then home to many artists,
including Robert Indiana, Ellsworth Kelly, James
Rosenquist, and Jack Youngerman.

Martin's early paintings, most of which she
destroyed, consisted mainly of landscapes and
biomorphic shapes floating against single-
colored backgrounds. Between 1957 and 1963, she
developed the style associated with her mature
work. At first she made constructions of objects
she would find on the street, attaching bolts
and nails to boards in strict geometric patterns.
She then began working with grids and
rectangles, lines, and points, drawn with pencil
on canvas. In 1967, Martin stopped painting,
traveled around Canada and the West, and
settled in New Mexico. She returned to painting
in 1974, again using the grid format, but
applying broad bands of translucent color over
pencil. Martin currently lives in Taos.

Further reading

Ashton, Dore. *Agnes Martin: Paintings
and Drawings 1957–1975.* Exh. cat. London: Arts
Council of Great Britain, 1977.

Glimcher, Mildred. *Indiana, Kelly, Martin,
Rosenquist, Youngerman at Coentis Slip.* Exh. cat.
New York: Pace Gallery, 1993.

Haskell, Barbara, ed. *Agnes Martin.* Exh. cat.
New York: Whitney Museum of American Art,
1992 [text by Anna C. Chave, Barbara
Haskell, Rosalind Krauss, and Agnes Martin,
extensive bibliography, exhibition history].

Schwarz, Dieter, ed. *Agnes Martin:
Writings/Schriften.* Exh. cat. Winterthur, Switz.:
Kunstmuseum, 1992.

Martin's first escape to New Mexico and can be read as the controlled searching
for an individual voice through reiteration of a single action (similar to a
single word repeated or chanted, creating a sense of stability in the interstices of
the sound). *Untitled No. 3*, on the other hand, demonstrates the achieved
serenity of the artist whose training has been completed and who is able with
fewer actions to express a sublime moment of joy. "That which takes us by
surprise," Martin asserts, "moments of happiness—that is inspiration," which
she also calls "moments of perfection."[4]

4. Martin, "Lecture at Cornell University"
 (1972), in *Writings/Schriften*,
 61, and "Reflections" (1972), ibid., 31.

Agnes Martin, *Beauty Is the Mystery of Life*, 1989,
Agnes Martin, cat. no. 42.

Agnes Martin, *Grey Stone II*, 1961, Emily Fisher
Landau, New York, cat. no. 39.

Agnes Martin, *The Beach*, 1964, Lannan Foundation, Los Angeles, cat. no. 37.

Agnes Martin, *The Tree*, 1964, The Museum of
Modern Art, New York, Larry Aldrich Foundation
Fund, 1965, cat. no. 38.

Agnes Martin, *Leaf*, 1965, Mr. and Mrs. Daniel W. Dietrich II, cat. no. 39.

102

Agnes Martin, *Hill*, 1967, Mr. and Mrs. Daniel W.
Dietrich II, cat. no. 40.

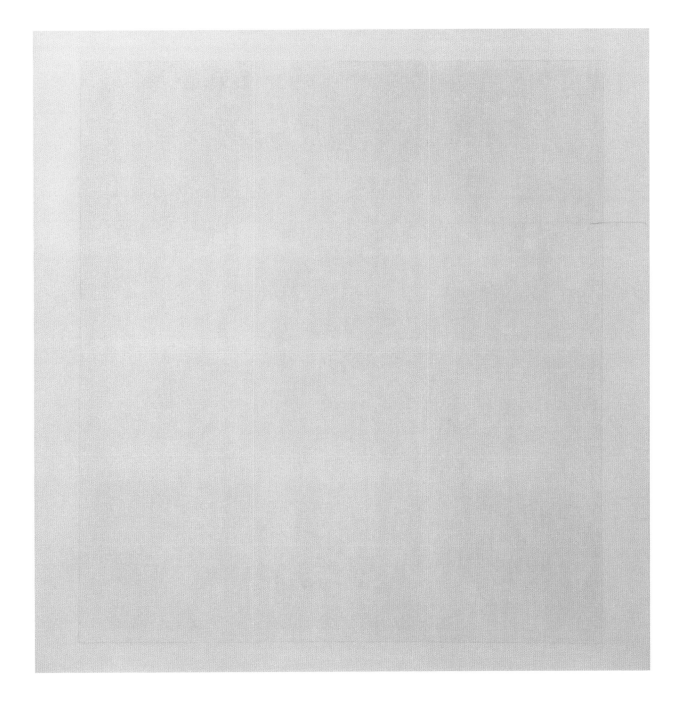

Agnes Martin, *Untitled No. 3*, 1974, Des Moines Art
Center, Iowa, Purchased with funds from the
Coffin Fine Arts Trust, Partial gift of Arnold and
Mildred Glimcher, Nathan Emory Coffin Collection
of the Des Moines Art Center, cat. no. 41.

My eyes longing for beautiful things together with my soul longing for salvation have no other power to ascend to heaven than the contemplation of beautiful things.

—Michelangelo Buonarroti[1]

Giulio Clovio's sixteenth-century *Rape of Ganymede* (cat. no. 12) is one of many copies of a drawing by Michelangelo Buonarroti. Michelangelo made the original as part of a group of drawings with mythological subjects that he presented to his cherished friend Tommaso de' Cavalieri in 1532. In Greek mythology, Ganymede was a beautiful young shepherd abducted by Zeus in the guise of an eagle. In his choice of subject, Michelangelo used the iconography of Greek myth and the philosophical ideas of the classical period in a new Renaissance interpretation favored by the Florentine Neoplatonists— who believed that the way to enlightenment was through the love of beauty.[2] *The Rape of Ganymede* relates to the theme of the exhibition and especially to the works of Francis Bacon, who spoke of the aesthetic and erotic inspiration he derived from studying Michelangelo's drawings:

> And I've always thought about Michelangelo; he's always been deeply important in my way of thinking about form. . . . [T]he work I like most of all is the drawings. . . . Actually, Michelangelo and [Eadweard] Muybridge are mixed up in my mind together, and so I perhaps could learn about positions from Muybridge [who conducted photographic motion studies of animals and humans] and learn about the ampleness, the grandeur of form from Michelangelo. . . . But, of course, as most of my figures are taken from the male nude, I am sure that I have been influenced by the fact that Michelangelo made the most voluptuous male nudes in the plastic arts.[3]

Michelangelo used the Ganymede story to represent what Charles de Tolnay described as "the ascension of the soul in the mystic union of love," or, in the artist's own words, "A single soul in two bodies becom[ing] eternal, Both rising to heaven on the same wings."[4] This drawing suggests a combination of physical and emotional rapture, which Bacon represents through his integration of classical art and a post-Freudian perspective. The experience of Agnes Martin, in her writings and paintings, consists in reaching, through emptiness, another state; one reading of the Ganymede story is as a release from the world to this higher plane.

1. Michelangelo Buonarroti, quoted in Robert J. Clements, *Michelangelo's Theory of Art* (New York: New York University Press, 1961), 9.

2. James M. Saslow, "Michelangelo: Myth as Personal Imagery," *Ganymede in the Renaissance: Homosexuality in Art and Society* (New Haven: Yale University Press, 1986), 17–62. See also Leonard Barkan, *Transuming Passion: Ganymede and the Erotics of Humanism* (Stanford, Calif.: Stanford University Press, 1991) and Michael Preston Worley, "The Image of Ganymede in France, 1730–1820: The Survival of a Homoerotic Myth," *Art Bulletin* 76:4 (December 1994): 630–43.

3. Francis Bacon, quoted in David Sylvester, *Interviews with Francis Bacon, 1962–1979*, rev. ed. (London: Thames and Hudson, 1980), 114.

4. Charles de Tolnay, *The Art and Thought of Michelangelo* (New York: Pantheon Books, 1964), 104–5.

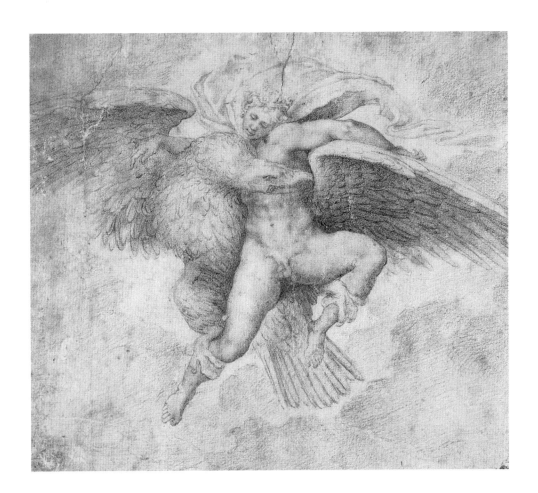

Giorgio Giulio, called Giulio Clovio, *The Rape of Ganymede*, after Michelangelo, after 1532, The Duke of Devonshire and the Chatsworth Settlement Trustees, Derbyshire, England, cat. no. 12.

Study for Saint Helena (c. 1842, cat. no. 28) is one of several studies prepared by Jean-Auguste-Dominique Ingres for a series of saints depicted in stained-glass windows commissioned for a chapel near Paris. The windows commemorated the death in a tragic accident of the Duke of Orleans, whose wife's patron saint was Helena. Saint Helena, the mother of the fourth-century Roman Emperor Constantine, became a Christian after her son, assured by a vision of Christ that the image of a cross would aid him in battle, easily defeated his enemy. Helena made a pilgrimage to Jerusalem, where she is reputed to have supervised the archaeology of Calvary, the site of Christ's crucifixion. She discovered three crosses, and proved the true cross by placing a dying man on each in turn until he was revived by the miracle. She also found nails "shining as gold" and these became her son's emblem. Helena is usually depicted crowned carrying or standing with the cross and nails and often with a representation of the sepulcher.

Francis Bacon enjoyed Ingres's sophistication, the quality of decadence and the distortions that enabled the artist to describe the character of his protagonists. Bacon copied Ingres on several occasions, remaking and recasting compositions with a brutality missing in Ingres. Andrew Forge notes that the terms of Bacon's discussion are dialectical, working through oppositions and "friction" to locate something much stronger and more resolute.[1] Bacon effects an extreme and highly charged distortion, which constructs rapture as a sexually and emotionally convoluted event.

1. Andrew Forge, "About Bacon," in Dawn Ades
 and Andrew Forge, *Francis Bacon* (London:
 Tate Gallery, 1985), 25.

Jean-Auguste-Dominique Ingres, *Study for Saint Helena*, c. 1842, The Art Institute of Chicago, Gift of Robert Allerton, cat. no. 28.

Men have gained control over the forces of nature to such an extent that with their help they would have no difficulty in exterminating one another to the last man. They know this, and hence comes a large part of their current unrest, their unhappiness and their mood of anxiety. And now it is to be expected that the other of the two "Heavenly Powers," eternal Eros, will make an effort to assert himself in the struggle with his equally immortal adversary.

—Sigmund Freud[1]

Francis Bacon maintained a lifelong distrust of dogma and an antagonism toward societal repression. His sexuality, which caused him to leave home at sixteen (his father found him wearing his mother's clothes) became a source of strength in his opposition to convention. In his painting, Bacon used this opposition to create an excitement that absorbs, subverts, and overwhelms the original subject. He invested a subject such as the Crucifixion, for instance, with a perverse delight, constructing it as a taboo icon, comparing the crucified Christ in a Cimabue panel to "a worm crawling down the cross," and deliberately inverting the image in reproduction to demonstrate his point.[2] He claimed the source of his many depictions of homosexual intercourse lay in an Eadweard Muybridge photosequence of wrestlers in *The Human Figure in Motion* (1887). In discussing such images, however, Bacon elided any actual religious or sexual excitement revealed in his painted forms; his words obscure his transgressive content or retain it in polite demeanor. It is as if for Bacon honest description comes in the physical act of painting rather than in its apology.

Although his works in this exhibition (cat. nos. 2–4) span more than thirty years, the strategies informing them are consistent and result from Bacon's working practice. His six hours in the studio each day enabled him to work through material he gathered in his daydreams: he talked of images dropping like slides into his mind and of the process of capturing them in paint on canvas. Always, he made it clear that he wanted to renew the experience, the complex of emotions that he converted in the daydreaming. These experiences were personal, but his need to make them universal was satisfied by referring to great works of literature (notably by Aeschylus, Shakespeare, Proust, and Freud) and by adopting symbols from other paintings and visual culture, such as medical textbooks.

In *Studies from the Human Body* (1970, cat. no. 3), Bacon has combined the religious format of the triptych with the subject of sexual intercourse and desire, as if the conjunction of sacred and taboo would increase the energy of both. "I knew I wanted to put two figures together on a bed," he explained, "and I knew that I wanted them in a sense either to be copulating or buggering . . . but I didn't know how to do it so that it would have the strength of the sensation which I had about it."[3] He spoke of the difficulty of working in this "void" of attempted representation with habitual irrational marks. "One of the things I've always tried to analyze is why it is that, if the formation of the image that you want is done irrationally, it seems to come onto the nervous system much more strongly than if you knew how you could do it."[4] Bacon's irrational marks become most explicit in the turning figures in the flanking panels.

1. Sigmund Freud, *Civilization and Its Discontents* (1930), *The Standard Edition of the Complete Psychological Works of Sigmund Freud*, vol. 21, trans. James Strachey (London: Hogarth Press and the Institute of Psychoanalysis, 1961), 145.

2. Francis Bacon, quoted in David Sylvester, *Interviews with Francis Bacon, 1962–1979*, rev. ed. (London: Thames and Hudson, 1980), 13.

3. Ibid., 102.

4. Ibid., 103.

FRANCIS BACON (1909–1992) WAS BORN INTO
an English family living in Dublin and moved
frequently between Ireland and England
throughout his youth. He settled in London on
his own in 1925, and began a career as an
interior designer, creating designs for rugs and
furniture, but abandoned this occupation for
painting in 1931. Sometime in the early 1940s,
Bacon destroyed nearly all his works and
stopped painting on a regular basis. He began to
paint again in 1944 or 1945, concentrating
on the theme of a crucifixion, a subject he had
depicted in 1933 and would return to through-
out his career. In 1951, he completed his
first series of paintings of popes, inspired by
the *Portrait of Pope Innocent X* (1650) by Diego
Velázquez. From 1964 to the mid-1970s, many
of Bacon's paintings depicted his lover,
George Dyer, and recorded the artist's responses
to this relationship and finally to Dyer's death
in 1971. In these paintings, Bacon forced
together religious imagery, particularly images
associated with Catholicism, and references to his
own sexuality. Until his death of heart failure
in Madrid, Bacon lived and painted in London.

Further reading

Ades, Dawn, and Andrew Forge. *Francis Bacon*.
Exh. cat. London: Tate Gallery, 1985 [extensive
bibliography].

Davies, Hugh, and Sally Yard. *Bacon*. New
York: Abbeville, 1986 [extensive bibliography,
chronology, and list of exhibitions].

Russell, John. *Francis Bacon*. Rev. ed. London:
Thames and Hudson, 1993.

Sylvester, David. *Interviews with Francis Bacon,
1962–1979*. Rev. ed. London: Thames and
Hudson, 1980.

On the left, the figure is ascending, on the right descending. In the left panel,
the artist himself appears, turning in the doorway as a voyeur, and his lover,
George Dyer, is depicted in the right. In *Study for a Portrait* (1949, cat. no. 2),
the most telling part of the picture is the blue shadowed image in the fore-
ground. We can read the complex connections among sexual desire, the glitter-
ing mouth, the concentration on the figure in the box, and the potential
portrait of a friend, but the shadow only becomes decipherable with reference to
the rest of Bacon's work: the blue shape relates to Aeschylus's Furies in Greek
tragedy, with all their hideous and vengeful overtones.

Mining his own daydreams for material, Bacon reminds us of Freud's
description of the creative process: the writer (and artist) conceals his fantasies
because they would repel us, but in transforming them into art he softens
the dreams and "bribes us by the purely formal—that is, aesthetic—yield of
pleasure." Freud goes on to suggest that this "fore-pleasure" "proceeds from
a liberation of tensions in our minds. . . . due to the writer's enabling us
thenceforward to enjoy our own daydreams without self-reproach or shame."[5]
For Bacon, who shares with Freud a distrust of religion and any form of
worship, the consistent determinant is the imagining, depiction, and transfor-
mation of the erotic. Bacon's formalism, what he referred to as his conser-
vatism, implicates the erotic in the manner of religious practice—that is, as a
kind of ritual that deals with the universal in controlled formal symbols.

5. Sigmund Freud, "Creative Writers and
Day-Dreaming" (1908), *Standard Edition*, vol.
9, 153.

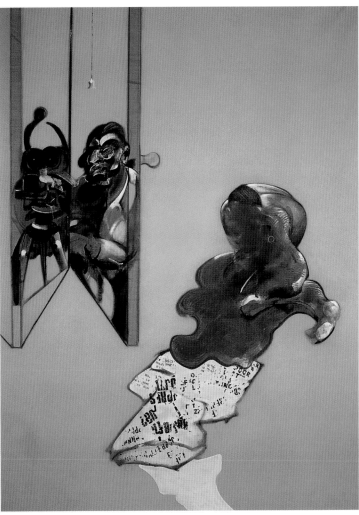

III

Francis Bacon, *Studies from the Human Body*, 1970,
private collection, cat. no. 3.

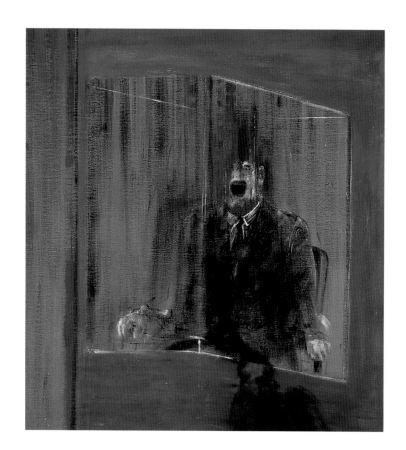

Francis Bacon, *Study for a Portrait*, 1949, Museum of
Contemporary Art, Chicago, Gift of Jory and Joseph
Shapiro, cat. no. 2.

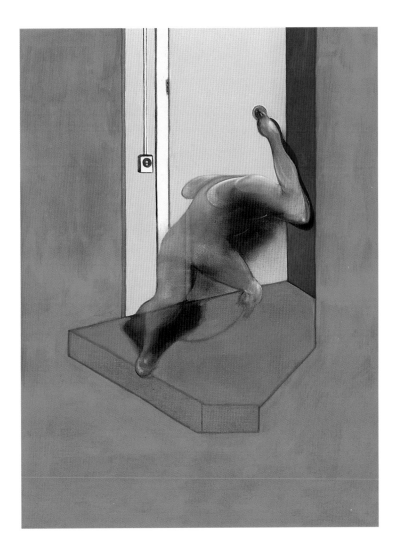

Francis Bacon, *Study from the Human Body*, 1983,
The Menil Collection, Houston, cat. no. 4.

Archangellis, angellis, and dompnationis,
Tronis, protestis, and marteiris seir,
And all ye hevinly operationis,
Ster, planeit, firmament, and speir,
Fyre, erd, air, and water cleir,
To him gife loving, most and lest,
That come in to so meik maneir . . .

—William Dunbar[1]

Paul Klee created *Angelus Novus* (1920, cat. no. 34) during a two-year period in which his work included several representations of airplane and angel flights and crashes; in his career, Klee would paint the image of the angel repeatedly.[2] *Submersion and Separation* from 1923 (cat. no. 35) takes up the theme of loss, but translates it into the more familiar motif of arrows. The former drawing, especially when considered along with what is accepted as its pendant, *Airplane Crash* (1920), relates to the theme of *Negotiating Rapture*, in particular to the works of Anselm Kiefer and Joseph Beuys (see cat. nos. 30–33 and 5–8). Each of these artists uses mythology and allegory to work through his own relationship to twentieth-century history, marred by war, in pictures or objects that concern personal or national memory. Klee, according to his diary, viewed *Angelus Novus* as emerging from a "rubble," which could be understood as the destruction of World War I.[3] Kiefer also uses images of angels, airplanes, and flight (see *Icarus–March Sand*, illus. p. 46), and other motifs to evoke aspects of German history, especially World War II, while the objects of Beuys's vitrines often pertain to the 1943 crash of his German air force plane. Walter Benjamin, who acquired *Angelus Novus* in 1921, wrote about the drawing several times, continuing Klee's association of the image to history:

> A Klee painting named *Angelus Novus* shows an angel looking as though he is about to move away from something he is fixedly contemplating. His eyes are staring, his mouth is open, his wings are spread. This is how one pictures the angel of history. His face is turned toward the past. Where we perceive a chain of events, he sees one single catastrophe which keeps piling wreckage upon wreckage and hurls it in front of his feet. The angel would like to stay, awaken the dead, and make whole what has been smashed. But a storm is blowing from Paradise; it has got caught in his wings with such violence that the angel can no longer close them. The storm irresistibly propels him into the future to which his back is turned, while the pile of debris before him grows skyward. This storm is what we call progress.[4]

Upon his death in 1940, Benjamin willed the drawing to his friend Gershom Scholem, philosopher and scholar of Jewish mysticism. *Angelus Novus* introduces to the exhibition the philosophies of the Kabbalah and sefirotic diagrams (see cat. no. 66), in which vehicles of movement are important symbols. Benjamin's short story "Agesilaus Santander" (second version, written in Ibiza, in August 1933) explicitly links the image to the Kabbalah. The story concerns a Jew who was given a secret name to protect his identity, in the tradition of assigning a child a Hebrew name, which is only later disclosed at his bar

1. William Dunbar, "Of the Nativity of Christ," in W. H. Auden, *A Certain World: A Commonplace Book* (London: Faber and Faber, 1970), 75.

2. See O. K. Werckmeister, *The Making of Paul Klee's Career, 1914–1920* (Chicago: University of Chicago Press, 1989) 237–42, and idem, "Walter Benjamin's Angel of History, or the Transfiguration of the Revolutionary into the Historian," *Critical Inquiry* 22:2 (Winter 1996): 239–67.

3. Werckmeister, *Paul Klee's Career*, 144–45.

4. Walter Benjamin, "Theses on the Philosophy of History," *Illuminations: Essays and Reflections*, ed. Hannah Arendt, trans. Harry Zohn (New York: Schocken Books, 1969), 257–58.

mitzvah. Benjamin writes of this sudden revelation of the name upon reaching maturity and says "it joins the life force in strictest union," continuing:

> In the room I occupied in Berlin the latter [i.e., the writer's secretly named self], before he stepped out of my name, armored and encased, into the light, put up his picture on the wall: New Angel. The Kabbalah relates that in every instant God creates an immense number of new angels, all of whom only have the purpose, before they dissolve into naught, of singing the praise of God before his throne for a moment. The new angel passed himself off as one of these before he was prepared to name himself. I only fear that I took him away from his hymn unduly long. As for the rest he made me pay for that. For in taking advantage of the circumstance that I came into the world under the sign of Saturn—the star of the slowest revolution, the planet of detours and delays—he sent his feminine form after the masculine one reproduced in the picture by way of the longest, most fatal detour, even though both happened to be—only they did not know each other— most intimately adjacent to each other.[5]

5. Walter Benjamin, quoted in Gershom Scholem, "Walter Benjamin and His Angel," *On Walter Benjamin: Critical Essays and Recollections*, ed. Gary Smith (Cambridge, Mass.: MIT Press, 1988), 58–59.

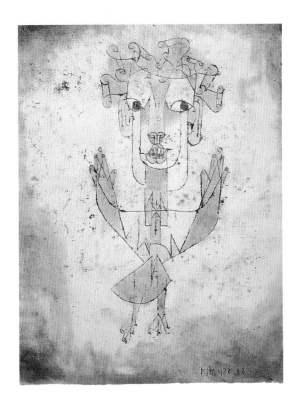

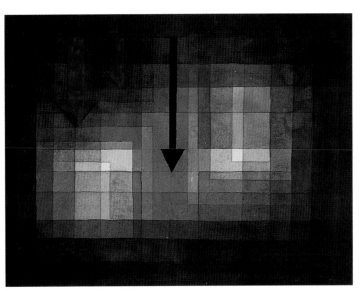

Paul Klee, *New Angel (Angelus Novus)*, 1920, The Israel Museum, Jerusalem, Gift of Fania and Gershom Scholem, John and Paul Herring, Jo-Carole and Ronald Lauder, cat. no. 34.

Paul Klee, *Submersion and Separation (Senkung und Scheidung)*, 1923, The Arts Club of Chicago, Arthur Heun Bequest, cat. no. 35.

nuit / *night*

Any state which provokes in the subject the metaphor of the darkness, whether affective, intellective, or existential, in which he struggles or subsides. . . . I experience alternately two nights, one good, the other bad. To express this, I borrow a mystical distinction: estar a oscuras *(to be in the dark) can occur without there being any blame to attach, since I am deprived of the light of causes and effects;* estar en tinieblas *(to be in the shadows:* tenebrae*) happens to me when I am blinded by attachment to things and the disorder which emanates from that condition.*

—Roland Barthes[1]

In Albrecht Dürer's enigmatic engraving *Melancholia I* (1514, cat. no. 15), an artist perhaps for the first time created an image full of arcane and scholarly symbols that also described a psychological and philosophical state. The significance of this representation in Northern Renaissance art helped to establish a new humanist concept of the personality. In the Middle Ages, persons of the melancholic temperament, one of the four humors, were thought to be anti-social, lazy, cowardly, disloyal, prone to studiousness and even insanity. Medieval pictures of the melancholic also portrayed him as avaricious and power-hungry, hence both money and keys are still attributes of the figure in Dürer's print. By the sixteenth century, however, this temperamental type, always under the influence of Saturn, underwent a transformation. Following the Florentine Neoplatonist Marsilio Ficino, the melancholic became associated with divine frenzy, elevated thought—Saturn was the "highest" of the planets—and artistic inspiration. "But those who escape the baneful influence of Saturn, and enjoy his benevolent influence," Ficino wrote, ". . . . give themselves over with heart and soul to divine contemplation, which gains distinction from the example of Saturn himself. Instead of earthly life, from which he is himself cut off, Saturn confers heavenly and eternal life on you."[2] Thus Dürer depicts Melancholy as an angel in contemplation, her face shaded by her clenched fist, surrounded by the symbols of her philosophical predicament. The figure's dark face, the dog, comet, and bat whose spread wings form a cartouche for the title of the engraving, all refer to the saturnine type. But Jupiter's counteracting, healing presence is also felt, in the talisman of the sixteen-sided *mensula jovis* or "Jupiter table" on the wall above the angel. Dürer's portrait extends the medieval tradition with the inclusion of the symbols of geometry (compass, sphere, polyhedron), tools of the carpenter, and magic square of the mathematician, which emphasize the significance of the mental construct.

The contrast between the dejected angel, lost in thought, and the busy child or cherub, seated on a millstone and absorbed in his drawing, captures the duality of abstract thinking and practical skill that informs artistic creativity. Mired in reflection, the figure of Melancholy is unable to act, trapped like Hamlet in an intellectually induced paralysis. Dürer identified with the melancholic type, and there is a subjective aspect to this image of frustration. In an incisive interpretation of his iconography, Erwin Panofsky and Fritz Saxl wrote: "If Dürer was the first to raise the allegorical figure of Melancholy to the plane of a symbol, this change appears now as the means—or perhaps the result—of a change in significance: the notion of a 'Melancholia' in whose nature the intellectual distinction of a liberal art was combined with a human soul's capacity for suffering could only take the form of a winged genius."[3]

1. Roland Barthes, "And the night illuminated the night," *A Lover's Discourse*, trans. Richard Howard (New York: Hill and Wang, 1978), 171.

2. Marsilio Ficino, quoted in Raymond Klibansky, Erwin Panofsky, and Fritz Saxl, *Saturn and Melancholy: Studies in the History of Natural Philosophy, Religion, and Art* (New York: Basic Books, Inc., 1964), 272–73.

3. Ibid., 318.

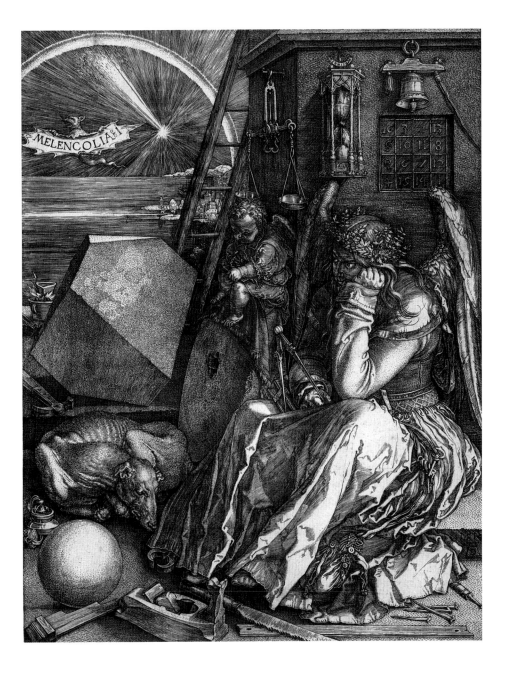

Albrecht Dürer, *Melancholy I (Melancholia I)*, 1514,
The Art Institute of Chicago, The Potter Palmer
Collection, cat. no. 15.

His head passed down a sky (as suns the
circle of a year).
His other shoulder, open side and thigh
maintained,
by law of conservation of
the graveness of his center,
their clockwise fall.
Then he knew, so came to apogee
and earned and wore himself as amulet.

—Charles Olson[1]

Kabbalistic diagrams vary considerably, from simple circular outlines of the ten divine manifestations, or Sefiroth, and their individual names to elaborate systems with additional attributes. Each Sefirah, as John Hallmark Neff explains, is said to contain its own sefirotic tree, each of which in turn contains *its* own, and so forth.[2] Hence we find specialized diagrams for angels, demons, the kings of Israel, the names of God, and syncretic hybrids with the corresponding signs from alchemy and the zodiac. For once understood, the concept of the Sefiroth can be adapted to most any situation to clarify complex interrelationships and extended to ever-lower levels of creation, each reflecting the divine plan. (One contemporary tree charts the research and development process of a new car, not unlike, Neff has noticed, the quality management diagrams of the late mathematician/consultant W. Edwards Deming.)[3] This nineteenth-century diagram (cat. no. 66), composed, it is believed, in North Africa, presents a complex arrangement of the levels of the sefirotic tree and multiple annotations.

The names of the ten Sefiroth and their divine attributes may vary; all have gendered principles associated with them, as well as various color codes. The following scheme is generally accepted, in descending order and right to left on the sefirotic tree: 1) *Kether*, "crown," is that aspect of the Infinite that turns toward manifestation. Also known as *Razon*, "the will," or *Ayin*, it has no "thingness," but is the source of all emanations. 2) *Hokhmah*, "wisdom," is the primordial point of light from which the divine light actually flows. It is also called "beginning" because *Kether* is eternal. 3) *Binah*, "understanding," also known as "palace" and "womb," is the female principle to *Hokhmah*'s male principle. 4) *Hesed*, "love," or *Gedullah,* "greatness," symbolizes the right arm of Adam Kadmon (the primordial man) and Abraham of the Patriarchs. Its attribute is grace, its color white. 5) *Gevurah*, "power," or *Din*, "judgment," stands for rigor, red, left arm, Isaac, north. 6) *Tifereth*, "beauty," or *Rahamim*, "compassion," is located on the center column and has multiple attributes, for it functions simultaneously on right and left: blessed holy one, heaven, sun, harmony, king, green, purple, Jacob, Moses, east. 7) *Netsah*, "endurance," is associated with prophecy, right leg, Moses; 8) *Hod*, "majesty," also with prophecy, left leg, and Aaron. 9) *Yesod*, "foundation," or *Zaddik,* "righteous one," stands for covenant, phallus, Joseph, south. 10) *Shekhinah*, "presence," or *Malkhuth*, "kingdom," symbolizes King David and the Communion of Israel; its attributes are Earth, moon, justice, queen, blue, black, apple orchard, west. The harmony between *Yesod* and *Shekhinah*, the male and female principles on the lowest level, is essential to continue the flow of energy throughout the Sefiroth. Not surprisingly, this harmony is the focus of much

1. Charles Olson, "The Moebius Strip,"
 Archaeologist of Morning (New York:
 Grossman Publishers, 1973), n.p.

2. We are grateful to our friend and colleague
 John Hallmark Neff for writing this
 entire four-paragraph description of sefirotic

diagrams in addition to his "Notes on
Kabbalistic Ideas and Imagery" for *Negotiating
Rapture.*

3. The tree is illustrated in Z'ev ben Shimon
 Halevi, *Kabbalah, Tradition of Hidden
 Knowledge* (London: Thames and Hudson,
 1979), 81, while the comparison with Deming's
 work belongs, again, to John Hallmark Neff.

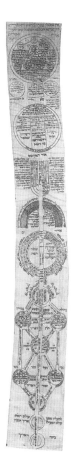

commentary because *Shekhinah*, the Communion of Israel, is the Jewish people, the Bride of God, a conjugal symbol for reunification and the end of exile, *Galuth*.

Within the sefirotic tree itself, there are three additional configurations of particular importance: the four levels, three pillars, and Adam Kadmon, all aspects of the One. The four levels visualize the hieratic division of the sefirotic spheres into triads representing the four levels of knowledge, corresponding respectively to the root, trunk, branches and fruit of the tree: *Atsiluth*, the world of emanation; *Beriah*, the world of creation; *Yetsirah*, the world of formation; and *Asiyah*, the world of action, the level of terrestrial life. Each level also corresponds to one of the four elements and each is characterized by a colored light: in descending order, fire/white light, air/blue, water/purple, earth/red. They are referred to also according to a pun on "Paradise," so that the four Hebrew letters forming PaRDeS—*Peshat*, *Remez*, *Derasha*, and *Sod*—stand respectively for the four ascending layers of meaning: literal, allegorical, talmudic and aggadic, and mystical.

Not all the Sefiroth are accessible. The uppermost level, *Atsiluth*, the closest to *En-Sof* or God "without end," is inaccessible except to prophets; the next, *Beriah*, is attainable only by those of exceptional spirituality, and so forth. Yet because there are aspects of all the Sefiroth in one another, and because *Asiyah* on the terrestrial level of humans contains and reciprocates all those above, the system is accessible, on this first level, to the dedicated. To ascend further requires yet another level of comprehension and good works. The interconnectedness of the Sefiroth may permit the mystic occasional flashes of the upper levels—without comprehension but as an inspiration to persevere. One of many allegorical paradoxes is that the more deeply one probes beneath the "shell," the higher one's spiritual ascent; the more complex the correspondences among supposedly disparate things, the more one affirms the unity of the whole. (The nut—shell, two inner layers, kernel—is another common four-tiered kabbalistic metaphor linguistically tied to atomic physics and evoked in Anselm Kiefer's equations of solar deities, Ragnorak or Twilight of the Gods, nuclear reactors, Chernobyl [see cat. no. 33], and apocalypse).[4]

119

4. See John Hallmark Neff, *Anselm Kiefer, Brüch und Einung* (New York: Marian Goodman Gallery, 1987), especially pp. 57–62.

possibly North African, *Schematic Diagram for an Amulet*, 19th century, Spertus Museum, Chicago, cat. no. 66.

Kabbalah, literally "that which has been received" or "tradition" in Hebrew, refers generally to Jewish mysticism, its literature and practice. But as scholars caution, the kabbalistic tradition is not one but many, forming a sophisticated spiritual discipline based on a complex, often paradoxical mix of rigorous logic and deep belief, with each detail subjected to intense interpretation and debate. From its apparent beginnings as an oral tradition prior to the sixth century c.e., to its flowering in medieval Spain, Provence, and Palestine with kabbalistic texts such as the *Sefer Yesirah*, or Book of Creation, and the Zohar, or Book of Splendor, Kabbalah has ebbed and flowed in influence. The object of aristocratic appreciation during the Renaissance (including a Christian Kabbalah devised to discover prefigurations of the New Testament), the learned or esoteric Kabbalah gave rise to the more accessible and popular white magic of the practical Kabbalah, so that by the sixteenth and seventeenth centuries "Kabbalah" was widely equated with the amulets and spells of superstition. In this guise, it was predictably rejected by the Enlightenment. By the end of the nineteenth century, kabbalistic esoterica featured prominently in Tarot cards, within the Rose-Croix revival in France, and in England in the poet Aleister Crowley's cult of the Golden Dawn. With exceptions, scholarly study of Kabbalah nearly disappeared until the 1920s, when Gershom Scholem (1897–1982) and others, mindful of the surge of charismatic mysticism of Hassidic Judaism in Poland and Central Europe, began to search out and analyze scattered kabbalistic texts in relation to other disciplines. By means of his translations, commentaries, and friendships, Scholem was largely responsible for the Kabbalah entering once again into the wider world of ideas.[1] It was to Scholem's books particularly that many artists referred for an understanding of Kabbalah as an historical and spiritual phenomenon.

John Hallmark Neff

NOTES ON
KABBALISTIC IDEAS
AND IMAGERY

Every religion is mystical to some degree and mysticism— whether Jewish, Islamic, Christian, or otherwise— arises from the individual's desire to commune with God and a belief in the possibility of experiencing union with that divine love or energy that existed before creation, before pure spirit mixed that matter. In rabbinic Judaism, the traditional means to attempt this union entailed a gradual, mediated process: study of the sacred texts, prayer, piety, and good works. For the mystic, however, this road was too narrow and impersonal. Other, suprarational means were required, such as ecstatic contemplation or spiritual intuition, through which one acquired knowledge of the mystery inaccessible to rational understanding alone. In the instant of spiritual breakthrough—a flash of light, a vision or voice—all would be spirit, a single undifferen-tiated whole, and the mystic would be completely enrapt in divine energy. Among the words used to convey this ecstatic transport out of oneself was "rapture."

The details and interpretation of mystical experience varied from one group to another, differing, for instance, on the individual's relation to the divine or the role of evil. Nor was such speculation welcomed by the mystics' more conservative coreligionists. Jewish mystics, however, often saw themselves as traditionalists, endeavoring to renew and strengthen the fundamental tenets of Judaism on the basis of their mystical insights and experience. Indeed, while most Christian mystics were laymen and -women, Kabbalists were orthodox rabbis. And like rabbinic Judaism, Jewish mysticism and Kabbalah were grounded in study of the Torah, the divine Word as revealed to Moses in the first five books of the Bible, as well as the Talmud ("instruction," containing additional civil and canonical law), Midrash (biblical exegesis), Mishnah (summarizing oral law), Gemara (commentaries on the Mishnah), and so on, including Halakha (traditional Jewish law) and Haggadah (parables and free interpretation of the Scriptures). Mysticism's risks, however, restricted permission to study the esoteric tradition to the most advanced students, effectively limiting the learned Kabbalah to an educated religious elite.

Kabbalah's precise origins are unknown. Scholem identifies texts with strong kabbalistic elements from the sixth century c.e. but states that the tradition itself had existed centuries earlier. Although the exact relationship between Jewish mysticism and belief systems such as Gnosticism, Neoplatonism, Sufism, and others is still uncertain, there is no question that each addressed fundamental questions about the mystery of life and the nature of God. All employed similar concepts, imagery, and symbols with syncretic origins in Asian, African, and European thought of late antiquity; Kabbalah shared, for example, the principle of emanations and the four levels of existence with Persian and Indian antecedents. As organized in Renaissance concordances (which related astrological and alchemical lore to Greek, Egyptian, Jewish, Roman, and Christian religion, philosophy, folktales, natural history, and myth), the most disparate phenomena were linked, thereby revealing the unity of being beneath the illusion of appearances and difference. These cosmopolitan treatises served also as veritable catalogues of imagery and metaphor, permitting artists and writers to align or compare their local traditions with classical civilization. To cite one much-studied example, recently reinterpreted by Anselm Kiefer, the planet Saturn (the seventh and slowest of the planets, the most distant and dull) is related to Saturday, the color black, the metal lead, black bile (one of the four humors), melancholic temperament, genius, death, and creativity, in addition to being linked with Osiris, the Egyptian god of the underworld (see cat. no. 31); Lilith, the she-demon of Jewish legend; and, not least, to the third Sefirah, *Binah*, on the sefirotic Tree of Life.[2] In this grand design, everything had its place, the material and visible microcosm understood as the true reflection of the macrocosm, invisible and transcendent.

At the center of this universe, and the key to understanding it, was the Kabbalists' fascination with language and number. According to Genesis, the world was created by God's Word, in tradition by the ten names of God. The twenty-two letters of the Hebrew alphabet, which are also numbers, are thus believed to be the direct revelation of the Divine. Hence the power of and prohibitions governing the divine names and the extraordinary significance attributed to the letters and their respective meanings—meanings derived from the letters' shapes, size, and order. Thus, *Aleph*, the first letter and also the number 1, symbolizes the One, the eternal God, as well as a ladder reaching to heaven; significantly, it is a letter without sound, therefore a symbol of the ineffable, before the Word. (So essential is each Hebrew letter/number combination in deciphering the sacred texts that a copy of the Torah with a single mistake cannot be used.) This intrinsic duality permits limitless interpretive possibilities, and numerous exegetical techniques were devised to mine the text for hidden meanings. *Gematria*, for example, calculated the numerical value of words or phrases in the Torah, then generated parallel, numerically equivalent texts to be plumbed for spiritual meaning obscured by reading the original literally. *Gematria* was a talmudic practice, but Kabbalists went further in applying mystical experience itself to textual interpretation, seeking the spirit and feeling behind the written words, insightful flashes that brought one closer to God.

Specific to Kabbalah is the three-fold conception of the manifestation of the Divine, first as limitation (or contraction, *Tsimtsum*), then destruction (the breaking of the vessels), and finally reparation (restoration or healing, *Tikkun*). These concepts were refined and collected in the writings of Rabbi Isaac Luria (1534–1572) of Safed, a Palestinian center of kabbalistic learning following the Jews' expulsion from Spain in 1492. The Lurianic Kabbalah combined traditional principles of individual salvation and the salvation of the Jewish people in an ingenious way that conceived this process as simultaneously healing the breach between God and all creation. For the Kabbalist, the concept of the transcendent God conflicted with the daily facts of material existence. But where negative theology explained the existence of the Divine by describing what it was not, the Lurianic Kabbalah posited a process in which the *En-Sof*, God "without end," contracts into himself (*Tsimtsum*) to make room for the world of his creation. According to tradition, this was so that the Unseen could view himself, hence the belief that God made the world in his own image. God does not enter directly into creation, however; he gives it form by emanating divine energy. (The Zohar beautifully allegorizes this mystical process, often in terms of blinding light and colored fire or in terms related to the water/desert fertility imagery of Exodus, words still used today in the lexicon of electricity or atomic energy: "current," "channels," "rods," "splitting.") God's emanations do not appear all at once

but in phases, each representing one of his ten names, from the most abstract and distant to the Creator. Appearing first as a point of light (symbolized by *Yod*, the smallest letter), divine energy descends to each level; in some meditative diagrams, the flow is shown as a zig-zag path or lightning flash. All the Divine made manifest—all creation—is subsumed in these ten principles, each contained in a "vessel" without which the energy would revert to infinity. The vessels' purpose is to control and balance this power because even good in excess can become evil. ("Emanations" of diverse materials recur frequently in Kiefer's work beginning in the 1980s [see cat. nos. 32–33], the means of their making as well as their appearance evoking kabbalistic overtones of heavenly manna or creative apocalypse. His unexpected superimpositions of ancient and modern imagery suggest a unity of human nature, belying mythic claims of racial purity. Kiefer's images witness, nevertheless, a precarious survival and project an uncertain future.)

The ten emanations are called Sefiroth (from *safar*, to count). The Sefiroth are the object of the most extended speculation and interpretation in Kabbalah because the qualities of each and their interrelationships are a reflection of the *En-Sof*—and therefore the key to spiritual knowledge. They are, according to Scholem, "the garments of the Divinity, but also the beams of light which it sends out."[3] Each Sefirah has particular characteristics derived from its name, number, and position in the hierarchy, but all are mutually dependent, containing aspects of one another. Tradition has it that when God—the Root of all Roots—first manifested himself, his emanations were too powerful and broke their vessels, scattering pure spirit or light throughout creation, corrupting spirit with matter. To enable the Divine to recover its original unity, a reciprocal process of ascendant and descendant relations was required. As the believer gradually purified matter through prayer and piety, this spiritualized substance was freed to ascend to the Divine, in turn releasing more energy/light/love to be emanated back through the Sefiroth to creation. In this way, the material world would become increasingly a world of spirit. When all the light was restored, all again would be spirit, difference would vanish, and the world of creation would cease to exist. A first restoration was nearly achieved when Adam broke God's commandment by eating of the Tree of Knowledge, introducing mortality and death. The Kabbalists' goal is thus to effect restoration (*Tikkun*) by overcoming evil, to hasten the healing/reunion that precedes the coming of the Messiah and the Day of Judgment. Because this process may require more than one lifetime, a theory of reincarnation developed to accommodate the spiritual task.

Special meditative practices also evolved, including visualization assisted by diagrams (such as cat. no. 66) which symbolized this mythic cosmogony/theogony in schematic form.[4] Such diagrams seemingly appeared

121

only in the Middle Ages because Kabbalah's oral transmission was limited to a prescribed number of initiates at a time. The new written texts and their commentaries so expanded the literature that a new audience required these visual aids, images at once too literal and arcane. (Scholem's and other scholarly studies are minimally illustrated. Significantly, and not surprisingly, the most moving works of art that refer to Kabbalah incorporate its concepts and abstractions but use its symbols indirectly or sparingly if at all.) The most familiar kabbalistic images depict the ten Sefiroth 1) as an inverted sefirotic tree with its roots above and the trunk, branches, leaves, and fruit extending to Earth—an image shared with other cultures; 2) as a schematic diagram with the ten Sefiroth distributed as spheres from top to bottom across three vertical pillars, also known as "The Tree of Life"; 3) as a vertical image of the primordial man, Adam Kadmon, with the seven lower Sefiroth corresponding to the primary organs of the head and body (the upper three Sefiroth are beyond human comprehension); 4) as a sphere or hemisphere of concentric circles with the Sefiroth descending from the perimeter (closer to the Divinity) to the center (in these last, a vertical beam most often bisects the sphere, the *kav* or beam of divine will, to be compared with Barnett Newman's "zips," the thin vertical elements in his *Onement* and post-1948 paintings [see illus. p. 147, cat. nos. 62–67]); and 5) as a circle within which the Sefiroth are disposed as a wheel around the perimeter and a central hub, the upper triad on the right-hand spoke.

These diagrams were limited only by the Kabbalists' imaginations. The Sefiroth could be superimposed on the menorah, or seven-branched candlestick (as in some of Kiefer's works), the Seal of Solomon, and the letter *Aleph* (or rather, the letter's shape as corresponding to the limbs of Adam Kadmon). Some of the most intriguing diagrams are composites of many different types on a single sheet, like visual equivalents to the talmudic textual supercommentaries themselves. (Both formats anticipate the contemporary cyberspace phenomenon of hypertext, where one may digress from the primary text on a CD-ROM to scan supplementary materials.) The ten Sefiroth may be shown diagramatically but separated, sometimes as spherical calligrams comprised of tiny exegetical texts. Most frequently, however, they are interconnected with twenty-two paths or pipes, one for each Hebrew letter: combined with the ten divine names, they constitute the thirty-two paths or ways of the Kabbalah. This tubular network dramatizes the reciprocal flow of energy, clarifying how dangerous imbalances—or evil—can destroy the entire system. The three pillars, for example, must balance severity and mercy just as *Binah*, "understanding," had to be checked by the second Sefirah, *Hokhmah*, or "wisdom." Of particular interest in regard to Kiefer is the inclusion on some diagrams of the so-called eleventh or "unseen Sefirah," *Da'at* or *Daath*, meaning "awareness" (literally, "knowledge"), centered below *Hokhmah* and *Binah*, its

circle represented by a dotted line. On Adam Kadmon, *Daath* corresponds to the mouth and throat because knowledge is conveyed by speech. The first letter of *Daath*, *Dalet*, the fourth letter of the Hebrew alphabet, itself symbolizes the four directions and the four worlds or realms of existence. The Tree of Knowledge of Good and Evil was identified, according to Scholem, with the oral Torah, the tradition that regulated conduct in daily life (as distinct from the Tree of Life, identified with the written Torah, the absolute, the age before the fall). The potential misuse of knowledge—as technology or by charismatic leaders—is one of Kiefer's ongoing leitmotifs, hence his cursive *Da'at*, which appears on several works at the appropriate location, juxtaposed with German transliterations of the Hebrew names for the four levels. In works evoking nuclear or ecological catastrophe (see cat. no. 33), Kiefer's *Daath* suggests that, enraptured by information or beauty, but lacking wisdom, we risk self-deception and destruction by attempting to control what we neither see nor comprehend.

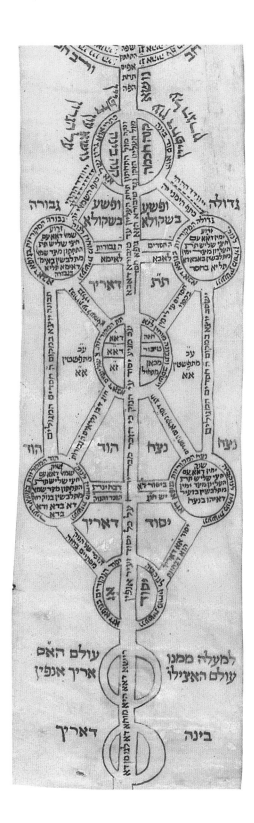

1. See especially Gershom G. Scholem, *Major Trends in Jewish Mysticism* (New York: Schocken Books, 1954), first published by Schocken Publishing House in Jerusalem in 1941 and dedicated to the memory of his friend Walter Benjamin (1892–1940). I have followed the Hebrew transliterations used in this classic Scholem text for the kabbalistic terms in this essay. See also idem, ed., *Zohar, The Book of Splendor, Basic Readings from the Kabbalah* (New York: Schocken Books, 1949); *On the Kabbalah and Its Symbolism*, trans. Ralph Manheim (New York: Schoken Books, 1965; 1st ed. 1960); and *Kabbalah* (New York: Dorset Press, 1987; 1st ed. Jerusalem: Keter Publishing House, 1974).

2. See John Hallmark Neff, *Anselm Kiefer, Brüch und Einung* (New York: Marian Goodman Gallery, 1987), 9–11 and notes; Armin Zweite, "The High Priestess, Observations on a Sculpture by Anselm Kiefer," in *Anselm Kiefer, The High Priestess*, foreword by Anne Seymour (London: Thames and Hudson and Anthony d'Offay, 1989) and notes; and Peter-Klaus Schuster, "Saturn, Melancholie und Merkur: Bemerkungen zu Kiefers 'Saturnischer Malkunst,'" *Anselm Kiefer* (Berlin: Nationalgalerie, 1991), 152–59. The primary source remains Erwin Panofsky, as in his *Life and Art of Albrecht Dürer*, 4th ed. (Princeton, N.J.: Princeton University Press, 1955).

3. Scholem, *Major Trends*, 214. See also Harold Bloom, *Kabbalah and Criticism* (New York: Seabury Press, 1975). Bloom's careful reading sees Kabbalah in rhetorical terms, seeking after "a primordial scheme." He proposes Kabbalah as a model for the revisionary impulse, a theory of reading poetry, and a base for his manifesto for antithetical criticism.

4. Compare this phenomenon with the spiritual exercises of Saint Ignatius of Loyola in Roman Catholicism, and visualization as a mode of discovery in modern science. See Arthur I. Miller, *Imagery in Scientific Thought* (Cambridge, Mass.: MIT Press, 1986), 154–55, and Moshe Idel, *Kabbalah, New Perspectives* (New Haven, Conn.: Yale University Press, 1988), 107–9ff.

possibly North African, *Schematic Diagram for an Amulet*, cat. no. 66, detail.

There are myriads lower than this, and more loathsome, in the scale of being; the links between dead matter and animation drift everywhere unseen. But it is the strength of the base element that is so dreadful in the serpent; it is the very omnipotence of the earth. . . . It scarcely breathes with its one lung (the other shriveled and abortive); it is passive to the sun and shade, and is cold or hot like a stone; yet, "it can outclimb the monkey, outswim the fish, outleap the jerboa, outwrestle the athlete, and crush the tiger." It is a divine hieroglyph of the demoniac power of the earth,—of the entire earthly nature. As the bird is the clothed power of the air, so this is the clothed power of the dust; as the bird is the symbol of the spirit of life, so this of the grasp and sting of death.

—John Ruskin[1]

In the 1980s, Anselm Kiefer produced a number of paintings and sculptures derived from literary and religious ideas. By 1984, Jürgen Harten demonstrated Kiefer's sources in Wagnerian operas, Norse mythology, Christian texts, and the philosophy of the first-century Dionysius the Areopagite, among others.[2] In Kiefer's works of this period there is also a reconstruction and reconsideration of Germanic thought ranging from the philosophical to the political, and a reworking of recent German history, including the campaigns and architecture of the Nazi period. Given the nature of that history in the national consciousness, we might characterize Kiefer's attempts as redemptive and recuperative.

In the three paintings in *Negotiating Rapture* (cat. nos. 30–33), there is a new emphasis on esoteric knowledge, particularly—as John Hallmark Neff's analysis revealed—that of the Lurianic Kabbalah.[3] Isaac Luria, exiled from Spain in 1492, developed a new Kabbalah in which redemption through creation was the principal goal. "For the New Kabbalah, death, repentance, and rebirth are the three great events which can elevate man toward the beatific vision of God. Humanity is menaced not only by its own corruption, but also by the world's corruption."[4] Luria was able to redefine the terms of kabbalistic discourse; his most important contribution was a potent combination of salvation through the Messiah and a mystical working method. Luria described three phases of creation: *Tsimtsum* (familiar as the title of Newman's sculpture of 1969, meaning contraction or withdrawl), *Shevirath Ha-Kelim* or the "breaking of the vessels" (the title of a major 1990 sculpture by Kiefer), and *Tikkun*, or the period when divine unity is restored.

In *The Order of Angels* (1983–84, cat. no. 30), Kiefer repeats the description by Dionysius the Areopagite in which he sets forth the Christian God's celestial hierarchy: ascending from angels to archangels, principalities, powers, virtues, dominions, thrones, cherubim, and, closest to God, seraphim.[5] These orders are numbered in the painting and linked by lead strips to corresponding painted rocks below or, for the highest levels, to serpents. The snake has often been used to symbolize angels but here it bridges two worlds, that of the seraphim who dispel darkness, and that of evil. Doreet Harten suggests that the snake in Kiefer's works stands for "the possibility of attaining earthly knowledge as it follows its progressive course." She also notes its associations with the *prima*

1. John Ruskin, "Serpent, The," in W. H. Auden, *A Certain World: A Commonplace Book* (London: Faber and Faber, 1970), 342–43.

2. Jürgen Harten, "Annotated Catalogue of Painting," and "Paraphrases on Kiefer's 'Studio,'" in R. H. Fuchs, Jürgen Harten, Marianne Heinz, Suzanne Pagé, *Anselm Kiefer* (Düsseldorf: Städtische Kunsthalle Düsseldorf, and Paris: ARC/Musée d'Art Moderne de la Ville de Paris, 1984), 22–137, 139–172.

3. See John Hallmark Neff, *Anselm Kiefer, Brüch und Einung* (New York: Marian Goodman Gallery, 1987).

4. Mircea Eliade, *A History of Religious Ideas*, vol. 3 (Chicago: University of Chicago Press, 1985), 171–72.

5. Mark Rosenthal, *Anselm Kiefer* (Chicago: Art Institute of Chicago, and Philadelphia: Philadelphia Museum of Art, 1987), 137. The text in question, *De Hierachia Celesti*, actually postdates Dionysius by some four centuries. The misattribution is now customarily acknowledged by referring to the unknown author as "Pseudo-Dionysius."

BORN IN 1945 IN DONAUESCHINGEN, GERMANY, in 1945, Anselm Kiefer grew up in Rastatt, near the French border. In 1966, after only three semesters at the Freiburg Academy, he abandoned his studies in law for art. Later that year, he made a trip to the Dominican monastery of La Tourette, designed by Le Corbusier, to see how the architect had translated religious ideals into material form; Kiefer remained three weeks to experience the routines of monastic life. During 1969, he produced a series of controversial photographs called "Occupations," in which he appeared ironically delivering the Nazi salute at various sites in Italy, France, and Switzerland. He studied painting with Horst Antes at the Academy in Karlsruhe and in 1971 began visiting Joseph Beuys at the Düsseldorf Academy.

In 1972, Kiefer moved to the village of Hornbach in the Odenwald, south of Frankfurt, and set up a studio in an old schoolhouse. His paintings presented mainly themes of the forest and the artist's studio. Kiefer undertook to investigate the dilemma of being German in a world after Hitler, and investigated subjects including Wagnerian opera, Teutonic myth, alchemy, fascist architecture, and the German land. His project came under attack when he was selected, along with the neo-expressionist painter Georg Baselitz, to represent Germany at the Venice Biennale in 1980. After traveling to Jerusalem in 1983 and 1984, Kiefer departed from exclusively German themes.

Since the early 1980s, Kiefer has often added straw, photographs, molten lead, even skis to his canvases; he has also produced handmade books, a genre he began to explore as early as 1969, and a number of freestanding sculptures. In 1982, he established his studio in a factory warehouse in Buchen, where he currently lives.

Further reading

Adriani, Götz, ed. *The Books of Anselm Kiefer, 1969–1990.* Translated by Bruni Mayor. New York: G. Braziller, 1991.

R. H. Fuchs, Jürgen Harten, Marianne Heinz, and Suzanne Pagé. *Anselm Kiefer.* Exh. cat. Düsseldorf: Städtische Kunsthalle Düsseldorf, and Paris: ARC/Musée d'Art Moderne de la Ville de Paris, 1984.

Gilmour, John C. *Fire on the Earth: Anselm Kiefer and the Postmodern World.* Philadelphia: Temple University Press, 1990.

Rosenthal, Mark. *Anselm Kiefer.* Exh. cat. Chicago: Art Institute of Chicago, and Philadelphia: Philadelphia Museum of Art, 1987.

Nationalgalerie Berlin, Staatliche Museen, Preussischer Kulturbesitz. *Anselm Kiefer.* Exh. cat. Berlin: Die Galerie, 1991.

materia, lead, and Mercury, "who is considered to be the inventor of evocation, the very act, by power of emanation, that takes place in Kiefer's creative activity. Evocation is how Kiefer describes the act by which the remnants he uses enact their meanings."[6] The restoration of a higher spiritual condition in both kabbalistic and Christian practice is explained by the metaphor of the emanation, of the heavenly made manifest and revealing its strength to the Earth. Kiefer shows this in *Yggdrasil* (1985–91, cat. no. 32), where the ancient tree grows upward to meet the flowing lead, which bridges heaven and the waters.

Lead, moreover, is a metal often taken to represent Saturn and its attribute melancholy; lead can be transmuted and converted to gold and silver in the arcane chemistry of the alchemists. In an equivalent process, lead can become the symbol of creativity itself. "But the chain that connects the separate entities does not stop here," Doreet Harten continues, "Saturn in his attributes corresponds to those of Osiris, despite the fact that the roles have been transposed. The story of Osiris. . . . parallels that of Saturn, who dismembered his own father."[7] Osiris, the ancient Egyptian god of the underworld, was murdered by his brother and cut into fourteen parts, which were dispersed throughout the world. Isis, wife and sister of Osiris, recovered all the parts but one, his penis, and re-created him, making him eternal. Isis became a goddess of fertility, for whom many temples were built. The image in *Osiris and Isis* (1985–87, cat. no. 31) may have come from a Roman ruin Kiefer had seen in Israel; he has added a circuit board and copper wires, through which the power of the sun as infinite energy source can be used to re-create Osiris. Kiefer links the subject of the Osiris painting to a group of works concerned with the potentials (both good and evil) of nuclear energy. Energy is transmitted by the wires either from the sun or from the pile of nuclear rods at the core of the reactor. This core is shown in *Brennstäbe* (*Fuel Rods*, a companion painting to *Osiris and Isis*) and in the book *Heavy Water* (1991, cat. no. 33), in which Kiefer explores in overpainted photographs the effects of a nuclear reaction and the meltdown of the pile at Chernobyl. The last spread (illus. p. 129) shows the immense destruction caused by the explosion.

Kiefer is searching in all this complex and sometimes obscure material for a means to reveal a missing presence (which we may want to relate to God). This revelation is made manifest to him in the recondite knowledge he converts into works of art.

6. Doreet LeVitte Harten, "Canticle for a God Unknown," *Anselm Kiefer: Lilith* (New York: Marian Goodman Gallery, 1991), 12.

7. Ibid.

Anselm Kiefer, *The Order of Angels (Die Ordnung der Engel)*, 1983–84, The Art Institute of Chicago, Restricted gift of the Nathan Manilow Foundation, Lewis and Susan Manilow, and the Samuel A. Marx Fund, cat. no. 30.

127

Anselm Kiefer, *Osiris and Isis (Osiris und Isis)*,
1985–87, San Francisco Museum of Modern Art,
Purchased through a gift of Jean Stein, by exchange,
the Mrs. Paul Wattis Fund, and the Doris and
Donald Fisher Fund, cat. no. 31.

Anselm Kiefer, *Yggdrasil*, 1985–91, McMaster
University, Hamilton, Ontario, Levy Bequest
Purchase, cat. no. 32.

129

Anselm Kiefer, *Heavy Water (Schwerenwasser)*, 1991,
Susan and Lewis Manilow, cat. no. 33. Left, cover;
right, final page spread.

You say I am repeating
Something I have said before. I shall say it
again.
Shall I say it again? In order to arrive there,
To arrive from where you are, to get from
where you are not,
 You must go by a way wherein there is no
ecstasy.
In order to arrive at what you do not know
 You must go by a way which is the way
of ignorance.
In order to possess what you do not possess
 You must go by the way of dispossession.
In order to arrive at what you are not
 You must go through the way in which
you are not.

 —T. S. Eliot[1]

The sphere is a perfect form, complete and unassailable, with no beginning and no end. Recognized as having this character in philosophy, mathematics, and religion, it represents for James Lee Byars, whose art has been a continual path toward perfection, a search for the perfect moment, the ideal. Byars has made works with spheres on numerous occasions. In 1955, for his university degree in visual arts, he exhibited for one day a series of large stone spheres in his parents' home—from which he had removed all the windows, doors, and furniture. *This This* (1985) consisted of two basalt spheres placed side by side; *The Table of Roses* (1989) wove 3,333 roses into a forty-inch sphere; and *The Head of Plato, The Head of Man* (1986), an eight-inch sphere (the volume of a human head if rounded out to a sphere), represents the human form converted into its platonic ideal. Byars has a strategy for his work, a form of teaching by saturation, which elicits attention from the student/audience without appearing to ask or demand. His process is one of intervention (minimal) and subvention (the major part) of the spectators' senses and cultural memory. The work derives its mystical character from the forms he has chosen (the sphere and the phallic column or lingam) and accumulates a sediment of meaning without overt statement.

The Monument to Language (1995, cat. no. 9) completes the cycle of Byars' meditations on the sphere. Cast in bronze and covered with gold leaf, it is a technical tour de force created for an ephemeral performance that lasted approximately twenty minutes: a person installed through the top of the sculpture read one hundred sentences by the French philosopher Roland Barthes.[2] This selection corresponds with the work's title,[3] since Barthes was responsible for much rethinking of the uses and limits of language in the 1960s, leading the movement from modern to postmodern thought. In the iteration of the work for *Negotiating Rapture*, the artist has asked that Barthes be replaced by T. S. Eliot.[4] Byars, in his searches through both Eastern and Western religions, has attempted to find the moment when perfection might be achieved, in Eliot's phrase, "at the still point of the turning world."[5] Any point on it marks beginning, end, and center—the position that, serendipitously, this sculpture

1. T. S. Eliot, "East Coker," *Collected Poems 1909–1962* (London: Faber and Faber, 1963), 197.

2. Barthes' text is printed in Jean-Michel Ribettes and Heinrich Heil, *James Lee Byars: The Monument to Language, The Diamond Floor* (Paris: Fondation Cartier de l'Art Contemporain, 1995), i–xvi.

3. It may also refer to Goethe's *Monument to Fortune* (1777), also a spherical sculpture.

4. Eliot's concern for the unity of Hellenic, Eastern, and Christian thinking grew more complex and embedded in his poems toward the end of his life. Byars suggested with some vigor that Eliot is the correct poet for the performance within *The Monument to Language* in the United States, as Barthes had been in France and Yeats in England.

5. T. S. Eliot, "Four Quartets: Burnt Norton," *Collected Poems*, 191.

JAMES LEE BYARS WAS BORN IN DETROIT IN 1932. From 1948 to 1956, he studied art and philosophy at Wayne State University and attended the Merrill Palmer School for Human Development. From 1956 to 1957, Byars made sculpture, which he exhibited in his parents' house, on a farm, and in outdoor settings. In 1958, funded for one year by neighbors of a Detroit patron who had commissioned an installation, Byars moved to Japan, where he stayed, principally in Kyoto, for the next ten years. He taught English, studied Japanese ceramics and paper making, and traveled through Japan, often returning to the United States. In the late 1950s and 1960s, Byars began working in a variety of formats: drawing with ink in stylized script on Japanese paper; making paper boxes and works on silk; creating sculptures in bronze, gold, and marble; and conducting "action" performances such as *Dress for 500* (1967) and *100 in a Hat* (1968).

In 1969, Byars was artist-in-residence at the Hudson Institute in upstate New York, and visiting artist at Nova Scotia College of Art and Design in Halifax. That year he met Joseph Beuys at the Düsseldorf Academy of Art. Beginning in 1972, Byars lived principally in Bern, traveling throughout Europe, often spending winters in Los Angeles, and one summer returning to Nova Scotia to teach a "Projects" class with artists Vito Acconci, Dan Graham, and Dennis Oppenheim. In 1982, Byars established a residence in Venice, from which he traveled throughout the Mediterranean region. His work of the last decade includes spherical, diamond-shape, and perfectly square sculptures crafted of materials such as stone, bronze, and gold leaf. He currently lives in Santa Fe.

Further reading

Elliott, James. *The Perfect Thought: An Exhibition of Works by James Lee Byars*. Exh. cat. Berkeley: University of California, 1990 [extensive bibliography and chronology].

Gachnang, Johannes. *James Lee Byars*. Exh. cat. Bern: Kunsthalle Bern, 1978.

Hickey, Dave. *James Lee Byars: Works from the Sixties and Recent Works*. Exh. cat. New York: Michael Werner Gallery, 1993.

Ribettes, Jean-Michel, and Heinrich Heil. *James Lee Byars: The Monument to Language, The Diamond Floor*. Paris: Fondation Cartier de l'Art Contemporain, 1995.

occupies in the exhibition. *The Monument to Language* acts as a metaphorical passage from life to death—and through it we can return to the earliest works and begin again. Ten years ago, Jürgen Harten wrote about Byars:

> Ultimately, death achieves the perfection of things external. In the cult of death life is sacrificed as if killing could both slaughter death and offer it another life for its own. Mortal decay is combated, although life is marked by death to the same extent that it perseveres against it. Or life becomes bound into transcendent, all-encompassing eternities that promise survival in the realm of death. . . . [The artist] imagines his own death—for survival in the shape of a small sphere, ever since a footnote taught him that Origines mentions a mystic tradition according to which resurrection from death was to be imagined as spherical. If Byars were capable of wresting his life from death, he would gladly compensate death with a burnt black pellet of bread. Instead he has resolved on his death to cancel all his work.[6]

6. Jürgen Harten, ed. *Philosophical Palace: James Lee Byars* (Düsseldorf: Kunsthalle Düsseldorf, 1986), 32.

▸ James Lee Byars, *The Monument to Language*, 1995, Fondation Cartier pour l'Art Contemporain, Paris, cat. no. 9, photograph of installation at Fondation Cartier.

*As John to Patmos, among the rocks and the
blue, live air, hounded
His heart to peace, as here surrounded
By the strewn-silver on waves, the wood's
crude hair, the rounded
Breasts of the milky bays, palms, flocks, the
green and dead*

*Leaves, the sun's brass coin on my cheek, where
Canoes brace the sun's strength, as John, in
that bleak air,
So am I welcomed richer by these blue scapes,
Greek there,
So I shall voyage no more from home; may I
speak here.*

*This island is heaven—away from the
dustblown blood of cities;
See the curve of bay, watch the straggling
flower, pretty is
The wing'd sound of trees, the sparse-powdered
sky, when lit is
The night. For beauty has surrounded
Its black children, and freed them of homeless
ditties.*

*As John to Patmos, in each love-leaping air,
O slave, soldier, worker under red trees
sleeping, hear
What I swear now, as John did:
To praise lovelong, the living and the brown
dead.*

—Derek Walcott[1]

Nicolas Poussin painted *Landscape with Saint John on Patmos* (cat. no. 68) and a companion painting, *Landscape with Saint Matthew* (now in Berlin), in 1640 in Rome, perhaps as part of a commissioned cycle of the four evangelists.[2] These are Poussin's first classical landscapes and include architectural elements to underscore the highly ordered compositions. Poussin worked in the classical landscape tradition of Annibale Carracci and Domenichino, preparing sketches out of doors for transfer to the final composition. The tightly composed layers of landscape and narrative combine to represent a particular view of nature and a religious story. Poussin admired the Stoics and, over the next decade, his most important landscapes reveal this philosophy of reason through the inherent harmony of nature. "My nature compels me," he wrote, "to seek and love things that are well ordered, fleeing confusion, which is as contrary and inimical to me as is day to the deepest night."[3] Nature is governed in Poussin's stoic world by the logos; man is in nature but always its master. The biblical tradition of the logos—"In the beginning was the Word," John's Gospel proclaims—and the stoic definition of logos as plan and reason for the order of the world would provide Poussin with a significant philosophic connection for his painting.

Saint John was exiled to the island of Patmos (Sporades) under Domitian, accused of practicing magic when he survived a cauldron of hot oil. Some believe that, while exiled, he wrote the Book of Revelation, using the outstretched wings of an eagle as a desk.[4] *The Oxford Companion to the Bible* states that "the risen Christ appears to John . . . and orders him to write to the seven churches; the messages warn the complacent and the worldly, and encourage the faithful."[5] John's account describes how a series of apocalyptic disasters follows the opening of the seals of God, Babylon is destroyed, and Satan is bound for a thousand years until he is released at the millennium for his final assault. God judges the world and "a new heaven and earth replace the old. The holy city, Jerusalem, the bride, comes down from God, and all the earth's splendor is gathered into it." The numerology of this narrative is based on seven, a figure repeated throughout the text. Despite its disputed authorship, Revelation is highly important for Christian belief, "with its echoes of the beginning, the tree of life restored, and no more curse, it is a fitting climax to the whole Bible story."

1. Derek Walcott, "As John to Patmos," *Collected Poems: 1948–1984* (New York: Noonday Press, 1988), 5.

2. Richard Verdi, *Nicolas Poussin: 1594–1665* (London: Royal Academy of Arts, 1995), 234–35.

3. Nicolas Poussin, quoted in Anthony Blunt, "Poussin and Stoicism," *Nicolas Poussin* (London: Pallas Athene, 1995), 175.

4. Poussin seems to have accepted what later scholars dispute, that the "John" of the Book of Revelation is the same as John the Apostle, the author of the Gospel of Saint John.

5. John Sweet, "Revelation, the Book of," *The Oxford Companion to the Bible*, ed. Bruce Metzger and Michael Coogan (New York: Oxford University Press, 1993), 651. Subsequent quotations are also from this source.

Nicolas Poussin, *Landscape with Saint John on Patmos*, 1640, The Art Institute of Chicago, A. A. Munger Collection, cat. no. 68.

Whenever we stir, the two resources which are the fairest of all attend us: nature, which is universal, and virtue, which is our own. Such was the design, believe me, of whatever force fashioned the universe, whether an omnipotent god, or impersonal Reason as artificer of vast creations, or divine Spirit permeating all things great and small with uniform tension, or Fate with its immutable nexus of interrelated causes. . . . This world, than which Nature has wrought nothing greater or handsomer, and the human mind, its most magnificent portion, which contemplates the world and admires it, are our own forever.

—Marcus Anneaus Seneca[1]

Henry David Thoreau's importance as an American writer and thinker has often been stated. John Cage wrote an elegant short biography of him:

> He lived in Concord, Massachusetts. For two years he lived alone in the woods, two miles from town by the side of Walden Pond. He built his home and grew his food, and each Sunday walked back to Concord to have dinner with his mother and father and other relatives and friends. He is the inventor of the pencil (he was the first person to put a piece of lead down the center of a piece of wood). He wrote many books including a *Journal* of fourteen volumes (two million words). His *Essay on Civil Disobedience* inspired Gandhi in his work of changing India, and Martin Luther King, Jr., in his use of nonviolence as a means of revolution. No greater American has lived than Thoreau. Emerson called him a speaker and actor of the truth. Other great men have vision. Thoreau had none. Each day his eyes and ears were open and empty to see and hear the world he lived in. Music, he said, is continuous; only listening is intermittent. He did have a question: Is life worth living? *Walden* [1854, cat. no. 79] is his detailed and affirmative reply.[2]

Thoreau's writings constituted an important contribution to the mid-nineteenth-century debate about nature's transcendent values. He became a pioneer in his attachment to the land and to his cabin at Walden Pond. "I do not know," he wrote in his journal in February 1851, "where to find in any literature whether ancient or modern—an adequate [ac]count of that Nature with which I am acquainted. Mythology comes nearest to it of any."[3] Nature, for Thoreau and Emerson, like the "natural" city for Walt Whitman (whose *Leaves of Grass* is shown here also), was of religious importance. They used the European discussion of the sublime, expressed by Edmund Burke, and extrapolated its vitality to the vastness of the American continent. The sublime becomes awesome and thus transcends man. Thoreau celebrated this deeply felt phenomenon in his journal entry for 3 January 1853 (cat. no. 80):

> I love Nature partly *because* she is not man, but a retreat from him. None of his institutions control or pervade her. There a different kind of right prevails. In her midst I can be glad with an entire gladness. If this world were all man, I could not stretch myself, I should lose all hope.

1. Marcus Anneaus Seneca, quoted in Anthony Blunt, "Poussin and Stoicism," *Nicolas Poussin* (London: Pallas Athene, 1995), 176.

2. John Cage, "Lecture on the Weather," *Empty Words: Writings '73–'78* (Middletown, Conn.: Wesleyan University Press, 1979), 3.

3. Henry David Thoreau, quoted in Kathleen Luhrs, ed., *In August Company: The Collections of the Pierpont Morgan Library* (New York: Pierpont Morgan Library, 1993), 206.

He is constraint, she is freedom to me. He makes me wish for another world. She makes me content with this. None of the joys she supplies is subject to his rules and definitions. What he touches he taints. In thought he moralizes. One would think that no free, joyful labor was possible to him. How infinite and pure the least pleasure of which Nature is basis, compared with the congratulations of mankind! The joy which Nature yields is like [that] afforded by the frank words of one we love.

The second half of the exhibition mediates between the organized and classically composed naturalism of Poussin and the yearning for transcendence before nature in Thoreau.

Henry David Thoreau, *Autograph Journal*, 31 August 1852–7 January 1853, The Pierpont Morgan Library, New York, Purchased by Pierpont Morgan with the Wakeman Collection, 1909, cat. no. 80.

"The war the Surrealists predicted has robbed us of our hidden terror, as terror can exist only if the forces of tragedy are unknown. We now know the terror to expect. Hiroshima showed it to us. We are no longer, then, in the face of a mystery. After all, wasn't it an American boy who did it? The terror has indeed become as real as life. What we have now is a tragic rather than a terrifying situation." These lines come from "The New Sense of Fate," an essay Barnett Newman wrote for the journal *Tiger's Eye* but which was discarded because of its length and replaced by the much shorter statement "The Object and the Image," published in March 1948.[1] Although the latter text builds on a general opposition between two poles (beauty and tragedy) that was elaborated in the longer essay, it does not retain from it the important distinction between terror and tragedy.

Yve-Alain Bois

BARNETT NEWMAN'S
SUBLIME = TRAGEDY

Such a distinction is not new in Newman's writings. He had used it in 1945, for example, to differentiate the art of Rufino Tamayo, who "tried to recapture the basic terror, the brutality of life," from that of Adolph Gottlieb, who "tried to capture a sense of the tragedy of life"; the first showed affinities with pre-Columbian art, the second with that of the Northwest Coast Indians. But at that time Newman had understood the two terms more as variations in degree rather than as marking an essential opposition (just as, in his 1946 essay on the "Art of the South Seas," he had distinguished the "terror" expressed in the art of Africa from that of ancient Mexico or Oceania).

On the contrary, in "The New Sense of Fate," Newman clearly saw the assimilation of terror with tragedy, or rather the reduction of tragedy to terror, as a mistake, the mistake of the Surrealists in particular: "To them," he wrote, "tragedy became an outside force that prevented man from acting. They thereby identified tragedy with terror. That is why they had to go to the ideas of the primitive world with all its overtones of terror. . . . But that time is over." There is some self-criticism in this statement.

What happened between 1945–46 and 1948 to cause the sharp cleavage of these two terms in Newman's mind? Obviously, not Hiroshima; in "Art of the South Seas," he had already alluded to the atomic threat as one more explanation for the kinship the modern artist feels for the "primitive" one. What happened was that Newman had painted *Onement I* (illus. p.59), or rather had created his first "zip" painting (on 29 January 1948) by "interrupting" his usual pictorial procedure on a given canvas, and had begun to mull over this extraordinary gesture. It took him eight months to comprehend it fully and to declare the picture as he had left it, finished.

Newman probably started writing "The New Sense of Fate" before (not) finishing *Onement I*, but in its final form the essay represents his first attempt to cope with his new discovery. The second, published in December 1948, just after he resumed painting (with *Onement II*), is "The Sublime Is Now." The two texts have to be read together.

Instead of the common opposition between Western art on the one hand and "primitive" and modern art on the other, Newman proposed another paradigm in "The New Sense of Fate": at stake now was the duality of the Greek legacy and the necessity to wrench ourselves from the seduction of the ideal beauty the ancient Greeks had invented in their art. According to Newman, we have to see this ideal beauty as a mask, a delusion: what the Greeks wanted to achieve was the majesty of the Egyptian pyramid, but since they could not grasp its content they read it as pure shape; as a consequence, their art evolved into one of "refinement and sensibility" after which all Western art was modeled. The writers were more successful (no shape was there to seduce them): they thought about fate; they stuck to the content, to tragedy.

Newman's attack on classicism and the notion of beauty pertaining to it, as well as on its pervasiveness in modernist art, dates back at least to the mid-forties. But the Greeks did not enter his discussion until 1948. Their appearance is partly prompted by the cultural context of the time. (Newman mentions Sartre's theater as a kind of Greek revival, undoubtedly alluding to *The Flies* [1943], which is set in antiquity; he also refers to Oedipus's plight, perhaps pointing to the common interest in psychoanalysis among his circle of friends.) But, most of all, the Greeks' arrival in Newman's discourse might also indicate that the artist had looked for an answer, with regard to the mystery of *Onement I*, in books on aesthetics, where Greek art pops up regularly in discussions about beauty. Whatever the case, the Greeks helped Newman give a new twist to his battle against "formalism." Against the empty reading of the pyramid as perfect shape stands "the *sublime* content of the Egyptian symbol." This is followed, a few lines later, by a quick dismissal of Kant.

The Egyptian pyramid is a famed example in Kant's "Analytic of the Sublime" in the *Critique of Judgment*, and this might indeed be where Newman found it. However, it was only a few months later, at the instigation of *Tiger's Eye*, that he examined more closely the notion of the sublime. He had already used it in passing, with reference to his work, in "The Plasmic Image," written around 1945. In "The Sublime Is Now," he invokes the classical treatises—Longinus, Kant, Hegel—and dismisses them all. He is less contemptuous of Edmund Burke's *Philosophical Inquiry*, though it "reads like a surrealist manual," because of its clear demarcation between the realm of the beautiful and that of the sublime. He dismisses again all Western art as well (down to Picasso and Mondrian), but this time more

Edwin H. Davis and Ephraim G. Squier, *Ancient Monuments of the Mississippi Valley*, 1848, The Newberry Library, Chicago, cat. no. 14.

precisely as a series of failed attempts at sublimity—with the exception of gothic or baroque architecture, "in which the sublime consists of a desire to destroy form, where form can be formless."

One thing is to be noted: "tragedy" is absent from "The Sublime Is Now." It will reappear in most of Newman's subsequent texts; "sublime," on the contrary, seems not to have been used again, but for one notable exception. That is to say, "sublime" is the name momentarily given by Newman to what he calls everywhere else "tragedy." Which is also to say that his understanding of sublimity had indeed little to do with its analyses in the treatises he read. The exception just mentioned is a case in point. Referring to the title of *Vir Heroicus Sublimis*, Newman told David Sylvester (in 1965) that "man can be or is sublime in his relation to his sense of being aware." Sublime, for Newman, meant something that gives one the feeling of being there, of being *hic et nunc*, confronting the human fate without the props of "memory, association, nostalgia, legend, myth." From 1948 on, he would insist that what he wanted to give the beholder was a sense of place, a sense of his or her own scale.

The sublime of the philosophers and that of Newman are not entirely opposed, however. In August 1949, in front of an Indian mound in Ohio (see cat. no. 14)—"a work of art that cannot even be seen, so it is something that must be experienced there on the spot"—Newman had an experience not foreign to Burke's treatment of the sublime as a feeling engendered by a vastness one cannot comprehend, nor to Kant's description, referring to the perception of the Egyptian pyramids, of the role of temporality in this sudden blank of comprehension. But for them the concept remained a universal category; they defined it in terms of a temporary feeling of lack with regard to an idea of totality. Newman wanted to speak not of space in general but of his own "presence," not of infinity but of scale, not of "the sense of time" but of "the physical *sensation* of time." This is what *Onement I* had meant to him: the affirmation of the tragic fate of man, standing alone in front of chaos. And this is what the Ohio encounter confirmed; in that sense, it also marked Newman's farewell to the philosophical concept of the sublime. Soon this concept would seem too universal to express "the idea that Man Is Present." It had helped Newman get over the shock of what he had done—inventing an art where the original extirpation from chaos is not represented but enacted for each beholder—but "sublime" appears ultimately to have been a misnomer.

139

1. Both these texts, as well as all the other essays by Newman mentioned below and his 1965 interview with David Sylvester, are collected in *Barnett Newman: Selected Writings and Interviews*, ed. John P. O'Neill (New York: Alfred A. Knopf, 1990).

[I]t can be said that the artist like a true creator is delving into chaos. It is precisely this that makes him an artist, for the Creator in creating the world began with the same material—for the artist tried to wrest truth from the void.

—Barnett Newman[1]

At the end of the 1940s, Barnett Newman's work changed substantially and became, with the *Onement* series (see cat. nos. 60, 63), characteristic of all his later production. During this period, Newman wrote as much as he painted, concerned in his essays with his own art and that of his peers but also with "primitive" art and natural phenomena. Newman read Thoreau carefully, even visiting Walden Pond during his honeymoon. Temporarily abandoning painting, he studied ornithology and botany, learning botanical illustration. Between 1946 and 1949, his change of subject matter is visible as biomorphic, plantlike forms on the verge of abstraction give way to large unmodulated areas of color divided by narrow bands of color, or "zips."

There are arguments about the degree of Newman's contact with and use of the Kabbalah.[2] But, in relation to the theme of the exhibition, it is clear that Newman assigns the artist the role of maker of mythology and mediator between man and nature. His great interest in native traditions and his partial disavowal of Hellenic ideas suggest that he was concerned with states and emotions that were not easily recovered from rationalist methods of artmaking. Newman used titles such as *Tsimtsum* (his *ZimZum* is an alternate spelling) that are specific to the Kabbalah and referred to details of the Zohar, the principal text of the Kabbalah, in his synagogue designs of 1963; and since we know he owned and apparently used copies of the exegetic texts of Gershom Scholem, we might assume that the Kabbalah was part of the apparatus that he drew upon.

He was searching for evidence of the subject matter that, as we have seen, interested him most: the extension of our thinking beyond the sublime of the Romantics. This search was probably part of a period of intellectual discovery that included Jungian psychology and the investigations of magic. These interests derived from the Surrealists and greatly influenced the avant-garde art

1. Barnett Newman, "The Plasmic Image" (1945), *Barnett Newman: Selected Writings and Interviews*, ed. John P. O'Neill (New York: Alfred A. Knopf, 1990), 140.

2. John Hallmark Neff's advice, information, and conversations about the Kabbalah have been invaluable; the inferences and conclusions are ours. The controversy began with Thomas B. Hess's publication, *Barnett Newman*, for the Museum of Modern Art retrospective of 1971, where he introduced not only kabbalistic title references but posited complex numerological and geometric connections. This was denied by Harold Rosenberg in his monograph, *Barnett Newman* (New York: Harry N. Abrams, 1978), and has been consistently refuted by the artist's widow, Annalee Newman. See also Michael Zakian, "Barnett Newman and the Sublime," *Arts Magazine* 62:6 (February 1988): 33–39, and Matthew Baigell, "Barnett Newman's Stripe Paintings and Kabbalah: A Jewish Take," *American Art* 8 (Spring 1994): 32–43.

BARNETT NEWMAN (1905–1970) WAS BORN in New York to nonorthodox Jewish parents. Beginning in high school and continuing through college, he studied painting at the Art Students League. He graduated with a B.A. in philosophy from the City College of New York in 1927, worked for his father's clothing manufacturing company for two years, and was employed as a substitute high-school art teacher from 1931 to 1940. Newman stopped painting in 1939–40 and studied botany and ornithology at the Brooklyn Botanical Garden and at Cornell University, Ithaca, New York. In 1944–45, after destroying all his early work, Newman returned to artmaking, rendering images of plant and seed fertilization and growth in various media on paper, and occasionally in oil on canvas. He began to choose titles for his paintings that related to the origin of the world or the act of creation, such as *The Beginning* or *Genesis–The Break* (both 1946).

In 1948, Newman established his mature painting style, generally characterized by a field of color divided by one or more vertical "zips," in *Onement I*. *Onements II* through *VI* followed from 1949 to 1953, as well as many other paintings with biblical titles, such as *Adam*, *Joshua* (cat. no. 62), and *Abraham*. With the fourteen paintings comprising *The Stations of the Cross, Lema Sabachthani* (1958–66), his final major work, Newman continued using the pictorial language he had developed to relate his feelings about sacred places, people, and heightened states of being. Newman was the author of many essays including "The Sublime Is Now" (1948), in which he articulated his understanding of the role of twentieth-century painting in the canon of European modernism, and explored the relationship of aesthetics and spirituality. At Betty Parsons' gallery, Newman exhibited with Abstract Expressionists including his friends Adolph Gottlieb, Ad Reinhardt, and Mark Rothko. Newman died in New York.

Further reading

Hess, Thomas B. *Barnett Newman*. Exh. cat. New York: Museum of Modern Art, 1971.

Newman, Barnett. *Barnett Newman: Selected Writings and Interviews*. Edited by John P. O'Neill. New York: Alfred A. Knopf, 1990.

Rosenberg, Harold. *Barnett Newman*. New York: Harry N. Abrams, 1978 [extensive bibliography].

Strick, Jeremy. *The Sublime Is Now: The Early Work of Barnett Newman: Paintings and Drawings 1944–1949*. Exh. cat. New York: PaceWildenstein, 1994.

world of New York. Newman therefore demanded of himself a highly intellectual art that reached beyond the anecdotal and representational (even in the terms of his fellow Abstract Expressionists), and he used the language of religious ecstasy to describe it.[3]

Newman had found a device in the "zip" of the *Onement* pictures that offered the chance to measure this desire against the ambition of the modernist painter. In an interview with Newman, David Sylvester suggested that he referred to the "zip" not as a line on a field but as "a field between two other fields," and Newman extrapolated the metaphor to "a field that brings life to other fields."[4] There is, in his writings and paintings, a single desire for a self-sustaining art that extends human experience. He expected his audience completely to absorb his rigorous physical and mental process:

> The basis of an aesthetic act is the pure idea. But the pure idea is, of necessity, an aesthetic act. Here then is the epistemological paradox that is the artist's problem. Not space cutting nor space building . . . not the accurate eye, all fingers, nor the wild eye of dream, winking; but the idea-complex that makes contact with mystery—of life, of men, of nature, of the hard, black chaos that is death, or the grayer, softer chaos that is tragedy. For it is only the pure idea that has meaning. Everything else has everything else.[5]

3. In Newman's article "Response to Reverend Thomas F. Mathews" (1967), *Selected Writings*, 290, he summarized his aesthetic and the guidelines to his work: "I said then that my entire aesthetic can be found in the Passover service. At the Passover seder, which was also Jesus's last meal, the blessing is always made to distinguish between the profane and the sacred: 'Blessed be thou, O Lord, who distinguishes between what is holy and what is not holy.' And when the Passover falls on the Sabbath, the Jew is caught in a dilemma between the holiness of the festival, and the holiness of the Sabbath, which is holier than any other festival except the Day of Atonement; and his blessing then becomes, 'Blessed be thou, O Lord, who distinguishes between what is holy and what is holy.' That's the problem, the artistic problem, and, I think, the true spiritual dimension."

4. Newman, "Interview with David Sylvester" (1965), *Selected Writings*, 256.

5. Newman, "The Ideographic Picture" (1947), *Selected Writings*, 108.

141

Barnett Newman, *Galaxy*, 1949, Lynn and Allen
Turner, cat no. 59.

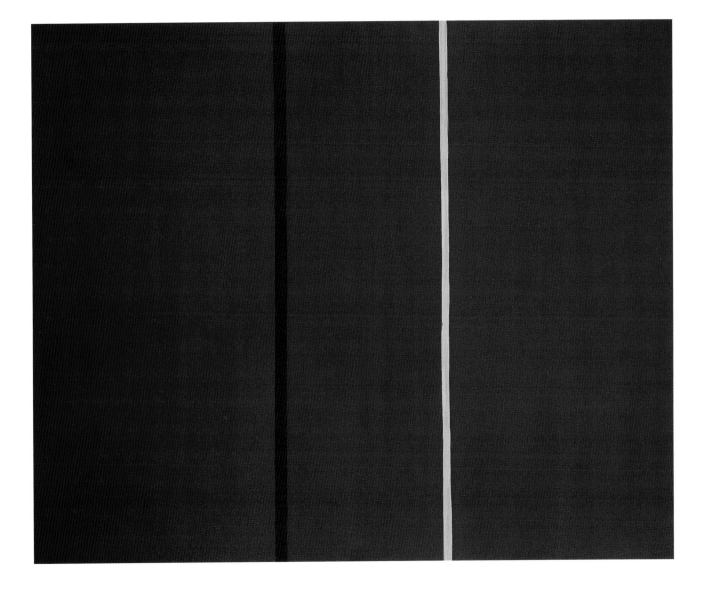

143

Barnett Newman, *Covenant*, 1949, Hirshhorn
Museum and Sculpture Garden, Smithsonian
Institution, Washington, D.C., Gift of Joseph H.
Hirshhorn, 1972, cat. no. 58.

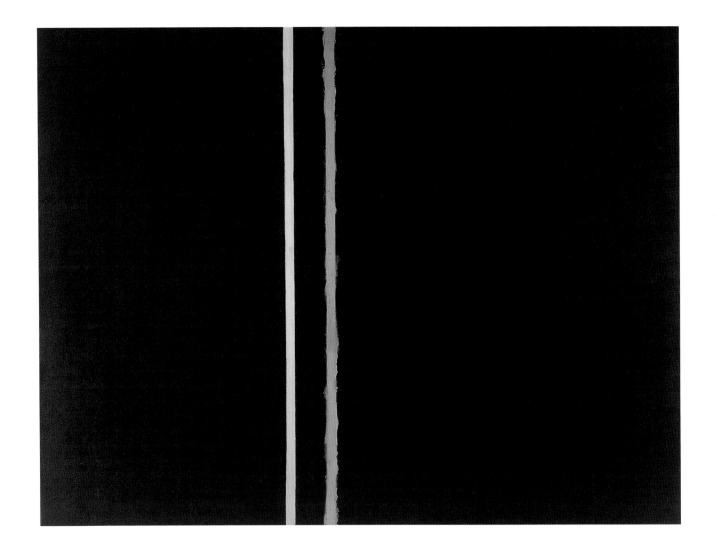

Barnett Newman, *The Promise*, 1949, Adriana and
Robert Mnuchin, cat. no. 61.

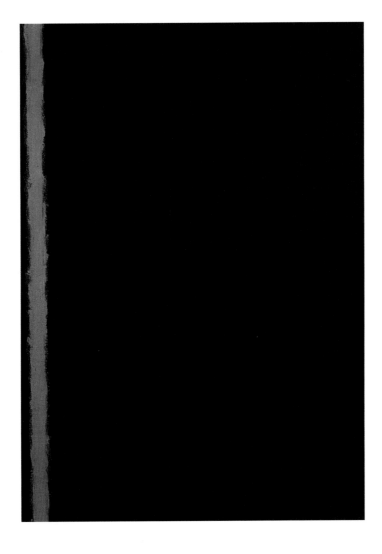

Barnett Newman, *Joshua*, 1950, Marcia and Irving
Stenn, Chicago, cat. no. 62.

Barnett Newman, *Onement IV*, 1949, Allen Memorial
Art Museum, Oberlin College, Ohio, Ruth C.
Roush Fund for Contemporary Art, National
Endowment for the Arts Museum Purchase Plan, and
an anonymous donor, cat. no. 60.

147

Barnett Newman, *Onement V*, 1952, Mr. and Mrs.
David Pincus, cat. no. 63.

These native-American artworks (cat. nos. 1, 11, 13, 25, 65, 67, 77, 82), an archaeological survey drawing of the Miamisburg serpent mound in Ohio (cat. no. 14), and records of the nuclear experiment (cat. nos. 57, 78) link two American artists, Bruce Nauman and Barnett Newman. Their mature work, separated by almost forty years, was made soon after the end of two wars, the Second World War and the United States' involvement in Vietnam. The works we have selected for the exhibition are intended to reflect the states of global conflict and the role that prehistoric or native-American art played in both their personal cosmogonies. Newman was a collector of Northwest Coast art and Nauman lives in New Mexico, near the site of the first nuclear tests in 1945. Annalee Newman, the former's widow, is from Ohio near the serpent mounds, which Newman called "perhaps the greatest art monuments in the world, for somehow the Egyptian pyramid by comparison is nothing but an ornament."[1] Our hope is that by bringing these diverse objects together, their connections will lead from Newman's apparently straightforward heroism to Nauman's existential irony.

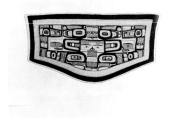

NORTHWEST COAST
INDIAN PAINTING

SEPTEMBER 30th–OCTOBER 19, 1946

BETTY PARSONS GALLERY
15 EAST 57th STREET, NEW YORK, N. Y.

Barnett Newman, *Northwest Coast Indian Painting*, William Morris Hunt Memorial Library, Museum of Fine Arts, Boston, cat. no. 64.

In 1947, Betty Parsons invited Barnett Newman to present several small exhibitions of what was then called "primitive" art at her new gallery in New York. Newman (whose interest in the art of the Northwest Coast was strong enough for him to accept a rare teaching assignment in Canada in 1959) selected a number of works from Max Ernst's collection for display, including a Tlingit box and several masks and Chilcat blankets, and wrote a brief introduction to the exhibition (cat. no. 64). While the Surrealists were fascinated by tribal cultures generally, the art of this region was especially appealing to them. Similarly, the anthropologist Claude Levi-Strauss, writing in the *Gazette des Beaux-Arts* in 1943, extolled the manner in which "this unique art unites in its figures the contemplative serenity of the statues of Chartres and the Egyptian tombs with the gnashings of Hallowe'en. These two traditions of equal grandeur and parallel authenticity . . . reign here in their primitive and undisturbed unity."[2]

The late-nineteenth century Nootka transformation mask from Vancouver Island (cat. no. 65) is worn in dances in the spring and fall to evoke ancestral spirits. Art historian Deborah Waite relates a myth about a Neentsa mask similar to the example displayed here:

> The Neentsa traced their descent from an eagle who flew down from heaven with his parents to Cape Scott, where they took off their eagle skins and became men. The eaglet . . . was drowned at sea one day while hunting seals; however, he awoke to new life and flew up to Heaven in the shape of an eagle. The parents . . . mourned [him] until they saw an eagle fly down out of the sun to their house and recognized this eagle as their son.

1. Newman, "Ohio, 1949" (1949), *Barnett Newman: Selected Writings and Interviews*, ed. John P. O'Neill (New York: Alfred A. Knopf, 1990), 174.

2. Claude Levi-Strauss, quoted in Dawn Ades, *Dada and Surrealism Reviewed* (London: Arts Council of Great Britain, 1978), 405.

Apache, *Basket*, 1880s, The Field Museum, Chicago,
Collected by Captain Crawford prior to 1890 and
donated by Edward E. Ayer in 1894 (17637), cat. no. 1.

Around his neck hung a ring of red cedar bark and he bore in his talons a small box. . . . His parents built a great fire and the young man began to dance around it. From the box he took out many flutes with which he imitated the sound of the eagle, and he wore a double mask representing on the inside a man and on the outside an eagle. After the dance he entertained the people. He had a large basin made in the form of . . . the fish that had . . . drowned him. The basin continually filled itself up with fish oil. . . .[3]

In many Northwest Coast traditions, as Wendy Doniger explains, communication with the spirit world is frequently the responsibility of a shaman, an individual who communicates with the supernatural through a trance state. Since the shaman is distinguished from the priest by his or her active and changing contact with the supernatural realm—rather than a stable and repeatable ritual process—the art of the shaman takes on characteristics that are perishable and mutable, and embodies the nature of the spirit it represents. Joseph Beuys often made comparisons between his life and art and the role of a shaman (see cat. nos. 5–8).

In the art of the Anasazi and the Pueblo of the Southwestern United States, the shaman is replaced by a priest figure who leads the group in the re-creation of images and dances. The Pueblo combat disease this way; the Navajo create cosmic sand paintings whose three-tiered planar universe is structured around a central core, often represented by a tree (the *axis mundi*). Both these societies depend on agriculture, and the art they create is often connected with this focus, such as the baskets and pots shown here.

The profound religious relationship of native residents to the land of the Southwest is in stark opposition to the nuclear experiments conducted there in the 1940s. At the University of Chicago, on 2 December 1942, the first self-sustaining nuclear chain reaction, the first controlled release of energy from the nucleus of an atom, was achieved by Enrico Fermi and his team of scientists. In a commemorative address given at the University twenty-five years later, at the height of the Vietnam War, President Lyndon B. Johnson cited the Book of Genesis: "Be fruitful, and multiply, and replenish the earth, and subdue it. . . . only in our lifetime have we acquired the ultimate power to fulfill all of that command."[4] Exhibited adjacent to the book by Glenn T. Seaborg (co-discoverer of plutonium) containing this presidential address (cat. no. 78) is a tourist road map of New Mexico (cat. no. 57), annotated to indicate the locations where the immediate effects of the first manmade nuclear explosion generated on 16 July 1945 at the Trinity Site could be seen, heard, and felt.

New Mexico State Highway Department, *1942 Official Road Map of New Mexico*, National Archives, Washington, D.C., cat. no. 57.

150

3. Deborah Waite, "Kwakiutl Transformation Masks," in Zena Pearlstone Mathews and Aldona Jonaitis, eds. *Native North American Art History: Selected Readings* (Palo Alto, Calif.: Peek Publications, 1982), 144.

4. Lyndon Johnson, quoted in Glenn T. Seaborg, *Nuclear Milestones* (San Francisco: W. H. Freeman and Co., 1972), 31–32 (cat. no. 78).

151

Nootka, *Transformation Mask*, 1890s, The Field
Museum, Chicago, Collected by Charles Newcombe
for The Field Museum, 1903–4 (85234), cat. no. 65.

Shamanism is an "archaic technique of ecstasy," and the shaman priest, who enters into an altered state of consciousness, is the great master of ecstasy.[1] Since shamanism is native to Siberia and Inner Asia (the term is derived from the Tunguz, later the Russian, *xaman*), purists would confine the phenomenon to that geographical area, including the peoples known to us as Inuit, Buryat, Yakut, Altai, and Samoyed. Others would extend shamanism to the contiguous areas of what is sometimes now called the Pacific Rim: Tibet, the Far East, Burma, Indo-China, North and South America (via the Bering Strait), the South Pacific, and Australia. And impurists apply the term generally to any religious phenomenon, anywhere, that has some or all of the characteristics found in Asian shamanism.

Wendy Doniger

SHAMANISM

Most shamans are born into their profession, while some have their shamanism thrust upon them by the spirits or the clan, and relatively few achieve shamanism by their own efforts. It is not a life that many would seek by choice, though it does have its benefits. The shaman undergoes a rigorous traditional training, learning the secret language, mythology, and genealogy, as well as an initiation into the trances and dream techniques, often through self-induced or even accidental ordeals involving sensory deprivation, self-torture, tobacco, or mind-altering drugs. Potential shamans are often identified through behavior so idiosyncratic that the culture perceives it as mental illness, but shamans are not themselves mentally ill. On the contrary, people who go mad may become shamans through curing themselves of their madness, the cure rather than the disease constituting their initiation.

Above all, a shaman is someone who dreams other people's dreams. The shaman may lie in a kind of trance for several days, during which demons or ancestral spirits are said to cut off his head and set it aside to witness his subsequent torture and dismemberment. Thus, like most dreamers, the shaman watches himself dream. This concept of the split soul, one part remaining in the body while the other travels outside, is the defining concept of shamanism. The initiation is usually traumatic; this dream is a nightmare. The shaman's eyes are ripped out of their sockets, his limbs hacked off, the flesh scraped off his bones—which are later clothed in new flesh. Sometimes an animal, usually a bear or walrus, tears the shaman to pieces or devours him. Often the shaman observes himself journeying down into hell or up to heaven, climbing the tree in the navel of the earth, where he meets spirits who instruct him in the healing arts.

Once initiated, a shaman is seldom helplessly possessed by the spirits of the dead, demons, or nature, but usually controls them and communicates with them by will, beating his drum to transform it into a vehicle that will convey him through the air; thus the drum is often called a boat or a horse. The shaman must find the center of the world in order to fly up through a hole in the sky or down through a hole in the earth, or climb up or down a sacred tree. His initiation teaches him how to overcome the obstacles he will meet on this adventure, a journey as wonderful as the initiatory journey was horrible. Once again the shaman becomes a voyeur with a schizoid consciousness, but this time he sees himself leave his body and fly through the air, and he watches himself becoming invisible (an experience that challenges not only the laws of physics but the basic concepts of epistemology). He gains powers, especially over space and time: he can sense things far away, kill things far away, and view events in the distant future. He can also turn into an animal, touch fire without harm, perform magic tricks with fire or other substances (the rope-trick, in which the magician climbs to the sky on an unsupported rope, is part of the repertory of some shamans), or capture the spirits of the dead. The audience is an essential part of the shaman's trance, which is a performance; they act as a chorus, ask questions, and assist him with the ritual.

The shaman may induce a trance for any of a number of reasons, but primarily to bring offerings to a god from the community, to retrieve the wandering soul of someone who has become ill as a result of the soul's departure, to guide the soul of a dead person on its final journey, or simply to hang out with superhuman creatures, perhaps to gain superhuman knowledge. In the first instance, the shaman may sacrifice a horse and conduct its soul to the throne of the lord of the upper world. There the shaman asks the god if the offering has been accepted, requests his protection and his blessing, and incidentally asks for predictions about weather and crops. When someone falls ill, it is usually believed that the soul has wandered away of its own will or has been abducted and held captive by Erlik Khan, the Siberian lord of the dead. If the soul has merely wandered away, the shaman must find it and put it back into the body, but if Erlik has taken it, the shaman must perform a sacrifice, sometimes even offering Erlik another soul in its place. The patient and the shaman decide who this substitute will be; the shaman becomes an eagle and tears out the soul of the scapegoat, who will die soon afterward, while the patient will live for a few more years. When someone has died, the shaman assumes the persona of the dead person (a male shaman will speak in a falsetto voice on behalf of a dead woman) and accompanies that person's soul to meet the dead, who quarrel (in the shaman's voice) and must be persuaded to let the newly dead person join them. Then the shaman returns alone, dancing until he falls down unconscious. Finally, the shaman may return from his journey (undertaken for whatever reason) able to describe the geography not only of earth, but of heaven and hell, in precise detail.

Certain aspects of shamanism have been isolated and identified in other cultures, among ancient Scythians,

Caucasians, Iranians, Greeks, and Indians (the word *shaman* was once thought to be connected with Buddhist terms for renouncers, Pali *samana* or Chinese *sha-men*). Thus, throughout the world, the initiatory priest may ride a horse to heaven or hell to question the dead, or leave his body to fly through the air, or engage in an initiatory marriage with a woman from the spirit world. In particular, rituals and myths in which the priest is metaphorically dismembered or his bones stripped of their flesh are often called "shamanic"; many shamans wear clothing decorated with bones, the tools and symbols of their trade. More broadly still, other sorts of psychic healers are called shamans, and the journeys of the heroes of many epics and of the priests of cults that make use of mind-altering drugs (such as peyotl or the magic mushroom, the *Amanita muscaria*), have been likened to, or even related to, the shaman's journey. The North American Shakers are sometimes said to show a shamanic influence. The use of drugs as a kind of short-cut may well have "democratized" the trance to a certain extent, but the true shaman remains an unusually gifted and unusually trained individual who has the power to mediate between our world and the worlds beyond.

1. See Mircea Eliade's standard text on the subject, *Shamanism: Archaic Techniques of Ecstasy*, trans. Willard R. Trask (London: Routledge and Kegan Paul, 1964). It should be noted that although I have used the masculine pronoun for convenience throughout this essay, the shaman priest may be male or female; indeed, Japanese shamans, for example, are almost always women.

Here the term "language-game" is meant to bring into prominence the fact that the speaking of language is part of an activity, or of a form of life.
Review the multiplicity of language-games in the following examples and in others:
Giving orders, and obeying them—
Describing the appearance of an object, or giving its measurements—
Constructing an object from a description (a drawing)—
. . .
Making up a story; and reading it—
Play-acting—
Singing catches—
Guessing riddles—
Making a joke; telling it—
Solving a problem in practical arithmetic—
Translating from one language into another—
Asking, thanking, cursing, greeting, praying

—Ludwig Wittgenstein[1]

Bruce Nauman remembers traveling from the University of Wisconsin at Madison to see exhibitions at the Art Institute of Chicago and being particularly impressed by a Barnett Newman painting where the signature was prominent on the front of the canvas: "It was amazing to me what a presence that name was in the field of color. He could have signed the painting quietly in the corner, but instead he made it declarative—so real and so there."[2] The painting was *Vir Heroicus Sublimis* (1950–51, now in the Museum of Modern Art, New York), the grandest and most dramatic canvas that completes the sequence of works shown in *Negotiating Rapture*. Nauman's concentration on the words in the painting perhaps signals both his dissatisfaction with painting as a medium and an interest in words as a way to convey meaning. Each of his works exhibited here (cat. nos. 54–56) incorporates words in relatively terse and ordinary phrases, pointing to a heritage in Jasper Johns or Marcel Duchamp and a connection to philosophy via Ludwig Wittgenstein, particularly the *Philosophical Investigations*, which Nauman read closely. Curators, particularly in Europe, have connected Nauman to writers of the 1950s and 1960s, such as Samuel Beckett and Alain Robbe-Grillet, whose language matched the pessimistic position of Jean-Paul Sartre and the French Existentialists. Nauman does share with them a bleak irony but it is modulated by his (American) confidence in the work ethic and his belief that he can always find a solution, alone in his studio, working through the problem. He has indicated an interest in the threshold between comfortable control and loss of control, the point at which one feels the need, in an empty house, "to whistle down a dark space— say cellar stairs—and fill the void to make sure nothing else is in there."[3]

Extending this notion of an uncertain threshold to the realm of language, Nauman has stated:

> I think the point where language starts to break down as a useful tool for communication is the same edge where poetry or art occurs. . . . If you only deal with what is known, you'll have redundancy; on the other hand, if you only deal with the unknown, you cannot communicate at all. There is always some combination of the two, and it is how they touch each other that makes communication interesting.[4]

154

1. Ludwig Wittgenstein, quoted in Robert Storr, "Beyond Words," in Neal Benezra and Kathy Halbreich, *Bruce Nauman: Exhibition Catalogue and Catalogue Raisonné*, ed. Joan Simon (Minneapolis: Walker Art Center in association with the Hirshhorn Museum and Sculpture Garden, Smithsonian Institution, 1994), 57–58.

2. Bruce Nauman, quoted in Brenda Richardson, *Bruce Nauman: Neons* (Baltimore, Md.: Baltimore Museum of Art, 1982), 24.

3. Nauman, quoted in Storr, "Beyond Words," 62.

4. Ibid., 55.

BRUCE NAUMAN WAS BORN IN FORT WAYNE,
Indiana, in 1941. He studied mathematics,
physics, art (especially painting), and, informally,
music and philosophy at the University
of Wisconsin at Madison, receiving his B.A. in
1964. In 1966, he received his M.A. from
the University of California, Davis, where his
teachers were Robert Arneson and William
T. Wiley; he decided at this time to abandon
painting and concentrate on sculpture,
performance, and film. After graduate school,
Nauman set up a studio in San Francisco and
moved to Mill Valley, California, the following
year. In 1968, a grant from the National
Endowment for the Arts allowed him to travel
to New York and to Europe. Returning
to California, he moved to Pasadena, where he
remained for ten years, exhibiting his work
widely in galleries and museums in Europe and
the United States Nauman's interest in
horse training, riding, and breeding began in
1979, with his move to Pecos, New Mexico,
intensifying in 1986 when he met horseman Ray
Hunt. In 1989, Nauman and artist Susan
Rothenberg, his wife, moved to Galisteo, New
Mexico, where they currently live.

Nauman's exhibitions since the 1960s and 1970s
have concentrated primarily on neon signs,
videotapes of performances, sculptural works,
and room installations. In all these media,
through the use of sound, image, text, and works
focusing on the human body, Nauman
has drawn attention to the negative aspects of
human experience, such as loneliness,
death, violence, alienation, helplessness, and
bodily decay.

Further reading

Benezra, Neal, and Kathy Halbreich. *Bruce
Nauman: Exhibition Catalogue and Catalogue
Raisonné.* Edited by Joan Simon. Minneapolis:
Walker Art Center in association with
the Hirshhorn Museum and Sculpture Garden,
Smithsonian Institution, 1994 [extensive bibli-
ography and exhibition history].

Simon, Joan, and Jean-Christophe Ammann.
Bruce Nauman. Exh. cat. London: Whitechapel
Art Gallery and Kunsthalle Basel, 1986.

Alternatively titled *The Mask to Cover the Need for Human Companionship*, *Consummate Mask of Rock* (1975, cat. no. 55) is concerned with the impossibility of communication and the emotional pressure upon both the assumed protagonist and the spectator through the combination of two elements— a typewritten poem and a room-size installation of sixteen large limestone cubes. Nauman considers poem and stones (arranged as a square or a diamond depending on where the viewer stands) to have equal weight. "At some point," he explains, "they came to mean the same thing to me. There was an analog. The whole installation is the mask of rock. Let it be ambiguous. . . . That's two pieces of information to put together or take apart."[5] Evoking the images and rhythms of the children's game "rock, paper, scissors," Nauman uses the game's processes (scissors cut paper, paper covers rock, rock smashes scissors) to enact a painful rite of passage to an existential condition where only the hardness of rock can prevail. The poem concludes:

> (This) man, (so often) taken as (a) child, finding his consumate [sic] mask of rock covered by paper, he finding his wedge being squeezed (from) between his desired truth (truth desired) and his desireless falsity (falsity desireless), he unable to arrouse [sic] his satisfaction, he unable to desire his needs, he proceeds into the gap of his fulfillment his relief lacking the task of human companionship. /Moral/Paper cut from rock, releases rock to crush sissors [sic]. Rock freed from restrictions of paper/sissors/rock, lacking context proceeds.

Nauman's use of language, words rather than poetry, becomes characteristic in neon pieces that involve word games, palindromes, and words nested in others to pursue his sardonic and increasingly disaffected view of society. (*SORE/ EROS* [1974] is one example of an inversion in which pain and pleasure are constantly flickering, like the switches in a binary system.) The artist has employed neon since the mid 1960s when he "drew" around parts of his body with the luminous tubing; later, under the influence of William T. Wiley, he began to present text in this medium. Using neon, a "public means of communication for private purposes,"[6] Nauman reveals the incertitude of existence as he acknowledges a Hobbesian vision of man. His most dramatic display is *One Hundred Live and Die* (1984, cat. no. 56), in which one hundred paired messages are arranged in four columns, not strictly oppositions, but each containing the imperative LIVE or DIE. They are programmed to present a sequence of phrases, which culminates in all the words being switched on before the cycle begins again. The first group is as follows: live and die, die and die, shit and die, piss and die, eat and die, sleep and die, love and die, hate and die, fuck and die, speak and die, lie and die. In the list of artistic modes Nauman wrote in 1966, he ends with the category: "5. Simple sounds—spoken and written words/Metacommunication messages/Feedback/Analogic and digital codification."[7] The sequencing of phrases in *One Hundred Live and Die*

155

5. Nauman, quoted in Benezra and Halbreich, *Bruce Nauman*, 265–66; cat. no. 238.

6. Nauman, quoted in Storr, "Beyond Words," 53.

7. Ibid., 58.

works in both these last categories—as an analogue for our personal interactions, living and dying, and, in a strange parallel, a digital, binary, on/off commentary on an existence without any anchors in religious belief. Human beings are alone in their choices. The repetition of phrases, not unlike the bleakly depressive but curiously life-absorbed reflections of Louis-Ferdinand Céline (who was, after all, a doctor) provide some sense of our dangerous self-preoccupation without reference to our soul. "Soul," as Robert Storr points out, is the word Nauman leaves out of his neons and the element that is consciously revoked in a series of rooms and large-scale sculptures that followed *One Hundred Live and Die*.[8] The absence of soul is perhaps both the loss of innocence and the inevitable consequence of our existential and purposeless journey. Nauman's contemporary aesthetic is a later version of English poet and cleric John Donne's regard for the soul, Nauman being without a belief in God but with a need to approach nature and its manifestations through the human. Donne wrote in "The Extasie":

> As our blood labours to beget
> Spirits, as like soules it can,
> Because such fingers need to knit
> That subtile knot, which makes us man:
> So must pure lovers soules descend
> T'affections, and to faculties,
> Which sense may reach and apprehend,
> Else a great Prince in prison lies.[9]

8. Ibid.

9. John Donne, "The Extasie," *Donne: Poetical Works*, ed. Herbert Grierson (London: Oxford University Press, 1966), 48.

156

Bruce Nauman, *One Hundred Live and Die*, 1984 (exhibition copy), Benesse Corporation, Naoshima Contemporary Art Museum, Japan, cat. no. 56.

The Consummate Mask of Rock

1. meat
2. fidelity
3. truth
4. life
5. cover
6. pain
7. desire
8. need
9. human companionship
10. nothing
11. cover removed
12. infidelity
13. painless
14. meat/mask
15. people
16. die
17. exposure.

1. This is my mask of fidelity to truth and life.
2. This is to cover the meat of pain and desire.
3. This is to mask the cover of need for human companionship.
4. This is to mask the cover.
5. This is to cover the meat.
6. This is the need of cover.
7. This is the need of the mask.
8. This is the need of cover of need.
9. Nothing and no
10. No thing and no mask can cover the lack, alas.
11. Lack before cover
 paper covers rock
 rock breaks meat
 alas, alack.
12. Nothing to cover.
13. This is the
15. This is the mask to cover my infidelity to truth.
14.
16. This is the mask to cover my infidelity to truth.
 (This is my cover.)
14. This is the need for pain that contorts my mask conveying the message of
 truth and fidelity to life.
15. This is the truth that distorts my need for human companionship.
16. This is the distortion of truth caused by my painful need.
17. This is the mask of my painful need distressed by truth and human companionship.
18. This is my painless mask that fails to touch my face but floats before its
 surface of my skin my eyes my teeth my tongue.
19. Desire is my mask.
 (Mask of Desire)
20. Desired desire
 cover revival
 desire revived
 cover reminded.
21. PEOPLE DIE OF EXPOSURE.

CONSUMATION/CONSUMMATION/TASK

[passive]
paper covers rock

[active - threatening]
scissors cuts paper

[active - violent]
rock breaks scissors

1. meat 4. desire
2. cover 5. need for human companionship
3. diminish 6. lack

desire covers meat

need for human companionship masks desire

meat diminishes need for human companionship

need for human companionship diminishes cover

desire consumes human companionship

cover lacks desire

THIS IS THE COVER THAT INSPIRES THE MASK OF LACK THAT CONSUMES THE NEED FOR
HUMAN COMPANIONSHIP.
THIS IS THE COVER THAT INSPIRES THE TASK OF THE NEED OF HUMAN COMP.
THIS IS THE TASK OF CONSUMING HUMAN COMP.

1. Some kind of fact
2. Some kind of fiction.
3. The way we behaved in the past
4. What we believe to be the case now
5. the consuming task of human companionship
6. the consummate mask of rock

(1.) Fiction erodes fact.
(2.) Fact becomes the way we have behaved in the past.
(3.) The way we have behaved in the past congeals into the consummate mask of rock.
(4.) The way we have behaved in the past contributes to the consuming task of
human companionship.
(5.) The consuming task of human comp. erodes the consummate mask of rock.
However (2.) Fact becomes the way we have behaved in the past may be substituted
into (5.) and (4.) so that
(6.) Fact congeals into the consummate mask of rock.
But (5.) the consuming task of human comp. erodes the consummate mask of rock or
the consuming task of human comp. erodes fact, then from (1.) it follows that
THE CONSUMING TASK OF HUMAN COMPANIONSHIP IS FALSE.

THE CONSUMMATE MASK OF ROCK HAVING DRIVEN THE WEDGE OF DESIRE THAT DISTINGUISHED
TRUTH AND FALSITY LIES COVERED BY PAPER.

1. [This young man, taken to task so often, now finds in his only
 sexual relief.]
2. [This young man, so often taken to task, now finds in his only
 sexual fulfillment.]
3. [This man, so often taken to task as a child....]
4. [This man, often taken to task, now finds it satisfies his sexual desires.]
5. This man, so often taken as a child, now wears the consummate mask of rock
 and uses it to drive the wedge of desire into the ever squeezing gap between
 truth and fidelity.
6. This man, so often taken as a child, now uses his consummate mask of his need
 to drive his wedge of his desire into his ever squeezing [him] gap between his
 truth, his falsity.
7. [This] man, [so often] taken as [a] child, finding his consummate mask of rock
 covered by paper, re finding his wedge being squeezed [from] between his desired
 truth (truth desired) and his desireless falsity [falsity desireless], he unable
 to arouse his satisfaction, he unable to desire his needs, he proceeds into the
 gap of his fulfillment his relief lacking the task of human companionship.

Moral

Paper cut from rock, releases rock to crush scissors. Rock freed from restrictions
of paper/ scissors/ rock, lacking content processes.

J. Human 1973

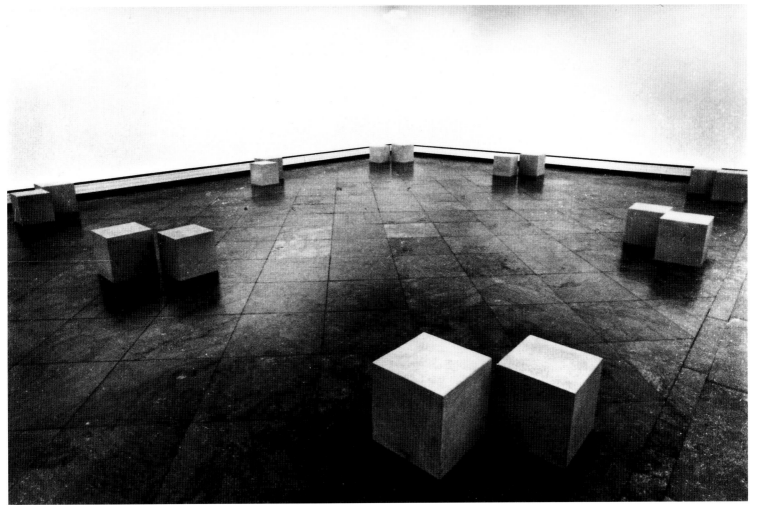

159

Bruce Nauman, *Consummate Mask of Rock*, 1975
(exhibition copy), Anthony d'Offay Gallery, London,
cat. no. 55. Above, limestone cubes installed; left, text
(see pps. 172–73 for transcription).

The Consumate Mask of Rock

I

1. mask
2. fidelity
3. truth
4. life
5. cover
6. pain
7. desire
8. need
9. human companionship
10. nothing
11. COVER REVOKED
12. infidelity
13. painless
14. musk/skum
15. people
16. die
17. exposure.

2

1. This is my mask of fidelity to truth and life.
2. This is to cover the mask of pain and desire.
3. This is to mask the cover of need for human companionship.
4. This is to mask the cover.
5. This is to cover the mask.
6. This is the need of cover.
7. This is the need of the mask.
8. This is the mask of cover of need.
9. Nothing and no
9. No thing and no mask can cover the lack, alas.
10. Lack after nothing before cover revoked.
11. Lack before cover
 paper covers rock
 rock breaks mask
 alas, alack.

12. Nothing to cover.
13. This is the
13. This is the mask to cover my infidelity to truth.
14.
13. This is the mask to cover my infidelity to truth.
 (This is my cover.)
14. This is the need for pain that contorts my mask conveying the message of truth and fidelity to life.
15. This is the truth that distorts my need for human companionship.
16. This is the distortion of truth masked by my painful need.
17. This is the mask of my painful need distressed by truth and human companionship.
18. This is my painless mask that fails to touch my face but floats before the surface of my skin my eyes my teeth my tongue.
19. Desire is my mask.
 (Musk of desire)
20. Rescind desire
 cover revoked
 desire revoked
 cover rescinded
21. PEOPLE DIE OF EXPOSURE.

3

CONSUMATION/CONSUMNATION/TASK

(passive)
paper covers rock

 (active - threatening)
 sissors cuts paper

(active - violent)
rock breaks sissors

1. mask 4. desire
2. cover 5. need for human companionship
3. diminish 6. lack

desire covers mask
 need for human companionship masks desire
mask diminishes need for human companionship

 need for human companionship diminishes cover
 desire consumes human companionship
cover lacks desire

4

THIS IS THE COVER THAT DESIRES THE MASK OF LACK THAT CONSUMES THE NEED FOR HUMAN COMPANIONSHIP.
THIS IS THE COVER THAT DESPISES THE TASK OF THE NEED OF HUMAN COMP.
THIS IS THE TASK OF CONSUMING HUMAN COMP.

5

1. some kind of fact
2. some kind of fiction
3. the way we behaved in the past
4. what we believe to be the case now
5. the consuming task of human companionship
6. the consumate mask of rock

(1.) Fiction erodes fact.
(2.) Fact becomes the way we have behaved in the past.
(3.) The way we have behaved in the past congeals into the consumate mask of rock.
(4.) The way we have behaved in the past contributes to the consuming task of human companionship.
(5.) The consuming task of human comp. erodes the consumate mask of rock. However (2.) Fact becomes the way we have behaved in the past may be substituted into (3.) and (4.) so that
(6.) Fact congeals into the consumate mask of rock.
But (5.) the consuming task of human comp. erodes the consumate mask of rock or the consuming task of human comp. erodes fact, then from (1.) it follows that
THE CONSUMING TASK OF HUMAN COMPANIONSHIP IS FALSE.

6

THE CONSUMATE MASK OF ROCK HAVING DRIVEN THE WEDGE OF DESIRE THAT DISTINGUISHED TRUTH AND FALSITY LIES COVERED BY PAPER.

7

1. (This young man, taken to task so often, now finds is his only sexual relief.)
2. (This young man, so often taken to task, now finds it his only sexual fulfillment.)
3. (This man, so often taken to task as a child. . . .)
4. (This man, often taken to task, now finds it satisfies/arrouses his sexual desires/needs.)
5. This man, so often taken as a child, now wears the consumate mask of rock and uses it to drive his wedge of desire into the ever squeezing gap between truth and falsity.
6. This man, so often taken as a child, now uses his consumate mask of his rock to drive his wedge of his desire into his ever squeezing (his) gap between his truth, his falsity.
7. (This) man, (so often) taken as (a) child, finding his consumate mask of rock covered by paper, he finding his wedge being squeezed (from) between his desired truth (truth desired) and his desireless falsity (falsity desireless), he unable to arrouse his satisfaction, he unable to desire his needs, he proceeds into the gap of his fulfillment his relief lacking the task of human companionship.

Moral

Paper cut from rock, releases rock to crush sissors. Rock freed from restrictions of paper/sissors/rock, lacking context proceeds.

B. Nauman 1975

The whole trend of our time is toward the secular. The endeavors of the mystics will be remembered as mere episodes. Despite our greater understanding of life, we shall build no cathedrals. Nor do the brave gestures of the Romantics mean anything to us, for behind them we detect their empty form. Ours is not an age of pathos; we do not respect flights of the spirit as much as we value reason and realism.

—Ludwig Mies van der Rohe[1]

Friedrichstrasse Skyscraper (cat. no. 53) by Ludwig Mies van der Rohe was the German architect's submission to a 1921 design competition for an office block in Berlin, bordered by the busy Friedrichstrasse, a railroad station, and the Spree River. Mies's design, rejected by the committee and disregarded without even an official mention,[2] proposed three arrowhead-shaped steel and glass towers, built around a central service core, with the corners of the buildings projecting into the corners of the triangular site. Glass walls had previously been used only on some public exposition spaces and department stores.

Mies's glass skyscraper projects have long been recognized as emblems of a modernist architecture that broke completely with its traditional and classical past. Far from being reasoned and merely realistic, these buildings suggest an aspiration for soaring technical brilliance that in itself approaches the mystical. The Friedrichstrasse proposal is included in *Negotiating Rapture* both to acknowledge the debt to Mies's vision of crystalline modernism (in Chicago, especially) and to suggest that the German philosophic idealism, which is part of the heritage of Joseph Beuys, was equally expressed in built form. The roots of this philosophy in the romantic sublime and its quasi-religious mythology is important for Anselm Kiefer also. Each of the artists (and architects) has created a place for him- or herself in this cosmology.

1. Ludwig Mies van der Rohe (1924), quoted in Philip C. Johnson, *Mies van der Rohe* (New York: Museum of Modern Art, 1978 [1947]), 191–92.

2. Franz Schulze, *Mies van der Rohe: A Critical Biography* (Chicago: University of Chicago Press, 1985), 96–100.

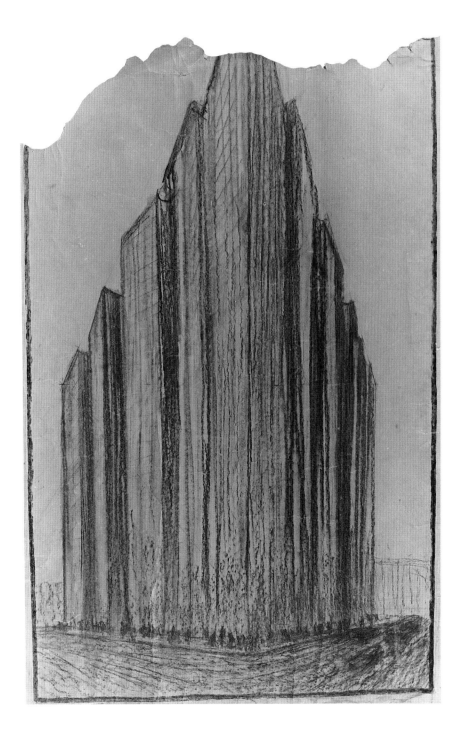

Ludwig Mies van der Rohe, *Friedrichstrasse Skyscraper*, preliminary perspective (north and east sides), 1921, The Mies van der Rohe Archive, The Museum of Modern Art, New York, Gift of the architect, cat. no. 53.

Frank Lloyd Wright designed Unity Temple in Oak Park in the prairie style, building, he claimed, "a *natural* building for natural Man." He was committed to creating structures whose lines worked in harmony with the land, and whose programs suited the needs of their users. In his design for the church (1904, cat. no. 86), Wright avoided traditional religious symbols, preferring that client and architect find their spirituality within their congregation and in association with nature: "The sense of inner rhythm," he wrote, "deep planted in human sensibility, lives far above other considerations in Art."[1] He described with some reverence the process of drawing up his plans:

> A thrilling moment this in any architect's experience. He is about to see the countenance of something he is invoking. Out of this sense of order and his love of the beauty of life—something is to be born maybe to live long as a message of hope and joy or a curse to his kind. . . . This is the faith and the fear in the architect as he makes ready—to draw his design. In all artists it is the same.

Wright is a pragmatic pioneer by comparison with Ludwig Mies van der Rohe (see cat. no. 53). Wright's skyscraper project (1924–25, cat. no. 85, which would have been built on Michigan Avenue less than two blocks from the new Museum of Contemporary Art) was for an insurance company. Its planning is straightforward and conventional; what distinguishes it is the architect's decorative detailing. He employed symbols both from nature and from the architectural history of several cultures, which become in his hands a search for a mythological grail of nature in the sense that Thoreau and Emerson envisaged it.

1. Frank Lloyd Wright, *Frank Lloyd Wright: Writings and Buildings* (New York: World Publishing Company, 1965), 75.

Frank Lloyd Wright, *National Life Insurance Company Building Project, Chicago, Illinois*, perspective, 1924–25, private collection, Chicago, cat. no. 85 (above).

Frank Lloyd Wright, *Unity Temple, Oak Park, Illinois*, perspective, 1904, LINC Group, Chicago, cat. no. 86 (below).

Only a few years separate Ludwig Mies van der Rohe's Friedrichstrasse office building projected for Berlin in 1921 from Frank Lloyd Wright's National Life Insurance complex designed in 1924 for A. M. Johnson. Both (unrealized) works were exercises in the dematerialization of mass through the application of a curtain wall covering the entire structure. Aside from this common attribute, no two works could be more unalike; the one a *bâtiment d'angle* filling an irregular street intersection, the other a stepped orthogonal complex dropped into the Chicago grid. Mies's prototypical high-rise was rendered as a neo-expressionist crystal, Wright's proto–art deco cluster block was an indented, tessellated fabric hung from the cantilevered floors of a reinforced concrete armature. Where the former depended for its effect upon the shadow-free play of multiple reflections across a faceted surface rising without a single break from sidewalk to skyline, the other cascaded down the perimeter of a set-back block like an oriental mosaic. Where the one was comprised of enormous planes of virtually frameless glass, the other was a giant *repoussée* fabric that alternated between copper cladding and glass infill. Both works were relatively scaleless and in retrospect their romantic appeal stemmed from their rising like shining mesas from the dark encrusted canyons of the nineteenth-century city. In other respects, they were quite distinct as much for the way in which they were conceived as for the level at which they were resolved.

Kenneth Frampton

"ALMOST NOTHING"

In Mies's case, we have essentially no more than two drawings: a typical floor, with the minimal indications as to elevators, stairs, partitions, and vertical supports, and a large perspective on rough paper, which in itself is nothing short of miraculous, for where did he learn to draw like this, this laconic *Baumeister* from Aachen? One thing is for sure, this is the first full manifestation of his famous aphoristic phrase "almost nothing," *beinahe nichts*. This slogan resonates in the mind as one contemplates this coarse but infinitely sensitive rendering, which is almost nothing both as a drawing and as a concept: a material immateriality in fact, brown paper, wax crayon, a touch of charcoal, the manifestation of stuff on stuff. It is a chimeric, metaphoric image of polished material that may in one instant be crystalline and opaque and, in another, totally transparent. It is exactly the same perceptual/conceptual oscillation that one finds in Mies's later buildings—glass used like stone and stone like glass, the one passing imperceptibly into the other.

In some measure, this is also Wright's aim, although rendered in an entirely different key, a tinted axonometric technically and tectonically resolved at a higher level. As with all of Wright's work, the essential pieces are fully articulated and appropriately dimensioned. We are left in no doubt as to the dimension of the elevators, stairs, and ducts, and as to the integration of the modular

fenestration with the flexible partitioning, along with the unorthodox character of the "pagoda" structure and its monolithic cantilevered floors. It is all there and eminently buildable, but what is also there, to equally ephemeral ends, is the transmutation of one material into another—copper into glass, opacity into transparency, and verdigris into iridescent crystal. Such a metamorphosis would have been facilitated here by the fenestration, which Wright conceived as woven into a two-way rectilinear grid, sustaining to an equal degree both the movable partitions and the infinite cupro-vitreous squares that envelop the building. A comparable fusion may be detected in Mies's Seagram Building (1959) where the illusion of a single material arises as much from the bronze fenestration as from the brown-tinted glass.

Both men sought an "other" architecture, with Mies grounding his feeling for the sublime in a multifaceted prism and Wright conceiving of his megastructure as an aggregation. Thus Wright refers to his exterior walls as dissolving into "suspended standardized sheet-copper screens."

> The walls themselves cease to exist as either weight or thickness. Windows become in this fabrication a matter of a unit in the screen fabric, opening singly or in groups at the will of the occupant. . . .The vertical mullions . . . project as much or as little as wanted. Much projection enriches the shadow. Less projection dispels the shadows and brightens the interior.[1]

Mies, on the other hand, would picture his megalith in more specular terms:

> In my project for a skyscraper at the Friedrichstrasse Station in Berlin, I used a prismatic form which seemed to me to fit the triangular site of the building. I placed the glass walls at slight angles to each other to avoid the monotony of over large glass surfaces. I discovered that the important thing is the play of reflections and not the effect of light and shadow as in ordinary buildings.[2]

For Wright, the trick was to be turned by modular shop production running from the tessellated skin to the movable metal partitions. For Mies, on the other hand, all such matters were left laconically vague. Nothing in fact was given beyond the tripartite plan with its triadic staircases—nothing, that is, save this precipitous iceberg rising from the miasma of the city like a ghost ship, the sublime as Caspar David Friedrich had imagined it.

While Mies would never return to the mystical expressivity of this Berlin high-rise, the sense of a building made out of a single material was surely as present in the metal model of the Seagram Building as in his wax-crayon *frottage* of Friedrichstrasse, which at times paradoxically

recalls the grain in a block of travertine. Now you see it, now you don't, in one instant a stone rubbing, in another, the highlights of faceted walls, executed in plate glass and dissolving into the ether. As he put it in his late prime, "I once went to Italy, it was awful. . . . I couldn't wait to get back to the north where the light is grey and subtle."

1. *Frank Lloyd Wright Collected Writings*, vol. 1, *1894–1930*, ed. Bruce Brooks Pfeiffer (New York: Rizzoli/New York in association with The Frank Lloyd Wright Foundation, 1992), 308.

2. Cited in Philip C. Johnson, *Mies van der Rohe*, 3d rev. ed. (New York: Museum of Modern Art, and Boston: New York Graphic Society, 1978), 187.

She swallowed a draught of tea from her cup held by nothandle and, having wiped her fingertips smartly on the blanket, began to search the text with the hairpin till she reached the word.

—Met him what? he asked.

—Here, she said. What does that mean?

He leaned downwards and read near her polished thumbnail.

—Metempsychosis?

—Yes. Who's he when he's at home?

—Metempsychosis, he said, frowning. It's Greek: from the Greek. That means the transmigration of souls.

—O, rocks! She said. Tell us in plain words.

—James Joyce[1]

Joseph Beuys, *From the Life of the Bees*, 1956, wood stain on torn paper, 18 7/8 x 25 3/8 in. (48 x 64.5 cm), irregular, Froehlich Collection, Stuttgart.

Personality and life history have dominated discussions of Joseph Beuys; his own hermetic and capricious text *Life Course/Work Course* (1964) establishes the basis for this tendency. Beuys conflated his artistic practice, his biography, and Norse and Germanic mythology to create a dominant persona in the postwar art world. The works exhibited here (cat. nos. 5–8) represent two paths Beuys followed throughout his career: the drawings investigate ideas about natural history, while the vitrines present his reflections on himself and his role as shaman. Beuys constructed the vitrines toward the end of his career, often recycling materials used in previous pieces and performances, recapitulating many of the themes of his major sculptural periods. Fat and felt represent his rebirth after his airplane crash and rescue by Tatar peasants in 1942–43; elements from his medical history (x-rays and specimen jars) indicate his personal frailty; the batteries and fragments of plants, bones, and blocks of wax refer to his self-created mythology as shaman.[2]

The botanical drawings date to Beuys's early career (before his artistic training) and to a later moment when he was revisiting many previous themes. Natural history had been a consuming interest for him as a young man; it came to stand for a universal equivalent to the eternal guiding force of creativity. Much has been written about Beuys's adoption of Germanic traditions and philosophies and mythological and spiritualist thought in his highly personal symbolic iconography. His preferred symbols include the stag, swan, hare, bee, representations of women, and geometric and crystalline forms. *From the Life of the Bees* (1956, illus. left), inspired by Maurice Maeterlinck's classic *Life of the Bee* (1901) and Rudolph Steiner's lecture "About Bees" (1923), is concerned both with the insect creating the solid hexagons of the honeycomb from amorphous wax and the transformation of a greasy substance into solid geometric form. This metamorphosis from formlessness to concrete form became the basis for Beuys's theory of sculpture.[3] In the botanical drawings, plants suggest the themes of birth, flowering, and rebirth; there are often allusions to curative powers. *Herb Robert* (1941, cat. no. 5) presents two pressed flowers of the *Geranium robertianum* variety, a common plant with medicinal uses, on a sheet covered by a list of botanical names. Beuys, like many of his contemporaries, had been a member of the Hitler Youth; he differed from them perhaps when he rescued books—such as Carl von Linné's *Systema Naturae* of plant morphology—from the Nazi bonfires. Later drawings, including *Ombelico di Venere–Cotyledon Umbilicus Veneris* (1985, cat. no. 8), a common European perennial, were made in Italy, adding a delicate and retrospective symbolism just before Beuys exhibited his vitrines for the first time.

1. James Joyce, *Ulysses*, ed. Hans Walter Gabler and Wolfhard Steppe (New York: Random House, Inc., 1986), 52.

2. Beuys included works he called "Fontana Tins," small lead boxes with slits in their tops, in some of his vitrines (see cat. nos. 7, 9), intentionally relating the objects to Lucio Fontana's paintings and tomb sculptures (cat. nos. 21–28).

3. Ann Tempkin, "Joseph Beuys: Life Drawing," in Bernice Rose and Ann Tempkin, *Thinking Is Form: The Drawings of Joseph Beuys* (New York: Museum of Modern Art, and Philadelphia: Philadelphia Museum of Art, 1993), 34–35.

BORN IN KREFELD, GERMANY, JOSEPH BEUYS (1921–1986) spent his childhood in Kleves and the neighboring town of Rindern, where his family ran a grain and feed store. In 1940, after his high-school graduation, he planned to study medicine in university but was drafted into the German air force and served as an aircraft radio operator until 1946. From 1947 to 1948, he studied sculpture at the Staatliche Kunstakademie in Düsseldorf. Beuys spent the 1950s in seclusion in Düsseldorf, creating thousands of works on paper (in oil, watercolor, ink, and pencil), depicting subjects found in nature (flowers, leaves, grass, the human body, animals, and insects) and Christian themes. In 1961, he became professor of monumental sculpture at his former academy, from which, in 1972, he was dismissed for unorthodox teaching methods. The following year, he helped found the Free International University for Creativity and International Research, where he worked until his death in Düsseldorf.

Beuys combined his life and artwork in the action performances he gave with the Fluxus group in 1963 and thereafter, and created his own personal mythology in a written narrative, *Life Course/Work Course*. He recounted how in 1943 his air-force plane had crash-landed during a snowstorm over the Crimean peninsula. Badly wounded, he was found and cared for by a group of Tatars, who saved him by wrapping him in fat and felt. Beuys employed these materials, as well as organic substances such as blood, bone, wax, fur, and hair, in his drawings, sculpture, and performance works of the next decades.

Further reading

Adriani, Götz, Winfried Konnertz, and Karin Thomas. *Joseph Beuys, Life and Works.* Translated by Patricia Lech. Woodbury, N.Y.: Barron's Educational Series, Inc., 1979.

Hergott, Fabrice, ed. *Joseph Beuys.* Exh. cat. Paris: Musée National d'Art Moderne, 1994.

Rose, Bernice and Ann Tempkin. *Thinking Is Form: The Drawings of Joseph Beuys.* Exh. cat. New York: Museum of Modern Art, and Philadelphia: Philadelphia Museum of Art, 1993 [extensive bibliography].

Stachelhaus, Heiner. *Joseph Beuys.* Translated by David Britt. New York: Abbeville Press, 1991 [extensive bibliography].

Tisdall, Caroline. *Joseph Beuys.* Exh. cat. New York: Solomon R. Guggenheim Museum, 1979.

Beuys was deeply concerned with two bodies of knowledge that relate closely to the themes of this exhibition: Anthroposophy and shamanism. Anthroposophy was a religion founded by Steiner, a leading German spiritualist early in this century. Influenced by the Theosophy of Madame Helena Blavatsky and a form of Rosicrucianism which was highly influential in modernist painting circles, Steiner developed a spiritualism whose goal was world change. In a certain sense, change too is the aim of shamanism (discussed already in relation to the masks of the Northwest Coast which had a common source in Siberian shamanic practice). Beuys pursued the curative faculty of shamanism principally in his lectures and demonstrations, where the religious aspect was often converted into a type of Utopianism, whose purpose was to revolutionize society.

Beuys was steeped in German spiritualist, classical, and religious literature; he often quoted Steiner's writings on art and society in both lectures and the drawings that accompanied them.[4] In a 1974 lecture, Beuys explored the conjunction of these ideas and his chosen language of drawing:

> They [the drawings] show an infinite number of aspects of topics, but I have tried to arrange them so that those concepts (that is, shamanistic concepts) that harken back, all these backward harkening constellations, are arranged so that formally they can awaken interest in the current consciousness of the viewer so that he becomes interested in a general view of man in time, not only presently, not only looking back historically, anthropologically, but also offering aspects for the future, offering solutions by way of an opening of problems. Opened thus, that interest orients itself towards a central point; the organization of human life evolving out of the future, happening through the present, and formulating new creative models for the formation of the present. Or, one could say to sculpt new models for the entirety of life.[5]

4. John F. Moffitt begins to make the argument in *Occultism in Avant-Garde Art: The Case of Joseph Beuys* (Ann Arbor, Mich.: UMI Research Press, 1988), chapter 5, where even a flawed analysis of the similarities provides ample evidence of Beuys's debt to Steiner.

5. Joseph Beuys, quoted in Bernice Rose, "Joseph Beuys and the Language of Drawing," in Rose and Tempkin, *Thinking Is Form*, III.

Joseph Beuys, *Herb Robert*, 1941, Edward C. Cohen,
New York, cat. no. 5.

171

Joseph Beuys, *Ombelico di Venere–Cotyledon*
Umbilicus Veneris, 1985, Christine and Isy Brachot,
Brussels, cat. no. 8 (four of ten).

Joseph Beuys, *Untitled (Vitrine)*, 1975–83, Tate
Gallery, London, cat. no. 7.

173

Joseph Beuys, *Untitled (Vitrine with Air-Raid Precautions) (Ohne Titel [Vitrine mit Luftschutz])*, 1962–83, Solomon R. Guggenheim Museum, New York, cat. no. 6.

. . . He set on your finger the royal signet so that you might become a ruler having authority.

Whoever circumambulates about the heart becomes the soul of the world, heart-ravishing.

The heart-forlorn becomes companion to the moth, he circles about the tip of the candle.

Because his body is earthy and his heart of fire—congener has an inclination towards congener.

Every star circles about the sky, because purity is the congener of purity.

The mystic's soul circles about annihilation, even as iron about a magnet.

Because annihilation is true existence in his sight, his eyes have been washed clean of squinting and error. . . .

—Jalaluddin Rumi[1]

This rosette, or *shamsa* (cat. no. 27), is similar to one from an album made for Emperors Jahangir and his son Shahjahan of the Mughal Dynasty of India, who reigned from 1569 to 1627 and 1628 to 1658, respectively. A patron of architecture and the decorative arts, Shahjahan commissioned the building of the Taj Mahal; the floral pattern and symmetrical composition of this sheet are characteristic of the works he favored, and the example in the Kevorkian Album (Metropolitan Museum of Art, New York) bears his name and title in Arabic in the center.[2] The geometric quality of this piece is typical of Islamic art. Because representational images are generally forbidden, Muslim artists rely on geometry and its continual reiterations to construct complex shapes that resemble nature, while calligraphy provides the "organic" counterpart. Calligraphy is as highly regarded as painting in Muslim culture; indeed, according to Annemarie Schimmel, "the calligrapher who was able to write the uncreated word of God—that is, the Koran—in flawless, beautiful letters was sure he would be admitted to paradise."[3] Scrutinized carefully, the mathematical generation of shapes in these works is an almost mystical revelation. There is a close visual connection between this album page and the geometry of Shirazeh Houshiary's squares (cat. no. 26), and our intention is to place her objects within the sacred traditions of Islam and, specifically, Sufism.

1. Maulana Jalal al-Din Rumi, *Mystical Poems of Rumi: First Selection, Poems 1–200*, trans. A. J. Arberry (Chicago: University of Chicago Press, 1968), 31.

2. Annemarie Schimmel, "The Calligraphy and Poetry of the Kevorkian Album," in *The Emperors' Album: Images of Mughal India*, introduction by Stuart Cary Welch (New York: Metropolitan Museum of Art, 1987), 80–81.

3. Ibid., 31.

Indian, Mughal Period, *Rosette (Shamsa) from an Album* , c. 1640–50, Arthur M. Sackler Museum, Harvard University Art Museums, private collection, cat. no. 27.

How can a man sit down and quietly pare his nails, while the earth goes gyrating ahead amid such a din of sphere music, whirling him along about her axis some twenty-four thousand miles between sun and sun, but mainly in a circle some two million miles actual progress? And then such a hurly-burly on the surface . . . and then that summer simmering which our ears are used to, which would otherwise be christened confusion worse confounded, but is now ironically called "silence audible."

—Henry David Thoreau[1]

Language was the subject of Shirazeh Houshiary's first exhibition in 1982, where Arabic words and letters were re-created in fragile, cracking sculptures made from clay and straw. The letters referred to, as Houshiary translated them into Western terms, earth, air, fire, and water—universals that govern her thinking about religion and the inner life. Houshiary is a Sufi, which means that she maintains her Islamic beliefs but has taken on additional ascetic tasks and exercises whose goal is communion with the deity through contemplation and ecstasy.

Sufism began in the eighth century and by the thirteenth the mystical poet Jalaluddin Rumi, living in Konya, Turkey, was its most important advocate. Rumi has remained a vital and important source of interpretive and religious support for Sufis and others. Like other Muslims, Sufis use the Koran to provide interpretations of the world, but they are especially mindful of allegorical or symbolic interpretations, and believe that every passage has both a literal and a hidden (or an outer and an inner) meaning. Their belief leads them constantly to search for the reality of God. Rumi's progress toward divine revelation is outlined in Annemarie Schimmel's essay, where the significance of "becoming," through transcendent exercises, dancing and whirling, leads to divine enlightenment.

Houshiary relates the metaphor of the spinning dance to cosmic motion, to the planets turning around the sun, but raises its intensity to a point "where all particles and planets dance in a divine festival. The more one turns, the more one undoes the forces of Earth's hold until, finally one can break free and fly towards the infinite."[2] In *Turning around the Centre* (1993, cat. no. 26), Houshiary has made four cubes, encased in lead, each containing a "spinning" square. The implied motion of the squares, which describes a circle, is to unify heaven and Earth. There is a progression from the darkness of lead, through two stages of an increasing ratio of gold to lead, to a full golden square where the work appears to emanate light. Houshiary associates this progress with enlightenment and the achievement of the transcendent experience of oneness. She writes of the dancer arriving at the moment of "breaking free": "Once there, every being unveils his true gold around which he continues to turn. With each rotation, the core of gold becomes more and more visible, reflecting the light's rays. Turning around the column of the self creates an intense experience of rapture, its vibrations striking the chords of every heart." The sculpture defines, in Sufi terms, the progress of the soul, "its origin, its descent to the material world, its life on Earth, and its ultimate quest to return to its true home. By recognizing (the) path that leads us to life itself," Houshiary continues, "one can no longer be content with the form, but seeks the inner meaning. The outer form passes away while the inner reality remains forever."

1. Henry David Thoreau, *The Heart of Thoreau's Journals*, ed. Odell Shepard (New York: Dover Publications, 1961), 4.

2. Shirazeh Houshiary, unpublished manuscript, "Turning around the Centre," ed. Regina Coppola, 1992, 1. Subsequent quotations are from pp. 1 and 2, respectively.

BORN IN SHIRAZ, IRAN, IN 1955, SHIRAZEH Houshiary developed an early interest in architecture, her father's profession. She was educated in Tehran, attending Drama School for one year before moving to England in 1973. Enrolled at the Hornsey College of Art for a year, she then studied at London's Chelsea School of Art from 1976 to 1978, and was awarded the junior fellowship at Cardiff College of Art, Wales, from 1979 to 1980. Subsequently, Houshiary taught at various art schools in London until 1985 when she began to concentrate full time on her own work. She currently lives and works in London.

From 1981 to 1982, Houshiary made sculptural works from organic materials such as clay, straw, and wood, and by 1984 began experimenting with metal in a series of welded steel sculptures. Since 1990, Houshiary has been working almost exclusively with aluminum, copper, lead, silver, gold, and platinum, creating sculptures and sculptural installations in which she integrates her interests in the mathematical symbolism and geometric forms of Islamic art, the poetry of thirteenth-century poet and preacher Jalaluddin Rumi, and Sufi philosophy.

Further reading

Hutchinson, John. *Dancing around My Ghost: Shirazeh Houshiary*. Exh. cat. London: Camden Arts Center, Dublin, 1993.

Lewison, Jeremy and Jo-Anne Birnie Danzker. *Isthmus: Shirazeh Houshiary*. Exh. cat. Grenoble: Magasin, Centre National d'Art Contemporain de Grenoble, 1995 [extensive bibliography].

Morgan, Anne Barclay. *Turning around the Centre: Shirazeh Houshiary*. Exh. cat. Amherst, Mass.: University Gallery, University of Massachusetts, 1993.

Salvadori, Fulvio. *Shirazeh Houshiary*. Exh. cat. Geneva: Centre d'Art Contemporain, and Oxford: Museum of Modern Art, 1988.

▶ Shirazeh Houshiary, *Turning around the Centre*, 1993, Lisson Gallery, London, cat. no. 26, photograph of installation at the University Gallery, University of Massachusetts, Amherst, 1993 (detail shown above).

I died as a mineral and appeared as a plant,
I died as a plant and reached the animal stage,
I died from the animaldom and became a human being—
Why, then, should I fear? When did I become less by dying?
Now I shall die to my human stage
and soar high to reach that of the angels,
and even from angelhood I must escape.
"Everything is perishing except His Face" (Sura 28:88).
Once more I shall be sacrificed and die from angelhood—
I shall become that which cannot be imagined.
Then I'll become non-existence.
Non-existence says, loud as an organ,
"Verily unto Him shall we return!" (Sura 2:156).

Annemarie Schimmel

JALALUDDIN RUMI—
MYSTIC SUPREME
OF THE
ISLAMIC WORLD

These verses were composed around 1263 by the greatest mystical poet in Islamdom, Maulana (our master) Jalaluddin Rumi. He was born in 1207 in or near the city of Balkh in present-day Afghanistan. With his father, a noted theologian, he left his native province for the West at the time of the Mongol invasion (1220 and the following decades) to settle finally in Konya (Anatolia), the capital of the Seljukid empire. In 1231, after his father's death, Rumi succeeded him in teaching Islamic theology and law; but the course of his life was changed by his meeting in 1244 with a dervish by the name of Shams-i Tabriz, "the Sun of Tabriz," who introduced him to the deepest mysteries of divine love. When Shams disappeared in 1246, Maulana, out of grief, gave himself to whirling dance at the sound of music and turned into a poet who poured out enthusiastic Persian verses. After more than a year, Shams was brought back; some months later, he disappeared once more, presumably murdered by jealous people in Maulana's entourage. Rumi finally realized that the lost friend lived in his heart, "radiant as the moon."

After being totally absorbed or, as he calls it, "burnt" in his friendship, Rumi encountered an illiterate goldsmith, Salahuddin Zarkob, who was able to act as a kind of spiritual mirror to him. This man was, Maulana felt, like a moon who could reflect the "Sun's" radiance. Maulana wrote a number of poems in his honor, and gave his eldest son in marriage to the goldsmith's daughter; his letters to this daughter-in-law show Rumi as a loving family man. Finally, in 1256, his favorite disciple, Husamuddin Chelebi, urged him to compose a *mathnawi*, a didactic poem in rhyming hemistichs, to teach the increasing circle of his disciples the essence of mystical life. This work is an encyclopedia of religious thought, mixed with tales, anecdotes, and aphorisms all bound together in a strange way, like the arabesques in Islamic art. Story grows out of story and turns into long commentaries on Koranic expressions or sayings of the Prophet Muhammad; or, a Koranic word triggers a new and often quite unexpected story. This work with its twenty-five thousand verses occupied Rumi to the end of his life (1273). Toward its close, the poem takes the reader or listener back to the very beginning, where the

poet had admonished Husamuddin not to divulge the secret of love, that is, the secret of Shams. Ultimately then, Rumi feels like a loving woman who hides her beloved's name in everything she utters, for there is no other beloved but he who radiates beauty.

Rumi's *Mathnawi* has been called "the Koran in the Persian tongue," and has been a source of inspiration for millions through the centuries. For the Western reader, Rumi's earlier, fiery poetry (some thirty-six thousand verses) is perhaps even more attractive than the *Mathnawi*, for the experience of overwhelming love is expressed more clearly in those Persian poems than in the slightly more didactic *Mathnawi* or in Rumi's prose writings. It is love, love in all its manifestations that forms the woof and warp of Rumi's verse. Divine love, which took him away from his scholarly pursuits (although he continued teaching to his last days) made him see everything in a special light. The Koran admonishes people to look at "God's signs in the horizons and in themselves" (Sura 41:53); Rumi is probably the only poet who took these words absolutely seriously: he saw the working of the Divine Spirit through the entire cosmos and well understood the Koranic words that everything is created to praise the Lord, the Creator. Thus whatever exists in this world became a "sign" for him. A sweetly caroling bird or an ass's foul-smelling dung, a slender tree or a hard rock, a proud lion or a wriggling worm—there was nothing that the touch of his poetry did not transform into a diaphanous sign of God's creative power. And that meant for him, the power of love.

Love, so he knew, transmutes everything. It changes sour grapes into sweet wine, grain into nourishing bread, copper into gold—provided that everything willingly undergoes the painful fermentation of love and is purified in the crucible of suffering. For every moment we die in a small way to be resurrected on a higher level, and in such a spiritual death we die to our mean and low qualities to reach a loftier stage of spiritual purity. This idea is implied in the *Mathnawi* verse with which we started our remarks. Life is a rising gamut of existence; it is, as Goethe called it, a constant process of "dying and becoming." One of the central adages for the Sufis was attributed to the Prophet Muhammad: "Die before ye die!" For as the moth casts itself into the candle's flame to become united with it, so everything rises to a new rung on the ladder of life by metaphorically dying time and again.

But this is not a theoretical, cerebral process, something negative or difficult; nay, Rumi saw the whole of life as a constant dance. He even saw creation as the response of not-being to the sweet music of the divine voice that addressed it: "Am I not your Lord?" (Sura 7:172). This dance permeates the whole universe, culminating in the dance of the stars around the central sun, which then is taken up in the dance of the dervishes whirling around

their own axes as well as around the master, the center who represents the "Sun." Casting off their black gowns and dancing in their wide white skirts, they symbolize in their movements the soul's purification and its final unification with the source of all creative love.

Rumi's work is inexhaustible; it has been studied to this day in the areas under Persian cultural influence. Numerous commentaries in the different Islamic languages were written through the ages, and there is barely a work in post-fourteenth-century Persian, and later Turkish, Urdu, and Sindhi literature, that does not refer to the *Mathnawi* or at least to its beginning, where Rumi admonishes his audience to listen to the sound of the reed flute as it talks about its separation from the reed bed. Likewise, the human soul constantly complains of being separated from its divine origin and longs to return to the eternal home. It is this yearning song which reminds us of our true home, and it is the power of love which leads us—sometimes in one enraptured leap, sometimes slowly and through painful periods of purification—to our origin or, in another image dear to Rumi, polishes our hearts so that they become radiant mirrors which finally reflect the beauty of the eternal Divine Beloved. All of life is nothing but the upward movement "from mineral to plant," which will end in the soul's return to the source of life, to the Divine Essence which, for Rumi, is nothing but love.

Hamm: I once knew a madman who thought the end of the world had come. He was a painter—and engraver. I had a great fondness for him. I used to go and see him, in the asylum. I'd take him by the hand and drag him to the window. Look! There! All that rising corn! And there! Look! The sails of the herring fleet! All that loveliness! [Pause.] *He'd snatch away his hand and go back into his corner. Appalled. All he had seen was ashes.* [Pause.] *He alone had been spared.* [Pause.] *Forgotten.* [Pause.] *It appears the case is . . . was not so . . . so unusual.*

—Samuel Beckett[1]

This lithograph by Michele Fanoli (1845, cat. no. 16) depicts eight of Antonio Canova's famous neoclassical tomb sculptures, including the tombs of Popes Clement XIII and XIV (1783–92, Saint Peter's, and 1783–87, Santi Apostoli, Rome), the tomb of Maria Christina of Hapsburg (1798–1805, Augustinerkirche, Vienna), and the centograph to the House of Stuart (1817–19, also in Saint Peter's). In each case, the marble mausoleum represents a barrier between the known and the unknown, between the world of the dead inside and the separate world outside. Closed doors prevent access from world to world, barring the living from entering. In Maria Christina's monument, however, figures walk toward and through the doorway, into the unknown, provoking the viewer to contemplate what they might find at their destination. The suggestion of another world is heightened by the presence of an angel to the right of the opening and the old man in rags at the end of the procession, distinguishing this journey from a standard funeral service. Using elements of his monument to Titian (1794–95, Venice, Museo Correr) in the design for the tomb of Maria Christina, Canova created a new kind of memorial, where "the centrality earlier accorded to the exaltation of the deceased is replaced by a meditation on the enigma of death, accompanied by a feeling of loss."[2]

1. Samuel Beckett, "Endgame," in Maynard Mack, ed., *The Norton Anthology of World Masterpieces*, vol. 2, 6th ed. (New York: W. W. Norton & Company, 1992), 946.

2. Correr Museum, Venice, and the Gipsoteca, Possagno, *Antonio Canova*, English ed. (New York: Marsilio Publishers, 1992), 166.

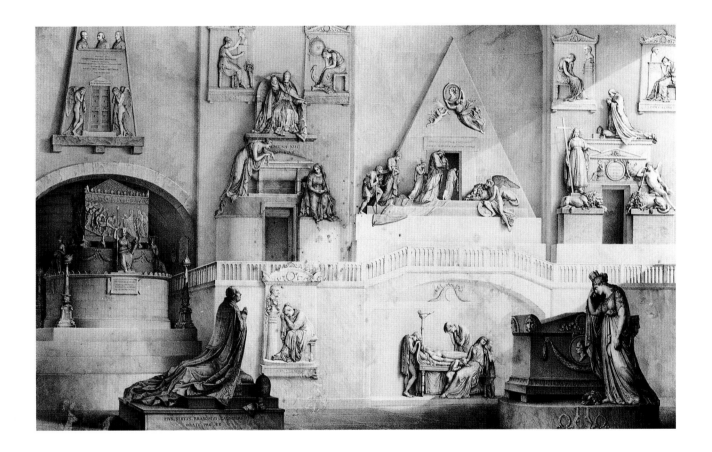

Michele Fanoli, *Tombs and Mausoleums in a Large
Underground Vault* (*Tombe e mausolei in un
vasto sotterraneo*), 1845, Museo Civico di Bassano del
Grappa , Italy, cat. no. 16.

. . . And since that's the case
I choke back my own
dark birdcall
my sobbing.
Oh who can we turn to
in this need?
Not angels
not people
and the cunning animals
realize at once
that we aren't especially
at home
in the deciphered world
What's left?
Maybe some tree
on a hillside
one that you'd see every day
and the perverse loyalty
of some habit
that pleased us
and then moved in for good. . . .

—Rainer Maria Rilke[1]

Many of Lucio Fontana's sculptures and paintings are titled *Spatial Concepts* (see cat. nos. 17–18, 20–24), expressing the artist's fundamental concern with the nature of space in art and inviting contemplation about the realms of the known and unknown. In his *White Manifesto* (1946), he asserted that art and science should be used together to create a feeling of the fourth dimension. He made painting—a traditionally two-dimensional medium entrenched in the modernist ideals of mid-century—reach into three dimensions, adhering elements to his canvases and puncturing and slashing his works. Through the holes and crevasses created by these ritual actions, the viewer sees black space, whose distance is not immediately determinable, evocative of a void beyond— much like the doors of Antonio Canova's tomb sculptures (see cat. no. 16).

Literally in works like the lead *Door of a Funerary Chapel* (1956, cat. no. 19), for the Saint Vito cemetery in Udine, Italy, or in sketches in clay and plaster for the doors of the Milan cathedral, Fontana explored the threshold, the physical separation between opposing realms. His religious sense is expressed entirely in abstract terms, as he imbues the act of cutting or excavating with mystical significance. The act itself becomes, as in some Zen procedures, the concentrated moment when a connection is made with something "beyond" the artist.

Fontana is distinguished in this exhibition by this act as the primary means of expression, so unlike Francis Bacon's productive use of the chance effects of thrown paint, for instance, or Ad Reinhardt's painting without marks of the brush. In the paintings, Fontana's act is destructive—he cuts or punctures through the surface; in the sculptures, many of which refer to plant forms (hence the generic title *Naturae* [cat. nos. 20–24]), the act is rapturous in the sexual sense—he invades the spherical shapes and, in effect, violates them.

1. Rainer Maria Rilke, *Duino Elegies*, trans. David Young (New York: W. W. Norton & Company, 1978), 19–20.

BORN IN ROSARIO, ARGENTINA, FOR MANY YEARS
Lucio Fontana (1899–1968) moved between
Argentina and Italy, until settling in Milan in
1947. Although he made a number of surrealist-
inspired drawings, his career until 1948 was
devoted to figurative and abstract sculpture; he
had worked in the sculpture studio of his father,
Luigi Fontana, and had studied sculpture
from 1928 until 1930 at the Accademia di Brera,
Milan. Throughout his life, Fontana was
involved with artist groups promoting avant-
garde and abstract art. Alone and with these
groups, he issued statements such as "First
Manifesto of Spatialism" (1947) and "Technical
Manifesto of Spatialism" (1951) in which he
related his theories of gesture and movement
(influenced by the Futurists) and of the relation-
ship of three- and two-dimensional space to
artmaking. Fontana began painting in 1948, and
in 1949 introduced punctures into a series
of canvases he titled *Buchi* (*Holes*). He integrated
collage elements such as pebbles, glass, and
ceramic chips into his works of the 1950s;
in 1958 or 1959, he slashed a canvas with a knife
out of frustration. From this point on, Fontana
fused his response to the act of slashing with
his ideas about dynamism and space in what he
called his *Concetti Spaziale* (*Spatial Concepts*)—
works in canvas, terra cotta, bronze, and paper.
Late in his life, Fontana made decorative
architectural projects, including ceilings using
neon. He died in Comabbio, Italy.

Further reading

Billeter, Erika. *Lucio Fontana, 1899–1968:
A Retrospective*. Exh. cat. New York: Solomon
R. Guggenheim Museum, 1977.

Blistène, Bernard. *Lucio Fontana 1899–1968*.
Exh. cat. Barcelona: Centre Cultural de la
Fundació Caixa de Pensions, 1988 [extensive
bibliography, exhibition history].

Celant, Germano. *The Italian Metamorphosis:
1943–1968*. Exh. cat. New York: Solomon
R. Guggenheim Museum, 1994 [manifestos
reprinted].

Licht, Fred. *Homage to Lucio Fontana*. Exh. cat.
Venice: Solomon R. Guggenheim Foundation,
Collezione Peggy Guggenheim, 1988
[chronology].

Van der Marck, Jan. *Lucio Fontana: The
Spatial Concept of Art*. Exh. cat. Minneapolis:
Walker Art Center, 1988.

Lucio Fontana, *Spatial Concept (Concetto spaziale)*,
1961, Penny Pritzker and Bryan Traubert, cat. no. 18.

Lucio Fontana, *Door of a Funerary Chapel (Porta della capella funebre)*, 1956, Private collection, Switzerland, cat. no. 19.

▸ Lucio Fontana, *Spatial Concept: Nature (Concetto spaziale: Natura)*, 1959–60 (cast 1965), Hirshhorn Museum and Sculpture Garden, Simthsonian Institution, Washington, D.C., Gift of Joseph H. Hirshhorn, 1980, cat no. 20–24.

Soon after graduating from the University of California, Davis in 1966, Bruce Nauman worked in a storefront studio in San Francisco. There he made two works, a Mylar screen with the inscription "the artist is an amazing luminous fountain" (illus. p. 44), and a neon spiral declaring "the true artist helps the world by revealing mystic truths" (1967, cat. no. 54). The neon was displayed in the window like a store sign, offering a clue to the identity of the artist and what it was he was making. Nauman's note on this work is an apt summary of the aspirations of this exhibition:

> The most difficult thing about the whole piece for me was the statement. It was a kind of test—like when you say something out loud to see if you believe it. Once written down, I could see that the statement, "The true artist helps the world by revealing mystic truths," was on the one hand a totally silly idea and yet, on the other hand, I believed it. It's true and not true at the same time. It depends on how you interpret it and how seriously you take yourself. For me it's still a very strong thought.[1]

1. Bruce Nauman, quoted in Robert Storr, "Beyond Words," in Neal Benezra and Kathy Halbreich, *Bruce Nauman: Exhibition Catalogue and Catalogue Raisonné*, ed. Joan Simon (Minneapolis: Walker Art Center in association with the Hirshhorn Museum and Sculpture Garden, Smithsonian Institution, 1994), 62.

Bruce Nauman, *Window or Wall Sign*, 1967, private collection, courtesy Leo Castelli Gallery, New York, cat. no. 54.

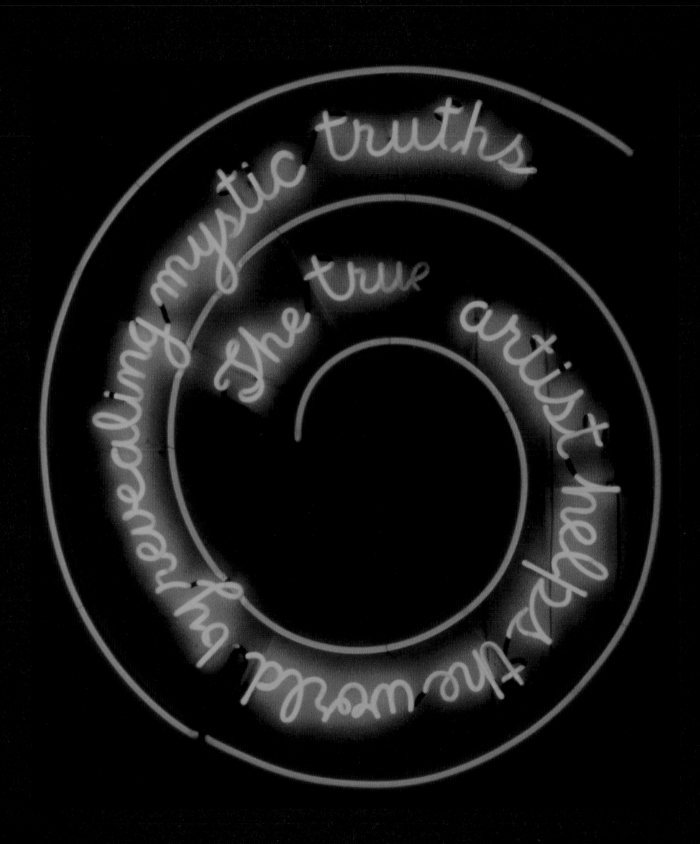

Dimensions are listed in inches followed by centimeters in parentheses; height precedes width precedes depth.

Apache (Arizona or New Mexico)
1. *Basket*, 1880s
Coiled fiber with geometric design
H. 5 (12.7), diam. 15 3/4 (40)
The Field Museum, Chicago, Collected by Captain Crawford prior to 1890 and donated by Edward E. Ayer in 1894 (17637)

Francis Bacon (British, b. Ireland 1909–1992)
2. *Study for a Portrait*, 1949
Oil on canvas
58 13/16 x 51 7/16 (149.4 x 130.7)
Museum of Contemporary Art, Chicago, Gift of Joseph and Jory Shapiro

3. *Studies from the Human Body*, 1970
Oil on canvas
Three panels, each 78 15/16 x 58 1/16 (200.5 x 147.5)
Private collection

4. *Study from the Human Body*, 1983
Oil and pastel on canvas
78 x 58 1/8 (198.1 x 147.6)
The Menil Collection, Houston

Joseph Beuys (German, 1921–1986)
5. *Herb Robert*, 1941
Dried and pressed flowers with pencil on paper
9 1/2 x 6 1/8 (24.2 x 15.5)
Edward C. Cohen, New York

6. *Untitled (Vitrine with Air-Raid Precautions) (Ohne Titel [Vitrine mit Luftschutz])*, 1962–83
Glass, painted wood, galvanized metal, containing: *Untitled*, 1962 (plastic container holding linseed oil, fat, knife, ladle, painted and collaged cardboard lid attached with string); *Air Raid First Aid Kit*, 1967 (painted metal box, printed list, butter, copper rod, paper, metal, mechanical parts); *Cake of Berry Seeds*, 1960s (red currant seeds, fruit pulp, felt); *Fontana Tin*, 1967 (tin can mounted on cardboard box); *I Know No Weekend*, 1972 (black cardboard suitcase); *Rose for Direct Democracy*, 1973 (glass, measuring cylinder, water); *Vino FIU*, 1983 (red wine bottle, cardboard carton of twelve red wine bottles); Immanuel Kant's *Critique of Pure Reason*; a bottle of *Maggi Würze*; *Untitled* n.d. (metal water bottle with Braunkreuz cross)
81 1/8 x 86 5/8 x 19 11/16 (206 x 220 x 50)
Solomon R. Guggenheim Museum, New York

7. *Untitled (Vitrine)*, 1975–83
Glass, painted wood, galvanized metal, containing: *Magnetic Rubbish*, 1975 (magnetized steel with razor blade); *Untitled*, 1976 (first castings for *Tramstop*); *Samurai Sword*, 1983 (steel blade, felt); *Element*, 1984–86 (felt); *Untitled* (copper battery); *Untitled* (copper, insulating tape); *Untitled* (felt, razor blades); *Untitled* (pig iron); *Untitled* (rail, hammer)
81 3/8 x 86 5/8 x 19 3/4 (206.7 x 220 x 50.2)
Tate Gallery, London

8. *Ombelico di Venere–Cotyledon Umbilicus Veneris*, 1985
Pressed plants with pencil on paper
Ten sheets: 8 3/4 x 8 (22.2 x 20.4); 9 1/4 x 8 1/8 (23.5 x 20.7); 8 1/4 x 9 (20.8 x 23); 10 1/4 x 13 1/8 (26 x 33.5); 8 3/4 x 18 1/4 (22.2 x 46.2) irregular; 9 3/4 x 14 5/8 (24.7 x 37.3) iregular; 7 3/8 x 18 1/8 (18.6 x 46.1) irregular; 10 1/8 x 15 1/8 (25.7 x 38.3) irregular; 16 1/2 x 20 (41.9 x 50.8) irregular; 16 1/2 x 19 3/4 (41.9 x 50.1) irregular
Christine and Isy Brachot, Brussels

James Lee Byars (American, b. 1932)
9. *The Monument to Language*, 1995
Bronze, gold leaf
Diam. 118 1/8 (300)
Fondation Cartier pour l'Art Contemporain, Paris

John Cage (American, 1912–1992)
10. *Chess Pieces*, 1943
Gouache with black and white inks on masonite
18 3/4 x 18 3/4 (47.6 x 47.6)
Private collection, Chicago

Chaco Black-on-White (New Mexico, Chaco Canyon)
11. *Pitcher*, 11th century
Fired clay, painted black-on-white geometric design
H. 6 3/4 (17.2), diam. 5 ½ (14)
The Field Museum, Chicago, Collected by Richard Wetherill prior to 1904 and purchased in 1905 (81508)

Giorgio Giulio, called Giulio Clovio (Croatia 1498–1578 Rome)
12. *The Rape of Ganymede*, after Michelangelo, after 1532
Black chalk on white paper
7 1/2 x 8 1/2 (19 x 21.6)
The Duke of Devonshire and the Chatsworth Settlement Trustees, Derbyshire, England

Cowichan (British Columbia, Vancouver Island)
13. *Box*, 1890s
Wood, painted in red and black, inlaid with abalone and opercula shell, hide string handle
12 3/4 x 29 x 15 1/2 (32.4 x 73.7 x 39.4)
The Field Museum, Chicago, Collected by Charles Newcombe for The Field Museum, 1902 (79389)
[withdrawn from the exhibition]

Edwin H. Davis (American, 1811–1888) and Ephraim G. Squier (American, 1821–1888)
14. *Ancient Monuments of the Mississippi Valley*
Washington D.C.: Smithsonian Institution, 1848
One volume, 304 pages
12 7/8 x 10 1/8 x 1 1/4 (32.5 x 25.5 x 4)
The Newberry Library, Chicago

Albrecht Dürer (German, 1471–1528)
15. *Melancholy I (Melancholia I)*, 1514
Engraving
9 7/8 x 7 3/4 (25 x 19.7), sheet
The Art Institute of Chicago, The Potter Palmer Collection

Michele Fanoli (Italian, 1807–1876)
16. *Tombs and Mausoleums in a Large Underground Vault (Tombe e mausolei in un vasto sotterraneo)*, 1845
From the series *Tavole Canoviane*, after Antonio Canova's tomb sculptures
Lithograph
24 15/16 x 32 3/8 (63.3 x 82.2), sheet
Museo Civico di Bassano del Grappa, Italy

Lucio Fontana (Italian, b. Argentina, 1899–1968)
17. *Spatial Concept (Concetto spaziale)*, 1949
Silver oil paint on canvas
19 11/16 x 29 9/16 (50 x 75)
Collection Fontana, Milan
[withdrawn from the exhibition]

18. *Spatial Concept (Concetto spaziale)*, 1961
Oil on canvas
43 5/16 x 31 7/8 (110 x 81)
Penny Pritzker and Bryan Traubert

19. *Door of a Funerary Chapel (Porta della capella funebre)*, 1956
Lead
62 13/16 x 29 1/2 x 1 9/16 (159.5 x 75 x 4)
Private collection, Switzerland

20. *Spatial Concept: Nature (Concetto spaziale: Natura)*, 1959–60 (cast 1965)
Bronze
H. 33 3/4 (85.7), diam. 41 1/4 (104.7)
Hirshhorn Museum and Sculpture Garden, Smithsonian Institution, Washington, D.C., Gift of Joseph H. Hirshhorn, 1980

21. *Spatial Concept: Nature (Concetto spaziale: Natura)*, 1959–60 (cast 1965)
Bronze
H. 33 1/4 (84.5), diam. 35 3/8 (89.9)
Hirshhorn Museum and Sculpture Garden, Smithsonian Institution, Washington, D.C., Gift of Joseph H. Hirshhorn, 1980

22. *Spatial Concept: Nature (Concetto spaziale: Natura)*, 1959–60 (cast 1965)
Bronze
H. 29 (73.7), diam. 35 (88.9)
Hirshhorn Museum and Sculpture Garden, Smithsonian Institution, Washington, D.C., Gift of Joseph H. Hirshhorn, 1980

23. *Spatial Concept: Nature (Concetto spaziale: Natura)*, 1959–60 (cast 1965)
Bronze
H. 36 5/8 (93), diam. 37 1/2 (95.2)
Hirshhorn Museum and Sculpture Garden, Smithsonian Institution, Washington, D.C., Gift of Joseph H. Hirshhorn, 1980

24. *Spatial Concept: Nature (Concetto spaziale: Natura)*, 1959–60 (cast 1965)
Bronze
H. 36 1/4 (92), diam. 43 3/8 (110.1)
Hirshhorn Museum and Sculpture Garden, Smithsonian Institution, Washington, D.C., Gift of Joseph H. Hirshhorn, 1980

Haida (Northwest Coast)
25. *Food Dish*, 1880s
Wood, carved with totemic designs, inlaid with opercula shell
8 x 18 x 14 (20.3 x 45.7 x 35.6)
The Field Museum, Chicago, Collected c. 1893 by James Deans for the World's Columbian Exposition (1900I)

Shirazeh Houshiary (Iranian, b. 1955)
26. *Turning around the Centre*, 1993
Lead, gold leaf
Four units, each 39 7/16 x 39 7/16 x 39 7/16 (100 x 100 x 100)
Lisson Gallery, London

Indian, Mughal Period
27. *Rosette (Shamsa) from an Album*, c. 1640–50
Opaque watercolor, gold on paper
14 7/16 x 9 7/16 (36.6 x 24)
Arthur M. Sackler Museum, Harvard University Art Museums, Private collection

Jean-Auguste-Dominique Ingres (French, 1780–1867)
28. *Study for Saint Helena*, c. 1842
Graphite on cream wove paper
10 9/16 x 7 3/16 (26.9 x 18.3)
The Art Institute of Chicago, Gift of Robert Allerton

Italian, Florentine
29. *Saint John the Baptist in the Desert*, c. 1440–50
Tempera on panel
14 15/16 x 10 3/4 (38 x 27.4)
Indiana University Art Museum, Bloomington, Kress Study Collection

Anselm Kiefer (German, b. 1945)
30. *The Order of Angels (Die Ordnung der Engel)*, 1983–84
Oil, acrylic, emulsion, shellac, straw on canvas with cardboard and lead
130 x 218 1/2 (330 x 555)
The Art Institute of Chicago, Restricted gift of the Nathan Manilow Foundation, Lewis and Susan Manilow, and the Samuel A. Marx Funds

31. *Osiris and Isis (Osiris und Isis)*, 1985–87
Oil, acrylic, emulsion, clay, porcelain, lead, copper wire, circuit board on canvas
150 x 220 1/2 x 6 1/2 (381 x 560.1 x 16.5)
San Francisco Museum of Modern Art, Purchased through a gift of Jean Stein, by exchange, the Mrs. Paul L. Wattis Fund, and the Doris and Donald Fisher Fund

32. *Yggdrasil*, 1985–91
Emulsion, acrylic, lead on canvas
86 5/8 x 74 13/16 (220 x 190)
McMaster University, Hamilton, Ontario, Levy Bequest Purchase

33. *Heavy Water (Schwerenwasser)*, 1991
Ten double-page photographic images, with gold paint, mounted on paper and bound with lead
27 5/8 x 20 3/4 (70 x 51 x 2)
Susan and Lewis Manilow

Paul Klee (Swiss, 1879–1940)
34. *New Angel (Angelus Novus)*, 1920
Oil transfer, watercolor on paper
12 1/2 x 9 1/2 (31.8 x 24.2)
The Israel Museum, Jerusalem, Gift of Fania and Gershom Scholem, John and Paul Herring, Jo-Carole and Ronald Lauder
[Available for loan for only a portion of the exhibition period.]

35. *Submersion and Separation (Senkung und Scheidung)*, 1923
Watercolor on paper
9 3/4 x 12 1/2 (24.8 x 31.8)
The Arts Club of Chicago, Arthur Heun Bequest

Agnes Martin (American, b. Canada, 1912)
36. *Grey Stone II*, 1961
Oil, gold leaf on canvas
74 3/4 x 73 3/4 (189.9 x 187.3)
Emily Fisher Landau, New York

37. *The Beach*, 1964
Oil, pencil, pen on canvas
75 x 75 (190.5 x 190.5)
Lannan Foundation, Los Angeles

38. *The Tree*, 1964
Oil, pencil on canvas
72 x 72 (182.9 x 182.9)
The Museum of Modern Art, New York, Larry Aldrich Foundation Fund, 1965

39. *Leaf*, 1965
Acrylic, graphite on canvas
72 x 72 (182.9 x 182.9)
Mr. and Mrs. Daniel W. Dietrich II

40. *Hill*, 1967
Acrylic, graphite on canvas
72 x 72 (182.9 x 182.9)
Mr. and Mrs. Daniel W. Dietrich II

41. *Untitled No. 3*, 1974
Acrylic, pencil, Shiva gesso on canvas
72 x 72 (182.9 x 182.9)
Des Moines Art Center, Iowa, Purchased with funds from the Coffin Fine Arts Trust, Partial gift of Arnold and Mildred Glimcher, Nathan Emory Coffin Collection of the Des Moines Art Center

42. *Beauty Is the Mystery of Life*, 1989
Mead Spell-write Steno notebook, one volume, handwritten notes for a lecture at the Carnegie Museum of Art, Pittsburgh, on 7 January 1989, and the Museum of Fine Arts, Santa Fe, in April 1989
9 x 6 (22.8 x 15.2)
Collection of the artist, courtesy of PaceWildenstein

Thomas Merton (American, 1915–1968)
43. *Grasses by Door*, 1960s
Modern photographic print
8 x 10 (20.3 x 25.4)
Merton Legacy Trust

44. *Rocks*, 1960s
Modern photographic print
8 x 10 (20.3 x 25.4)
Merton Legacy Trust

45. *Rocks*, 1960s
Modern photographic print
8 x 10 (20.3 x 25.4)
Merton Legacy Trust

193

46. *Rocks and Shadow*, 1960s
Modern photographic print
8 x 10 (20.3 x 25.4)
Merton Legacy Trust

47. *Tree Root*, 1960s
Modern photographic print
8 x 10 (20.3 x 25.4)
Merton Legacy Trust

48. *Tree Root*, 1960s
Modern photographic print
8 x 10 (20.3 x 25.4)
Merton Legacy Trust

49. *Tree Roots*, 1960s
Modern photographic print
8 x 10 (20.3 x 25.4)
Merton Legacy Trust

50. *Tree Roots*, 1960s
Modern photographic print
8 x 10 (20.3 x 25.4)
Merton Legacy Trust

51. *View from Inside*, 1960s
Modern photographic print
8 x 10 (20.3 x 25.4)
Merton Legacy Trust

52. *Water*, 1960s
Modern photographic print
8 x 10 (20.3 x 25.4)
Merton Legacy Trust

Ludwig Mies van der Rohe (German, 1886–1969)
53. *Friedrichstrasse Skyscraper*, preliminary
perspective (north and east sides), 1921
Charcoal, pencil on heavy, rough beige paper
42 3/4 x 29 1/2 (108.5 x 74.9)
The Mies van der Rohe Archive, The Museum of
Modern Art, New York, Gift of the architect

Bruce Nauman (American, b. 1941)
54. *Window or Wall Sign*, 1967 (exhibition copy)
Neon tubing with glass tubing suspension frame
Suspension frame: 59 x 55 x 2 (149.9 x 139.7 x 5.1)
Private collection, exhibition copy courtesy Leo
Castelli Gallery, New York

55. *Consummate Mask of Rock*, 1975 (exhibition
copy)
Limestone; typewriting, paper, and tape on paper
Sculpture: eight units, each 14 x 14 x 14 (35.6 x.35.6
x 35.6); eight units, each 15 x 15 x 15 (38.1 x 38.1 x
38.1)
Text: 39 1/2 x 10 1/2 (100.3 x 49.5), framed
Dimensions of installation variable
Anthony d'Offay Gallery, London

56. *One Hundred Live and Die*, 1984 (exhibition
copy)
Neon tubing mounted on four metal monoliths
118 x 132 1/4 x 21 (299.7 x 335.9 x 53.3)
Benesse Corporation, Naoshima Contemporary
Art Museum, Japan

New Mexico State Highway Department
57. *1942 Official Road Map of New Mexico*
Black printing inks with notations in black ink, red
pencil, black felt-tip marker, colored crayon, on
off-white paper, c. July 1945
20 x 16 1/2 (50.8 x 41.9)
National Archives, Washington, D.C.

Barnett Newman (American, 1905–1970)
58. *Covenant*, 1949
Oil on canvas
47 3/4 x 59 5/8 (121.3 x 151.4)
Hirshhorn Museum and Sculpture Garden,
Smithsonian Institution, Washington, D.C., Gift
of Joseph H. Hirshhorn, 1972

59. *Galaxy*, 1949
Oil on canvas
24 x 20 (61 x 50.8)
Lynn and Allen Turner

60. *Onement IV*, 1949
Oil and casein on canvas
33 x 38 (83.8 x 96.5)
Allen Memorial Art Museum, Oberlin College,
Ohio, Ruth C. Roush Fund for Contemporary Art,
National Endowment for the Arts Museum
Purchase Plan, and an anonymous donor

61. *The Promise*, 1949
Oil on canvas
52 x 70 (132.1 x 177.8)
Adriana and Robert Mnuchin

62. *Joshua*, 1950
Oil on canvas
36 x 25 (91.4 x 63.5)
Marcia and Irving Stenn, Chicago

63. *Onement V*, 1952
Oil on canvas
60 x 38 (152.4 x 96.5)
Mr. and Mrs. David Pincus

64. *Northwest Coast Indian Painting*
New York: Betty Parsons Gallery, 1946
One folded paper sheet, 4 pages
8 5/16 x 11 (13.5 x 27.9)
William Morris Hunt Memorial Library, Museum
of Fine Arts, Boston

Nootka (British Columbia, Vancouver Island)
65. *Transformation Mask*, 1890s
Carved and painted wood, feathers
H. 21 1/4 (54) overall, w. 12 3/16 (31) closed, l. 28
3/16 (72) overall
The Field Museum, Chicago, Collected by Charles
Newcombe for The Field Museum, 1903–4 (85234)

possibly North African
66. *Schematic Diagram for an Amulet*, 19th century
Ink on parchment
50 x 3 1/4 (127 x 8.3)
Spertus Museum, Chicago

**Pima (Arizona, Maricopa County, Salt River
Reservation)**
67. *Basket*, 1890s
Coiled willow and devil's claw with radiating star
pattern
H. 5 1/2 (14), diam. 19 (48.3)
The Field Museum, Chicago, Collected by
Stephen C. Simms for The Field Museum, 1901
(63214)

Nicolas Poussin (French, 1594–1665)
68. *Landscape with Saint John on Patmos*, 1640
Oil on canvas
40 x 53 1/2 (101.8 x 136.3)
The Art Institute of Chicago, A. A. Munger
Collection

Ad Reinhardt (American, 1913–1967)
69. *Abstract Painting, 1950–51*, 1950–51
Oil, acrylic on canvas
78 x 24 (198.1 x 61)
Lannan Foundation, Los Angeles

70. *Abstract Painting, Blue*, 1952
Oil on canvas
75 x 28 (190.5 x 71.1)
The Carnegie Museum of Art, Pittsburgh, Gift of
the Women's Committee

71. *Untitled (Composition No. 104)*, 1954–60
Oil on canvas
108 1/4 x 40 1/8 (274.6 x 101.6)
The Brooklyn Museum, New York, Gift of the
Artist

72. *M*, 1955
Oil on canvas
47 7/8 x 11 7/8 (121.6 x 30.2)
Walker Art Center, Minneapolis, Gift of Virginia
Dwan

73. *Small Painting for T. M. (Thomas Merton)*,
1957
Oil on canvas
10 1/2 x 8 (26.7 x 20.3)
Abbey of Gethsemani, Trappist, Kentucky

74. *Abstract Painting, 1960–1965*, 1960–65
Oil on canvas
60 x 60 (152.4 x 152.4)
Lannan Foundation, Los Angeles

75. *Abstract Painting*, 1962
Oil on canvas
60 1/8 x 59 7/8 (152.7 x 152)
Museum of Contemporary Art, Chicago, Gift of
William J. Hokin

76. *Untitled* (*manuscript*), n.d.
Ink on typing paper
Two sheets, each 11 x 8 1/8 (28 x 21.6)
Anna Reinhardt, courtesy PaceWildenstein

Reserve Black-on-White (New Mexico, Ancient
Mongollon Culture)
77. *Pitcher*, 11th century
Fired clay, handle, black-on-white painted
geometric design
H. 8 1/2 (21.6), diam. 8 1/2 (21.6)
The Field Museum, Chicago, Collected by Henry
Hales prior to 1893 and purchased in 1894 (21250)

Glenn T. Seaborg (American, b. 1912)
78. *Nuclear Milestones*
San Francisco: W. H. Freeman and Company,
1972
One volume, 390 pages
8 1/2 x 5 7/16 x 7/8 (21.6 x 1.38 x .24)
The University of Chicago Library

Henry David Thoreau (American, 1817–1862)
79. *Walden, or, Life in the Woods*
Boston: Tinknor and Fields, 1854
One volume, first edition, 357 pages
7 7/16 x 5 x 1 5/16 in. (19 x 12.5 x 3)
The Newberry Library, Chicago

80. *Autograph Journal*, 31 August 1852–7 January
1853
One of 40 volumes
Bound notebook, c. 164 pages, written in brown
ink
10 x 8 3/4 (25.4 x 20.3 1.9)
The Pierpont Morgan Library, New York,
Purchased by Pierpont Morgan with the Wakeman
Collection, 1909

Tibetan
81. *The Mandala of a Yi-dam*, 19th century
Tangka in colors on cotton, mounted on brocade
33 1/2 x 24 5/8 (85.1 x 62.5)
The Nelson-Atkins Museum of Art, Kansas City,
Missouri, Bequest of Joseph H. Heil

Tularosa Black-on-White (Arizona, Ancient Anasazi
Culture)
82. *Jar with Relief Animal Head*, 12th century
Fired clay, black-on-white painted geometric
design
H. 6 (14.2), diam. 5 1/2 (14)
The Field Museum, Chicago, Collected by F. J.
Wattron, c. 1898 and donated to The Field
Museum by Stanley McCormick in 1901 (73953)

Bill Viola (American, b. 1951)
83. *Room for Saint John of the Cross*, 1983
Projection screen, cubicle, with desk, color
monitor, pitcher, glass of water
Cubicle: 71 x 59 x 67 (180 x 150 x 170), dimensions
of installation variable
The Museum of Contemporary Art, Los Angeles,
The El Paso Natural Gas Company Fund for
California Art

Walt Whitman (American, 1819–1892)
84. *Leaves of Grass*
Brooklyn, N.Y.: [N.p.], 1855
One volume, first edition, first issue, 95 pages
11 1/2 x 8 1/4 x 3/8 (29 x 20.5 x 1)
The Newberry Library, Chicago

Frank Lloyd Wright (American, 1867–1959)
85. *National Life Insurance Company Building
Project, Chicago, Illinois*, perspective, 1924–25
Pencil, color pencil, ink on paper
49 1/2 x 41 1/2 (125.7 x 105.4)
Private collection, Chicago

86. *Unity Temple, Oak Park, Illinois*, perspective,
1904
Pencil, ink on paper
10 1/4 x 12 1/4 (26 x 31.2)
LINC Group, Chicago

HOMI K. BHABHA is Professor of English and Art History at the University of Chicago and writes a regular column for *Artforum*. He is the editor of *Nation and Narration* (1990) and author of *The Location of Culture* (1993). He is currently working on two books, *A Measure of Dwelling*, and a history of cosmopolitanism.

YVE-ALAIN BOIS is Joseph Pulitzer, Jr. Professor of Modern Art at Harvard University and an editor of *October*. He has contributed to several exhibition catalogues, including *Ad Reinhardt* (1991), *Ellsworth Kelly: The Years in France 1848–1954* (1992), *Ed Ruscha: Romance with Liquids, Paintings 1966–1969* (1993), and *Henri Matisse: 1904–1917* (1993), and co-curated *Piet Mondrian 1872–1944* (1995). A compilation of his essays was published as *Painting as Model* (1991). Bois is organizing an exhibition with Rosalind Krauss titled *L'Informe* for the Centre Georges Pompidou, Paris, and has two books in progress.

GEORGES DIDI-HUBERMAN is an art historian, philosopher, and professor at the Ecole des Hautes-Etudes en Sciences Sociales, Paris. Didi-Huberman is the author of eleven books, including *Devant l'image* (1990), *Fra Angelico: Dissemblance et figuration* (1992, reprinted in English, 1995), *Le Cube et le visage: Autour d'une sculpture d'Alberto Giacometti* (1993), and *La Ressemblance informe* (1995). He has three books in press.

WENDY DONIGER is Mircea Eliade Professor of the History of Religions at the University of Chicago, in the Divinity School, the Department of South Asian Languages and Civilizations, and the Committee on Social Thought. She is the author and editor of numerous books on religion and Hindu mythology including, most recently, *Other People's Myths: The Cave of Echoes* (1988). In progress are books on *The Mythology of Horses in India*, *The Bed Trick: Sex, Myth, and Masqurade*, and a novel, *Horses for Lovers, Dogs for Husbands*.

KENNETH FRAMPTON is Ware Professor of Architecture at Columbia University, New York. He is the author of numerous essays and several books including *Modern Architecture: A Critical History* (1980) and *Studies in Tectonic Culture: The Poetics of Construction in Nineteenth- and Twentieth-Century Architecture* (1995).

RICHARD FRANCIS is Chief Curator and James W. Alsdorf Curator of Contemporary Art at the Museum of Contemporary Art, Chicago. Formerly, Francis was a curator at the Tate Gallery, London, and was the founding curator of the Tate Gallery Liverpool. He is the author of *Jasper Johns* (1984), and the curator and author of *Radical Scavenger(s): The Conceptual Vernacular in Recent American Art* (1994). Francis is the curator of *Negotiating Rapture*.

MARTIN E. MARTY is Fairfax M. Cone Distinguished Service Professor at the University of Chicago, where he teaches in three faculties. Marty is the author of forty-five books including *Righteous Empire* (1972), for which he won the National Book Award. His most recent book is *Under God, Indivisible*, the third volume in his Modern American Religion series for the University of Chicago Press, which is also publishing the six-volume outcome of the Fundamentalism Project, which he directed for the American Academy of Arts and Sciences.

DAVID MORGAN is Associate Professor of Art History and chairman of the Department of Art at Valparaiso University, Indiana. Morgan is the editor of *Icons of American Protestantism: The Art of Warner Sallman* (1996) and is currently completing a book on *Imaging the Faith: Mass-Produced Imagery and American Protestant Piety*, which examines the historical relations among media, mass production, and popular religious belief.

JOHN HALLMARK NEFF is Director of the Art Program and Art Advisor to the First National Bank of Chicago and a member of the Board of Directors of the College Art Association. Neff has written extensively on Barnett Newman and Anselm Kiefer, contributing an essay to *Anselm Kiefer: Brüch und Einung* (1988), as well as Roger Ackling, Agnes Denes, and Robert Irwin. He is currently conducting further research on Kiefer and writing an essay on contemporary museum architecture.

ANNEMARIE SCHIMMEL was Professor of Indo-Muslim Culture at Harvard University from 1966 until 1992. She is the author of more than eighty scholarly works in German, English, and Turkish, including a book on Jalaluddin Rumi, an introduction to Islam, *Calligraphy and Islamic Culture* (1984), and, most recently, *Deciphering the Signs of God: A Phenomenological Approach to Islam* (1994). She lives in Bonn.

SOPHIA SHAW is a curatorial assistant at the Museum of Contemporary Art, Chicago, and coordinator of *Negotiating Rapture*. She assisted Charles F. Stuckey with the exhibition and catalogue *Claude Monet: 1840–1926* (1995), and is currently preparing a history of the permanent collection of The Arts Club of Chicago.

LEE SIEGEL is Professor of Religion at the University of Hawaii. He has written numerous articles and eight books, including *Sacred and Profane Love in Indian Traditions* (1979), *Laughing Matters: India's Comic Tradition* (1990), *Net of Magic: Wonders and Deceptions in India* (1991), and *City of Dreadful Night: A Tale of Horror and the Macabre in India* (1995). He is currently at work on *Love in a Dead Language*, a romance novel about India.

HELEN TWORKOV is editor-in-chief of *Tricycle: The Buddhist Review* and author of *Zen in America: Profiles of Five Teachers* (1989).